THE
STORY
OF
WHAT
IS
BROKEN
IS
WHOLE

THE STORY OF WHAT IS BROKEN IS WHOLE

AN AURORA LEVINS MORALES READER

Aurora Levins Morales

DUKE UNIVERSITY PRESS *Durham and London* 2024

© 2024 DUKE UNIVERSITY PRESS
All rights reserved
Printed in the United States of America on acid-free paper ∞
Project Editor: Liz Smith
Designed by Matthew Tauch
Typeset in Adobe Jenson Pro and Canela Text by Westchester
Publishing Services

Library of Congress Cataloging-in-Publication Data
Names: Levins Morales, Aurora, [date] author.
Title: The story of what is broken is whole : an Aurora Levins Morales
reader / Aurora Levins Morales.
Other titles: Aurora Levins Morales reader
Description: Durham : Duke University Press, 2024. | Includes
bibliographical references and index.
Identifiers: LCCN 2023057431 (print)
LCCN 2023057432 (ebook)
ISBN 9781478030935 (paperback)
ISBN 9781478026686 (hardcover)
ISBN 9781478059912 (ebook)
Subjects: BISAC: SOCIAL SCIENCE / People with Disabilities | SOCIAL
SCIENCE / Jewish Studies | LCGFT: Literature.
Classification: LCC PS3562.E915 S76 2024 (print) | LCC PS3562.E915
(ebook) | DDC 814/.54—dc23/eng/20240510
LC record available at https://lccn.loc.gov/2023057431
LC ebook record available at https://lccn.loc.gov/2023057432

Cover art: Portrait of Aurora Levins Morales by Rebeca
Garcia-Gonzalez.

publication supported by a grant from
The Community Foundation for Greater New Haven
as part of the **Urban Haven Project**

Contents

Gratitudes

How do you begin to acknowledge the people who helped to shape an entire writing life? That would be a memoir. The list is too long and I know I would wake up in the night, after the book is in production, and remember people who should most obviously have been mentioned with gratitude and slipped between the fingers of memory.

So I will start with the most essential, material, and mundane.

My parents, Rosario Morales and Richard Levins, who bought and held onto this land where I now live; my father, who proposed that they subsidize my life as a disabled revolutionary artist for the last decade of his life, and advanced me funds from a future inheritance to build my nontoxic movable tiny house; and Ricardo, my brother, and his wife, Paula, who repaid that loan so I wouldn't have to. All the people who donated money so I could build and live in this little house that I brought to Puerto Rico, where I sit at my mother's old sewing table, looking out into the rainforest, and write.

Luz Guerra and I were young Puerto Rican poets together in the San Francisco Bay Area of the 1970s. Many years later, she became my part-time administrative assistant, work she does remotely from Texas. Her capacity to handle the administrative side of my life, tasks that my brain injuries either don't allow me to do at all, or only poorly, with many mistakes and much exhaustion, makes my writing life, and many other areas of my day-to-day existence, possible. She works with efficiency and grace, and I am more grateful than I can say.

Gwyn Kirk has been my friend and person to think and groan and laugh and brainstorm with since 2005. We talk twice a month, and I call her whenever I get stuck on a piece of thinking or poisoned by the idea that I haven't done or am not doing enough. Gwyn is a living compass for me, blessed with political and intellectual clarity, humor, and healthy skepticism, all of which she offers me on a regular basis.

Nola Hadley and I have been close friends since Kosta Bagakis created a writing group for me to lead back in 1983, we think. We can laugh so hard

over the ridiculous ways of the world, and strengthen each other through all the trials of what we have to handle. We've navigated being subversive historians, lifting up Indigenous and female and working-class and decolonial truths from our different kinships and places, through the same storms of deceit and erasure. We've parented side by side, and survived. This writing life would have been impoverished without her.

Minnie Bruce Pratt was one of my most important teachers, mentors, allies. I called her up before I applied to Union Institute because I knew I would only do so if she agreed to be my core faculty person, a far richer and more engaged role than just an advisor. She got my back every step of the way, which I needed, embarking on a feminist, anti-colonial, anti-racist, class-conscious retelling of the history of the Atlantic world, centered on Puerto Rican women and written in prose poetry. She would not allow anyone to disrespect me or my work, block me with arbitrary gatekeeping, or behave dismissively. Her incisive questions and razor-sharp defenses of me were always delivered softly, in her honey warm southern voice. When anyone tried to put me in my place, she would lock eyes with them and say firmly that "we consider Aurora to be one of our most brilliant scholars." We remained connected, speaking rarely, but treasuring each other's presence in the world. That her death was swift and unexpected was a shock, but having witnessed the slow, cruel decline of her beloved Leslie, I am glad she didn't have to endure the same. Dearest Minnie Bruce, thank you for everything.

No writer, at least no writer of my kind, creates in isolation. I have had the fortune to move among many circles of politically committed poets, essayists and fiction writers, scholars and performers, some of them friends and collaborators, some inspiring and bracing me from afar, without their knowledge. I moved in rivers, pools, confluences of people and ideas and art that are far too complex to name in a list of thanks. There are a few that strike me today.

The Berkeley Women's Center Writing Workshop, led by Susan Lurie, that launched me into public readings in 1977.

Cherríe Moraga, whom I met the summer of 1978 when we were both working for Diana Russell's NIMH (National Institute on Mental Health) study on the prevalence of sexual violence. We wrote and dreamed together for a while and she dragged me into *This Bridge Called My Back*, written by a dazzling and ferocious crew of radical women of color, together making the soil in which I grew.

Nancy Bereano, who invited my mother and me to write *Getting Home Alive* for her brand-new press, Firebrand Books, and Loie Hayes, who in-

vited and edited the first edition of *Medicine Stories*. Those two books, more than any others, lifted my voice and made me widely visible and read.

La Peña Cultural Center, a hotbed of Latin American–centered radical art making, where I was part of a large collaborative team and cowrote scripts for big multimedia performances on Latin American history and culture, organized a radical poets' series, and was an interpreter for some of the great figures of the Latin American New Song movement.

The Latina Feminist Group, to which Rina Benmayor invited me, feminist scholars who rewrote a grant to allow us to study ourselves and each other as Latina feminist intellectuals grappling with often oppressive institutions and making room for our authenticity through the Latin American practice of social autobiography known as testimonio.

I write about most of the literary influences on my work in the introductory essay of this book. I want to mention here the more intimate influences, friends, and colleagues with whom I've been in extended conversation, some long ago, some right now, or whom I thought of as older siblings in politics and art.

Ahimsa Bodhran, Beckly Logan, Cherríe Moraga, Eli Clare, Irena Klepisz, Jenny Helbraun, Jessica Rosenberg, Joe Kadi, Leora Abelson, Luisah Teish, Margaret Randall, Max Dashu, Melanie Kaye/Kantrowitz, Monica Gomery, Raquel Roque Salas Rivera, Roy Brown, Zoraida Santiago, and my sharp-witted daughter, Alicia, who read and critiqued some of these pieces.

There are five people who have been in close during the writing of this book. Urayoan Noel told me I had to create an Aurora Levins Morales reader, and is always, consistently, and generously supportive of my work. My brother, Ricardo, is always a sounding board for the nuanced analysis, the tangled moment, the clarity and love of complexity we were raised to treasure. Dori Midnight is my writing buddy, keeps me centered in my own voice against the gravitational pulls of obligation and other people's urgencies, and cocreates a magical space within which we become bolder and more true. April Rosenblum has been a beloved thinking partner since we worked together on an important document about antisemitism produced by Jews for Racial and Economic Justice. We bring each other thorny problems, uncertainties about how to say what needs to be said and have it reach who needs to be reached, how to be in integrity as we work our ways through the highly reactive political landscape of our times.

Finally, Elizabeth Ault has been a dream editor, thoughtful, perceptive, warm, both flexible and adamant as needed, and working with me through

the alternate timelines of the chronically ill to move this project forward in a sustainable way.

As always, honot to the ancestors who brought me here, and the generations to come who will reap all that we sow. To all of you, and everyone else, my deepest thanks.

Introduction: Explico Algunas Cosas

This book has come into being as I enter the fourth year of my rematriation, my return to the mountain farm my parents bought in 1951 in the highlands of western Puerto Rico, and where I spent most of my childhood. Rematriation is a much richer and more entangled thing than relocation. It's an act of recovery and reinvention, a countercolonial migration, swimming upstream against the currents of departure, and to be honestly undertaken, requires more than joy at a deep longing fulfilled.

After half a century, I have left a rich country at the center of world domination, which, for all its abundant and beautiful legacies of resistance and mutual care, is inundated in lavish overconsumption, 24–7 glittery distractions, and the increasingly ruthless privatization of pain. I found so much and so many to love in the United States, but in all my years there, I never felt settled, and my writing was a product of and response to that displacement.

Now I am back in the exact place I longed for, a wild mountain farm in a looted colonial homeland, deeply impoverished, in the front lines of climate disaster, being relentlessly drained of its wealth. I wake up every morning in a subtropical rainforest, in the presence of trees and birds, fungi and insects, lizards and frogs, water and soil that form the ecosystem that made me, within a Caribbean culture that in spite of all the harm done to us and all the harmful ways we carry those scars, remains life-affirming and communally oriented. There are muscles I never knew were tensed that loosen here.

But what does it mean for me, a writer since the age of seven, and why has it led to this book?

A week after my tiny house and I landed on this mountaintop, the earth began to shake constantly. A 6.4 quake followed by thousands of aftershocks kept me and my neighbors awake for weeks, unable to trust the ground beneath us enough to fall asleep. Those shocks continue into the present, but the worst of it died down exactly as the pandemic dawned on us. Even without disaster, moving here meant letting go of First World comforts and conveniences. Disaster underlined this. For more than two years I had

no running water in my home, and my toilet is a bucket with sawdust. If it rains for days on end, I lose my electricity. I bathe by pouring a bucket of warm water over my head. I can't believe people call this a "simple" life. It's a life full of logistical complication. But it's changed my relationship to water, to weather, to the red clay soil that gets into all my clothing, to time. Physical effort and rural quiet declutter my senses. My mind is more like the empty bowl I always keep in my writing space to invite the words that want me to speak them.

While I am relearning rural Puerto Rican culture, I am also in some ways replicating the world my parents made for us, a world of books and microscopes, art materials and political discussions.

I am shedding fifty-two years of painfully imposed assimilation, the constant pressure to be someone else, to be quieter, more polite, less angry, less lush, less collectively oriented, more isolated, more market hungry, less border-defying, less colorful, more beige. To care more than I ever have about honors/bribes/privileges/titles/awards/conventions/literary analyses/trends/influences. I'm freer to care more about liberation, about finding the readers who most need what I create, to think of my words as medicine and magic, navigation and prophecy, not stepping stones in a career but honed imagination to energize and expand our capacity for the Great Turning of our human societies that the biosphere needs. I am trying to recover from the exhaustion of having to constantly explain myself to skeptics and fight for my own voice, because even when you win, it's unbelievably tiring.

I am engaged in a reclamation of self that inevitably shifts how I write. So it's also inevitably a time to look back over what I've done, why I've done it, and how it's changed over time.

———

WHAT CHANGED

What I write about, and how I bring myself to the telling, has in many ways stayed the same since I moved into the world as a writer in my early twenties. What has changed is the depth and nuance that comes with living an engaged life, in conversation with lots of people, places, and movements, for a long time. I have always been a revolutionary writer, a writer creating within the streams of people trying to make livable lives for all of us. Being an embedded writer within social movements and radical communities, I have honed not only my craft, my facility with language, my truth telling, but also my understanding of the complexities of the world.

Take, for example, my writings about Israel/Palestine and the politics of Jewish identity. Raised far from any Jewish institutions other than summer camp, in an internationalist communist family, I identified strongly with Palestinians and not at all with Israel. In my twenties I was a member of New Jewish Agenda but was woefully ignorant about Jewish politics as a whole, and knew almost nothing about Israel. I had good instincts but no nuance. And yet the work I do today springs from the same place as my early, less complex writings. I come from Jews who rejected Zionism as a solution to antisemitism even as pogroms raged around them, and who, in the wake of genocide, saw no reason to change their minds. I am a Latin American, Caribbean anti-imperialist and so I am against settler colonialism, no matter who does it. I have spent decades delving into the political implications of collective trauma, and how oppression is internalized and reenacted upon others. So now I have nuance. I know more. I can articulate my perspective, transparently grounded in my own life and the history that made me. I write liturgical poetry consciously aimed at shifting the ways that trauma has impacted Jews, holding the historical differences in how that has come about. I write essays about why Palestine solidarity is both the only moral stance and the best way forward for us as Jews. I have more subtlety, but I haven't changed my mind.

My most reproduced poem, "Child of the Americas," which proclaims my wholeness as a person of multiple heritages "born at a crossroads," underlies far more sophisticated work on what it means to claim Indigenous heritage but not membership, to grieve the losses of forced migration and also embrace its gifts, to proudly uplift diasporic Puerto Rican culture and history, and consciously resist Acquired US Superiority Syndrome, which sometimes leads returnees to think we know what's best for Borikén.

Heritage, membership, identity. I grew up knowing that the polished axe heads and shards that lay in the creek bed were akin to me, that my roots in the land that birthed me went seven thousand years deep, that my mother's cheekbones set into my face proclaimed an Indigeneity rarely spoken of, complicated and messy in this hacked-up Caribbean world of colonized national borders, of tourist souvenirs scratched with petroglyphs, and self-proclaimed caciques digging through priestly chronicles for remnants of beliefs filtered through a savage Christianity. And yet here we are, 530 years later, emerging from shadows, our lineages ragged, hanging by a thread, but still. In 1998 I wrote in mockery about "The Tribe of Guarayamín" (you have to say it out loud), believing the myth of my own extinction, that any continuity was wishful thinking and a trespass on the lives of Native people

raised tribal, raised with elders, with at least the possibility of a language. That we were wannabes.

But there is a world of nuance I couldn't grasp back then, a deep historical difference between survivors of wars fought in the sixteenth and nineteenth centuries, the way delicate-seeming strands persist as wiry roots in the soil of five centuries. What it means to be born in a place called Indiera, to speak words of ancestral tongues without even knowing it, *bejuco, guares, nagua, coa, colibrí,* to know to the absolute core of my being that I am part of something hidden and unnamed, without a rez, a tribal council, even an accurate name, Taíno being a misunderstanding by invaders who spoke to us in Hebrew and Latin and thought the word for the Arawak aristocracy was the name of our people. In 1998 I had not witnessed the phenomenon of "pretendians," explored how blood quantum meets tribal sovereignty meets reclaiming lost children, had not been welcomed as kin at Standing Rock. Today Guarayamín has evolved into *Daca, I am. Guakía, we are. Yahabo, still here.*

"Sugar Poem," written in 1979, is a declaration about the uses of poetry, echoed, expanded, and made explicit in "a poet on assignment" some thirty-odd years later, while "Listen, Speak," written in 2011, expands the earlier statement that my poems "come from the earth, common and brown" into a passionate summoning of stories that come from our bodies, especially sick and disabled bodies like my own:

Come beloveds from your narrow places, from your iron beds, from your lonely perches, come warm and sweaty from the arms of lovers, we who invent a world each morning, and speak in fiery tongues. . . . We are striking sparks of spirit, we are speaking from our flesh, we are stacking up our stories, we are kindling our future.

Listen with your body. Let your body speak.

My work is deeper, broader, and more subtle and leans more into what my body knows, not only my conscious, intellectual mind.

A WORD ON GENRE

Many years ago, a feminist historian at a conference asked me what my "period" was. I replied, "Yes." I was writing a doctoral dissertation in prose poetry that retold the history of Boricua women beginning with our deep

ancestry 200,000 years ago and ending, in that first edition, with the year of my birth. My "period" was everything relevant to my purpose.

When I am asked about the genres in which I write, I have a similar response. I grew up being read a wide range of poetry and prose, learning cadence, rhythm, grammar, form, not by studying them but by absorbing sound. I was equally intoxicated, and in the same way, by Dylan Thomas's poems and Sean O'Casey's memoirs with his multipage run-on sentences. By Pablo Neruda's poetry and Eduardo Galeano's prose. Are Toni Morrison's novels prose? I hear them as poetry. Judy Grahn's *Common Woman* poems could be essays. You can dance to Nicolás Guillén. I don't presume to decide the shapes of other people's words, but very few boundaries of art seem impermeable to me. I can stretch toward straight-up creative prose on one side and poems with line breaks on the other, but I love best the intertidal zone between them. I had the good fortune to be taught early on that language was mine, and no one has been able to uproot my conviction that I can do with it whatever pleases me.

Over the course of my writing life, there have been quite a few people who told me what I was doing was against the rules. The college professor who said there was no audience for bilingual literature when I sprinkled some Spanish into an English-language story. The students in an advanced fiction class who parroted the Eurocentric assumptions of their teachers, telling me I had too many people in my stories and needed to devote myself to the individual angst inside one character's head. The editor who, having asked me to write about Latina authors, thought referring to the group as "we" was unprofessional, and told me my writing style was "not English." The agent who saw an early draft of *Filigree* and said, as if it were a natural law of the universe, "Mysteries end when you know who committed the crime." I continue to mix genres and languages, populate my imaginary worlds with crowds, and the story ends when I say it does.

SHAPING THIS BOOK

This collection is not really an anthology. It's a kind of memoir of a writing life embedded in the social movements of my time. At this writing, I am sixty-eight years old, in the beginning of a new life stage. I am deep in the renewal of my relationship with the ecosystem that made me, and so I do a lot of sifting and sorting—of seeds, of leaf litter, of compost—and a lot of listening, to birds, to weather, to my own aging body, to my desires. I am

listening, as well, to what I mean to *be* as a female elder artist, someone in the prime of her writing life.

The pieces included here come from many places—works published in books and journals, pieces I wrote on assignment for the radio, or in rapid-response blog posts, or as part of my current project to create radical Jewish liturgy. They are doors into those spaces where I wrote them. Those of you who know my work well have been in some of those rooms with me, have encountered me within some of the big conversations of our times. This book allows old friends and new ones to encounter me in many ways, and directs you to the books and blogs where you can read more, follow a thread, continue an argument, discover a new place where we can intersect.

There is work taken from my seven books, *Getting Home Alive* (1986), *Remedios* (1998), *Medicine Stories* (1st ed., 1998), *Kindling: Writings on the Body* (2013), *Cosecha and Other Stories* (2014), and *Medicine Stories: Essays for Radicals* (rev. ed.) and *Silt: Prose Poems*, both released in 2019.

There are also pieces that have appeared only in anthologies assembled by others, books pulled together to address US Jewish grappling with Israel, Palestine, Zionism, and antisemitism. Books tackling feminism and the ecological crisis of the world. Books of rebellious ritual, and my own collaborative project, *Rimonim*, in which I engage the body of traditional Jewish prayer as a radical, raised secular, Puerto Rican Ashkenazi poet. You can follow any of these pieces home and find more ways to connect. And there are pieces that appeared only on my web page, in online showcases, or have not yet been published anywhere.

As for the shaping of this book itself, the pieces I have gathered are not ordered chronologically, by genre, or by theme. They are arranged by purpose, by the work each set of words does in the world. Because I am first and foremost a writer of connections, of multiplicities, symbioses, and interwoven stories, it would be impossible to sort my writings by subject matter. Chronology seems dull and inorganic. My themes constantly cross, loop back, tangle together, and repeat.

As I wrote in the introduction of *Medicine Stories: Essays for Radicals*, I come from peoples who know how to use call-and-response, communal chorus, refrain, rhythm, and repetition to make a point. Perhaps because of the rich tapestry of identities I wear, the languages and countries and sexualities I claim, I have always been a collagist, carefully matching the colors and shapes of torn edges to make a new whole, and joyfully transgressing borders of genre and discipline. This book is shaped like torn pages of magazines, matched by color, shape, resonance, and is rich with repetition.

When people ask me who I am, I always begin with my parents because, more than most people I know, my life was shaped by their decisions and our enduring comradeship. My mother, Rosario, was a working-class Harlem child of small-town landed gentry from Puerto Rico who'd fallen on hard times, raised in the Depression, a lover of books, with a clear, critical mind, who said Marx made sense of her life. My father, Dick, was a first-generation Brooklyn Ukrainian Jew, fifth-generation radical, the middle-class grand-child of garment workers, and he knew he was a scientist when he was eight. They met at eighteen at a communist youth event and got engaged two weeks later, after a lecture by Black Trinidadian communist feminist Claudia Jones on "the woman question." They were married a year later, in 1950, just as the Korean War broke out, and decided to go to Puerto Rico until they were parted, expecting that my father's refusal to fight would land him in jail.

It didn't. But the blacklist blocked my biologist father from any work in his own field, so they bought an abandoned coffee farm in the western highlands, and I was mostly raised here until the age of thirteen, when, for layered reasons, all of them political, my family moved to Chicago. Growing up the child of communists in the 1950s and early 1960s was scary in many ways, but when I talk about it now with friends who grew up in a US culture saturated with anticommunism, I say this: I wouldn't trade it for anything.

My parents were not the grim, humorless caricatures of US popular culture. They were joyful, fun, intellectually curious, creative people who taught us that living a revolutionary life, aimed toward universal justice, was the most satisfying way to be. My father was a groundbreaking mathematical biologist/ecologist who also created hilarious illustrated stories. My mother was a multifaceted feminist artist-intellectual who studied anthropology, botany, philosophy of science, and women's fiber arts, a painter and print-maker, poet, essayist, and fiction writer. I was raised at the confluence of art, ecology, and social justice, in a subtropical rainforest house full of books.

MY LIFE OF WRITING

I began writing in first grade. I read voraciously, memorized and wrote poems, and kept a diary. I learned the names of plants, lizards, and birds, trapped fruit flies for my father and looked at them through his microscope,

climbed trees to bring my mother orchids and bromeliads, and learned from her the names of a hundred colors—those in her palette of oil paints, threads, yarns, and fabrics and the ones she pointed out to me in the lush landscape and ever-changing sky.

I learned the acerbic poems of Bertolt Brecht, found the ruby heart of Nazim Hikmet, and the impassioned Spanish Civil War poems of Pablo Neruda, including his manifesto on writing overtly political poetry, "Explico algunas cosas," and when my family moved to Chicago, writing, filling stacks of grey lab notebooks, was how I navigated the ecological and cultural shock of migration.

At thirteen I found one poem by Nicolás Guillén in an anthology as I was scouring my Chicago high school library for anything Latin American, and I memorized it on the spot.

> Quemaste la madrugada
> con fuego de tu guitarra:
> zumo de caña en la jícara
> de tu carne prieta y viva,
> bajo luna muerta y blanca.

He taught me that if he could write in the language and to the rhythms of Afro-Cuban music, then the voices of my rural Puerto Rican neighbor women were also entitled to a place in poetry. I could write in any language and style I loved.

In 1968, at the age of fourteen, I spent the summer in Cuba with my family and came back changed. I had discovered the lyrical journalism of Raúl Valdés Vivó writing from South Vietnam, saw Cuban historical sagas on film, and immersed myself in the lively range of revolutionary storytelling. By the end of the summer, my horizons had become vastly bigger and I'd lost my tolerance for the mind-numbing restrictions of high school. I recited Guillén, now national poet of Cuba, sang anti-war and feminist songs, and skipped class to go to demonstrations.

I had landed in the university neighborhood of Hyde Park just as the women's liberation movement was exploding into vibrant life. At fifteen I joined the Chicago Women's Liberation Union and a consciousness-raising group of women six to ten years older than me, and one day in 1970, one of them brought me back a handmade book of poetry by feminist writers in California—Adrienne Rich, Susan Griffin, Alta—and I read Judy Grahn's *Common Woman* poems and learned that women's everyday lives were wor-

thy subjects of literature. This series of literary encounters opened up my sense of the possible and gave me permission to speak out, wholeheartedly, about everything I cared about.

At sixteen I coproduced a feminist radio show, left home, and took part in sit-ins and guerrilla theater. I read and kept writing my way through all the turmoil of those years.

In 1972 I went to Franconia College in northern New Hampshire, where I first fell in love with a North American landscape. By the ice-cold waters of the Pemigewassit and the Gale, among forests of birch and maple and fir, I had the great good fortune to be reunited with Donald Sheehan, one of the adults who helped me survive my teens, who came to Franconia as an English professor and director of the Robert Frost Place and was my poetic godfather. Under his tutelage I translated Neruda, delved deep into Shakespeare's sonnets, and learned to trust myself in new ways.

It would be a few more years before I found the Black women who were breaking into print and making a way for the rest of us. Toni Morrison, Audre Lorde, Alice Walker, Maya Angelou, Toni Cade Bambara, Jamaica Kincaid burst upon me and my mother at the same time. We were constantly calling each other up to read lines aloud. We began reading our writings at events, becoming known. But the heart of this story is that we both found our way into published visibility through the collective raising of voice.

———

MOVEMENTS

I describe myself as a writer embedded in social movements, but the truth is that I have refined the art of speaking from the margins.

In 1976, in my early twenties, I moved to the Bay Area and became part of the cultural ferment of that time and place. I began working at La Peña Cultural Center, founded after the Chilean coup of 1973 as a focal point for solidarity with the Chilean resistance and more broadly with Latin American movements against the death squads and dictatorships that gripped the continent. There I met poets and musicians from all over Latin America and discovered the poet-songwriters of the Nueva Canción/Nueva Trova movements: Violeta Parra, Mercedes Sosa, Silvio Rodriguez, Sara Gonzalez, Pablo Milanés, Isabel Parra, Daniel Viglietti, Inti Illimani, and Quilapayún, and Puerto Ricans Roy Brown, Andrés Jimenez, Zoraida Santiago, and many others. In their music I found multitudes of declarations about what

it means to be a socially committed artist. They gave me context and support and new kinds of lyrical inspiration.

And there I met exiled Chilean men with low tolerance for female leadership, still less for outright feminism, and wielding vicious antisemitic tropes, who, first chance they got, demoted the core group of women in our project from political education and scriptwriting to photocopying and making coffee, and whose dishonorable sexual conduct tore its way through the hearts of women, many of them newly on fire with a passion for justice, sowing bitterness instead.

Still, I read Mario Benedetti's "Soy un caso perdido," in which he agrees with his critics that he is not impartial and that to pretend to be in these times is immoral. Heard Violeta Parra singing:

> Yo no tomo la guitarra
> por conseguir un aplauso.
> Yo canto la diferencia
> que hay de lo cierto a lo falso,
> De lo contrario, no canto.

> [I don't take up the guitar
> to get applause.
> I sing the difference
> between what's true and what's false.
> Otherwise I don't sing.]

For the first time, I was part of a community of radical artists. I joined the women's writing workshops at the Berkeley Women's Center. Through my membership in the Puerto Rican Socialist Party, I was invited to a training in radio work at the Third World News Bureau of KPFA and began producing short news bulletins and longer feature pieces. At La Peña, we started crafting large, multimedia performances about Latin American history, politics, and culture, for which I was a scriptwriter, and I wrote the Haggadah for a solidarity Passover seder. I was a member of New Jewish Agenda, my first community of progressive Jews outside of my own family, and lived within a constantly evolving eruption of radical culture, with poets, singers, actors, dancers, and graphic artists from all over the world.

And I was bisexual at the edges of Latina and women of color lesbian circles, when bi women were presumed to be closeted lesbians or straight girls slumming it for thrills, where my politics and poetry won me partial

acceptance, but one group I joined spent four months debating whether inviting me into a discussion of race, class, and antisemitism had been a betrayal of lesbian sisterhood, and I hung in because I was that hungry for comradeship.

I was a Boricua among white feminists who tokenized me, a Caribbean Jew among white Ashkenazim who could not even wrap their minds around the idea that Jews of Color existed, seeking ways into Jewish ritual as a radical raised with no relationship to Judaism itself or to Israel, and Palestine solidarity posters from Cuba on the walls. It was the totality of movements that added up to home.

TURNING POINTS: BRIDGE AND BEYOND

In the summer of 1978 I was hired as an interviewer for a study by white South African feminist Diana Russell on the incidence of rape and other forms of sexual violence. No one had ever done a randomized study to find out how common sexual violence actually was. Estimates based on police reports were useless, given the devastating ordeal of the legal process that kept most women from reporting rape and the rape culture that kept many of us confused about our right to boundaries and consent.

The directors had recruited an interviewing team made up of underemployed women of color (WOC) writers and activists, many of whom became well known in the years that followed. Among them was Cherríe Moraga. We became friends and writing buddies, and in 1981 I stood on the dais at Arlington Street Church in Boston with nine other women, including my mother, Rosario, for the first public reading from *This Bridge Called My Back: Writings by Radical Women of Color*, the book that changed so many lives. Suddenly I was credentialed. I began speaking at colleges and universities, while my mother, less of a traveler, worked New York, Boston, Vermont, and Western Mass.

Each of us began reading some of the other's words when we performed, and in 1983, after my mother read both of our works in Ithaca, New York, we were approached by Nancy Bereano, then an editor at Crossing Press, to do a book together. Nancy left Crossing to start Firebrand Books, and we were among the first authors to sign with her. *Getting Home Alive* was a breakthrough book for us, and something new in Puerto Rican diaspora literature. But not just in the way of novelty. People would come up to us after readings with battered copies they carried everywhere, asking us to

sign the crumpled pages. They said they had never seen themselves between the covers of a book before. We had held up a mirror capable of holding our contradictions.

We were two Puerto Rican women, mother and daughter, with different migration stories. My mother was born in New York in 1930 and migrated to Puerto Rico as an adult, when that was still a rare journey. I was born in Puerto Rico in 1954 to a Nuyorican mother and migrated to Chicago. The book, published in 1986, broke rules, mixed genres, and expressed love and critique for both our countries. We also both wrote about Jews, I as a Puerto Rican Jew, my mother as someone who had found her deepest early alliances with Jews. The pieces from that book are still the most widely anthologized of my work.

During the early 1980s, as I entered my thirties, I began connecting with more of the Jewish left, specifically Jewish feminists, and those who were taking just stands around Palestine. I contributed frequently to the Jewish feminist journal *Bridges*, attended Jewish feminist conferences in San Francisco, and began finding other Jews of Color, though it would be a long time before Jews of Color organizing reached enough of a critical mass to become a home base for me. For the moment, community was finding each other in the hallways of feminist conferences trying to decide between Jewish and WOC caucuses. But it was a start.

———

MAKING MEDICINE: *REMEDIOS, MEDICINE STORIES,* AND *TELLING TO LIVE*

Between 1986 and 1998 I didn't publish any books. In 1988 I gave birth to my daughter, and when she was six months old, to build something other than diapers into my daily life, I started taking a class or two at Mills College. Mills made me fight for the right to study Latina literature, and one of my professors, Gabriel Melendez, encouraged me to skip finishing my BA and apply to graduate schools that would give credit for life experience. In 1990 I began graduate school at the Union Institute, an outgrowth of the 1970s University Without Walls experiments. I had told them I thought I had a master's in cultural organizing, and they agreed.

I felt called to rewrite the history of Puerto Rican women and our ancestors into something medicinal, to extract the active ingredients that would strengthen us and lift us up, knowing whose shoulders we stood upon, from whose hands we could receive the tools, remedies, and lessons we needed. The ones I needed.

I started therapy with a feminist trauma specialist within two weeks of starting grad school, moving between vast histories of harm and resistance, and my own struggle to heal, crafting a kind of survivors' support group across time. Facing my own history of sexual exploitation as part of a global system, and specifically a Caribbean system of imperialism, Indigenous genocide, and slavery, helped me truly understand how impersonal it had been, not about me at all.

In 1995 my marriage ended and I maxed out my student loans to finish grad school, knowing if I stopped I would never start again—and I single parented in poor health while grappling with complex PTSD, as nightmare fragments coalesced into memory, barely keeping my head above water, raising a beloved daughter with one hand tied behind my back, desperately under-resourced and trying with limited success to shield my child from the storms raging inside me.

In the early 1990s a group of eighteen Latina feminist scholars got a grant, originally to explore and compare the work we were doing on US Latinas. But at our first gathering, when we went around the room sharing our intellectual autobiographies, we realized that this was the story we really wanted to tell. So we rewrote the grant agreement and went to a retreat center in the Rockies where we spent two weeks turning the tools of our disciplines onto our own lives, and wrote a kind of collective social memoir about what it was like to be who we were, highlighting the Latin American tradition of "testimonio," in which life stories illuminate larger social realities. So many of us had lived a split between public lives of apparent success for which we paid in excruciating private struggles carried on in secrecy and isolation. So we told the truth, asking each other the questions no one had asked us, and entered a rich and nourishing collaborative process that continued throughout my graduate school years, giving me sisters, elders, comadres. That collaboration continues to this day.

I spent five years researching and writing my doctoral dissertation, which became two books. *Remedios* is a prose poetry retelling of the history of the Atlantic world through the lives of Puerto Rican women and our kinfolk in the Indigenous Americas, North and West Africa, and mostly southern Europe. I told the story in a collage of short poetic vignettes, inspired by the work of Susan Griffin and Eduardo Galeano, both of whom had brilliantly tackled vast historical landscapes with a similar structure.

I imagined the book as medicinal history, antidotes to the dominant and dominating versions of the past designed to justify oppression and keep us hopeless. I saw myself as a curandera, bearing witness to our wounding and

also our survival, drawing on ancestral human voices and the voices of the plants that had fed and healed us on our journeys.

The core of the first edition of *Medicine Stories* was the theoretical portion of my dissertation, examining how we heal from collective trauma, drawing from the work of feminist therapists and the movements to heal from and eliminate rape and incest. It also included essays based on talks I was giving about a wide range of liberation issues, from the politics of childhood to the ways Puerto Ricans claim Indigenous identity.

When I was approached by South End Press to do an essay collection, I was hesitant because I was in the throes of finishing *Remedios*. I called my mother for advice and she said I should do it, but as a B− book, not an A+ one. That I had to not be perfectionist about it. I learned that the difference between A+ and B− was mostly worry. *Medicine Stories* then surprised me by becoming my best-selling book. Both books were published in 1998, and in 2001 my comadres and I produced *Telling to Live: Latina Feminist Testimonios*.

BODY SPEAKS

The twenty-first century has held my middle years, from forty-six to sixty-eight, during which I matured into much greater power and reach and faced immense challenges. I wrote and published books, won wider recognition, and was called into bigger work. I was part of the emergence of the Disability Justice movement and Healing Justice framework and a rapid expansion of Jews of Color organizing, all of which created spaces in which I could be much more fully and complexly myself.

At the same I spent a huge amount of my energy and time managing my health, being my own advocate, researcher, health coordinator—an entire Ministry of Health, if truth be told. Which is why between 2001 and 2013—although I published pieces in anthologies and journals, my audience grew in leaps and bounds, and I did public speaking in Puerto Rico and Cuba and all over the US—there were no new books. I started a mystery novel and wrote poetry at Hedgebrook in 2000, wrote "Shema" at Norcroft in 2001, started my prose poetry collection *Silt* at A Studio in the Woods in 2005, but I didn't finish any of them.

My intellectual life was in motion, maybe even flourishing, but my health was unstable, and there was not yet a collective emergence of the chronically ill as a political force. Disability justice had not yet widely challenged the narrow premises of the disability rights movement, and people like me

remained largely invisible, writing from our beds, absent from conferences, meetings, marches that should have been about us, too, grappling with loneliness, isolation, and the deep dangers of a profit-based medical-industrial system incapable of meeting us where we lived, in the complex chronic illnesses that are signatures of our times.

I spent a lot of insomniac nights dealing with toxicities from poor digestion, a sluggish liver, inflamed gallbladder, and intense environmental illness that had left me unable to tolerate the buildings in which I lived, the pesticides with which my neighbors casually drenched their backyard, or the fragrances permeating public spaces. I lived with crushing fatigue, too tired, many days, to walk as far as the corner to mail a letter.

I had multiple major health crises and just years of feeling miserably sick with amorphous, complicated ailments. These realities—the lives of my mind and body—often seemed like parallel tracks in different universes. Who puts brain injury–induced aphasia or the repetitive strain injury (RSI) that made me dictate a whole book with rudimentary speech recognition software—events that changed my relationship to language—into their writing resumes? The reams I was writing about being sick and disabled did not yet have anywhere to go, especially since I didn't have the capacity to go looking for public landing places for them.

Throughout the next two decades, the realities of wounded body and wounded earth, ecology and disability, chronic illness, the medical industrial complex, and the searing battles of single parenthood while sick and poor dominated much of my life. I was living the physical consequences of ecological and sexual violence, digging into the shared roots of inflammation and oppression, bodily and systemic toxicities, just trying to get through my days and especially nights.

We don't talk of such things as part of a writing life, as if the language centers of our brains had nothing to do with the rest of our bodies, with aching backs or bloated bellies. Or even as if our creativity and intellect hovered ethereally over our desks. Unless we decide to, unless we push against the currents of disembodied mind and root ourselves defiantly in our flesh.

I had had my first epileptic seizures as a child, small interruptions and changes of consciousness nobody noticed, and I didn't know to tell anyone about, because as children the strangeness of life is still new and often inexplicable. But in my late teens and early twenties I began to have tonic-clonic seizures, colloquially called grand mal. I started to fall and crack my head on hard surfaces, which led to many of the brain injuries usually called MTBIs. M stands for mild, as compared to crushed skulls and brain bleeds. They

are not mild in their consequences, though. One of those, in late 2005, left me in need of personal attendant care, with life-altering struggles that lasted for many months.

I had just returned from my first stay at A Studio in the Woods, a remarkable writing residency in New Orleans, on the west bank of the Mississippi River. I had been working on an early version of *Silt*, an exploration of the interwoven natural and social histories of the Mississippi River system and the Caribbean Sea. It was just months before Katrina unleashed disaster on the Gulf Coast, but it was my own inner storms that forced me to lay the book aside for what became thirteen years.

In 2007 I had a stroke, which I sometimes refer to as my best bad thing. After a year of minimal and largely ineffective treatment, I was told I was done and given half the cost of a power wheelchair. The resources that my debilitating chronic illnesses, routinely dismissed by the medical establishment, could not get me, the stroke did. I had reliable mobility for the first time in years, and zooming around in my bright-yellow chair, my struggles became visible to others for the first time. I had been carrying massive student debt, unable to pay and trying month to month to avoid the worst consequences of default. The stroke allowed me to cancel that debt.

I could enter the disability community and had the great good fortune to go to a show by Sins Invalid, the brilliant disability justice performance and organizing project, into which I leapt. Suddenly there was a place where my body's voice was treasured, and in the company of other beloved crip artists, we cleared a public space for all the fury and laughter and vision we had been holding alone. As a commissioned artist for Sins Invalid, I wrote a wide variety of pieces that I and others performed, some of which are included in this collection. So I had a web of people, a network, a huge Facebook group of the sick, disabled, and queer, people who were awake in some time zone when I needed an answering presence.

————

TRANSITIONS

Then in March 2011 my beloved mother and closest collaborator died of multiple myeloma, a blood cancer closely associated with dieldrin, a pesticide my parents used on our farm in the early 1950s. She and I had been in political and artistic conversation for forty years, and I didn't understand being in a world where I could not reach her on the phone to read her my latest draft, to talk politics, fabric, and recipes.

My parents had been together since the age of eighteen, which meant my father had never been a single adult. In the fall of that year I moved to Cambridge, Massachusetts, to live with him and help him adjust to the loss of my mother. I ended up staying for the rest of his life, which was five years.

I moved into my mother's room, slept where she had slept, wrote where she wrote. I was in deep grief, living three thousand miles away from most of my friends, and managing my father's support system and frequent medical emergencies mostly by myself, and the health gains of the previous year evaporated. Even when I insisted we hire a personal care attendant for him, and the marvelous RayRay Ferrales joined the team, the work was exhausting. But, for the first time since I was sixteen, I was living with my father, a kind, affectionate, brilliant, and funny man who would lie on the couch and as I walked by, snag me into hours-long, wide-ranging speculative conversations that crackled and sparked in my mind long after.

My father paid for the necessary upgrades to make the house healthy for me, and for the first time I had rent-free housing that was both secure and safe, and enough financial support to ease my long-standing money panic. In spite of a major back injury that left me bedridden and immobilized for months, and figuring out how to get off opioid painkillers and then suffering intense withdrawal and several seizures, I still became prolific. During my time there I wrote and published two books, *Kindling* (on a computer suspended over my bed) and *Cosecha and Other Stories*, and achieved my dream of designing and building a sustainable and healthy mobile tiny house, where I now live.[1]

I was also writer in residence with Jews for Racial and Economic Justice, initiating and writing a first draft of a groundbreaking left analysis of antisemitism, in conversation with many people, including their Jews of Color and Mizrahi caucuses. Along with other members of Jewish Voice for Peace, I helped form a Jews of Color, Sephardi, and Mizrahi (JOCSM) Caucus, began producing the blog Unruly.org, and attended the first Jews of Color National Convening.

All these projects contributed to much greater visibility and impact by Jews of Color, and white-dominated Jewish organizations began reaching out to us for help addressing racism among Jews, sometimes thoughtfully, sometimes in tokenizing ways, but I am now part of a rich web of BIJOCSM organizing that has generated many new discussions, projects, and organizations and I have the privilege of sitting on the steering committee of the Jewish Liberation Fund and helping fund them.[2]

In January 2016 my father died of congestive heart failure while we sang him the revolutionary songs we'd grown up on. Grief upon grief, and suddenly

I was the oldest of our mishpucha-familia. That summer I finished my tiny house and began making my way west, via a berry farm in Ashfield, Massachusetts, a week at Standing Rock, blizzards, floods, parking lots, and gorgeous public lands, until I came to rest in Tomales, California, at True Grass, a "restorative grazing" cattle ranch where I lived for two and a half years. The land was beautiful, quiet, easy on my heart, a place of grassy hills and live oaks, raptors and water birds, creeks and fog, blackberries and California poppies, and the lowing of cattle.

In the peace of that place I completed a new edition of *Medicine Stories*, with twenty new or deeply revised essays. A poem I had written in 2016, in response to the massacre of mostly Puerto Rican LGBTQ youth at the Pulse nightclub in Florida, went viral. It was based on one of the core prayers in Judaism, the V'ahavta, and spoke to the power of imagining winning the world we want, in which such acts as these are ancient, barely imaginable barbarities of an age that is past. It suddenly and vastly accelerated the use of my poetry in Jewish ritual and organizing, and led to a flood of requests for more from rabbis and revolutionaries (and people who are both), leading to the collectively supported Rimonim Project, soon to enter the world as a richly illustrated collection of Jewish liberation theology poetry.

But first came the devastating autumn of 2017. On September 20, Hurricane Maria slammed into Puerto Rico as a Category 5 storm and tore my country up by the roots, but what killed the roughly five thousand people who died in its wake was neither wind nor water but unabashedly racist neglect, genocidal in its scope. Crouched at my computer desk in California, I scanned message boards of the diaspora, people desperately trying to locate friends and family. It took us a month to get any news at all of our home community. On September 30, I delivered my synagogue's Yom Kippur morning sermon, filled with hurricane metaphors, about joy as the only reliable fuel source for a lifetime of audacious action.

On October 9, I woke up to strange white powder covering my car. It took a moment to realize the sky was full of ash. Santa Rosa, only twenty-five miles away, was burning. Caught between two apocalyptic landscapes, both of them climate emergencies, I was locked down with my air filter and my burning lungs. A few months later I began having heart symptoms and in May 2018 had surgery to place a stent in a coronary artery that was 99 percent blocked—by grief and rage, my cardiologist said.

But I had been offered a second residency at A Studio in the Woods to complete the project about the river and the sea, which I'd had to set aside in 2005. The residency came with enough funding to cover the cost of a

road trip along the Mississippi River from Minneapolis to the Gulf Coast, a journey I took with Naiomi Robles, a young Puerto Rican community historian, writer, and activist from Holyoke. I finished the second version of *Silt* in six months. *Medicine Stories: Essays for Radicals* was released by Duke University Press in April 2019, and I published *Silt: Prose Poems* through Palabrera Press in August 2019.

My two 2019 books came off the presses during another major upheaval in my life. As an aging woman of color with chronic illness and disabilities, I was struggling with the level of isolation and individualism I faced in rural Northern California, and thinking about how to set up a better web of community support for myself. I was also thinking about where I could best sink roots and take a stand around the climate emergency.

Spending time in New Orleans reminded me that there are more communally oriented cultures, but much as I love New Orleans, Louisiana is a dangerously toxic ecosystem, and I knew my health could not withstand it. Then I went on my first post-Maria trip to Puerto Rico with my friend Susan Raffo, and on the first day was deeply called to move back to the land I grew up on. In October 2019, I left California forty-three years after I arrived and made my way across the US and into the Caribbean. I landed on the farm where I grew up on December 20, a week before earthquakes ravaged the already hurricane-demolished country. A few months later, as we were still clearing rubble, the pandemic struck. Let's just say it's been a tumultuous reentry.

I am writing these words in the winter of 2022–23 as we continue to clear the rubble of Hurricane Fiona, more than three years into my new life in the land of my birth. I am writing new words with a clear mind, a passionate heart, and a firm hand, rooting into the tiny world that made me, scattering seed on the wind. I am drawing on a whole lifetime of wrestling with how to story the lives we want into existence, honing ideas and words to a fine, sharp edge. This is what it is to be in my prime, primed.

I'm crafting a new edition of *Remedios*, weaving in new threads pulled from research done by people who thirty years ago had no access to the tools and money they needed, and who have challenged and changed so much of what we thought we knew. I am finding my way through the thicket of Rimonim, a practice of coming home again and again to what it is that I long for, what spiritual tools I need in my own hands. I completed the historical mystery I started half a life ago, am blogging on my Patreon page, recording podcasts and my first audiobook, while I plant food and talk with agroecology farmers and climate organizers, artists and teachers, finding the people with whom to work, and thinking about how I, as a disabled elder artist,

can best contribute to our collective fight for human societies that nourish rather than extract.

As I lean into the future, I am looking back over my writing life, and this is what I see. I've rewritten Puerto Rican women's history and the story of my sick and disabled flesh, written about Jews living in the tension of oppressed oppressor and how Jews of Color hold one way of cracking that story open, how Indigenous and Jewish genocides weave and fray through my family tree, about the movement of water and people through the natural and historical landscapes of the Mississippi River and the Caribbean Sea, and a million facets of how to imagine and build a better world.

Most of that writing was done in Northern California, where I worked in a web of interconnected, often quarrelsome movements: Latin American exiles and radical Jews, feminist agitators and researchers, lesbian publishers and producers, disability justice pioneers, women of color writers and scholars, Indigenous grandmother climate activists, and every kind of artist.

But no matter what I do, the common currents have been the same: art, ecology and justice, my mother's colors and questions, my father's love of complexity, knowing that "the truth is the whole," the expansive vision of the possible my parents gifted me, and all those generations of radical people, centuries of them, reaching for a bigger, brighter common good, a rainforest house full of books, and the voices of the earth itself and all its burgeoning, endangered life.

Now all those streams have brought me back to where I began, to where my young parents planted ideas, vegetables, and children in this red clay, where I live in a frontline island colony disaster zone, in homestead conditions, hauling water, growing food, and writing, and all I can say is, I wouldn't trade it for anything.

.............

Notes

1 Aurora Levins Morales, *Kindling: Writings on the Body* (Palabrera Press, 2013); Aurora Levins Morales and Rosario Morales, *Cosecha and Other Stories* (Palabrera Press, 2014).

2 Black, Indigenous, Jews of Color, Sephardim, and Mizrahim (BIJOCSM) addresses the problem of the unique historical experiences of Indigenous and Black people being merged into an amorphous category of People of Color and applies that to Jews, adding Sephardic and Mizrahi Jews, complex identities in themselves.

1 THIS IS MY NAME

I became a writer when I first understood the alphabet and fell in love with its magical powers. I became a writer devouring books. But I became a writer in the world within the social movements of my time, and it was the women's liberation movement that first made room for my voice and carried me onto the printed page and into classrooms.

I open this section and this book with "Sugar Poem," written in the Berkeley Women's Center Writing Workshop in 1977, my first public declaration of intent as a writer. The teacher had offered us a writing prompt so abstract and convoluted that I literally had no idea what she meant. It was fashionable to see incomprehensible writing as better, more sophisticated, more cultured than the accessible. "Sugar Poem" was my infuriated response.

"Child of the Americas" is probably my most reproduced piece of writing and has been widely used as a writing prompt on the complexities of identity.

"Class Poem" and "Wings" are both answers to critiques of how I move in the world, the first from those who believed that Latinas, who were just beginning to be published in the early 1980s,

somehow lost our identities if we had any professional success. The second speaks to the ongoing attempt to strip Jewish credentials from Jews who are critical of Israeli injustices toward Palestinians and of Zionism itself.

"Truths Our Bodies Tell" and "Yerba Bruja" bring my body directly into my autobiography, talking about sexual violence and disability. "Stricken" was my first attempt to write after a stroke. "Listen, Speak" was written for Sins Invalid, a groundbreaking disability justice organization and performance project.

"Dulce de Naranja" is a snapshot of my childhood in Puerto Rico in the 1960s, and "First Snow" is a story of love and loss in my first year of college but also about learning to love a North American landscape. Finally, "That Bridge," written for the release of the fourth edition of *This Bridge Called My Back* in 2015, is about a formative moment for women of color organizing in the United States, a moment that also clarified my understanding of what I was here to do.

Sugar Poem

Poetry
is something refined
in your vocabulary,
taking its place at the table
in a silver bowl: essence
of culture.

I come from the earth
where the cane was grown.
I know
the knobbed rooting,
green spears, heights of
caña
against the sky,
purple plumed.
I know the backache
of the machetero,
the arc of steel
cutting, cutting,
the rhythm of harvest
leaving acres of sharp spikes
that wound the feet
and the sweet smoke
of the llamarada:
rings of red fire burning
dark sugar into the wind.

My poems grow from the ground.
I know what they are made of:
heavy, raw and green.
Sugar,
you say, is sweet.

One teaspoon in a cup of coffee . . .
life's not so bad.

Caña, I reply,
yields many things:
molasses
for the horses,
rum for the tiredness
of the machetero,
industrial
alcohol to cleanse,
distill, to burn
as fuel.

I don't write my poems
for anybody's sweet tooth.

My poems are acetylene torches
welding steel.
My poems are flamethrowers
cutting paths through the world.
My poems are bamboo spears
opening the air.
They come from the earth,
common and brown.

 ❧ From *Getting Home Alive* (1986)

Child of the Americas

I am a child of the Americas,
a light-skinned mestiza of the Caribbean
a child of many diaspora, born into this continent at a crossroads.

I am a US Puerto Rican Jew,
a product of the ghettos of New York I have never known.
An immigrant and the daughter and granddaughter of immigrants.
I speak English with passion: it's the tongue of my consciousness,
a flashing knife blade of crystal, my tool, my craft.

I am Caribeña, island grown. Spanish is in my flesh,
ripples from my tongue, lodges in my hips:
the language of garlic and mangoes,
the singing in my poetry, the flying gestures of my hands.
I am of Latinoamérica, rooted in the history of my continent:
I speak from that body.

I am not African. Africa is in me, but I cannot return.
I am not Taíno. Taíno is in me, but there is no way back.
I am not European. Europe lives in me, but I have no home there.
I am new. History made me. My first language was spanglish.
I was born at the crossroads
and I am whole.

 From *Getting Home Alive* (1986)

Class Poem

This is my poem in celebration of my middle-class privilege
This is my poem to say out loud
I'm glad I had food, and shelter, and shoes,
glad I had books and travel, glad there was air and light
and room for poetry.

This poem is for Martita, my best friend
who played in the dirt with me
and married at eighteen (which was late) and who was a scientist
but instead she bore six children and four of them died
Who wanted to know the exact location of color
in the hibiscus petal, and patiently peeled away the thinnest,
most translucent layers to find it
and who works in a douche bag factory in Maricao.

This poem is for the hunger of my mother
discovering books at thirteen in the New York Public Library
who taught me to read when I was five
and when we lived on a coffee farm
subscribed to a mail-order library,
who read the Blackwell's catalogue
like a menu of delights
and when we moved from Puerto Rico to the States
we packed 100 boxes of books and 40 of everything else.

This poem is for my father's immigrant Jewish family.
For my great-grandfather Abe Sackman
who worked in Bridgeport making nurse's uniforms
and came home only on weekends, for years, and who painted
on bits of old wooden crates, with house paint,
birds and flowers for his great-grandchildren
and scenes of his old-country childhood.

This poem celebrates my father the scientist
who left the microscope within reach,
with whom I discovered the pomegranate eye of the fruit fly,
and yes, the exact location of color in a leaf.
This poem celebrates my brother the artist
who began to draw when he was two,
and so my parents bought him reams of paper
and when he used them up, bought him more,
and today it's a silkscreen workshop
and posters that travel around the world,
and I'm glad for him and for Pop with his house paints
and Tita staining the cement with crushed flowers
searching for color
and my mother shutting out the cries of her first-born
ten minutes at a time
to sketch the roofs and elevated tracks
in red-brown pastels.

This is for Norma
who died of parasites in her stomach when she was four.
I remember because her mother wailed her name,
screaming and sobbing,
one whole afternoon in the road in front of our school,
and for Angelica
who caught on fire while stealing kerosene for her family
and died in pain
because the hospital she was finally taken to
knew she was poor
and would not give her the oxygen she needed to live
but wrapped her in greased sheets
so that she suffocated.

This is a poem against the wrapped sheets,
against guilt.

This is a poem to say:
my choosing to suffer gives nothing
to Tita and Norma and Angelica
and that not to use the tongue, the self-confidence, the training
my privilege bought me

is to die again for people who are already dead
and who wanted to live.

And in case anyone here confuses the paraphernalia
with the thing itself
let me add that I lived with rats and termites
no carpet no stereo no TV
that the bath came in buckets and was heated on the stove
that I read by kerosene lamp and had Sears mail-order clothes
and that that has nothing to do
with the fact of my privilege.

Understand, I know exactly what I got: protection and choice
and I am through apologizing.
I am going to strip apology from my voice
my posture
my apartment
my clothing
my dreams
because the voice that says the only true Puerto Rican
is a dead or dying Puerto Rican
is the enemy's voice—
the voice that says
"How can you let yourself shine when Tita, when millions
are daily suffocating in those greased sheets . . ."
I refuse to join them there.
I will not suffocate.
I will not hold back.
Yes, I had books and food and shelter and medicine
and I intend to survive.

 ❧ From *Getting Home Alive* (1986)

Wings

Cuba y Puerto Rico son
de un pájaro las dos alas.
Reciben flores y balas
en el mismo corazón.

Lola Rodríguez de Tió

[Cuba and Puerto Rico
are the two wings of one bird
receiving flowers and bullets
into the same heart.]

Two wings of one bird said the exiled poet
whose words burned too many holes of truth
through the colonial air of a different iron-toothed occupation.
Nothing divides the suffering of the conquered.
Two wings, she said, of a single bird, with one heart between them,
taking bullets and roses, soldiers and prison bars and poetry,
into one pulse of protest. One bird she insisted
as the ship pulled away from San Juan headed for Havana, 1879.
A century later we are still the wounded wing,
fluttering, dragged through the waves, the next empire
plucking feathers from living flesh. *White egret within the foam,*
cried another poet, returning after long years in the dry solitude of Spain:
garza, garza blanca. Those ruffled reefs are infested now
with unexploded bombs. Pastures where white birds
still grace the backs of cattle, are dusted with the toxic waste
of rehearsal for invasion, that seeps into the blood of children,
so that cancer is a required course in the high schools of Vieques,
giving a whole new meaning to the term "drop out."
I was born into an occupied country. I am that wing.

What kind of Jew are you, receiving bullets and roses
as if in a Palestinian heart?
I am the Jewish great-great-granddaughter of Puerto Rican slaveholders.
I am the Puerto Rican great-great-granddaughter of Ukrainian socialists.
I am the surviving branch of a family tree
split at the turn of the last century

holding the photograph of nameless cousins
who missed the last train to Siberia
and fell into the trenches of summer
as Nazi armies rolled across the farmlands of Kherson.
I am the educated granddaughter of a Puerto Rican seamstress
who never went past the eighth grade,
whose fingers bled into the spandex of sweatshop assembly line girdles,
a long subway ride from the barrios where she lived, the granddaughter
of an electrician wiring battleships in the Brooklyn Navy Yard,
of a communist studying law at night
and serving deli by day, and of a social worker
trying to plug the holes in immigrant lifeboats.
I am a daughter of occupation and conquest, of deportation and escape.
I am a daughter of people who were outgunned and refused to die.
I am a colonial subject with a stone in my hand when I listen to the news.
I am a fierce Latina Jew holding out a rose to Palestine.

I am the Jewish grand-niece of a Puerto Rican WWII soldier
cracking up in the bloody Pacific,
in the service of an army that always sent the brown men in first.
I am the Puerto Rican cousin
of Jewish evacuees trying to flee eastward, shot in the back
by Ukrainian collaborators who lived just down the road.
I am the daughter of red pacifists married in the year of Korea,
a two-winged child conceived as the Rosenbergs died, born as Lolita was
 shackled
into her quarter century of punishment for shooting into the air.
I was born Jewish in an occupied Caribbean land, speaking Spanish
with the accent of escaped slaves and hungry coffee laborers,
because my great-grandfather would not fight Japan for the tsar,
because he evaded yet another imperial draft, and washed up in New
 York City
where barrio meets shtetl, girl meets boy and solidarity was my lullaby.

What kind of independentista are you, to weep for Israeli soldiers
drafted into accepting atrocity as a fact of life,
beating out the ritmo of kaddish for colonialists killed in rightful revolution
on the conga of your caribe heart?
I am the proud cousin of a banned Boricua writer climbing out of his
 deathbed

to raise the flag of Puerto Rico on the third anniversary of the US invasion,
just two weeks before he died of TB
contracted in the bitter prison cells of Valladolid.
I am a distant relative of the first woman of Puerto Rico burned
by the Inquisition, in the name of Christ, for being a secret Jew.
I am the descendant of hacendados
who worked their own slave children to the bone in tobacco fields ripening
over the traces of uprooted plantings of casabe
and of the pale brown daughters of dark women,
taken into the marriage beds of landholding men,
criada servants deemed good enough for younger sons,
setting their wide cheeks and mouths into their children's bones.
I am the descendant of invaders and invaded,
now riding high on history's wheel, now crushed below,
of those evicted and their village burned,
of those who rode the horses and set the flames.

What kind of song is this? Whose side are you on?
Two wings, I say with the exiled poets of my country
to my dispossessed and dispossessing cousins
in the land it seems that everyone was promised.
Two wings with a single heart between them:
intifada and partisaner, refusnik and cimarrona.
Nothing divides the suffering. One bird full of bullets and roses,
one bird with its wounded pinions,
one heart that if it breaks is broken. I *know* there are two bloody wings,
but it is one bird trying to lift itself into the air,
one bird turning in circles on the ground, because
two wings rising and falling together,
is the forgotten principle of flight. Two wings
torn by tempestuous weather.
One bird struggling into the light.

 ૎ First published in *Wrestling with Zion: Progressive Jewish-American Responses to the Israeli-Palestinian Conflict* (2003)

Truths Our Bodies Tell

I am Aurora Levins Morales, daughter of Rosario Morales, an Indigenous heritage working-class Puerto Rican woman, a multitalented feminist radical with migraines, depression, and anxiety, born in Harlem, and Richard Levins, a first-generation middle-class Ukrainian heritage Jewish communist scientist with heart disease and diabetes born in Brooklyn. My mother died of a blood cancer linked to one of the pesticides marketed and often imposed on farmers in Puerto Rico and around the world, by companies repurposing World War II nerve gasses and expertise to kill insects while promising better living for all.

I am both disabled and chronically ill. I live with epilepsy, with the aftereffects of multiple brain injuries and a stroke, a predisposition toward diabetes and a childhood of self-medicating with sugar, but most of all, of massive pesticide exposure during my childhood, made worse by impaired liver function, and extreme sexual abuse at the hands of international traffickers in child pornography, which overpowered and impaired my body's natural defenses and set all my bodymind systems on red alert. And then we migrated to Chicago, where my schoolmates sang *Puerto Rico, my heart's devotion, let it sink into the ocean.* Puerto Rican, Jewish, female, epileptic, and bisexual, living on my own at sixteen, I could have been sterilized five times over by twentieth-century eugenicists who didn't stop cutting epileptics in Illinois until 1970.

These assaults on my personhood are the result of a global drive to turn every possible gift life offers into private money, and extract from our bodies and our planet, our cultures and our ordinary needs, every single penny's worth of profit, no matter what the cost. In Puerto Rico, they are expressions of colonialism. This is what it means to me to be disabled, sick, and Puerto Rican.

We are the ones whose bodyminds don't comply with that project, the ones who can't be standardized, whose uniqueness, variety, adaptation, gets in the way of efficiently exploiting our labor, so we're defined as liabilities.

Like all living things, we are repositories of stories, archives of what I call histerimonias, because testimonio comes from the custom of Roman

men swearing on their testicles, which I don't have, and because the idea of "hysteria" has been used for many centuries to dismiss and silence those who are considered unreliable witnesses, especially women.

Who here has heard of Puerto Rican Syndrome, the only ethnically titled psychiatric condition in the DSM, first observed by US army psychiatrists among young Puerto Rican men drafted into the US military and about to be sent to war in Korea? Where I grew up, that was called an ataque. People who had them screamed and fell on the ground, writhed and jerked, cried out, and tore at their hair and clothing until it passed. It was a culturally respected response to an unbearable shock or loss, but instead of tracing its roots into the colonized soil of my country, instead of tracing it back to the stripping away of land and customs and sovereignty, instead of understanding it as the right response to the mass sacrifice of our young men's lives in wars for imperial control, foreign experts studied, footnoted, and analyzed it into a disorder, something wrong with *us*.

But what if we rolled back the diagnoses, and opened the floor?

What if each body could speak in its fullest voice and be heard?

Every form of social injustice demands that we silence our bodies, from our infancies when we were taught to eat, sleep, move, be still, piss and poop, be quiet or talk to suit adult needs and not our own. From the first schoolroom in which learning was divorced from movement, from nature, from touch, and we had to sit in our rows of desks for hours. From the start, we're taught to manage our flesh for other people's benefit, to train ourselves to be the workers the system needs. We are denied and learn to deny ourselves fresh air and exercise, clean water and healthy food, rest. From the start, we are taught to subordinate our truths, change our names, tame our tongues, told to stop crying because it doesn't hurt when it does, told that we can't have the lives we want because we aren't people enough.

As Latinx humans, born from the confluence of Indigenous, African, and Iberian ancestors, and embracing many other streams of migration, the supremacy of the white, Protestant, Northern European elites already violently targets our bodies and minds as dangerous, wrong, and disposable. Our entire histories are preexisting conditions that, according to the rulers, disqualify us, not only from Republican health care but from full humanity.

Those of us whose bodyminds are in addition an explicit problem for the profit machine are punished for it. Warehoused in institutions, left alone in our rooms, seen as bad investments and refused resources, the job of inclusion is left on our laps so that we have to construct every single door we need to go through, build it from scratch, over and over and over again.

We are written in their ledgers as obstacles. We get in the way of extraction. Or so I hope.

Because this is one of our gifts to the world. By our very existence, we challenge the ruling definitions of human worth, the nature of work, of ability, of aliveness, what it means to produce, what we should value. We survive, when we do, because we are able to build webs of relationships, able to tend to each other, feed each other, able to chain ourselves to fences in loudly chanting groups, able to insist on our own stories about who we are.

Our movement has power and potential far beyond creating access to the status quo. We have the power to lead every movement for justice toward sovereignty, respect, and tenderness for all bodies, all minds, to practice universal inclusion now, while we're struggling to shift and repair and re-make the fabric of the world. We have the power to teach our movements, to teach the people around us who believe they are invincibly able-bodied, how to listen to and trust their own bodies and minds, respect the limits of capacity, how to rest and have needs, how to move from our centers and build social justice practices that are rooted and resilient.

Listen:

As a sick and disabled woman of color in my sixties my body feels like a wild terrain, both wounded and filled with resilience and a refusal, an in-ability, to meet the demands of a profit-driven society. When I was younger, I was able to override the needs of my body in order to drive my mind, and my productivity, and my social responsibilities. We all learn to do this. Learning to listen to the histerimonias of my body, what I find there is the history of the world. Migration, environmental destruction, sexual violence, war, yes, and also my kinship with the soil, with water, with plants and animals and spirits. I find the unruly, honest flesh. Over time, my body has become my compass. When I write, when I speak, when I engage ideas, I am aware of how this complex biosocial organism responds—how my stomach, my jaw, my hormones, my skin, my breath react, and those reactions become my guide. They tell me when I am speaking important truths and insights, when I am missing something, off target, too clever, have surrendered to what's expected of me. Now, when I gather the stories of others, I ask: what does your body have to say about this? The more I rely on my body's voices, the more I am aligned with my most powerful truths. My body is not a pristine zone of liberation. It is filled with injury, but it doesn't lie. Each time I claim its authority, I become less colonized. I am rebound into the natural web of life we are robbed of. And when we do this together, great rivers of healing enter the world.

All organisms are inherently sovereign. All organisms resist harm and repair damage. This is our nature. And our nature is to tell stories about it. Because the story of what is broken becomes something whole. The story of what was forgotten becomes memory. The story of how we survived becomes communal medicine. The story of what we lost becomes new soil. The story of how we are the same as everyone and the story of how we are unique are a braided lifeline.

The story of what my injured brain does with information is a story about human brains. The stories about genetic roadblocks that slow down my ability to shed toxins, about the thud of my head landing from five feet nine inches onto a concrete floor, about what strobe lights and perfume do to my nervous system, about how after the stroke I painted my tiny hallway yellow, one trembling brushstroke at a time, how it took weeks, propped on a walker, about the deep pleasure of laying that sunlit color on another six square inches of wall and then lying down to rest, these are all part of the great encyclopedia of human bodies, and each of you has a volume full.

Listen:

In 2009, I went to Cuba because the balancing act of getting authorization for forty-five-minute once-a-week sessions of physical therapy in which there was only time to teach me how to adapt had ended with a half share in a power wheelchair, not because that was all that I needed but because that was what they were willing to spend on me. My father had been training Cuban ecologists for decades and so he asked, and they said yes, and I prepared by reading the published papers of experts at the clinic where I was headed. During the same week in which, after filling out reams of forms, all designed to make me give up and feel guilty for having asked, I was once again denied disability benefits, I read a Cuban article about how to persuade an injured person to accept free medical care and take on the hard work of rehab. The author said that every human being has irreplaceable gifts and if rehab would allow someone to more easily offer them to the world, then it would be a great benefit to society, a public good.

I spent ten weeks in a clinic where therapists hugged patients, where privacy was replaced by solidarity, where the children of staff climbed on the equipment without being scolded, where I had thirty-seven hours of rehab a week and was encouraged to sing about it, and people listened to what I had to say about the pain of my body struggling back toward integration, how numb and scalded my skin felt, how tired I was. The point isn't that I learned to walk again. The point is how. That I was held in a web of relation, where nothing was wrong with me.

When I was getting ready to leave, the staff psychiatrist told me that I needed to cultivate solidarity in my life back home, that the key to well-being was to find people who shared my values, find important work to do together, and have fun doing it.

There are ways that my body will not ever shift toward the so-called norm, white patches on my MRI that will not darken back into the rest, liver pathways that will always be sluggish and leave piles of debris deposited in my own tiny superfund sites, trails I will never hike. Some of the ways I am impaired make it a lot harder to survive the toxicity that greed creates. For me to have real access requires a whole new economy, ecologically responsible, one that listens to my body speak about dieldrin and DDT, benzenes and parathion, and takes heed. But that is true for us all. The only lasting access is justice.

Our stories are not just personal compasses. They are navigation for the world. What does your body have to teach us about architecture and language, time and flexibility, and the act of breath? How would we have to shape our society for nothing about you to be disabling? Where does your body want to lead us??

I like to say that metaphor is both my research methodology and my system of analysis. How I map connections and resonances, from my thinking heart, from my analytical gut, my poetic brain, a way to be sensipensante, to merge thinking and feeling, rooted in the sparkling electricity of nerves, my unique genetic alphabet and cascades of biochemical reaction, red pumping muscle and sapling green bone of my body. Poetry is the most accurate equation I know.

• From *Medicine Stories* (1999)

Stricken

FIRST POEM WRITTEN AFTER MY 2007 STROKE,
WHICH TOOK ALL DAY TO TYPE.

what a dish
half woman
half noodle.

most people prefer that she top herself
with something creamy
and cheerfully mild

worried she might be
frightfully bitter
or just frightening

secretly
she is chewing arugula
and dandelion greens
into a stinging pesto
of bad attitude.

staring at a can she wonders
can she train her teeth
to chomp around the edges?
life is no zip top.

dexterity comes from dexter
to be adroit in a right-handed world.
who knew it took such intricate cooperation
to floss your teeth?

she imagines the millions who knew
wielding one-handed toothpicks

stringing thread between their toes
refusing to surrender their mouths.

she tries to write
but her hand pours itself
all over the keyboard
spills between the space bar
and the letter N.

she wakes up tied to her muscles
feeling like lead,
hating how the sun
calls to her through the curtains.

nothing has prepared her
to do nothing
but be.
she feels disobedient
or shallow
for not feeling enlightened.

the shallowest river she's ever seen
was the Gale River, only a handspan of ice-green water
gurgling between hard, delicate
winter glass above, and a bed of stones.

through that narrow translucent space
mountain water, achingly cold,
made silent eddies—
graceful, frozen curls of white,
across the river's face.

she imagines herself
a twig twisting through gaps between rocks,
a one-legged newt buried in bottom mud.

Already it's time for lunch,
bowl held tight to the apron-covered chest
in the crook of the weak arm, held up with pillows,

dipping a spoon with the strong left hand
that doesn't know how.

in the afternoons she listens to spring birds in the oaks
lies very still on her bed
moves fingers, legs, toes in her mind
feeling nerves tingle
with the force of her will for them

at night she dreams
she is picking up tiny blue beads
dropping them one by one
into a black bowl

impulses of light
in a curve of silence.

 From *Kindling: Writings on the Body* (2013)

Listen, Speak

1

Come. You. Yes, you. Tonight we are gathering stories, ours, yours. Each of us with our bundles of sticks, each of us with our strands of cord. The word in your pocket is what we need. The song in your heart, the callus on your heel.

Come into the clearing. Bring your tinder. Together, we will strike sparks and set the night ablaze. Come out of the forest, the woodwork, the shadows to this place of freedom, quilombo, swamp town, winter camp, yucayeque, where those not meant to survive laugh and weep together, share breath from mouth to mouth, pass cups of water, break bread—and let our living bodies speak.

Come with your triggers, your losses, your scars. When something you hear, something you see, makes your wounds ache and throb, it's only memory rising, a piece of our history. Bring it into the circle. We will hold it together.

Our history is in our bodies—what we do to breathe, how we move, the sounds we make, our myriad shapes, our wild gestures, far outside the boundaries of what's expected, the knowledge bound into our bones, our trembling muscles, our laboring lungs—like secret seeds tied into the hair of our stolen ancestors, we carry it everywhere. Our stories erupt in the dances we invent, in the pleasure rubbed from our bodies like medicine from crushed leaves, spicy, astringent, sweet.

We are the children of Anacaona, Golden Flower of the Taíno, from the lands we called Hayti, Jamayca, Cuba, Borikén, who witnessed the shattering of the Caribbean world, the house of feasting set on fire. A poet warrior speaking truth in a landscape of ashes, speaking beauty into the dark. Though she died at the hands of invaders, we, her descendants, guakía guali, are still here, still speaking unspeakable truths, still making beauty in the marketplace of those who want us dead.

Here come Peg Leg Joe and Moses, the cripple and the epileptic, following their stars across swamps and mountains and cold clear water, saying

with their feet, with their backs and hands, no life belongs to another, our bodies are not acreage, livestock, overhead, disposable tools. They hum as they travel, songs heavy with maps that lead us back to ourselves, singing you, yes you, are irreplaceable.

And these are the sterilized multitudes, women of Puerto Rico, one out of three, migrant worker mothers in labor told to sign what they can't read, the poverty-stricken, the weak-limbed, the feebleminded, the queer, a poor white girl from Virginia, deemed too stupid to breed, the ones who get migraines or drink or like sex, dark-skinned, immigrant, colonized, Jew, people like me, people like you . . . strapped down under surgeons' knives, their bloodlines severed, their children disappeared by stone-faced people desperately building a master race to rule the world. Yet here we are, and here we are fruitful, our stories flower, take wing, reproduce like windblown seeds. No surgeon's knife can cut the lines of spirit. Our family tree remains.

———

2

Open up. Make room. Let the circle grow.

From the shadows steps a man of Tuskegee, syphilis raging untreated through his veins, gone blind, lame, and speechless while white doctors took notes, but here he speaks with a voice like a drum. At the light's edge a girl with no face who lived ten years locked in a room holds the hand of an old man with no relatives and blue numbers tattooed on his arm. Trace the lines in the maps of our bodies. They run like furrows, side by side. They move like rivers, enter each other, make tributaries and forks.

Make room for the children raised on locked wards under a flickering fluorescent light, the shocked and injected, the measured and displayed, tormented, fondled, drugged, called defective. Their small blunt faces look out from sterile hallways, grey buildings, medical case files, toward this fire that we become. They come wheeling and hobbling over thick tree roots to sit by the flames, cry out in childish voices, for water, for hands to hold, for us to listen as they give themselves new names.

We unwrap our tongues, we bind our stories, we choose to be naked, we show our markings, we lick our fingers, we stroke our bellies, we laugh at midnight, we change the ending, we begin, and begin again.

3

Come beloveds from your narrow places, from your iron beds, from your lonely perches, come warm and sweaty from the arms of lovers, we who invent a world each morning, and speak in fiery tongues.

Come you with voices like seagulls, dissonant and lovely, with hands like roots and twigs. Come limbs that wander and limbs like buds and limbs heavy as stone, come breathless and swollen and weary, fevered and wracked with pain. Come slow and heavy, come wary and scarred, come sweet and harsh and strong. Come arched with pleasure, come slick with honey, come breathless with delight.

You. Yes, you. Take the cord of memory from my hands, and tie a knot to mark your place. Each body knows its own exhausting journey, its own oases of joy, its bellyful of shouting, resilience and shame and jubilation. We mark the trail for each other, put lanterns by the door, scratch our signs in the dirt, make signals with fingers in palms, sing coded freedom songs. Strike the stick of aliveness on whatever will make a sound. Bind your stories together. This is how rope is made. Each strand is essential to the strength of the braid. Bring your body closer. Lean in toward the heat and the light. We are striking sparks of spirit, we are speaking from our flesh, we are stacking up our stories, we are kindling our future.

Listen with your body. Let your body speak.

 From *Kindling: Writings on the Body* (2013)

Yerba Bruja

Bryophylum pinnatum, fam. Crasulaceas.

Nombre vulgar: bruja, yerba bruja, life plant.

Este yerbajo, típico de las regiones cafetaleras, sobrevive casi todos los tratamientos eradicación, desde el desyerbo a mano hasta concentraciones altas del yerbicida 2,4-D. El nombre vulgar de bruja hace referencia a su resistencia a los tratos más crueles que puedan dársele. El tallo carnoso retoña con facilidad; y cada ondulación o mella de las hojas también carnosas, es una región potencial para el desarrollo de una matita, aún guardadas en libros o suspendidas en clavos, las hojas suelen retoñar.

[This plant, typical of the coffee regions, survives almost all efforts at eradication, from hand weeding to high concentrations of the herbicide 2,4-D. Its common name, "witch," refers to its resistance to even the most cruel treatment that can be inflicted on it. The fleshy stalk sprouts easily; and every indentation or notch in the leaf, which is also fleshy, is a potential site for the development of a seedling. Even when kept pressed between the pages of books or hung on a nail, the leaves will sprout.]

from *Plantas tropicales* by Ismael Vélez

Bruja. It grew lush and inextinguishable all over the farm, in among the acres of impatiens and coleus, which we called alegría and vergüenza, joy and shame. It grew wild and flourishing in the shade of the coffee forest; in the grassy, weedy clearings blazing with full tropical sun, everywhere. The flowers hung pale and creamy, blushed with purple, long puffy bags filled with air, that we kids would pop between our fingers. The thick fleshy leaves we would pin down with a rock or bit of dirt, and watch for the "daughters" to spring up from the notched edges of the "mother." Like a coven gathered

around their wounded elder, the seedlings always grew in a circle, marking the place where the long-decayed leaf had lain.

How the shapes we grow into mark long-gone places, residues of ash or blood or iron, broken shards, the print of a foot, a kernel of corn, a fragment of rope. This story is about reading the residues of two intertwining histories. One is the vast web of women's stories spinning out in time and space from the small island of Puerto Rico and encompassing some of the worst disasters to befall humanity: the Crusades, the Inquisition, the African slave trade, the witch persecutions, the European invasions of America, Africa, Asia, and the Pacific, the enclosure of common lands in Europe itself, that sent a land-starved and dispossessed peasantry out rampaging in the wake of greedy aristocrats, merchants, and generals across the world; and all the plagues, tortures, rapes, famines, and killings that accompanied them. It is also the story of endless resourcefulness, courage, hard work, defiance, friendship, risk-taking solidarity, and the stubborn refusal to be extinguished.

The second story is exactly the same: invasion, torture, rape, death, courage, solidarity, resistance. It is a much smaller history. It does not sweep across continents and there are only a few people involved, but it has taken up as much space in my life during this writing as the larger weave. On that same land where bruja continues to thrust up seedlings in spite of herbicides, machete blades, and uprooting hands, I was ritually abused by a group of mostly male adults for a period of about six years.* These men had everything in common with their conquistador ancestors, with their slave-holding ancestors, with men who tortured as both routine policy and sadistic pleasure.

It was not my original intention to include this second story here, but throughout the writing of *Remedios* I was simultaneously engaged in two tasks: digging up the histories of Puerto Rican and related women and their responses to the often brutal conditions of their lives; and recovering the buried memories of my own experience of and responses to brutality. I used my own history to help me understand the choices of women long dead, and increasingly the lives of these women from different centuries and lands gave me insight and strength to face what had happened to me. In fact, I began therapy and the graduate school program in which I researched and wrote *Remedios* within two weeks of each other. I do not think this was accidental. I created for myself the possibility of healing my own wounds as I explored the collective wounds of Puerto Rican women's oppression and the medicinal powers of history. I became my own laboratory.

It is the laboratory of an herbalist. One who gathers what is growing wild, and with the help of handed-down recipes, a little fire and water, and a

feel for plants, prepares tinctures, concentrating faint traces of aromatic oils, potent resins capable of stopping a heart or healing it. The history I gathered here is like the medicinal plants growing in a long-abandoned garden. The herbal is lost, burnt by inquisitors. The plants that cure scurvy, tone the kidneys, purge parasites are buried in the tangle of weeds whose pollen sweetens the air but which do nothing for human bodies. I must taste the leaves, looking for that trace of bitterness, that special aroma of sweetness. I must let the plant act in my body in order to know what it is.

There are compelling reasons to do this beyond my own need for a tonic, for digestive bitters. Between seven hundred and five hundred years ago, a series of devastating blows fell upon humanity. They were not the first or even necessarily the worst such blows to fall in the course of human history. But these are the wounds we have inherited, the foundation of our current world order, the unhealed injuries that fester in contemporary life. During that period, the elites of Europe launched a series of wars upon their own people. The peasants were driven off common lands and into wage labor. At least hundreds of thousands and possibly millions of European women were attacked, tortured, and killed as suspected witches. Throughout Europe we saw the rise of new ideologies that severed peoples' ties to the land and to their own bodies, that burned women at the stake for knowing plants, feeling kinship with animals, knowing how to heal each other and birth babies without having to look up procedures in books.

The Crusades and long-standing economic competition with the Islamic world had set up a racist frame of reference for conquest. In Spain, the Christian reconquest of the peninsula from Islamic rule gave rise to the extreme nationalism of a newly assembled country, with all its accompanying bigotry and religious intolerance. Jews and Muslims were expelled, forced to convert or die, barred from practicing their crafts and trades, and had their belongings confiscated.

Out of this world of famines, epidemics, evictions, multiplying numbers of landless beggars, a tidal wave of pillage swept out over the planet. The rise of European merchants, companies, transnational corporations into dominance has been disastrous for all the world's people. Africa was and continues to be devastated by three centuries of mass enslavement and even longer colonial occupation. The Americas and the Pacific Islands were invaded, their lands and resources stolen, and their peoples destroyed or reduced to exile and poverty in their own countries. Great portions of Asia were also invaded, captured, and occupied for European markets. And people were not the only sufferers. Great forests, herds, flocks, schools of creatures abundant

beyond belief are gone, devoured by a frenzy of greed that killed five million passenger pigeons, all but exterminated many kinds of seals, whales, beavers, clear-cut forests once many days' travel across, leaving barren, eroded lands. All these events have had immense consequences for our capacity to live with the earth and each other.

The stories of women's lives that I have gathered here range over much of the time and geography of these events. In finding and distilling them, I am moved by an urgent sense that in order to invent new strategies and ways of living together, in order to find those paths that lead to the continuation of life on earth, we must come to understand the nature of these blows: how and why they fell, what was lost, what was hidden away and saved, and most of all, what we, the majority of humans, have learned from the long process of resisting, surrendering, accommodating, and transforming ourselves so we could live. In the stories of these women's lives, I am seeking information about how to tip the balance toward survival for all of us.

Or to return to the herbal metaphor, the medicines I seek as I wander in these long-abandoned gardens (I found most of these women in footnotes, appendices, in single lines buried in books about men) are not only the home remedies and daily comforts that heal scratches, stomachaches, and runny noses. I am particularly looking for that special class of plants called adaptogens, plants that contain substances capable of altering our bodies' ability to resist attack, to withstand stress, to defeat toxins and tumors, to enter into the core of nearly overwhelmed immune systems and bring energy and hope.

.

One of the ironies of my own history of abuse is that it took place in Indiera, a place of refuge for Indigenous and African people escaping from enslavement and control in the fertile coastal zone of Puerto Rico. As a child, I once found shards of Arawak pottery buried in the clay and another time, carved and painted images on a rock. Indiera was the site of a settlement of Indigenous people, both those from the island and those brought by force from Tierra Firme, who, according to the chronicles, retreated farther and farther from the Spanish until they reached the crest of the cordillera and made a community with their mixed-blood kin.

The people who abused me were not necessarily from Indiera. One was an elementary school teacher whose family lived in a coastal town, and was probably descended from some of the Spanish conquerors of the Canary Islands. Another was a doctor from the United States. Most of them were

not known to me outside the context of the abuse, where they often wore masks. They were invaders, anonymous in their power.

In writing about what happened to me, I have found myself identifying with the original inhabitants of the land on which I was born and raised, and all the runaways and rebels that found their way there over the centuries. As a child, I was proud of the heritage of resistance that seemed to linger. I could imagine them in the deep, wild valley to the north of our house, still living off wild guavas, green bananas, and stolen chickens. My parents, communists who were frequently under surveillance and harassment from the authorities, were obvious inheritors of this tradition; it was fitting that we lived within a mile of where Matias Brugman, a leader of the uprising against Spain in 1868 and probable descendant of Jews, was killed by Spanish soldiers. These heroic ghosts stood near me at the worst moments of abuse, and I could imagine the red clay recognized me as one of them. It gave me courage not to feel quite so alone.

It was also the land itself, its burgeoning life, its sweeping views of the distant sea, often shrouded and half-hidden by cloud, its abundant sweetness, its thick, viscous mud, the cleansing rains, the smell of water and greenness, chattering birds, hot yellow sun in tropical blue sky—all these things provided me comfort and consolation, mute friendship, when I could not tell anyone what was being done to me. In its complexity, its contradictory strands, in its beauty and hardship, this book springs very much from the rain-drenched red earth of Indiera.

ŝ❧ From *Remedios* (1998)

Dulce de Naranja

In Puerto Rico, Las Navidades is a season, not a single day. Early in December, with the hurricane season safely over, the thick autumn rains withdraw and sun pours down on the island uninterrupted. This will be a problem by March, when the reservoirs empty, and the shores of Lake Luchetti show wider and wider rings of red mud, until the lake bottom curls up into little pancakes of baked clay and the skeletons of long-drowned houses are revealed. Then, people wait anxiously for rain and pray that the sweet, white coffee blossoms of April don't wither on the branch. But during Navidades, the sun shines on branches heavily laden with hard green berries starting to ripen and turn red. Oranges glow on the trees, aguinaldos dominate the airwaves of Radio Café, and women start grating yuca and plantain for pasteles, and feeling up the pigs and chickens, calculating the best moment for the slaughter.

It was 1962 or maybe 1965. Any one of those years. Barrio Indiera Baja of Maricao and Barrio Rubias of Yauco are among the most remote inhabited places on the island, straddling the crest of the Cordillera Central among the mildewed ruins of old coffee plantations, houses, and sheds left empty when the tides of international commerce withdrew. A century ago, Yauco and Maricao fought bitterly to annex this highland acreage from one another, at a time when Puerto Rican coffee was highly prized as the best in the world. But Brazil flooded the market with cheaper, faster-growing varieties. There were hurricanes and invasions and the coffee region slid into decline.

In the 1960s of my childhood, most people in Indiera still worked in coffee, but everyone was on cupones except the handful of hacendados, and young people kept leaving for town jobs or for New York and Connecticut.

Those were the years of modernization. Something was always being built or inaugurated—dams, bridges, new roads, shopping centers, and acres of housing developments. Helicopters crossed the mountains, installing electrical poles in places too inaccessible for trucks (keeping an eye out for illegal rum stills). During my entire childhood the acueducto, the promise of running water, inched its way toward us with much fanfare and very little result. When the pipes were finally in place, the engineers discovered that there was rarely enough pressure to drive the water up the steep slopes

north of the reservoir. About once a month the faucets, left open all the time, started to sputter. Someone called out "acueduuuuucto" and everyone ran to fill their buckets before the pipes went dry again.

Navidades was the season for extravagance in the midst of hardship. Food was saved up and then lavishly spread on the table. New clothing was bought in town or made up by a neighbor and furniture brought home, to be paid off in installments once the harvest was in.

One of those years, her husband bought Doña Gina an indoor stove with an oven, and all the neighbors turned out to see. They were going to roast the pig indoors! Not a whole pig, of course, but I was there watching when Don Lencho slashed the shaved skin and rubbed the wounds with handfuls of mashed garlic and fresh oregano, achiote oil and vinegar, black pepper and salt. Doña Gina was making arroz con dulce, tray after tray of cinnamon-scented rice pudding with coconut. The smells kept all the children circling around the kitchen like hungry sharks.

This was before every house big enough for a chair had sprouted a TV antenna. My brother and I went down to the Canabal house to watch occasional episodes of *Bonanza* dubbed into Spanish: I liked to watch the lips move out of sync with the voice that said, "Vámonos, Hoss!" And by 1966 there would be a TV in the seventh-grade classroom at Arturo Lluberas Junior High, down near Yauco, where the older girls would crowd in to watch *El Show del Mediodía*. But in Indiera and Rubias nobody was hooked on TV Christmas specials yet. When the season began, people still tuned up their cuatros and guitars, took down the güiros and maracas, and started going house-to-house looking for free drinks. So while Don Lencho kept opening the oven to baste the pig, Chago and Nestor and Papo played aguinaldos and plenas and Carmencita improvised lyrics back and forth with Papo, each trying to top the other in witty commentary, the guests hooting and clapping when one or the other scored a hit. No one talked much about Cheíto and Luis away in Vietnam, or Adita's fiancé running off with a pregnant high school girl a week before the wedding, or Don Toño coughing up blood all the time. "Gracias a Dios," said Doña Gina, "aquí estamos."

During Navidades the cars of city relatives started showing up parked in the road next to the red and green jeeps. My girlfriends had to stay close to home and wear starched dresses, and the boys looked unnaturally solemn in ironed white shirts, with their hair slicked down. Our relatives were mostly in New York, but sometimes a visitor came all that way, announced ahead of time by letter, or, now and then, adventurous enough to try finding our farm with just a smattering of Spanish and a piece of paper with our names.

The neighbors grew their own gandules and plantain, but except for a few vegetables we didn't farm our land. My father drove to San Juan every week to teach at the university and did most of our shopping at the Pueblo supermarket on the way out of town. Sometimes all those overflowing bags of groceries weighed on my conscience, especially when I went to the store with my best friend Tita and waited while she asked Don Paco to put another meager pound of rice on their tab. My father was a biologist and a commuter. This was how we got our frozen blintzes and English muffins, fancy cookies and date nut bread.

But during Navidades it seemed, for a little while, as if everyone had enough. My father brought home Spanish turrón—sticky white nougat full of almonds, wrapped in thin, edible layers of papery white stuff. The best kind is the hard turrón you have to break with a hammer. Then there were all the gooey, intensely sweet fruit pastes you eat with crumbly white cheese. The dense, dark red-brown of guayaba, golden mango, sugar-crusted pale-brown batata, and dazzlingly white coconut. And my favorite, dulce de naranja, a tantalizing mix of bitter orange and sugar, the alternating tastes always startling on the tongue. We didn't eat pork, but my father cooked canned corned beef with raisins and onions and was the best Jewish tostón maker in the world.

Christmas trees were still a strange gringo custom for most of our neighbors, but each year we picked something to decorate, this household of transplanted New Yorkers—my Puerto Rican mother, my Jewish father, and the two, then three, of us "Americanito" kids growing up like wild guayabas on an overgrown and half-abandoned coffee farm. One year we cut a miniature grove of bamboo and folded dozens of tiny origami cranes in gold and silver paper to hang on the branches. Another year it was the tightly rolled, flame-red flowers of señorita with traditional, shiny Christmas balls glowing among the lush green foliage. Sometimes it was boughs of Australian pine hung with old ornaments we brought with us from New York in 1960, those pearly ones with the inverted cones carved into their sides like funnels of fluted silver and gold light.

The only telephone was the one at the crossroads, which rarely worked, so other than my father's weekly trip to San Juan, the mail was our only link with the world outside the barrio. Every day during las Navidades when my brother and I stopped at the crossroads for the mail there would be square envelopes in bright colors bringing Season's Greetings from faraway people we'd never met. But there were also packages. We had one serious sweet tooth on each side of the family. Every year my Jewish grandmother sent metal tins full of brightly wrapped toffee in iridescent paper that my

brother and I saved for weeks. Every year my Puerto Rican grandfather sent boxes of Jordan almonds in sugary pastels and jumbo packs of Hershey's kisses and Tootsie rolls.

Of course, this was also the season of rum, of careening jeeploads of festive people in constant motion up and down the narrow, twisting roads of the mountains. You could hear the laughter and loud voices fade and blare as they wound in and out of the curves. All along the roadsides were shrines, white crosses or painted rocks with artificial flowers and the dates of horrible accidents: head-on collisions when two jeeps held on to the crown of the road too long; places where drivers mistook the direction of the next dark curve and rammed into a tree, or plummeted, arcing into the air and over the dizzying edge, to crash down among the broken branches of citrus and pomarrosa, leaving a wake of destruction. Some of those ravines still held the rusted frames of old trucks and cars no one knew how to retrieve after the bodies were taken home for burial.

It was rum, the year my best friend's father died. Early Navidades, just coming into December and parties already in full swing. Chiqui, Tita, Chinita, and I spent a lot of time out in the road, while inside, women in black dresses prayed, cleaned, and cooked. Every so often one of them would come out on the porch and call Tita or Chiqui, who were cousins, to get something from the store, or go down the hill to the spring to fetch another couple of buckets of water.

No one in Indiera was called by their real name. It was only in school, when the teacher took attendance, that you found out all those Tatas and Titas, Papos and Juniors were named Milagros and Carmen María, José Luis and Dionisio. The few names people used became soft and blurred in our mouths, in the country Puerto Rican Spanish we inherited from Andalucían immigrants who settled in those hills centuries ago and kept as far as they could from church and state alike. We mixed yanqui slang with the archaic accents of the sixteenth century so that Ricardo became Hicaldo while Wilson turned into Güilsong. Every morning the radio announced all the saints whose names could be given to children born that day, which is presumably how people ended up with names like Migdonio, Eduvigis, and Idelfonso.

Anyway, Tata's father was dying of alcoholism, his liver finally surrendering to forty or fifty years of heavy drinking and perhaps his heart collapsing under the weight of all the beatings and abuse he had dished out to his wife and fourteen children. Tata was his youngest child—ten, scrawny, fast on her feet. Her city nieces and nephews were older, but in the solemn days of waiting for death, she played her status for all it was worth, scolding them

for laughing or playing, reminding them that she was their aunt and must be respected. All day the women swept and washed and cooked and in the heat of the afternoon sat sipping coffee, talking softly on the porch.

In our classroom, where we also awaited news of the death, we were deep into the usual holiday rituals of public school. The girls cut out poinsettia flowers from red construction paper and the boys got to climb on chairs to help Meesee Torres hang garishly colored pictures of the Three Kings above the blackboard. We practiced singing "Alegría, Alegría, Alegría," and during Spanish class we read stories of miraculous generosity and goodwill.

Late one Tuesday afternoon after school, we heard the wailing break out across the road and the next day Meesee Torres made us all line up and walk up the hill to Tata's house to pay our respects. We filed into their living room, past the open coffin, each placed a single flower in the vase Meesee had brought, then filed out again. What astonished me was how small Don Miguel looked, nested in white satin, just a little brown man without those bulging veins of rage at his temples and the heavy hands waiting to hit.

The next night the velorio began. The road was full of jeeps and city cars, and more dressed-up relatives than ever before spilled out of the little house. For three days people ate and drank and prayed and partied, laughing and chatting, catching up on old gossip and rekindling ancient family arguments. Now and then someone would have to separate a couple of drunken men preparing to hit out with fists. Several of the women had ataques, falling to the ground and tearing their hair and clothing.

The first night of the velorio was also the first night of Hanukkah that year. While Tata went to church with her mother to take part in rosarios and novenas and Catholic mysteries I knew nothing of, my family sat in the darkened living room of our house, lighting the first candle on the menorah, the one that lights all the others. Gathered around that small glow, my father told the story of the Maccabees who fought off an invading empire, while across the road, Tata's family laughed together, making life bigger than death. I remember sitting around the candles, thinking of those ancient Jews hanging in for thirty years to take back their temple, what it took to not give up; and of all the women in the barrio raising children who sometimes died and you never knew who would make it and who wouldn't, of people setting off for home and maybe meeting death in another jeep along the way. And in the middle of a bad year, a year of too much loss, there were still two big pots of pasteles and a house full of music and friends. Life, like the acueducto, seemed to be unpredictable, maddening, and sometimes startlingly abundant.

That night I lay awake for a long time in the dark, listening to life walking toward me. Luis would never come home from Vietnam and Cheíto would come home crazy, but the war would end someday and most of us would grow up. My father would be fired from the university for protesting that war, and we would be propelled into a new life, but I would find lifelong friends and new visions for myself in that undreamt-of city. Death and celebration, darkness and light, the miraculous star of the Three Kings and the miracle of a lamp burning for eight days on just a drop of oil. So much uncertainty and danger and so much stubborn faith. And somewhere out there in the dark, beyond the voices of Tata's family still murmuring across the road, the three wise mysterious travelers were already making their way to me, carrying something unknown, precious, strange.

 ❧ From *Cosecha and Other Stories* (2013)

First Snow

.....

For Robin Sterns, 1953–1972

.....

I never knew you in a season of green leaves and flowers. When we met, it was early gold in New England, and the first frost of September had just touched the last thick grasses of August. Five years in this country, and I had never yet loved a piece of land. I'd come straight from the lush tropical forests of a Caribbean mountain range to the South Side of Chicago, a landscape that hurt my senses, and although Lake Michigan's steely windblown waters sometimes won my grudging admiration, though I stood still to watch the smoggy, prune-colored skies bruise into color at sunset, there was nothing that tempted me to root. That summer I decided to leave before another sooty winter clamped down on the city. At the last minute I got into a small college in the White Mountains of New Hampshire that was within my means and an easy hitchhike from my boyfriend's school in Vermont. All I wanted was out.

Riding the bus north from Boston, we swung through the dark, following a thread of lights, stopping to let silent passengers off in front of small-town post offices and supermarkets. Untalkative women and men and sleepy children stepped out into the leafy-smelling dark, and the bus ground back onto I-93, while the land rose in ever sharper granite shadows out of reach of the headlights. You came the other way—the bus from White River Junction that meets the New York train.

That first night they put us all at the inn until the dorms were ready. Your tentative knock came just as I was pulling out a nightgown, trying to settle down from the strange thrill of being a thousand miles from home. "Oh God," I thought, "a debutante. What on earth are we going to talk about?" You looked like a model, and I was horrified to discover that you were one. Tall, thin, a head covered with true-gold hair the exact color of the looted Egyptian treasures at the Oriental Institute, big blue eyes, and a touch of Texas in your soft voice. I was fresh from the rallies over Cambodia, fresh from discussing the myth of vaginal orgasm and the politics of housework. I wore old mauve lace and flowered cotton dresses from secondhand stores one day, lumberjack shirts and painter's pants the next, my rarely brushed

hair hanging in dark tangles around my face. "Oh well," I thought, "it's just for the night."

But in the morning it was a new world. The roads we had barreled down in the dark were lined with the pale yellow and shocking white of thick-standing birch trees whose peeling skin revealed glimpses of smooth touchable pinks and creamy oranges. A glittering frost had spread its net over the landscape, each blade and stalk of grass outlined in winking, shifting flashes of light; acres of sparkling beauty without iron gates and railings, without parking meters or fire hydrants. And just down the road a swift shallow river sang between a bed of brown pebbles, and the thinnest possible layer of green, translucent ice. Equally new to northern seasons, we were unanimous in our exhilaration.

From first frost to snowfall we were drunk with glory. The college administration made us roommates, and we became inseparable. Neither of us was quite what we had seemed. You had a wild, manic sense of humor and an iron tang that your easy curls and winsome charm made surprising, while I was much shyer than my stride. I showed you my poems, scratched in green ink into my journal, and you took them to heart, probing them, tasting the words, asking intently after each scrap of meaning. You played me your favorite rock bands with that same intentness . . . "You see? You hear that? There! That!" until I had satisfied your urgency to share the one beat you loved best.

We filled our room with the litter of the shedding trees, each new magenta or salmon leaf as astonishing as the last. In your long, grey coat you walked in the flaming woods for hours, coming back silent, full of autumn, the season neither of us had ever seen before. And you waited for snow. Growing up in Houston, and this last year in Israel, you had never seen it fall. You wanted to be outside when it began, you said (like girls planning their first embraces), to see the first flakes spinning down, and lift your face to the kiss of winter.

Meanwhile we told stories, talking from bed to bed in the dark. I remember your face in the lamplight, soft and hard, telling me about your father's affairs with girls your age, your mother's ambitions for you, your unripened ovaries that let you forget about birth control, all the stupid things men said in order to bed you. Your misfortune in looking like Goldilocks.

I lent you books. You drew me pictures. Our lives began to knit together, like the matted roots of wildflowers, blooming in the narrow openings of the forest. Nights while the stars swung overhead, we leaned in slow, delicious free fall toward each other's arms, knowing we would arrive in our own good time. Apples, berries, nuts, pumpkins, late corn all spilled their abundance

from the roadside stands. Around us the trees glowed in the colors of sun-ripe fruit, flickering and bright as faces turned to a hidden fire. But all the time the roots were reaching for a place deeper than the approaching frost, a race against the tilt of the earth's axis.

David still came every other weekend. Whenever he arrived, you whisked yourself out of sight and went to stay with a friend, pushing privacy on us just a little too soon, ruining the tact of your exit with a wry and hilarious wink, your falsetto voice drifting back to us over your shoulder, as you waltzed across the empty fields, singing, "Roooooses, oh, roooses and moooonlight!"

I dream sometimes of catching you as you run, crying Robin, don't go, come back, with your saucy, tea-cup-blue eyes full of maple leaves. Stay here, with your bad dreams from the forced sale of your girlhood to modeling agents who fingered you while your mother took the cash, saying that's the price of glamour. Come back with your hair of Jerusalem gold and your monkey screeches in the dark, and give me time to leave him for you. But you turn, laughing, and wave, and leave me here among the living.

Ten years later, and a thousand miles west of the place where I first heard the news, I wake with the same muscle spasm freezing my neck. This grey, blizzard-ridden morning in the Midwest, I can still imagine you as I did all the first winter of your absence, walking toward me through the snow-choked forests, on endless pilgrimage back to me, to life, to the lighted windows of our house. "It took me weeks to get here," you would say, coming in and stamping the snow from your boots, "months, years, it took me ten years to get here, but I had to let you know I was alright. It wasn't me in the car. It was someone else."

Like you, I was asleep when it happened, or I would have felt you tear away. I woke from a deep, dreamless dark to find David bending over me, and your note, "Gone to Maine for the weekend with Mary and Jeff. Back Sunday night. I love you." Then I was in the kitchen, stooping to take the soufflé out of the oven. Sorry I had missed your departure. Looking forward to food. I had the casserole in my hands, just setting it on the counter, when they came in together, the three of them, solemn as storks stepping through the door. "I wanted to tell you because you're her friend," he said, and I thought Robin, you've been annoying the dean again. Now he's angry, you and your jokes. But why tell *me*? "Robin and Jeff were killed," he said, "in an accident two hours ago in Maine."

Wait a minute. What? What did you say? Wait a minute. My mind stuttering, trying to catch up with my body, which was already clinging to David, and sobbing so hard that when the others ran in, I couldn't even say your name.

Nothing was real, except once I remember Beverly's shocked face in my doorway saying, "Their things are still in their rooms!" It made no sense. That, and the way my mind went in circles, wondering where the hell you were when I needed you, because, Robin, something terrible happened, and then remembering, each time with a slightly smaller sickening jolt, that the terrible thing and your absence were the same. On your wall was a postcard with a painting of the Snow Queen, white and bloodless on her silver sleigh, driving away into the blizzard with young Hans, bound by cruel enchantments, clinging to the back. I lay and watched it for hours, waiting for you to come home.

Much later, when she could talk again, Mary told me how it was. You were dozing, your head cushioned against the door. Jeff was driving, and she sat between you. She said the car slid outward into the curve, and she turned to Jeff and said, "We're going to hit that truck," and his last words were "I know," and then she was lying on the road watching the reflection of red flashing lights on the wet tar. They lifted her into an ambulance, and put Jeff beside her. She kept asking where you were, and they'd tell her you were being taken care of, and she would know from their voices, but she kept on asking anyway, over and over. Your body was lying sideways across the edge of the road where it was flung after you flew away. Do you remember? Your head was like a coconut shell the boys throw on the rocks, shattered and leaking.

You were shipped back to Texas, your head bandaged together for burial, your black Gaza dress with the winking mirrors eased onto your body. You were put away into the ground and I never saw you again. Nothing was real.

That night, after they told me, I went outside to breathe, to cross the dark field to our friends, to find one last molecule of you. I couldn't believe your warm mouth would not cross the final gap to mine. But when I stepped off the porch and looked up, the stars were gone. Soft cold feathers brushed against my cheeks. It had come at last. The first snowfall of winter. Huge, slow flakes spinning lazily down like a silent drift of flowers, settling on the dry branches, filling the ruts in the road, covering the last red leaves in a blanket of white, hiding the path, and falling endlessly, for heartbreaking months on end, out of the low grey sky.

Spring was a long time coming that year. I wrote and wrote and wrote, while the snow landed its powdery blows, bruise after bruise, and the cold made the roads heave up and the stones crack. Grief and winter gripped my body and opened me, while I sat at my desk without you, sinking my first deep roots into North America. I forced the icy sap to flow in my veins, cold as the rivers that fall from the Presidentials. I listened to the branches breaking under their own frozen weight and refused to break. I watched

the sputtering of the northern lights over the empty road of leafless trees and rose from my bed to fill trackless sheets of paper. I drank with small, hungry wild things at frozen pools and gnawed the astringent needles of pine for their tangy taste of endurance.

And one day the roots went deep enough. It would be too much to say I forgave the universe your death, but when I bent to look at the blunt elbows of crocuses shoving their way into the air and saw the sun calling dry sticks into swollen bud, I called them good. I learned that wild cherries bloom deep in the forest where nobody sees them, that humans don't matter to the tender sap-filled wood. Twigs swelled like young breasts and unfurled in a thousand fans of pale green. Never in all my years of tropical profusion had I seen blossom break out of silence like this. Ice cracked from the shore and was swept away on leaping waters.

One night in the middle of our friendship you told me about your trip into the Sinai. Leaping off the bed, you showed me how, convinced of miracles, you struck at the rocks with your staff again and again, certain of water. You said you knew exactly how it would taste. You held the stones in your hand, hefting them, measuring their weight, joyfully cracking the stick of your aliveness against their rough sides.

I have outlived you so long now, your ghost could be my daughter. That winter as you walked the starry road away from us I learned perseverance, and this has been my reward. Even here, facing the hard rock of despair that blocks my way, in the most barren places I hear it: the trickling of water, sweet and sharp as the first wild strawberries, that spring after they buried you. It is always with me, coaxing the words from my tongue. Sometimes it breaks my heart with thirst, sometimes it runs into the cup of my palms, the miracle of those who endure, the ice-cold water of hope, in the desert where you left me, to find my own way home.

 ♺ From *Cosecha and Other Stories* (2013)

That Bridge

In 1981 I had been in the United States for fourteen years. I had joined the Chicago Women's Liberation Union at the age of fifteen and experienced the exhilaration of a mass movement of women against sexism, but in that vast upheaval, in which, contrary to popular mythology, many women of color took part, our lives were nevertheless erased. I was also active in the struggle for Puerto Rican independence, support for the Black Panthers, and the Latin America solidarity movement, all of them rife with sexual exploitation and a constant belittling of women, where being a strong, outspoken feminist made me the target of hostility and ridicule.

Three years earlier, I had met Cherríe Moraga when we both worked, with a host of other woman of color writers, on Diana Russell's 1978 study of the incidence of rape in San Francisco, the first study of its kind. I remember sitting around after a day of intense interviews, joking about an agency called Dial-A-Token, because each of us had "represented" as the sole woman of color on endless panels.

I had only been reading my work publicly since 1977, but Cherríe and I formed a two-member writing group and pushed each other's work forward, so I was right there when she and Gloria Anzaldúa began work on *This Bridge*.

Jump forward to June 1981, Arlington Street Church in Boston, Massachusetts, because that was when I felt the earth move. We had spent the afternoon draping the bright fabrics of our many cultures over the white marble busts of dead white men, hung the massive pulpit with African batik, southwestern Indigenous rugs, my mother's stash of tropical prints, and hung silk kimonos on the walls behind. My mother's wooden pilónes and offerings of ancestral foods graced a small table. We thought we were ready.

But when we came out and stood, arms akimbo, all sass, along the front of that church, packed to 50 percent more than its supposed capacity, before any of us had spoken a word, the crowd surged to its feet and gave us a standing ovation, and in that moment I understood that this had nothing to do with individual talent, except that because of those skills, and accidents of time and place, we had the privilege of being, in that moment, the tongue of

an immense and furious animal. They applauded us because we spoke our shared truth. That's when I knew that this was what I would do with my life.

This Bridge Called My Back caused a tectonic shift in a bedrock of silencing. Our collective shout unlocked thousands of other voices. The dog-eared copies, the way our words were pirated and passed hand to hand, became graffiti, posters, theater, were photocopied for classes and study groups and stuck on bedroom walls, are evidence of how catalyzing it was. We slammed our agenda down on the table of liberation discourse, refusing to be split anymore, and refusing to wait. We said *radical women of color*, which had not been spoken before. We said every single thing about us belonged in every room we entered and we would enter every room that mattered.

For me, it became an overnight license to speak. That great roar credentialed me, a high school and college dropout, to lecture at universities. It was the ground on which I stood and continue to stand, still radical and still writing.

In 2015, we need the core of radicalism and complexity that this book holds every bit as much as we did in 1981. Maybe more. We are in a tipping point time for humanity, when the insatiable greed of endless conquest had brought us to an ecological brink and keeps us in a state of perpetual war. We face the increasing militarization of daily life, mass imprisonment of people of color, a coordinated assault on women's rights, the accelerated concentration of wealth at the top and the slashing of resources for the rest of us. But we are also in a time of mobilization, of popular outrage, of Black Lives Matter and BDS,[1] Zapatista feminism and Indigenous autonomy, a time when the former neocolonies of Latin America have built a powerful block of resistance to imperialism, and women have reshaped its revolutionary movements away from the machista militarism of the 1970s.

This new edition of *This Bridge* is long overdue and right on time. May it be passed from hand to hand to hand again, and may new generations of us feel the ground shift, and open up their throats and roar.

> ☙ Written in 2015 for the release of the fourth edition of *This Bridge Called My Back: Writings by Radical Women of Color*

.............

Note

1 BDS = boycott, divestment, and sanctions.

2 EARTH BODY

Land and body, body and land, these have never been separate stories for me. My sense of embodied ecology comes from lived experience, from growing up the child of an ecologist father and an amateur naturalist mother, in a subtropical rain forest in the mountains of Puerto Rico, where I was also sexually trafficked by one of my elementary school teachers. My identification with the land, tormented, invaded, exploited, and yet flowering and abundant with life, helped me survive. I flew my spirit into the embrace of the trees to escape the harming of my body. The land literally holds my story.

This section weaves the stories of my body, my land, and the biosphere, a selection of poems and essays whose relationships to each other range from obvious to subtle. Here you will find nationalism and ecology entwined with land ownership, Indigenous ancestry with sexuality, sickness with disobedience, civil and otherwise, and the story of two journeys—one of them westbound across the United States, the other my migration back to the land I grew up on.

This is as good a place as any to talk about the name of that land. The original inhabitants, known only as "arcaicos," didn't leave

behind their name for the islands they inhabited or visited, but they were here, eight thousand years ago. The people the Spanish called Taínos, arriving a few thousand years later, did name the separate islands of an archipelagan homeland united by language and custom. The island I live on was called Borikén, but all around it were related islands, part of an extended world that included what are now, by virtue of colonialism alone, separate countries. Cuba, Jamaica, Ayiti, Bimini, Bieke. So when I speak of Anacaona, cacica of my people, the fact that she was born in what is now Haiti does not make her foreign to me.

My journey back into this land is also a journey into the past of the land itself and how that past lives in the difficult present and in the future we dream. We speak of being embodied, but we are also enlanded.

"Monense," my first published poem (in *Revista Chicano-Riqueña*), is a lament for one of my coworkers, Héctor O'Neill, whom I met in the summer of 1974, when I was a twenty-year-old biology research assistant on Isla de Mona, an early expression of the way landscape was alive for me—about a friendship rooted in a specific ecosystem.

Outside consumers of Latin American magical realism often fail to understand that writing in this way is sometimes the only way to speak the truth without going numb. "A Story" is one example.

"chicken house goat girls" roots a childhood romance in the older and deeper stories of this place. "Nadie la tiene: Land, Ecology, and Nationalism" challenges the ways that nationalism imposes itself on ecosystems, forcing them into symbolic roles that serve domination. "Mountain Moving Day" began as a paper for a Gloria Anzaldúa conference and evolved into a chorus of disabled and sick women's voices.

"Patients," "Coming Out Sick," and "Burnt Light" are about the realities of living with chronic illness in a society that demands we always "function" and insists on precision of diagnosis when we don't. "Teeth" speaks to dentistry, class, and disability, while "Fatigue #1" is a declaration about the roots of exhaustion. "Body Compass" describes my journeying in a tiny mobile house, somewhere between the housed and unhoused, while "Poem for the Bedridden" talks about the millions of us who couldn't take to the streets in the explosive summer of 2020 but listened from our beds. Finally, "Rematriation: A Climate Justice Migration" is the story of my country in this moment of time, and the reasons and ways of my return to Borikén.

Monense

.....

para Héctor O'Neill en
la Isla de Mona

.....

Pie con pie pisábamos
en la luz extraña de noche
arena pirata, color espejo
entre las aguas cambiantes,
buscando las sendas anchas
de pesadas criaturas marinas:
estelas náufragas.

Andábamos como borrachos
Entre arrecifes rumorosos
Y oscuridad que entraba
Con olor de piedras
Hasta las raíces de los ojos.

En esa hora más callada y blanca
te levantabas,
en las alturas de mariposas
allí estudiabas
vida verde de los pájaros.
Tú con tus ojos de risa y sueño
eres pájaro entre las ramas.

Última madrugada,
arribada final.
Llegó completa la paz—
la vimos llegar
con la brisa de alborada
que sale del mar.

Subimos, tú y yo
en ese avión que nos trajo el día.

Adiós barrio de amistades.
De vuelto a la lejanía.

Qué mucha gente hay en el mundo
que no son ni tú, ni yo,
ni tortuga,
ni paloma,
ni pescador.
Y ahora, muerto de aire,
muerto familiar,
amaneceres monenses
no te pueden despertar.
Por un millón de agujeros
se te escapó el movimiento.
Eres aire de mediodía,
sin respiraciones,
sin viento.
Sólo el vuelo de tus aves,
sequía fragante.

[In the strange light of night
we walked, step by step
the mirror-colored pirate sands
between changing waters
looking for the wide tracks
of heavy sea creatures,
shipwrecked wakes.

We walked like drunks
between murmuring reefs
and a darkness that entered
with the smell of stones
to the roots of our eyes.
In that quietest, whitest hour you rose,
and in those butterfly heights you studied
green lives of birds.
You, with your sleepy, laughing eyes
a bird among the branches.

Last sunrise.
Final beaching.
Peace came to us whole
we saw it come
with the dawn breeze
that rises from the sea.

We climbed, you and I,
into that plane the day brought us.
Farewell, barrio of friendships.
Return to distances.
How many people there are in the world
who are neither you, nor I
nor sea turtle, nor dove
nor fisherman!

And now, my airy, familiar ghost
Mona sunrises cannot wake you.
Through a million pinholes
all your movement has escaped.
You are the air of midday,
no breath, no wind.
Only the flight of your birds,
fragrant drought.]

❧ First published in *Revista Chicano-Riqueña* (1977)

A Story

He said this was something that happened in his own city, before he fled for the border with his young wife, who was pregnant. His face is round, childish, shy. His eyes are dark and still. He speaks in a low, even voice as if he could make the words he says lie down, be less sharp, but he can't, and we see that they hurt his throat as they come out and that they hurt his chest when he tried to keep them in.

He says he was walking down a street in his city with a friend. It was dawn, and they were on their way to work. The woman was lying on the pavement, dead. She had been shot in the head. The soldiers had come for her husband, but he was away in the mountains so they killed her instead. He says that she was very pregnant. That she must have been just about due. Her belly was huge. As he passed the body, he saw the child was still alive inside her cooling flesh, moving, pushing, pulsating in her womb. His hands ached to reach into her and pull it free, but the soldiers were still standing at the end of the street, and he knew how quickly and easily they would shoot him, too, if he tried to help. We had to keep walking, he tells me. He has never forgotten the light that beat from that unborn child, trapped in its dead mother's body. He said it filled the street with a flickering radiance, like the sun reflected from water, that it peeled the paint from the walls, bleached the wood, and left strange, pale marks on his skin for days.

> From *Getting Home Alive* (1986)

chicken house goat girls

We were the only girls who wore pants, she said, sitting across the orange plastic table at a fast-food joint in Brooklyn, forty years after we said goodbye on a rainy morning in late spring in the cordillera of our hearts. Now we live in cities but we both dream in unfurling fern leaves under the shade of towering pomarrosas. We still have red clay mud in our bellies, in our pores, in every cell. What we are made of: mud, pomarrosa, cold spring water.

Among all the skirted girls of the barrio, among all the women in their flowered cotton dresses worn thin from pounding on river rocks, among all the women and girls sitting on porches shelling beans at dusk, I answer, we were the only ones who climbed trees, *guamá, guayaba, flamboyán, pino,* the only girls with skinned knees and burrs in our hair, with dirt under our nails, the only girls who let the dogs sniff our crotches and laughed. *No seas cabra*, the neighbor women would snap, and their daughters would settle back onto the porches and smooth their skirts down, waiting to be called on. You and I, we bucked and skipped and played with boys, and ran shouting through the dusk among the fireflies.

La vieja told me her Taíno grandmother was caught stealing food on the hacienda, decked only in her long black hair, was hunted with dogs, locked in a room, forced into a dress and a marriage. The rest of her life they called her La Tormenta because she would as soon smack a man across the face with a dried salt cod as look at him. But she taught her granddaughter how to make the birthing mats, where to dig for the best roots, how to keep her own name in a secret place under her tongue, at the back of her knees, a dark pool of knowing.

We would steal fruit from fenced-in trees, run from dogs, take off our clothes, throw rocks at our enemies. We had our own rebellions.

Do you remember the chicken house? she asks and I think *the smell of fertilizer*, sacks of it piled in the back, old broken furniture, hoes and rakes, an outgrown tricycle. Of course I do. Her skinny little hips, lying back on a bag of clothes, the cement floor, sunbeams full of dust motes,

the hummingbirds in the bushes, the lizards skittering up the walls, thickets of ginger standing guard, and two girls with Taíno eyes, our hair full of twigs, dirt under our nails, laughing as we sniffed, our scabbed knees parted, digging for roots.

 🌿 From *Cosecha and Other Stories* (2013)

Nadie la tiene: Land, Ecology, and Nationalism

¿Puedes venderme tierra, la profunda
noche de raices; dientes de
dinosaurios y la cal
dispersa de lejanos esqueletos?
¿Puedes venderme selvas ya sepultadas, aves muertas,
peces de piedra, azufre
de los volcanes, mil millones de años
en espiral subiendo? ¿Puedes
venderme tierra, puedes
venderme tierra, puedes?
La tierra tuya es mía.
Todos los pies la pisan.
 Nadie la tiene, nadie.

[Can you sell me the earth, the deep night
of roots, dinosaur teeth and the scattered lime
of distant skeletons?
Can you sell me long-buried jungles, dead birds,
fishes of stone, volcanic sulfur, a thousand
million years rising in a spiral? Can you
sell me land, can you
sell me land, can you?
The land that is yours is mine.
Everyone's feet walk it.
No one has it, no one.]

African Cuban poet Nicolas Guillén, *¿Puedes?*

1

Spring 1995. I sit on the shoulder of our family mountain, one of the highest in this part of the Cordillera Central of Western Puerto Rico, in the pine forest that rises like a Mohawk haircut off the smooth deforested slope to the east, a profile easy to recognize from miles away. Sitting on the slippery reddish needles in a green shade, I look out between the straight trunks of Honduran pine over rolling miles of cleared land planted in bananas, coffee, oranges and drenched alternately in full tropical sunlight and the quick-moving rain showers of the season. Each time my brother, Ricardo, or I return to this farm where we spent the most important years of our childhoods, we make pilgrimage to this exact place where, after the fire in the early sixties, the forestry service paid us to plant pine seedlings. They wanted to start a small timber seed industry and our farm became part of the test acreage. In fact, it was Lencho who planted the trees, not us. Hundreds of seedlings in black plastic bags spaded into the blackened hillside. Lencho had been doing odds and ends of agricultural and other work for our family for several years. In the midst of the Korean War, my communist parents called the land "Finca la Paz," Peace Farm, but Lencho called it "Monte Bravo"—fierce mountain.

In 1966, my father was denied tenure at the University of Puerto Rico, where he had been teaching biology. He had been an active participant, as a professor, in the 1965 student protests against the war and it was his unpaid teaching of Marxism and organizing, his trip to Cuba the previous winter, his egalitarian and innovative way teaching of biology in a stodgy department that lost him his job. Because he was in essence blacklisted from teaching on the island, because of my approaching adolescence in a rural community with inadequate education and a high rate of pregnancy among my friends, because my mother wanted to go back to school, my father accepted a job in Chicago and we moved there.

The day we left, the pine trees were still spindly, seven-foot saplings, but somehow the knowledge of how they grew without us, how the farm continued to flower and decay, sustained my brother and me. The memory of it, the smells and sounds and colors, was one buoyant piece of driftwood in the shipwreck of our intense culture shock. We sent our spirits there for imaginary refuge from the harshness of our new lives and invoked it at night so we could sleep among the alien noises of Chicago. I dreamt of walking up the path into the farm every night for years.

Now we return to it as if checking on a buried treasure. Our ownership of these thirty-four acres preserves the land from clear-cutting, and the fact of that ownership is balm for exile. The colonial economy, the lack of the kind of social and political community we now need, the structures of our personal lives all keep us from coming here to live, but we need the knowledge of that deep valley full of rain, protected from bulldozers. Ownership is a foothold in a slippery place of identity and longing, of necessity and choice.

From my bedroom thousands of miles from here, this piece of earth and the land stretching out around it become a kind of amulet against dispossession. I imagine the rain falling on it, the hawks circling above it, the lizards skittering across it like a chorus of affirmation that I am rooted. That in spite of generations of shifting nationality and loss behind me, in spite of the unpredictably changing jobs, relationships, rented houses, I have a home on earth. The land makes me safe.

But whenever I sit here listening to the wind in the trees, the haunting cry of lizard cuckoos in the valley proclaiming the coming downpour, smell the sunbaked ferns and decaying banana leaves and feel the dense clay under me, the symbolism begins to unravel. Slowly, as I listen to it, the land becomes itself again. Not mine, not anyone's. Talking to me, yes, but not any more than it talks to the fire ants building their nests or the bats bones becoming humus or the endlessly chirping reinitas twittering among the señorita flowers.

2

I am an ecologist's daughter. I grew up in a house where the permeable boundaries of other worlds crisscrossed our own. At night you could hear the termites munching inside the walls and the slow trickling grains of digested wood. Rats ran in the attics, and if we ventured into the kitchen after hours they stared offended at our intrusions. Lizards hunted daily on the glass fields of our windowpanes, stalking moths and wasps, and hummingbirds, momentarily stunned from crashing into those windows, would lie in our hands, then shoot back into the hibiscus bushes. Around the ripening bunch of bananas that hung from the kitchen ceiling, clouds of fruit flies rose each time we pulled off a piece of fruit. Autumn evenings of rain, a single tree frog would sing from the moist crevices under the sink. In my parents' bedroom, a long tendril of jasmine had crept between roof and wall, and wound sinuously across their shelves of paperbacks. It was never our house.

My father would take me walking sometimes, show me the last fading scar of the old road, the Camino Real, poke into the holes of rotten tree trunks, peer into the cups of flowers to see the teeming insect life. I grew up in a place where a tree might fall and within a week, new seedlings sprang from the dead wood. The mountain slid and shifted under the heavy autumn rainfall, the garden left untended grew lush and tangled overnight and it was never the same place for long. How can you own something that changes under your hands, that is so fully alive? Ecology undermines ownership.

———

3

My parents bought this farm in 1951 for $4,000. It was ninety acres of abandoned coffee plantation that had fallen back into wilderness after the coffee market crash of 1898, the hurricanes of 1899 and 1928, and the economic devastation of the '30s and '40s. Near the house I grew up in were the ruins of cement washing tanks and a wide drying platform where we rode our bikes: the last remaining evidence of the coffee boom of the last century, when immigrants from Corsica and Mallorca, and refugees from the Haitian Revolution, carved up the mountains into landholdings and turned the subsistence farmers, who had for centuries cultivated where they pleased, into landless laborers. Climate, soil, expertise, and work combined to produce the best coffee in the world for wealthy patrons in Paris, Vienna, and New York.

When my parents bought it, the coffee had gone wiry, wild ginger choked the pathways, and bitter orange, grapefruit, and bananas flowered untended under the imported shade trees, brought in to protect the precious crop. My father, unabashedly speaking Brooklyn high school Latin, would stand at the counter of the tiny roadside colmado drinking beers with the coffee workers until he had enough Spanish to talk politics and begin organizing. My mother used the Agricultural Extension Club to get women out of their houses and learning about leadership and organization at the same time that they learned how to sew and make lard cans into stovetop ovens. After a couple of years my parents sold off half the land at prices the landless or nearly so could afford, and for years people would come around trying to buy land from the Americano who didn't know better. But how else do communists own land?

They raised chickens and the vegetables my father peddled from their battered red truck. He worked as a lab tech at the hospital in Castañer and taught in San Germán while my mother took science courses, farmed, raised

me and my brother, washed all the diapers and sheets and work pants by hand, cooked, cleaned, and tended the machete wounds and cooking burns of the neighbors at the first-aid station. The week my parents married, the Korean War had broken out. They had come to Puerto Rico uncertain what the consequences would be. But he was declared unfit for service, and they stayed, raised children, made a life, and loved the land for its beauty and peace.

4

For my ancestors, land had different potency. When Eusebio Morales died in 1802, the lands that were measured for division among his heirs stretched between landmarks like "the old ceiba on the slope above the river." But what lay between those markers was money. Money extracted from the land by enslaved labor and the so-called free labor of the landless. They grew coffee and tobacco, raised cattle, and grew sugar cane and rice. Land and slavery stood behind the petition of Eusebio's grandson Braulio to found a new town, behind the club of wealthy men who rotated among themselves the offices of mayor and militia captain, marrying their children to each other so obsessively that I am descended from the same patriarch by six different lines of descent.

Land and slaveholding still stood behind my grandfather in the Depression. When he worked as a janitor and then as a stock clerk in a New York City public school cafeteria. When he fed his family on food the supervisor pretended not to notice he was taking home. It was there in his certainty of his own rightness, in the phrase "por lo derecho," which meant that he lived righteously, with dignity and correctness, not like all those wrong-living títeres that surrounded them in Harlem.

My grandmother Lola expressed that pitying sense of superiority even more overtly than my grandfather. She would speak of some African American neighbor who was "so nice, poor thing." Although she complained that the Moraleses thought her not good enough, her own ancestors had all taken their turns administering class power. It was the service of her ancestors, the Díaz brothers, leading the militia against the English invasion of 1797 for which her family was rewarded with lands in Barrio Anones. Although her father had gambled away the family store and she did garment work in New York, although she distanced herself from her relatives and liked the bustling anonymity of New York, she still wore her "buena familia" like an especially nice perfume and was sorry for those who didn't have it, until at the end of her life it became a weapon against the staff of one nursing home

after another where she reduced the dark-skinned, working-class nurses' aides to angry tears.

———

5

My great-grandfather Abraham Sakhnin also grew up on a farm his family owned. This was in the southern Ukraine, up the railroad line from Odessa. In his old age he painted his memories of it: the horses, the cellars full of pumpkins, the harvesting of wheat. The Sakhnins had come from Lithuania in the days of Tsar Nicholas I when Jews were promised draft exemption if they settled on the borders as a buffer against the Turks. They were given land and taught to farm it by German settlers imported for the task. For five generations they did so. But land, for Jews, in Eastern Europe, was not the foundation it was for Catholic hacendados in Puerto Rico. My great-grandfather fled the farm in 1904 rather than fight in the war against Japan. Pogroms were on the rise along with revolutionary violence, and although the family were Bolshevik sympathizers and some stayed to take part in the revolution, Abe left for Canada and then New York, his first cousin Alter went to Buenos Aires, and his sister married and left for Siberia. In 1942, the entire settlement, known as Yazer, was destroyed by Nazis. Land was no guarantee.

———

6

Land is no guarantee, but in the mythmaking of exiled and dispossessed nationalisms it becomes a powerful legitimizing force. The central symbol of Puerto Rican nationalism, the phrase most often used to mean that which is struggled for, is "Madre Patria," usually translated as "Mother Homeland." Just as the enthusiastic propagandists of the 1898 US invasion feminized and sexualized the land, describing "her" as well endowed, fruitful, and docile, a young girl who "surrenders herself graciously to our virile marines," so, too, the Nationalists have portrayed the colonized country as a captive woman, the "madre tendida en el lecho" (mother stretched out upon the bed) in the hands of foreigners who rape her.

The idea of "patria" is deeply rooted, like patriotism itself, in both patriarchy and its raison d'être, patrimony—the inheritance passed from father to son. And the basis of that inheritance is land. Under the rhetoric of "madre

patria" lies that which is most despised and exploited in practice, most ig-
nored in nationalist programs, most silently relied on as the foundation of
prosperity for the future republic, the basis for its industrial development
and for a homegrown class of owners. The unpaid and underpaid labor of
women, the labor of agricultural workers, and the generous and living land
itself, these, in nationalist rhetoric, become purely symbolic sentimental
images, detached from their own reality.

Nationalism has tremendous power. It mobilizes just rage about colonial
oppression toward a single end. It subordinates all other agendas to that end.
It silences internal contradictions among the colonized, postpones indefinitely
the discussion of gender, sexuality, class, and often "race," endowing nationalist
movements with a kind of focused, single-minded passion capable of great
force. But although that force draws its energy from the real pain and rage
and hope of the colonized, nationalism does not attempt to end all forms of
injustice. Nationalism is generally, both in the intent of its leaders and in its re-
sults, a one-point program to capture patrimony for a new group of patriarchs.

7

In nationalist rhetoric, land does not move. No wonder it is so often por-
trayed as a mother. Eternal, loyal, and patient, it waits for its exiled children
to come home. It would know them anywhere. But the real land, made of soil
and rocks and vegetation, is never still. In the United States the average acre
of land loses five tons of soil every year, blown by wind across property lines
and fences, municipalities and national borders, washed by rain into river
systems that drain a thousand miles downstream. Even massive shapes like
the Grand Canyon shift and collapse and move continually. Each autumn in
Puerto Rico the water running off our mountain turned a heavy orange and
flowed away downhill, leaving the silt of our property spread over hundreds
of square kilometers of flatlands and leagues of sea.

This fact has occasionally been used as part of imperial reasoning. In the
late nineteenth century, one US statesman claimed that Cuba was naturally
theirs because it must have been formed by mud washing out of the mouth
of the Mississippi. It was literally US soil. But "national soil" is a nonsensi-
cal statement. Places have history, but soil does not have nationality. Just as
the air we breathe has been breathed by millions of others first and will go
on to be breathed by millions more; just as water falls, travels, evaporates,

circulates moisture around the planet—so the land itself migrates. The homeland to which Jews claim to have returned (land of the Canaanites before them and many others since) is not the same land. The earth that lay around the Temple could be anywhere by now. So what exactly is it we've been dreaming of for so long?

———

8

Land and blood. Mystical powers that never change their identity so that a speck of Mississippi mud and an individual red blood cell are both seen as carrying unalterable identity, permanent membership in human cultures. This is the mysticism that allows fascist movements to call up images of long-dispersed and recombined ancestral peoples like the ancient Aryans and Romans, or entirely mythic genetic strains like White Race, and then scream for genocide to return them to a state of purity.

The reality is that people circulate like dust, intermingling and re-forming, all of us equally ancient on this earth, all equally made of the fragments of long-exploded stars, and if, by some unlikely miracle, a branch of our ancestors has lived in the same place for a thousand years, this does not make them more real than the ones who have continued circulating for that same millennium. All of us have been here since people were people. All of us belong on earth.

So what about the stealing of land? What about all the colonized places on earth? What of Indigenous peoples forcibly removed by invaders? The crime here is a deeper and more lasting one than theft, akin in some ways to enslavement. Before land can be stolen, it must become property. The relationships built over time between the land and the human members of its ecosystem must be severed just as ties of family and village and co-humanity were severed so that slavers could enslave. The Indigenous peoples of the Americas did not own land in the European sense. They lived with and from the land and counted it as a relative. The blow that cracked Hawaiian sovereignty was the imposition of land ownership. At gunpoint, Hawaiians were forced to divide sacred and common land, to commodify it, price it, allot it. In Europe itself, it was the enclosure of the commons, the grazing lands and great forests from which people subsisted, that created a massive class of landless laborers to fill the factories and transport the goods of industrial capitalism. Earth-centered cultures everywhere held our kinship with land

and animals and plants as core knowledge, central to living. The land had to be soaked with blood and that knowledge, those cultures, shattered before private ownership could be erected. It wasn't just theft.

———

9

And yet owning has seemed like such a good defense. With the commons gone, strive to own. With the land commodified and confiscated, struggle to enforce treaties. If you are driven away, fight to return. For Jews, barred for centuries from landholding, how legitimating, how healing, what a chance to strike back at history it is to acquire land. Why should we alone be excluded? When Baron von Hirsch sought to help the Jews of Eastern Europe escape the pogroms, he bought them land: in Argentina, in New Jersey, in other places, and settled them there to farm. Landlessness had been a central feature of Jewish oppression. Having land became a symbol of resistance. Our own connections with land have been severed time after time. We would come to know and trust a particular landscape, to understand Babylonian weather, to know the growing seasons of Andalucía, to recognize the edible wild foods of the woods around Rouen, the wildflowers on the Dnieper or the Rhine or the Thames, and it would be time for another hurried departure. To have land, to farm became one of the most emotionally powerful images of Jewish freedom, even when getting land meant severing someone else's ties to it. Even when it meant tearing the olive trees and the fragrant dust and the taste of desert spring water out of the lives of Palestinians whose love for the land was hundreds of generations deep.

In the 1930s my father's family sang this song, translated from the Yiddish of Russian Jews:

> On the road to Sebastopol,
> not so far from Simferopol
> Just you go a little further on.
> There you'll see a collective farm,
> run by sturdy Jewish arms
> and it's called Zhankoye, Zhan.
> Aunt Natasha drives the tractor,
> Grandma runs the cream extractor

as we work we all can sing this song:
Who says Jews cannot be farmers?
Spit in his eye who would so harm us.
Tell him of Zhankoye, Zhan.

———

10

Land ownership was only a hundred years old in Indiera when I was grow-
ing up. Its hold on people's imaginations was still tenuous. It was not until
the 1860s that the Massaris and Nigaglionis, Agostinis and Pachecos began
filing title claims to large stretches of mountain lands. That there were al-
ready people living on and from that land was irrelevant, because none of
them had surveyed it, fenced it, paid a lawyer to draw up deeds to it. Since
at least the 1570s, the mountains had been worked by wandering subsistence
farmers who would clear and burn off a bit of forest, cultivate it for a few
years, and move on while the land renewed itself. Descendants of Arawak
and other Indigenous peoples enslaved by the Spanish, runaway slaves and
poor Europeans, the people of the mountains didn't own the land. They
moved across it and lived from it.

The new settlers owned and profited. Our own farm was carved out
by a Corsican named Massari, who, like the others, planted the new boom
crop, arábica coffee, for faraway markets. Then it was owned by Pla, who
was Mallorcan. Then by my parents. But the neighbors who held small plots
and worked other people's land for cash never seemed to take boundaries
seriously the way my neighbors in New England did. Everyone harvested
bananas, root vegetables, oranges, and wood from the farms of the Canabals,
the Nigaglionis, or Delfín Rodriguez, who only kept Hacienda Indiera as a
tax write-off to protect his sugar profits. Our neighbor to the north, Chago
Soto, was always moving the fence between our properties. On one visit we
found that Cheito Agostini had built pens for his pigs on our side of the
road. Another time, exploring the deep overgrown valley on the back side
of our land, my sister-in-law and I stumbled across a cement holding tank
built over one of the springs and plastic pipes leading the water out to a
house and garden. It was only when we introduced ourselves to the man
loading a truck in front of the house and saw his chagrin that we realized
that the water was on our side of the property line.

So what do communist landholders do with privilege? My father says
you have to get rid of it or use it for the common good. So we tell Cheito

he can keep the pigs there, but no more dumping piles of Pampers, and no permanent structures. We let the farmer to the north know that we understand the water came from our land, and for now it's OK. But what are we doing with this land at all, now that we don't live there?

———

11

Class privilege allows us this option, to see ourselves as stewards of this land. Because we don't need to live from these thirty-four acres we can resist the pressure to sell. Our neighbors keep asking: can't you sell us a piece of the farm to expand my coffee, my bananas, to build a house? After all, you're not using it. Poverty does not allow them the luxury of thinking twenty or thirty years ahead, but we know that the land they want now for farming cash crops will pass through their hands and into other uses and that in thirty years this place would be lots for cement houses. My mother says the rich ruin the poor and the poor ruin the land.

From up here in the cordillera you can see where the rich ruin land directly. We grew up with the smudge of poisoned air over Guayanilla, where the oil refineries used to make such a stench we would always buy sweet maví to drink before we got there so we could hold the cups over our noses as we went by. There are puffs of dust where the limestone hills are being bulldozed and ground into cement for more housing developments, shopping malls, factories. So much of the land has been paved, in fact, that the drenching rains of autumn have nowhere to soak in. The water runs off into the sea now, and the water table has dropped so much that last year some neighborhoods in San Juan went without water for weeks at a time. But up here it hasn't yet been worth the developers' while. Here it's the desperation they've created in the lives of the poor that does the work for them.

Between the land hunger of the poor to turn acreage into a little money and the commodification of the earth into real estate, only privilege seems able to preserve the land. The Rockefellers, buying up islands, keep pockets of wildness alive in the Caribbean while deforestation and massive shopping malls destroy the freshwater supplies of Puerto Rico, leaving everyone thirsty.

This is what we want our privilege to buy, my brothers and I. Because of how we lived there, because of the ways our parents cherished and nurtured our intimacy with the land, we know we're kin to it. We don't want it to die. But we also want to give the land a chance to tell its story and the story of

the people who have worked it. On that overgrown abandoned coffee farm in the middle of increasingly cleared and pesticide-soaked lands, we want to build a cultural center and museum of the history and ecology of Indiera, where the community can participate in retelling its past. We hope that in this process of storytelling, the people of Indiera will rediscover pride in their heritage of work and a new sense of their connection to this land. By drawing tourist dollars from the nearby Panoramic Highway, we also want to model another way of living from the land, in which livelihood comes not from extracting the land's wealth but from telling, in as much detail as we can, the complex story of our relations with it.

I imagine this museum filled with family photographs, letters from the migrant children who moved away, and recorded voices of elders testifying. I imagine showing the people who grow coffee the faces of the people who drink it and vice versa. I imagine a narrow pathway winding down into the rain valley through the forest of tree ferns, South American shade trees, wild guavas, and African Tulip trees. I remember how my father used to take his microscope down to the schoolhouse and how the children would crowd around waiting for a turn to be amazed at what the world looks like close-up. I imagine the children of the barrio walking among the photographs and voices and trees that way, renaming their place on this land and in the world.

———

12

Because the land is alive, our relationship with it is real. We are kin to the land, love it, know it, become intimate with its ways, sometimes over many generations. Surely such kinship and love must be honored. Nationalism does not honor it. Nationalism is about gaining control, not about loving land. But it wears the cloak of that love, strips it from its sensual and practical roots and raises it into a banner for armies. The land invoked as a battle cry is not the same land that smells of sage, or turns blue in the dusk, or clings thickly to our boots after rain. That land is less than nothing to the speechmakers.

The land invoked to the beating of nationalist drums is what lies at the linguistic roots of the term *real estate*, meaning royal property. It is the land my hacendado forebears kept in the bank, ransacked, used to pay the bills. The land bristling with "No Trespassing" signs, the land the lords of Europe enclosed against the peasants in the infancy of capitalism, the land as symbol of power over. It is the land we can be mobilized to recapture

because, with its fences and mortgages and deeds, it has been the symbol of our dispossession.

———

13

Ownership shatters ecology. For the land to survive, for us to survive, it must cease to be property. It cannot continue to sustain us for much longer under the weight of such a merciless use. We know this. We know the insatiable hunger for profit that drives that use and the disempowerment that accommodates it. We don't yet know how to make it stop.

But where ecology meets sculpture there is another question. How do we hold in common not only the land but all the fragile, tenacious rootedness of human beings to the ground of our histories, the cultural residues of our daily work, the individual and tribal longings for place? How do we abolish ownership of land and respect people's ties to it? How do we shift the weight of our times from the single-minded nationalist drive for a piece of territory and the increasingly barricaded self-interest of even the marginally privileged toward a rich and multilayered sense of collective heritage? I don't have the answer. But I know that only when we can hold each people's particular memories and connections with the land as a common treasure can the knowledge of our place on it be restored.

꩜ From *Medicine Stories* (1998)

Mountain Moving Day

Dear Gloria—

Well, here it is el Día de las Muertas again and I've come to sit with you awhile. The living are busy trying to excavate your soul, writing all kinds of papers about the meaning of your life, spinning analyses from your words, arguing about the true significance of when you said this or that, digging up quotes to prove that you do or don't posthumously support hundreds of positions on thousands of issues. It's the usual mix of thoughtful insight and the absolute nonsense people invent when they're forced to churn out theory in order to keep their jobs in the middle of a depression. Some of them, I'm sorry to say, have even canonized you! I know. It's a hell of a thing to do to a flawed human being just because she had some great ideas and a strong writing hand and told her own truths. People are desperate for guides, so they remake us into oracles and miss half the lessons our lives could offer them.

The questions on this particular table are about why you refused to identify as a disabled woman, and what illness and pain have to do with what you called the Coatlicue state, that well-mapped region of chaotic breakdown leading to revelation.

That question about how people identify, which battles we take on, and how and when and with whom, gets so loaded with judgment, with accusations of having let down the team, with diagnoses of self-betrayal by those who made different choices. We choose which ground to fight on for such a mix of reasons: what feels urgent, what feels hopeful, whether we have a good band of fighters to stand with, how much of ourselves we can bring to each struggle. I spent years reading the lives of early twentieth-century Jewish feminists, trying to decipher what led them to fight on the terrains of gender, class, and Jewishness in varying combinations. So much depends on solidarity.

In the late seventies and early eighties there was no place for me to stand as a bisexual woman. The fluidity of "queer" did not yet exist, and the lines of sexual identity were rigidly drawn. The oppression was bitterly painful, between the toxicity of heterosexism on one side and the often brutal rejection by lesbians on the other, cutting me out of the places I most longed

to be. But there was not yet a critical mass of people I could fight beside to claim my place.

Most of the rooms I entered in those years were impossible to bring my whole self to, for many different reasons. But some of those silencings, those barriers, were being thought about and struggled over by many, many people, and we took it on together. So I fought about racism and then about antisemitism, and the battles were difficult and complex (as a Jew of Color, they still are), but there was often critical mass. I had enough people who shared enough ground that I could fight for myself and others, win some battles, and not be demolished.

For you to shout out to the world, "Hey, not only am I a dark-skinned working-class Tejana lesbian, but I'm disabled, too!" to draw attention to yet another way you were oppressed, and for this to do you good, you would have needed a strong, vocal, politically sophisticated, disability justice movement led by queer working-class women and trans people of color who understood your life, and it wasn't there yet. You would have needed people who saw that all the ways our bodies are made wrong, held responsible for our own mistreatment, blamed for showing the impact of oppression, all the ways our nature is called defective, are connected, rooted in the same terrible notions about what is of value. Who would have understood to the core your reasons for brewing all those herbal teas, knowing it's dangerous to enter the doors of the medical-industrial complex, and that there are things we need in there.

If you were here now, maybe what we've been constructing these last few years would be enough, would look to you like a place to rest, to be known. Oye, comadre, sometimes history leaves us stranded, waiting for a train that's still being built, five or ten years up the tracks. Have some pan dulce. Can't touch it myself, what with the diabetes and the gluten allergy, but the dead can eat whatever they want.

What I'm really interested in is that state you named after your ancestral goddess, the Coatlicue state, in which a shattering lets in light. Of course being Boricua, not Mexica, I call it the Guabancex and Oyá state, after the storm goddesses, the deities of creative destruction, of my Taíno and West African ancestors. The landscape of my homeland is regularly uprooted by hurricanes, those wild, whirling spirals of wind and water spreading out vast arms to pluck trees and houses and lives from solid land, drive bits of metal right through tree trunks, and take giant bites out of cement.

In the structure of a hurricane, the strongest, deadliest winds are closest to the core, but the core itself is clear, calm, full of light. Illness has been one long hurricane season for me, chunks of cement and metal roofing flying

through the air, big trees made into heaps of splinters and shredded roots. What takes me to the core, to the place of new insight, is listening with all my being to the voice of my own flesh, which is often an unbearable task. What lets me bear it is political, is a deep, ecological sense of the web in which my flesh is caught, where the profound isolation of chronic illness forces me to extend my awareness beyond individual suffering, beyond the chronic pain of my muscles and joints, the endless exhaustion, the mind-bending buildup of toxins where nausea and nightmare meet, dragging me from my bed at 3 a.m. to lift cups of bitter tinctures to my lips with cramping hands and leach the poison from my own liver.

In the steepest pitch, the darkest hour, in the ring of deadly wind, the only salvation is to expand, to embrace every revelation of my struggling cells, to resist the impulse to flee, and hold in my awareness both things: the planetary web of life force of which I am part, and the cruel machinery that assaults us: how greed strips and poisons landscapes and immune systems with equal disregard, how contempt for women, and the vastly profitable medical-industrial complex conspire to write off as hysterical hundreds of thousands of us bearing witness through decades in bed, while we're told all we need is a change of attitude.

To think, for example, not just about the side effects of anti-seizure drugs, or the need for stable sleep, but also society's hatred of unruly bodies, the frequent killing of epileptics by cops, and those twentieth-century eugenicists who built "colonies" to protect society from our bad seed, yes, the same people who sterilized 37 percent of all Puerto Rican women of child-bearing age, the same people who traveled to Nazi Germany to lecture about building a master race.

When my body feels as if it's tearing itself apart, when I'm in the nightmare condition, shaking and nauseated, my vision full of flashing lights, my legs too weak to stand, the only path out is deeper. Did you hear that Mami has cancer in the marrows of her bones? For her the key to peace is acceptance and a mind fixed on the present, but for me the material roots of my illness and hers are essential, medicinal, and rage clarifies things for me. I need to map it, and not just for myself. Our bodies, the bodies of two Caribbean women who were born and grew up in the twentieth century, amid war and industry and political repression, hold political truths about the world we live in, about damage and resistance, about truth telling and healing, and so did yours, with its infant bleeding and rocketing glucose.

There are days when I pretend I have no body, not to enter the windstorm of physical, spiritual, emotional, and political pain that waits there.

Sometimes clarity is intolerable. If I write about our bodies I will be writing about the "chemical revolution" that began by retooling leftover weapons into peacetime products and has saturated our environment with 100,000 new molecules, which, in a reckless euphoria of avarice, we were all blithely assured would bring better living to all. If I write about our bodies I am writing about the land and what has been done to it. I am writing about unbreathable cities and abandoned coffee farms and tainted water, about starvation and death by thirst deliberately built into business plans. I am writing about the agricultural choices forced on people whose economic lives are ruled from afar, of shade trees clear-cut for slightly higher production, leaving a wake of cancer and erosion, of massive advertising campaigns to persuade Puerto Rican women that canned vegetables and Tang are more "civilized" than fresh calabaza and orange juice, about what crossing the border does to the Mexicana pancreas.

And going in, going deeper, allowing the pain, there is the moment when I come clear: this isn't just a tale of damage. It's also a chart of where we need to go. The transformation of the planet into a sustaining and sustainable ecosocial system moves along pathways we can't entirely see, but with their hungers and injuries and amazing capacity for renewal, our bodies have both a great store of critical information and something like night vision. These three bodies I am writing about, my mother's, my own, and yours, are not "statistically significant," but we have other significance. We are not representative, but we are extremely relevant.

The mountain moving day is coming. DDT on my father's work clothing entered the fatty tissue of my toddler body and is still there. Parathion sprayed in our home against disease-carrying mosquitoes ignites the nerve pathways in my brain. Sexual violence has impaired my digestion and increased the excitability of my neurons. *I say so yet others doubt it.* Formaldehyde leaking from new carpets and particleboard in the place we moved to when I was pregnant has left tracks of hysteria throughout my immune system. *Only a while the mountain sleeps. In the past all mountains moved in fire.* All over the world women sick in bed are thinking about these things. Those of us with electricity and computers and literacy write to each other. Susan in Santa Fe and María in Cayey and Beverly on Vashon Island and Julie in Arizona and Lisa in Washington, DC, and Naomi in New York City. All over the world people whose bodies tremble and mutate, whose lungs labor, who sweat and cramp and can't remember what they were saying, are making connections. *Yet you may not believe it.*

Gloria, if you were here now, among us, with your endlessly bleeding womb and glucose making tidal waves in your blood, you would not be silent about this, because you would not be alone. I think if we called on you to bring the story of your body to this circle, you would come.

There is no neutral body from which our bodies deviate. Society has written deep into each strand of tissue of every living person on earth. What it writes into the heart muscles of five-star generals is distinct from what it writes in the pancreatic tissue and intestinal tracts of Black single mothers in Detroit, of Mexicana migrants in Fresno, but no body stands outside the consequences of injustice and inequality. *O man, this alone believe.*

These words are the lyrics to a creative collaboration across time between late nineteenth- and early twentieth-century Japanese feminist poet Yosano Akiko and Susan Abod, a young singer-songwriter who played with the Chicago Women's Liberation Rock Band, founded by Naomi Weisstein, feminist psychologist, neuroscientist, and founding member of the Chicago Women's Liberation Union. That song was the soundtrack to my awakening as a young feminist in Chicago in the early 1970s. I saw it silkscreened onto posters by members of the Chicago Women's Graphics Collective, with whom I lived after I dropped out of high school in 1970. *All sleeping women now awake and move.*

All women whose muscles ache with permanent inflammation, all women who find lumps, all women whose babies miscarry one after another, whose life expectancy is stunted by malnutrition, who, because of industrial farming and "free trade," no longer own plots of land to grow food, who work in dangerous factories or sell sex in urban slums. My body and your bodies make a map we can follow.

We are connected to every jobless reservation and scarred, stripped tract of rainforest, every factory takeover and vacant lot community garden, every malaria death and clean water project, every paramilitary gang and people's constituent assembly. Our bodies are in the mix of everything we call political.

What our bodies, my mother's and yours and mine, require in order to thrive is what the world requires. If there is a map to get there, it can be found in the atlas of our skin and bone and blood, in the tracks of neurotransmitters and antibodies. We need nourishment, equilibrium, water, connection, justice. When I write about cancer and exhaustion and irritable bowels in the context of the treeless slopes of my homeland, of market-driven famine, of xenoestrogens and the possible extinction of bees, I am tracing that map with my fingertips, walking into the heart of the storm

that shakes my body and occupies the world. As the rising temperature of the planet births bigger and more violent hurricanes from the tepid seas, I am watching the needle of my anger swing across its arc, locating meridians, looking for the magnetic pulse points of change. When I can hold the truth of my flesh as one protesting voice in a multitude, a witness and opponent to what greed has wrought, awareness becomes bearable, and I rejoice in the clarity that illness has given me. As my aching body and the storm-wracked body of the world tumble and spin around me, I enter the clear eye at the heart of all this wild uprooting, the place our sick bodies have brought us to, where light breaks through, and we can see the pattern in the broken forests and swollen waters and aching flesh—the still and shattered place where transformation begins.

– From *Kindling: Writings on the Body* (2013)

Patients

Why do they call us "the patient"?
We are not patient. We endure.
The anxious tedium of public hospital
waiting rooms, because waiting
is the punishment of the poor;
interminable buses to inconvenient places
where we count up our cash, calculating
whether we can take a cab home
instead of riding our exhaustion;
the angry contempt of specialists, taught to believe
any pain they cannot explain is insubordinate,
deliberate, offensive.

We are not patient. We are denied.
Not medically necessary, they say, not proven.
Feel free to appeal. We are experts at appealing,
so we begin again, gathering documents, faxing releases,
collecting letters and signatures,
giving our numbers, all our numbers,
to dozens of indifferent, underpaid clerks,
stacking up evidence for the hearing, where we will declare
as civilly as we can to the affronted panels
that it is necessary that we breathe,
sleep, digest, be eased of pain, have medicines
and therapies and machines,
and that we not be required to beg.

While I am waiting, I am using my pen,
steadily altering words.
Where the card says "medically indigent"
I cross it out and write *indignant*.
Where my records say "chemically sensitive"
I write *chemically assaulted, chemically wounded,*

chemically outraged. On the form listing risk factors
for cancer, I write in my candidates: agribusiness,
air fresheners, dry cleaning, river water, farm life,
bathing, drinking, eating, vinyl, cosmetics, plastic, greed.

I am making an intricate graffiti poem
out of mountains of unnecessary paperwork.
Where the doctor has written "disheveled" I write *untamed.*
Where it says "refused treatment," I write *refused to be lied to.*
Where it says safe, side effects minimal
I say *prove it. What do you mean minimal?*
What do you mean side? I write
unmarketed effects unmentionable.
Where it asks, authorization? I write
inherent, authorized from birth.

Are you the patient? she asks, ready to transfer my call.
I say *only with my own sweet, brave body.*
I say, *Not today, no. I have no patience left.*
I am the person who is healing, I say,
in spite of everything.
I will have to put you on hold, she says. *Yes,*
hold me, I say. *That would be good.*

 🙖 From *Kindling: Writings on the Body* (2013)

Teeth

This is the year I lose my teeth,
fractured by the absence of molars
I could not afford to replace with fakes
when I could no longer travel
to the place where they were almost affordable.
Half a million dead from pandemic,
the Amazon burning at the hands of ranchers and planters,
Indigenous defenders of the earth killed
day after day in the south lands,
people snatched off the streets of Portland
the way they are snatched in countries around the world,
so many of our griefs are immense and shared.

But today I am weeping with the small
intimate grief of a broken mouth,
these parts of me, like old-growth trees,
rooted in my jaw since my baby teeth fell out
like little grains of rice, traded for tooth fairy coins,
and this now jagged ivory grew in, strong, they said,
grown up teeth, permanent.
Beyond repair. Bits breaking off
like shattered polar ice.

I'm not one to surrender, even in the worst of times.
Hope grows wild in me, like some ineradicable mint.
Crushed underfoot, the scent of it still clears my head.
I believe we can win. I believe
there is so much we can still save.

But, one by one my teeth
are going the way of the golden toad,
the red gazelle and the little blue macaw,

adding their tiny white splinters
and my teaspoon of tears
to this year's oceans of grieving
and mountains of bones.

Coming Out Sick

Living with my father, for the first time I am managing my health in full view of a family member. Until she moved out at eighteen, my daughter lived with my chronic illness and the series of catastrophic crises it routinely generates. She had to navigate the choppy seas of a childhood full of emergencies and the vast doldrums of my exhaustion, inevitably more of a caretaker than she should have had to be.

In that world of impending shipwrecks, avoiding the tips of icebergs was enough to handle. The deep, cold roots of my condition, the massive flanks and fissures, were places I went alone, in the dark, filling notebooks in sleepless nights of poring over self-help books and websites and listservs organized by shared and overlapping diagnoses, drafting new protocols (liver cleansing, chelation, alkalinity, rotation diets, EMF shielding), looking for explanations, or at least relief, consulting one narrowly focused healer after another, trying out the pills, potions, and practices that resonated, tracking changes (seizures, menstrual cycles, sleep and appetite and pain, mood swings, dreams, the clarity of my mind), traveling by sonar.

The people by my bedside saw the cups of bitter tea and bowls of pills but not the insomniac research behind them.

I am living with my father for the first time since I was sixteen. Not since the full-impact years of single motherhood have I had this much responsibility for another person's well-being, and I'm drowning, unable to balance his needs and my own, both of us in shock at our changed worlds since my mother died and I uprooted myself to come here. I am struggling to exercise self-care, which is hard enough without this balancing act, hard enough when no one's watching up close, seeing each choice I make.

For decades I have studied my body and its responses, learned what helps and what doesn't. I have encyclopedic knowledge of the effects of nutrients, herbs, externally applied substances, and internal energy practices, am adept at adding micrograms of this and that to the scales, balancing pain relief with a need for alertness, the adrenal boost, and the sleeping potion. Tonight I introduce him to the plants we both take as bedtime tinctures, show him pictures of long-standing allies, the companions I've turned to in pain-wracked

nights and sleepless pre-dawns. The purple bells of skullcap, periwinkle stars of vervain, maroon-and-yellow blossom of wild stream orchid.

I tell him that last night I was drenched in sweat. Do I know why? he asks. I explain that I live at the hub of multiple diagnoses, where symptoms crisscross and can be claimed by any of a handful of causes. Night sweats can be Bartonella or Babesia, two of the co-infections of Lyme, or CFIDS (chronic fatigue and immune dysfunction syndrome), that uncharted sea of devastating neuro-immune dysfunction that some people still insist is hysteria. Adrenal stress alone can drench the sheets.

We've just watched an episode of *The West Wing* in which President Bartlett has an MS (multiple sclerosis) attack. The First Lady wipes down his damp brow, says gently that he's sweated through his clothes, and the Surgeon General explains to the gathered staff that tiring himself could lead to spasms of his legs. Suddenly my eyes fill with tears. The severity of my illness has been dawning on me in a new way, again. I, too, sweat through my clothes, wake up in damp sheets, and for the last two years, the muscles of my calves and feet have gone into frequent, excruciating spasm. I don't know much about MS, what the relationship is between demyelination and sweat, but my own MRIs show a multitude of "punctate areas of high signal intensity" in the white matter of my brain. Maybe it's the scars in the white matter that are making me sweat.

The constellations of lesions in my brain are interpreted differently by each specialist who looks at them. Like astronomers from different cultures, they impose their own meanings, seeing different pictures in the patterns of light and dark, the Dipper or the Great Bear, Lyra or Weaving Girl, a rabbit or an old man in the stains of shadow on the moon. Those splotches revealed by magnetic resonance have been explained to me as degenerative vascular disease, multiple sclerosis, the scars of dozens of seizures, the tracks of Lyme or Bartonella or both, the wreckage left by hundreds of complicated migraine episodes constricting blood flow, or whatever it is that allows CFIDS to damage the brain. Like the classic fable of the blind men and the elephant, no one can offer me a complete picture.

But in the highly politicized, profit-driven worlds of the medical industry and the labyrinths of publicly funded social services, which of the overlapping diagnoses I pursue, and in what order, and in whose view, may ultimately be a strategic rather than a medical decision. The symptoms may be the same, but it's easier to get resources under some identities than others. After thirty years of advocacy and research, it may be better, at least officially, to have CFIDS than chronic Lyme, a diagnosis that has lost physicians their

licenses in some states and is at the center of a raging war for profit, power, and prestige.

So, late into my insomniac night, I revisit CFIDS after a few years of doing my suffering under other names. What strikes me is the accumulation, in recent years, of solid evidence not only that CFIDS is a physical, measurable illness but also documenting its severity. After decades of ridicule and dismissal, it's been less exhausting to downplay the intensity of how sick I feel than to deal with the emotional battering of people's skepticism, the assumption that this is attention-seeking melodrama, the endless unsolicited recommendations of everything from chamomile tea to affirmations. But I think the worst of it is my inability to tell the truth of what I experience without feeling like every word must be a gross exaggeration, when in fact it's usually a serious understatement.

In a 2010 speech, leading CFIDS researcher Dr. Anthony Komaroff cited a major study on the severity of CFIDS, using a research survey called the SF-36, considered one of the best tools for measuring how sick people are. When compared to subjects with heart failure and depression, CFIDS patients had a physical status similar to heart failure patients, the highest levels of pain and lowest levels of vitality and social functioning of all three groups, and substantially better mental health than the depressed patients. Another study looked for physiological evidence of the wiped-out feeling known as "post-exertional malaise," comparing levels of molecules that detect pain and fatigue in CFIDS patients and healthy controls. For the healthy subjects, the levels peak eight hours after exercising, at two and half times the pre-exercise level. For those with CFIDS, the levels continue to climb until they are nine times higher than normal, and they stay that way up to forty-eight hours after exercising.

These are only two among many studies cited, and reading them is like suddenly discovering that I've been granted citizenship, amnesty, and can come out of hiding. I feel vindicated, like a crime victim whose testimony is finally believed. And then, browsing through the introduction to Peggy Munson's groundbreaking anthology *Stricken*, I find this: "Dr. Mark Loveless, an infectious disease specialist, proclaimed that a CFIDS patient 'feels every day significantly the same as an AIDS patient feels two months before death.'"

I have a dear friend who is facing a second bout of ovarian cancer, an exquisite being whose honesty and vulnerability, courage and humor affect me like the most potent of my medicinal tinctures, an essence of integrity. When she writes, I write back, even when I'm very ill. This week I wrote to her about the words *terminal* and *interminable* side by side, about life-

threatening and life-draining as categories of illness. When my mother was in her last several years of living with multiple myeloma, she would call me for advice on how to live with such exhaustion, how to cope with such limited energy, such restricted capacity, and I would tell her how I do it. I held her hand while she passed through the territory I live in, and on out of life. Now I live in the room she died in, and I'm still exhausted.

Although people with CFIDS, environmental illness, and similar conditions have a high rate of suicide, and epileptics are six times more likely to be seriously depressed than healthy people, I am fully committed to being alive. But there's an intensity of suffering for millions of us, that most people have no idea of, and the crazy-making result of its invisibility is that at the same time that I'm struggling to tender my body and soul the very best loving care I can, silently affirming my capacity to heal, all the while that I'm trying to live as fully and joyously as I can within these states of exhausted pain—in order to protect myself from complete collapse, in order to get access to even minimal support and ridiculously inadequate care, I have to write on form after form, chant loudly and continuously to agencies and authorities, acquaintances, family, and friends: I'm sick, I'm sick, I'm sick.

I have another dear friend whose body instantly declares her disability to the world, who must fight to be seen as competent, while I fight to be seen as needing help. Within the ever-shifting dynamics of capacity and incapacity, illness and health, vulnerability and strength, each of us holds truths that are partly submerged. I know my survival depends on communicating both my competence and incompetence, my resilience and know-how, and my stark limitations; that I have to hold my own and surrender, accept limits and push against them.

So this is what I'm thinking about these days, days that fall away from the clock, when I sleep from dawn to noon, or, like today, from midnight to 5 a.m. How to be publicly sick and empowered. How to bring my whole self into view and still be safe, supported. How to be sick and undiagnosed and unashamed; or overdiagnosed, in a storm of contradictory instructions and stories, and stay calm, accepting uncertainty. How to shed the million ways I am named by others and just be. How to wear my own face.

 ☻ From *Kindling: Writings on the Body* (2013)

Burnt Light

Many years ago, I was trained in Model Mugging, a powerful form of self-defense based on the physical advantages of female rather than male bodies. We practiced the moves over and over until they were ingrained, learned at the level of nerve and muscle. Our teachers wanted our bodies to go on automatic if the need arose. And that does seem to be how it works. We were told a story about a woman who was attacked at a subway station, eight years after she graduated from the training. She didn't even remember the name of the course, but her body flew into action and carried out its moves without her. She has no recollection of what she did to her attacker. She had to deduce it from the hospital reports of the damage done.

I can't tell you what my body does when it has a grand mal, tonic-clonic seizure. My nervous system decides it's had enough and throws a switch and I go down. There's a lightning storm that I never see. I wake up in the landscape of its aftermath, in a field of debris, and trace its path by the damage done. I wake up incoherent, stumbling after words, language shredded and scattered, my tongue bloody, my pants drenched in urine. Burnt light, is what I say this time. Over and over, whispering to myself. Burnt light.

I wake up in the middle of a sentence, half an hour into a conversation, the first part of which is hidden from me. This time it's my niece telling me, "She died." She died?! "When?" I ask. "Of what? Was I there?" Because it seems I was asking for my mother. I often wake up asking for someone who is missing, so I must be aware, somewhere inside me, of a gap. Or else I was just with her. I ask if I still live on California Street, trying to figure out which chapter of my life I'm in right now. It could be any one of a number of years.

The inside of my head feels scorched, the way our eyes get from staring at the sun. It's always like this: a light too bright to be tolerated has shone into every cell of my brain and I can't see, have spots of unthought floating across my mind. Dragging the words I want to say, one at a time, out of the storage bins of words is exhausting, as if each one weighs a ton.

Then there are the muscles. In those few seconds of wildness, they have contracted hard enough to crack stone. They have clenched beyond anything I could do with my waking will. Every strand hurts. My sacrum is jammed,

my right hip excruciating, my left knee and ankle pulled awry. My arms, my back, my thighs, my face—it's as if each separate part of me climbed its own mountain range and is aching from the labor of it. It's as if I was beaten up from the inside. I'm all bruise.

The storm no longer strikes without warning, or rather, I've become a storm reader. Instead of green skies and tornado sirens, I begin to have trouble retrieving words. Someone speaks, and there's a long delay before I understand what was said and can begin to reach for an answer. It means parts of my brain are already flickering on the edge of the hypercoordinated dance that will sweep in and take over from lovely randomness.

I recognized the storm warnings on Wednesday, but it had been four years since I had a knock-down, drag-out seizure and I was cocky. I even had a visitation. A beautiful blue jay perched on a branch outside my window, and I told my helper, "That's my mother." The bird began to peck at a branch and I said, "She's telling me to eat," but I didn't do it. I thought lying down and sipping passionflower tonic would be enough. So, after a while I got up and went to the dining room. The last thing I remember is standing facing the fridge. The next thing I remember is my niece saying, "She died."

I learned to recognize my danger zones from a woman named Donna Andrews, who not only woke herself from a vegetative state but learned how to stop her ten seizures a day, some forty years ago, and, with neurologist Joel Reiter, developed a protocol for teaching others. She taught me to listen to my body, to recognize the risk factors unique to my being, to know where the limits of safety lie, for me. In the last six years I've stopped many seizures, identifying what stressors were dragging me toward that edge and reducing them, one by one, until my brain no longer needed to throw an emergency switch.

But in the last few months, stressors have piled up one on top of another and my ability to know how I'm doing has been numbed. Donna always told me I could go out on one limb or two but not three. I was out on about five limbs last Wednesday, without knowing it.

I cultivate awareness of the subtle states of my bodymind in many ways. I control my immediate environment as much as I can, so that I notice changes. I make my room a sanctuary, where subtle shifts will show up against a soothing background. I retreat to my introvert's cave at the first hint of overstimulation. Sleep, food, exertion, temperature, emotion, sensory input, a buildup of stories. These are the compass points, the factors whose levels I must be aware of. If I'm not sleeping well, I have to eat extra carefully. If I'm upset, I need to rest and stretch. If I am collecting stories,

I have to write them, give them away before they pile up in my head and trigger an avalanche.

But half my belongings are 3,500 miles away and I can't find that red velour sweater, or the golden mask of the Epileptic Ancestor that I've been working on. I packed up a thirty-five-year life and drove across the continent to my father in the hospital, in and out and in again, half a dozen times, had barely unpacked before I was flying home to Puerto Rico for the first time in six years, learned something shocking while I was there that interrupted my sleep for weeks, and also felt more drawn to live there than ever before (excitement is as dangerous as being upset), came back to more medical emergencies and unpacking, all the while moving into my mother's room, moving her belongings out, then drove to Albany, cocky still, I suppose, from my cross-country trek, gave a talk and got food poisoning and had to be fetched because I was too sick to drive. For the last few weeks my father was extremely anxious, his worries confused and repetitive, and I spent my waking hours talking him down from ledges, my adrenaline sky-high around the clock. There wasn't enough help and I was on all the time. My fine-tuned sensors got overwhelmed and after four years and a carefully built-up buffer zone, I thought I was safe. But I spent it all down in three hectic months.

This is where the Model Mugging metaphor is more accurate than it seems. My body was in fact acting in my best defense, protecting me from unbearable levels of stress by blowing a circuit, like those little red buttons in bathrooms. My beautiful, sensitive brain threw itself on the assailants, did those Model Mugging moves without my conscious participation, and left me to read the hospital reports.

❦ From *Kindling: Writings on the Body* (2013)

Body Compass

Testimonio is used in Latin America to describe a way of telling our individual life stories that bears witness to our times and places, that is both personal and social. But the term comes from Roman men swearing on their testicles. So I coined the word *histerimonia* to replace it, to honor our deep bellies as sources of knowing and acknowledge the long suppression of women's stories by labeling us hysterical, which means suffering pain in the womb but is used to ridicule and invalidate female experience.

As a sick and disabled woman of color in my sixties, the body from which my stories arise feels like a wild and broken terrain, both wounded and filled with resilience, leafy with its refusal, its untamed inability, to comply with the demands of our extractive, harsh, belittling society. When I was younger, I could override some of the needs of my body in order to drive my mind, my productivity, my social responsibilities. It's not only age that makes this less and less possible.

Learning to listen to the histerimonias of my body, what I find there is the history of the world. Migration, environmental destruction, sexual violence, war, and also my kinship with the soil, with water, plants, animals, ancestors, with you. I find the unruly, honest flesh. Over time, my body has become my compass. When I write, when I speak, when I engage ideas, I am aware of how this complex biosocial organism responds—how my stomach, my jaw, my hormones, my skin, my breath react, and those reactions become my guides. They tell me when I am speaking important truths and insights, and when I'm missing something, off target, too clever, when I have surrendered to what's expected of me and lost my authentic voice. The more I rely on the voices of my own flesh and bone, the more I am aligned with my most powerful truths. My body is not a pristine zone of liberation. It is filled with injury, but it doesn't lie. Each time I claim its authority, I become less colonized. I am rebound into the web of rebellious life that greed keeps trying to subdue. And when we do this together, great rivers of healing enter the world.

Living in my handmade vessel, this conscious extension of my physical self, I experience the finite nature of our resources in a visceral way. There are fifty-five gallons of water in my tank when it's full. As I use it, there comes a

point when no more water comes out of the faucet and I can't bathe, or make tea, or wash dishes. When my composting toilet is full, I must empty it. I have a very small amount of storage space. When something new enters my home, something else has to leave. My batteries absorb a specific amount of energy from the sun, which I can read from digital displays on my control panel. On sunny days I can spend more electricity. I can vacuum, run the Crock-Pot all night, bake something in the toaster oven. When it's rainy or overcast, I must use that energy more carefully, postpone the slow-cooked stew, use the less thorough broom. My vessel is a microcosm of the planet, a tiny world, and living in it keeps me awake, intentional. In it, I am stripped of the illusions of unlimited supply that fixed houses with grid power and city water allow.

Traveling across this North American continent, anchoring in campgrounds, driveways, empty lots, farms, beaches, forests, and the parking lots of schools and stores, I am aware of weather, landscape, and history as never before. Crossing Ontario, I can feel the northern slant of the light, and a historical marker reminds me that this is the place the Drinking Gourd pointed escapees from slavery toward. This is where they arrived, traveling on foot out of the slavery of the South, to the crisp scent of fir and impending snow. Skirting four of the five Great Lakes, I am deeply conscious of how precious and rare fresh water is, that these silken bodies of blue hold one out of every five drops of it on earth. Feel them churn in the wakes of barges and freighters, swirl around the gates of the great locks, bring a fresh, moist texture to the air of Buffalo where lakes converge. And I know that Great Lakes ships are one lane in the filthy highway of sex trafficking, targeting Native women and girls from all its shores. The Bakken oil fields just north of my route are another.

I suspect it will be different in the Southwest, but crossing North Dakota, Montana, Wyoming, I know the friendly people who freely share water, diesel, and advice can't read the darker ancestors who live beneath my toasted almond skin. White men repeatedly advise me to carry a gun. Body and landscape are layered with a thick sediment of history, the creation of whiteness by settlers who ground bodies like mine, and the ones I come from, into this soil.

Traveling in this intimate way, I notice the changing colors of the earth, the density and shapes of crops, how small farms are wedged between vast monocultures, what is offered on roadside stands. I notice rivers. As I travel, the landscape feels less and less separable from my body, which makes me both more and less vulnerable, more awake, more anchored, less numb, more conscious of our shared scars.

For several weeks now, I've been anchored in Berkeley, California, where the city council has issued me a permit to park in the streets and show off my movable chemically accessible home. Strangers stop and gaze, ask questions, offer stories. But the privatization of water makes it a more challenging place to be than the farms and campgrounds I've been staying at. The city manager's office makes it clear to me that it would take a letter from God to open their faucets to me. In triplicate. My guides to this terrain are the burgeoning population of homeless people sleeping in cars, ramshackle trailers, in the lees of buildings. They tell me where the best showers are, which dumpsters are unlocked and can receive my trash after hours, the bathrooms where I can empty my urine bottle, and the quiet flatlands streets where no one will complain if I park for a week or two. But a few days ago a tent city of homeless people was rousted out, their belongings seized, and now many of my former neighbors are sleeping on the steps of City Hall.

Their access to shelter is far more fragile than mine. I had the resources, my own and my community's, to build this vessel, and extend my body into the landscape without risking pneumonia, the loss of everything I own, or a billy club to the head. Between the homeless and the anchored, I am a nomad, navigating by the resonances my body finds with this vast topography of stories, where human and natural history blend, so that blue shadows fall across snow-dusted slopes and the sites of massacres, mine shafts and mountain ranges, and the voices of people, earth, and my own ailing body rise together in defiance and hope.

Fatigue #1

Je suis tres fatigué my mother would say, and
fermé la bouche. She taught me the art of not sleeping,
passing my open bedroom door at midnight,
book in one hand, and a steaming mug of tea.
I used a flashlight and fiction to keep my eyes
propped open against the natural desire to go dark.

My father napped on the couch, the sound
of his coughing rumbling through the air
as familiar as birdsong, a man with limitless
passion for a world of justice, and
a deep well of resignation for himself.

I don't think I began to be tired
until my uncle stuck many parts of himself
between my four-year-old legs.
There's a photograph of me in the park,
after. I can tell by my dark child eyes,
wary, wounded, watchful,
too tired for my age.

Je suis tres fatigué. Fermé la bouche.
Or the other way around.
My mouth a thin line, a zipper
behind which crouched men
loaded up with threat. I carried
a continent of the silence
they beat into me with their dagger looks.
It weighed a lot. I was
an exhausted seven-year-old.

.

The summer I was nine I could no longer walk up the hill at the summer camp my grandmother paid for me to go to just like my white Jewish cousins. I got out of breath. I didn't have asthma. I didn't have a lung problem. I was just incredibly exhausted from being so afraid all the time and the effort it took to hide it because when the men said if I showed in word or deed what they were doing to me they would murder my family, I believed them. So I learned to play recorder and etch designs into copper and ride a horse in circles in a barn, but I stopped walking up hills.

I don't really understand rest.
I know distraction. I know
refusing to read the avalanche of emails,
I know not wanting to do anything,
but I only remember this: 1974
the summer I was twenty
making up a biology incomplete
by learning sea turtles,
one afternoon in a hammock
strung between the veranda posts
of the old lighthouse
I watched the blue flower of the sky
keep opening and opening
and my cluttered attic of a mind
went empty, swept clean.
I think that may have been rest.

I plummet into sleep
afraid not of the depths
but of the twilight.
I keep myself awake
until I know I can fall swiftly off the edge
rush past the old broken fangs
of a crouching menace decades gone
into the blue trench
into the waters of Olokun, the darkness
of her indigo worlds. Could that
be rest?

I imagine writing one hundred
poems about fatigue.

I imagine shedding them the way
eucalyptus trees shed strips of bark
long ribbons that curl and fall
not in flecks of dust like human skin
but in rusty lengths
that become soil.

There should be more words for tired.
Years ago I was in rehab for one of a dozen
bad blows to the head because of epilepsy
and the man I was hauling around at the time
compared the shattered wiring of my brain
my inability to initiate the action I had chosen
to his own habit of putting things off
and the therapist said no, because
if I gave you fifty dollars to do a thing on your list
you could and she can't. There should be
a stronger word for can't.

People who are not crushed with fatigue
think we should be able to push through.
That when we say we're tired, those of us who *are*
crushed, we mean what they mean
after an ordinarily tiring day.

There should be a word
for a weariness that coats everything with dust.
There should be a word for
all the blood in my body draining out
through the soles of my feet, and
no oxygen going to the muscles it would take
to stand up.
There should be a word
for trying to do your lover's homework,
pulling double shifts
trying to bank emotional labor
in someone else's leaky account
which is not how it works, ever,
how exhausting it is to keep
pouring your heart down a hole

trying to believe it will this time
because the men with knives
made you forget how to walk away.

A word for living under the weight
of a white Protestant class-bolstered
normal normal normal with its
million and one ways of being wrong
its million and one deadly ways.

When I say I'm too tired, people don't believe me.
They don't understand the shorthand.
That I am demolished by the wrecking ball of silence.
That I am trying to shed the bark of it.

The men said don't move, so I don't.
Now people tell me to exercise. They
tell me how good it will be for me,
and maybe it's true, and maybe it's not, because
post-exertional malaise,
but when I think of moving,
I remember centuries of stone,
an ocean bed of sedimentary rock,
pushing down on me, pinning me,
those men, those empires
until I think I am only
a fossil of motion
trapped in rock.
Get up and move, they say.
Just do it.

Je suis tres fatigué.

✐ First published in *Zoeglossia* (February 28, 2022)

Poem for the Bedridden

In times to come
when the generations look back
on the Great Uprising of 2020
and speak of the people in the streets,
the people healing wounds, cooking food,
making signs,
because so much will have changed by then
they will also speak our names, the ones
who could not join the crowds
or write manifestos
or cook vats of soup
or deliver supplies,
whose fields of action were our beds,
our chairs set by the windows
where we could watch you march by.
They will say these are the ones
who carried the consequences of the bad old days
in their bodies, who shouldered the harm
in lungs that wheezed, in guts that churned,
in aching muscles and crushing fatigue,
whose hearts burned beside our own
as the old world fell, and as we marched
and toppled monuments and governments,
did the work of resting
for the sake of the whole new world.

Rematriation: A Climate Justice Migration

> If the *patria* is defined by ownership, by flags and borders and
> treaties of states, then the *matria* is this: the densely woven kinships
> of the land, this single organism of roots and fungi, mist and pollen,
> anthills and circling red-tailed hawks, their feathers turned amber
> in the sun, centipedes and berries and the billions of microbes
> unmaking the dead in the soil. All this matted interdependence is
> made of water, the one liquid being to which we belong, and all the
> molecular codes of creation it carries. . . .
>
> Everywhere on earth the matria cries out to us to come home, to
> weave ourselves back into a fabric that is torn, fraying, falling into
> pieces, dying of separation. Everywhere on earth, molecules of
> water move though skin and sky, tracing the flows that bind us,
> teaching us to be woven.
>
> **Aurora Levins Morales, "Water Road"**

Living in Puerto Rico in the age of the PROMESA Act and its junta of rob-
ber barons, in the aftermath of Hurricane Maria and an unprecedented
swarm of earthquakes, watching devastation piled upon devastation by the
colonizer racism of the US government and the corrupt thievery of the
colonial regime, I have been thinking a lot about Anacaona, a leader of my
people in the terrible 1490s, a time when the world of my Taíno ancestors
was similarly being torn apart by greed.[1] Who, side by side with her brother
Behechio, was one of the main negotiators with Columbus. She was an
acclaimed poet dealing with a treacherous invader, who did not see her or
her people as fully human, who set up a gallows to hang thirteen Taínos in
honor of Christ and his disciples, who invited Taíno chieftains to a feast,
barred the doors of the house, and set it on fire. Who executed people for
refusing to be enslaved. Anacaona was offered an alternative to death. To

become the sexual slave of a conquistador, to be raped every night and bear her rapist's children. When she refused, she was hanged.

I am writing these words from Indiera, a place of refuge for Taíno people in the western mountains of my homeland. On a clear day you can see the coast of Ayití, where Anacaona lived and died. I moved here in December of 2019, to the exact land where I spent my childhood.

I came home because I was called. I came home because I wanted my ecosocial resistance to be wholehearted and here is where my heart is whole. I came home to rejoin the ecosystem that gave birth to me and taught me how to be part of something, how to be accountable from within. I came home to plant new stories in the red clay of Indiera, in the highlands of a frontline colony know as Puerto Rico, Rich Port, portal to a vein of extraction, a place where genocide is packaged as disaster relief, as debt relief, as relief. But its name is not Loot. Its name is Borikén.

This is Borikén in 2020: 527 years of invaders sucking wealth from our land and our bodies. A sacrifice zone of medical experimentation[2] and genetic manipulation[3] of cash crops, of orchestrated starvation and unregulated contamination—broken thermometers leaking mercury in rivers, estrogen sprayed on pineapples and fed to chickens, causing six-year-old girls to menstruate, 37 percent of all women of childbearing age sterilized because they want fewer of us, think we are unfit to reproduce, that our existence gets in the way of their profit. Warehouses full of expired food meant to be distributed to hungry people after a devastating hurricane, kept behind locked doors instead. A place where, like our foremother, we have been saying no to violation every single day since then.

What would Anacaona say to Monsanto, now Bayer, distributing glyphosate herbicides that strip the hillsides not only of weeds but of everything, that spray cancer into people's lymphatic systems, that offer a feast of crops and set the house on fire?

I am living in a disaster zone made of cracked buildings and colonial chaos, a frenzy of embezzlement and appropriation in which Wall Street vulture funds are directly in charge of our economy, closing schools by the hundreds, privatizing everything within reach. The rulers of our devastation even want to privatize the sun and charge us for using solar energy instead of their coal and gas. They want to raise the price of water and power and bill us whether there's water in our pipes or not, whether anything happens when we hit the light switch or not. They want to tax our breath.

In the aftermath of Maria, in the aftermath of a president tossing paper towels and contempt at people towing each other from drowned houses, in a

place where thirty thousand still live under blue tarps two and a half years after the storm, as hundreds of thousands evacuate the crumbling infrastructure and decimated social safety nets, a deeply eroded economy and mountains of manufactured debt, across the vast diaspora of our people, some of us are being called home. Many of us are women in our middle and later years, artists, writers, healers, gardeners, and organizers returning to this archipelago, a small but steadily swelling stream we call *rematriation*. We come with seeds and water filters, street skills and friendships, movement-building muscles and tools of discernment we acquired by living in those northern cities.

Whether from the streets themselves or in video clips posted on Facebook that we watched jubilantly from far away, we witnessed the uprising of July 2019, a million people, more than a quarter of our population, in revolt against the open contempt and shameless robberies of our governor and his cronies, knowing there are a thousand just like him standing in line, but needing to bring him down, needing to feel our power, and led by young people, queer people, artists, and feminists.[4]

Whether we name it so or not, our return migration is rooted in the global ecological emergency, but we are not refugees, we rematriots are justice migrants, moving into the local eye of a global storm in order to join in the cultivation of sovereignty. Across the archipelago, agroecology projects, many of them led by women, are springing up to address the profound food insecurity of our people, forced to import 90 percent of what we eat at inflated prices. Disgusted with the corrupt intent and massive incompetence of the electrical authorities, town after town is creating its own solar microgrid and ever larger numbers of households are looking for ways to finance a shift to sunlight over coal and gas.

Leaning toward each other over a picnic table, I talk with Magha García, owner of the Pachamama Bosque Jardín, an agroforestry project in nearby Mayagüez, and part of the coordinating council of the Organización Boricuá agroecology movement.[5] Her project's Facebook page is a photo gallery of luscious passionfruit, pineapples, achiote seeds and root vegetables, wild mushrooms and ginger flowers. Absorbing as the work on the farm is, she also travels to conferences and meetings, most recently to a women's conference with the Brazilian Movimento dos Trabalhadores Rurais Sem Terra (MST, Movement of Landless Rural Workers), with which Boricuá has been building ties.

She says we must build models of the possible, small pockets of sovereignty in a deeply colonized landscape, build rainwater tanks and permaculture farms, power our engines with sun, wind, and tide, abundant enough to

fully replace fossil fuels, revive our Indigenous traditions of respect for trees, reforest the stripped slopes, teach people to distrust the toxic lies of pesticide makers and organize transitions toward sustainable farming, rainwater catchment, local food, and from the small scale, the neighborly, intimate, immediate, fuel the fight for systemic transformation: reclaim and defend our universities, slated for crippling budget cuts, reopen and take over our schools, drive out the junta and the corporations it represents, take back our privatized coasts, rebuild our crumbling health care system and infuse it with traditional medicine, community-based care, equality of access. These are all different ways of saying sovereignty, which requires independence, but independence is much too small a goal for our times.

Jacqueline Perez is the director of the Fundación Bucarabón, dedicated to building the economy of our hometown of Maricao, of which Indiera is part, by empowering women's entrepreneurship in agriculture. Women have always worked the land here but rarely owned the money our labor generates. The Fundación, housed in a closed-down junior high school, offers a wide array of workshops and trainings and has facilities where women can process their crops, adding value that stays in their hands—canning, drying, packaging food and medicine for the market. It's another pocket of possibility, an alternate story of what women's lives can look like. At the peak of the earthquake swarm, the Fundación became one of the main distribution points for donated supplies but also hosted a series of readings and discussions of Latin American literature, attended by people living in tent encampments. Although most of the work is on pause for the pandemic, I'm excited to have joined the Fundación's board, a place to put my ideas and energies into the common pot with other women of Maricao, and join forces to build a local economy based on women's cooperation and sovereignty.

Madeleine Pacheco is the principal of the local K–8 public school. When the government tried to close it, as it has done with hundreds of other schools, the community blocked the gates to prevent equipment from being removed, and won. The school has started an agriculture program, and children are growing vegetables on-site, relearning the arts of homegrown food their grandparents practiced and that were lost to the general collapse of agriculture, migration, heavy marketing of processed food, and changes in people's work lives that made it harder to tend their gardens. Together we're planning a project where seventh- and eighth-grade students conduct an oral history survey of the skills and knowledge of community elders. As first the earthquakes and then the pandemic have kept classrooms closed, government officials here, as everywhere, have looked for ways to cash in on

the crisis, and tried once again to reassign local children to another school so they could close this one, but were once again blocked, at least for now.

Krys Rodríguez, half an hour down the road, manages her four hundred cuerdas of coffee and cacao on her own, and has converted a couple of old coffee-washing pools into tilapia tanks. She says when I repair an old water tank for the purpose, she'll give me "seed" to start my own fish pond. She offers me shoots of plantain and says women farmers have to stick together.

The land I have returned to was a large coffee plantation in the late nineteenth and early twentieth centuries. This part of the mountains, long-occupied by subsistence farmers who fled the power of church and state into the wild lands, was privatized into export crop haciendas in the 1860s, and the people who lived here became landless laborers, producing gourmet coffees that supplied the Vatican, J. P. Morgan, and the Rockefellers. In 1951, when my blacklisted parents decided to buy land, so they could feed themselves through a time of political repression, the farm was largely abandoned, the cement tanks made for washing the berries filled with weeds. But they cleared the mountaintop and planted beds of vegetables, which my father sold from the back of a battered red truck, and raised hens to sell the eggs.

My father was not yet the ecologist he would become, my mother not yet the well-rounded researcher whose passions included the impacts of environmental toxins on women's health, and so they used DDT and dieldrin, lindane and parathion. They didn't know, no one did yet, that dieldrin is strongly linked to multiple myeloma, the bone marrow cancer that eventually killed my mother.

All around me I see clear-cut hillsides scarred with the gullies of erosion, bare earth drenched with Roundup where not a single weed grows, a dry fold of land that was once the forested spring where we all went to fetch water and wash clothes, now just another bare slope planted in rows of bananas.

But for more than half a century, this piece of land we call Finca La Lluvia has been left to recover. A dense tangle of subtropical rainforest covers most of the thirty-three acres that remain of the original farm. Rain has washed the soil, microbes and fungi have broken down toxic residues, and even the longest-lasting of the pesticides are undetectable now in the soil. It took weeks with chainsaws, followed by bulldozers, to open up the clearing where my family's home once stood. The machines have left a wide swath of raw, red clay, a highly acidic, low-nutrient soil underlying the topsoil they scraped away. Bit by bit, doing my best in the middle of the pandemic, I feed the soil, while I wait for my compost to ripen. I give it broken-up dried leaves, chicken manure, ground limestone and bone meal, and grow sunflowers

and gandules, green beans and kale, zucchini and tomatoes, bok choy and chard on hillocks of enriched dirt. I plant fruit trees and berry vines and tiny sapling hardwoods that may not flower in my lifetime.

There is a photograph of my mother in 1953, pregnant with me, standing in a thicket of sunflowers taller than her, beaming. She organized local women by teaching an agricultural extension course in which women learned to make ovens out of metal cracker cans and to confide in each other about their lives. I plant the sunflowers in her honor, missing her, feeling her hand on mine as I dig holes for sweet potatoes with my hand trowel.

The sunflowers also remind me of civil rights organizer Fannie Lou Hamer, whose grave I visited in Sunflower County, Mississippi, in 2018, and who understood the power of food sovereignty for people working to get free. Leah Penniman, author of *Farming While Black*, quotes Hamer in an interview with *The Sun*: "If you have four hundred quarts of greens and gumbo soup canned for the winter, no one can push you around or tell you what to do."[6] The same is true if you have dry-farmed rice and your own pigeon peas and beans.

This work, the rebuilding of soil, the preservation of forest, the growing of food, is what anchors my other job, the work of words. In this soil, I am creating a farm not only of food crops but of stories. A ripe tomato handed to a neighbor is a poem about solidarity and nourishment. A flush of mushrooms on a fallen log is an eruption of new ideas. Bees humming in the pumpkin flowers between stalks of sunflowers and tumbling bean vines tell an ancient story of reciprocity and symbiosis. In a place ravaged by malnutrition and diabetes, each fistful of greens is an antidote. That I am doing this as an elder woman living alone, extending my own mycelium through the social soil, is also poetry. To free ourselves, we have to feed ourselves, body and soul.[7]

There is nowhere that we can find the poetry of Anacaona except here and now, except as it rises from this harsh and hopeful moment. So I listen to the night wind and the whirring and gurgling voices of múcaros, tiny earth-dwelling owls whose faces my ancestors carved into stone. The Taíno dead, the spirits known as opías, are said to eat guavas and walk the roads at night, kissing the living. At the edges of the newly cleared ground of Finca la Lluvia, my visiting family and I have been planting guavas, at the border of the wild, an invitation to the ancestors to join us in seeding the soil with possibilities, with choices both ancient and new. We plant medicine and food, but they are only the implements with which we are rewriting the future. I listen to farmers, their hands dyed red-brown with clay, telling me the right moon phases for

planting, the ways to feed the soil without chemicals, their memories of these once forested slopes, talking about the ghosts of long-dried-up springs. I listen to women whose mothers bore all their children at home, whose grandmothers grew most of their food and knew which plants strengthened anemic bodies, drove out the chill from lungs damp with rain, eased laboring hearts.[8] I listen to the deep distrust of and desperate clinging to politicians and ask, *what if?*

Another world is possible is a catchphrase, a slogan, a T-shirt, but it is also a prayer, a principle, an act of courage. It begins with that question, *what if?* It's a question we ask in words, but it's also a question asked by what we plant, whose stories we lift up, by filling an abandoned water tank with tilapia and challenging the seeming convenience of glyphosate. Hard-pressed small farmers can't afford to pay for manual labor to clear the land, and a collapsed rural economy has led to emigration, so there are labor shortages anyway. In the short run, it's cheaper and easier to saturate the soil with herbicides that decimate the land and their bodies. What if we poured resources into the farming of food? Subsidized manual weed control? Paid good wages and taught the young to value this work?

What if we practiced mulching, and went back to growing coffee and our many root crops in the weed-smothering shade of roble, pomarrosa, and guamá? What if we counted the cancer in the cost per pound and recalculated the price we pay?

We ask *what if* by putting equipment, seeds, and land into the hands of rural women and blocking the gates of a tiny public school slated for closure. Each morning I walk a route of interconnected paths through my barrio, where people sleep poorly, braced for earthquakes that still shake our homes daily, asking how did you sleep, how are you today, did you feel the one at 3 a.m., do you have water and lights, do you think it will rain today, any word on when the school will open again, handing bottles of donated tinctures over fences—this is for nerves and sleeplessness, this is for your daughter's asthma, this is for the cough that won't go away, this is for fear, building a network of fungal threads and rootlets, strengthening my local web, linking it to a sprawling continental fabric of interconnected life. The medicines I put in people's hands come from herbalists all over the US, most of them women and genderqueer folks in the western United States. Packages of tincture bottles and teas arrive every few days from people building their own community-based health care, local projects with expanded reach. Among them are many immune boosters, for people living outdoors in rainy season, and nervines and adaptogens for stress, which turn out to be far more necessary than we imagined.

The ground is still shaking along the south coast as the pandemic, born of ecological devastation and globalized markets, arrives by cruise ship and jet plane. For nearly a month I struggle to breathe, make brews of marshmallow, elecampane, and mullein multiple times a day, drink teas of medicinal mushrooms, take immune-boosting capsules of beta glucan and transfer factor, breathe eucalyptus steam, working hard to avoid a trip to a woefully understaffed and underfunded hospital.

Again I think of Anacaona, and the first epidemic to arrive from Europe, sweeping Borikén within weeks of the Spanish invasion: swine flu, from imported herds of pigs. So many of our doctors have left, and Donald Trump has cut Medicaid for Puerto Rico by half. With massive job losses under the quarantine, popular protest has reopened public school lunchrooms so food can be distributed.

As far worse food shortages loom, with supply chains breaking down in the US, which maintains a price-gouging monopoly on all shipping to my country, food security is critical. Social movements are demanding that the government reallocate $9 billion it has set aside to pay Wall Street and use it for the health and basic nutrition of our people. Magha García says, if we can't eat, we can't do anything else. Planting food is an act of resistance.

I live, like all of us, between dreams of transformation and nightmares of violent extraction and cruelty fueled by greed, in a frontline colony, on red earth alive with potential and targeted by Monsanto for total chemical-genetic control, with seeds modified so we can't save them but have to buy each year afresh, that spread sterility into the wild, and toxic Roundup killing biodiversity and sowing cancer cells; using every part of myself to enrich the chances that dream will overcome nightmare, starting right here, patting a guava seedling into place, planting bitter melon to fight the diabetes that leaves so many in this poorest of municipalities with amputated feet, gazing out toward the coasts from these heights from which my ancestors watched invaders come. That invasion, often overwhelming in its brutality, has continued for 527 years now, but like Anacaona, I refuse to lie down for it. Like her, I continue to find a thousand ways to ask the fundamental question of a poet in a field of ruins: what if?

&2; From *Mapping Gendered Ecologies: Engaging with and beyond Ecowomanism and Ecofeminism*, edited by K. Melchor Quick Hall and Gwyn Kirk (2021)

Notes

1 The 2016 PROMESA Act installed a fiscal board of control that is empowered to control the Puerto Rican economy on behalf of Wall Street creditors, privatizing public resources to pay off manufactured debt. The colonized can't owe money to the colonizers who have stolen their wealth.

2 Twentieth-century medical experiments conducted on Puerto Ricans include the following: In 1930 Dr. Cornelius P. Rhoades came to Puerto Rico to "study" anemia, injecting patients with cancerous cells and treating them with radiation to study the effects. In the 1960s, birth control pills were tested on Puerto Rican women, resulting in deaths. To test the toxicity of AIDS drugs, 171 experiments were performed, including 24 tests on children carried out over nearly two decades. Children under four years old were given cocktails of seven drugs. In 1996 Dr. Gary G. Clark conducted experiments in which he released dengue-contaminated mosquitos in poor neighborhoods to study the speed of contagion. Monsanto products aspartame and Agent Orange were tested in Puerto Rico, the latter being sprayed on our forests. These are just a few of many examples.

3 US companies have been experimenting with genetically modified (GM) soy, corn, and cotton seeds in Puerto Rico since 1983. All of Monsanto's GM cotton, soy, and corn seeds originate here. Chemicals used on its fields are making employees and neighbors sick. Iris Pellot, a former agronomist at Monsanto, became so sick handling unlabeled chemicals that she almost died, but Monsanto won't reveal what chemicals she worked with.

4 In July 2019 the Centro de Periodismo Investigativo (Center for Investigative Journalism) in Puerto Rico published nearly 889 pages of Telegram messages between then governor Ricky Roselló and his close associates, filled with extremely misogynistic and homophobic comments, insults and threats against female elected officials, and jokes about feeding the corpses of the hurricane dead to the "crows," meaning critics of his administration. Mass protests shut down the capital, with a peak of one million protesters on July 17. There was strong leadership from Colectivo Feminista en Formación, and many artists, LGBTQ activists, and community organizers, as well as many who had never taken part in political protests before. On July 24, Roselló was forced to resign.

5 Pachamama Bosque Jardín, https://www.facebook.com/maghabhayali/.

6 Tracy Frisch, "To Free Ourselves, We Must Feed Ourselves," *The Sun*, July 2019.

7 Leah Penniman, *Farming While Black* (White River Junction, VT: Chelsea Green, 2018), 316.

8 Pioneering herbalist and oral historian Maria Benedetti has written several books on Puerto Rican herbal medicine and farming traditions, such as *Dolores and Milagros: A Story for Our Innocence* (2019) and *Earth and Spirit: Medicinal Plants and Healing Lore from Puerto Rico* (1998).

3 THE TOOL OF STORY

This section is about the conscious use of storytelling as a tool for change.

"Art and Science" is a lecture I gave at Tulane University in 2005, in which I talk about metaphor as a form of systems analysis, and how both art and science can uphold or subvert domination. "The Historian as Curandera," originally part of my dissertation, and published in the first edition of *Medicine Stories* in 1998, looks at the retelling of history as essential activist work. "a poet on assignment" is about being a poet on payroll to a news program following 9/11 and why it matters to humanize the impersonal narratives of war.

"Civil Disobedience" was part of a series of poems reaching for the humanity of people whose actions were abhorrent to me, and imagining their liberation from those roles. "Paris" and "Baghdad Birthday" are examples of how the personal story can illuminate large-scale events that are hard to wrap our minds and especially our hearts around. I wrote "Paris" about my meeting, as part of an anti-war delegation, with Nguyễn Thị Bình, who represented the Viet Cong at the Paris Peace Conference. I found "Baghdad Birthday" combing through news stories for raw materials on

the eve of the US war on Iraq. "Guanakán" is about our extended bodies, our bodies in relationship to ecosystem, as storytellers in search of healing.

My brother, Ricardo, likes to say there are two kinds of organizers, those who know that storytelling is the basis of all organizing and those who haven't figured it out yet. This is about figuring it out.

Art and Science

I am a historian of context and connection, looking at the world around me with an awareness of both its underground roots and its broadly branching global implications. But even more, I am a poet, and metaphor is both my theoretical approach and my research methodology. Last week, I went into the swamp with Dave Baker, the Studio botanist. My father is a prominent ecologist, and I was raised with a microscope on the kitchen table, went on field trips to small tropical cays off the coasts of Puerto Rico and the Virgin Islands, and am ecologically literate. So when we stop to ponder the strange defensiveness of the water locust, why it sprouts clumps of thorns from its trunk, I know how to consider the question in evolutionary terms.

But at the same time, I am thinking about African people escaping from enslavement, about how people recently transported from a half-dozen different West African ecosystems and having to adapt very quickly to alien swamps would evaluate this environment; how they would go about comparing known to unknown, cautiously tasting, testing the edges of survival with a long stick, using experiences gained in a different world to make sense of this one. Of course, some of the time, they had the benefit of expert help, based on thousands of years of local research and the common languages of the persecuted, but sometimes they didn't.

I also am watching the way kingfishers stitch their way back and forth across the bayou ahead of our canoe and trying to remember what I know of kingfisher lore, of the significance of the bird to various peoples, knowing that the stories of Indigenous peoples about well-known plants and animals contain a wealth of observation coded into mythic personality traits. A navy jet roars across the sky in another layer of the atmosphere, far above the pair of red and white ibis that have just glided a few feet over our heads. Thoth, the ibis-headed god of the Egyptians, was said to have invented writing and to insist on truth. Humans bent on war tend to favor eagles as their icons. Bird stories shimmer at the edge of my observations and field notes.

And always in my awareness, everywhere I go, like a double exposure projected across the landscape, is the history of the so-called removals, the murder, expulsion, and relocation of the peoples of the southeast to arid

and unknown terrain in Kansas and Oklahoma, where after only a few years, they were once more attacked and massacred, the survivors driven into smaller and smaller corners of land. We pass a shell midden, layers of clamshells several feet thick, deposited by people eating in this spot for a very long time. I think of their descendants starving in Oklahoma in the 1860s, vigilantes burning the corn, and the green memory of the elders: where I stand is the place they dreamt of, told stories about, sometimes drank to forget, were haunted by. I think of the Choctaw Nation, touched by news of the Irish famine, only a few years off their own hunger trail, sending $710, a fortune in those days, for famine relief, hunger speaking to hunger.

Rags of human history are attaching themselves to the smell of swamp water, the profiles of herons. I think of the undefeated Seminoles, fighting ferociously in mud, retreating into places their enemies could not imagine, bringing Africans with them. Of Osceola and Bolek and Alligator. I am enraged and grief-stricken and give honor with all my heart, out of my heritage of Mandinka captive and Arawak refugee, Andaluz colonizer, wandering Litvak Jewish peddler, Ukrainian Jewish farmer, and raiding Kalinago. I watch the glistening red knees of cypress poke out of a lime-green illusory meadow of duckweed, smooth surface, dank gassy water below, reacting to what I see through a tangle of past as matted and thick as peat moss. I consider memory, what a powerful thing it is, lying dormant in ravaged populations, ready to be ignited.

Then Dave points to the broad branches of a majestic live oak, clearly a survivor from before the time of logging and sugar cane and oil. That's polypodia, he tells me, resurrection fern. The many-footed survivors, that turn brown and dead-looking when the weather is dry but respond to rain by springing into a green profusion along the tops of the branches, and stand unfurled like a multitude on a narrow road. My metaphors are making connections between the resourcefulness of relocated peoples and the genetic traditions and innovations of plants, between the strategies of water locusts and maroons, between the ways that ferns and exiles remember absent rain.

Metaphor is a kind of systems analysis, a different and equally valid approach to understanding complexity, as the mathematical modeling my father does. Metaphor constantly theorizes relationship and meaning. Artists do this work out of their own broad or narrow views, have their own parameters for sampling the data, their own biases about what goes with what, as do scientists. When I decide there is a poetic link between the behaviors of resurrection fern and historical memory, I am responding to a deep resonance inside of me, but that resonance is trained by a lifetime of

studying the nature of resonances, of mapping the interconnected webs of human and wild communities. I have an informed feel for it.

This is no more or less subjective than the feel that scientists have for their work. It is both a theoretical and esthetic leaning that causes US medical researchers, trying to duplicate the healing effects of rainforest plants, to fail, because they assume that the action is an expression of a single potent alkaloid and not the synergy of multiple parts that are ineffective alone. It is a sensibility born in part out of a scientific marketplace in search of patentable product, in part out of a host of assumptions about parts and wholes. In science and art alike, our imaginations are constrained by who we are, who we work for, what we believed before we began, where we draw the margins of what's relevant.

Art and science are not yin and yang, feminine and masculine, subjective and objective, soft and hard, wishful and factual, imagined and proved. They are not opposites, and they are much more than complementary. They are two modern branches of an ancient curiosity, and in many cultures they remain one thing. Both involve starting from the known and moving into the unknown, guided by theory and experience, using a variety of tests and leaps of faith to arrive at new perception.

The disdain of science for art as a tool for understanding reality is a relatively recent innovation, coming out of a period of intensely mechanistic thinking in Europe, when part of the population dedicated itself to understanding how things worked through the metaphor of machines. Because they hungered for pure explanations, as unarguable as gears, they went about isolating phenomena as much as possible, trying to take themselves out of the equation, to look with a single eye. As a result, they saw amazing and singular things, and their approach became a monopoly.

At the same time, another branch of European knowledge was being burned at the stake for holding fast to multiplicities, to the magical kinships between humans and everything else, from root bark and spider webs to iron filings and wax, and the science that went up in flames, the ecologically minded science of peasant women and men, was also an artistry full of pigments and dyes, fluting and string plucking, stitchings and carvings, knotted threads and rhymes.

As Europe reached out to dominate other places and peoples, both art and science, artificially split nearly to the root, either served empire and its special interests or survived in the undergrowth, hidden, disregarded, rebellious. The popular sciences and arts were called superstitions and crafts. Real science (and the word *real* comes from *royal*) found laws and formulas

that helped to dominate nature and those people defined as naturish. Real art idealized this venture. Everywhere they went, colonizers wiped out Indigenous science and scientists, collected and captured Indigenous art and artists, and understood and respected neither.

Imperial science measured my ancestors' heads and pronounced their evolutionary destiny as slaves; imperial art celebrated the virtues of a greedy aristocracy and painted our bodies and our islands as delectable trophies. Science lobotomized angry women and ransacked sacred graves. Art fiddled while continents burned, harps were broken, and sacred drums were outlawed.

But science also put moldy bread onto wounds, though village women got no credit, domesticated maize into corn, grew pea plants in a monastery, measured the wings of finches, dreamt molecular rings and the double twist of possibility, recorded the words of dying shamans, extracted and explained the potency of wild yams, deciphered root languages, planted ant nests among the sweet potatoes instead of pesticides, traced the movements and mixtures of our ancestors, declaring us all African in our marrows, and traced bone cancer from those same marrows to benzine dumped in the drinking water, looked so deeply into matter as to come out the other side, and learned to speak some of the billion languages of the universe.

Art resurrected the suppressed dreams of the conquered and redeclared their unique sovereignties in a thousand tints and rhythms, charted a map toward freedom across the bright squares of slave quilts and traced intricate geometries of Celtic philosophy in the whirling dance of immigrant Irish feet, drew jazz out of a universe of sorrow, defiance, and desire, carved the bombing of Guernica in angular shock across yards of canvas, brought a hundred dazzlingly different Asian worlds into shared choreography of silk and drum on San Francisco stages, conjured up the other side of history in novels written out of the roots of cane and the streets of railroad cities, used light and silver to catch the deep gaze of a Lakota man, the spill of water over a Yosemite rock, the glowing structures of microscopic life, the blue curve of the planet's cheek against galactic blackness. Art forged, carved, wove, stretched, inked, typed, and twirled the matter of the world into living stories, which are the opposite of obedience.

Art is not the sweetener of science. Science is not the dry bones of art. Scientists and artists are both investigators and narrators, trying to discover and perform the story of what everything is (and does), what it used to be, and what it might become. Story is the ground of action, the place from which we step out into the world and decide to take one path or an-

other. Our stories define our possibilities, which is why Chilean dictator Augusto Pinochet outlawed both the concept of evolution and the charango, a stringed instrument made from an armadillo shell. Our stories determine whether we teach poor children how to write poetry or apply counterinsurgency formulas to their lives like insecticides, so they learn only to mimic militarism. Our stories lead us to choose the damming of rivers for factory farms or sustainable agriculture appropriate to each ecosystem, to prescribe antidepressants in record numbers or to make people's lives more satisfying. To assign *Bless Me, Ultima*, a Chicano novel of Indigenous healing, as a literary text of southwest culture or burn it as witchcraft in a Colorado schoolyard. To cut some trees, or thousands, or all of them. To consider the world downstream from our decisions, or not.

Art and science are two instruments for sampling the world, two hands of one body, tapping at the same drum, two palms that between them cup all our questions. Two ways of speaking, syllable by syllable, the stories by which people and planet may live.

The Historian as Curandera

Until lions write books, history will always glorify the hunter.

South African proverb

One of the first things a colonizing power, a new ruling class, or repressive regime does is to attack the sense of history of those they wish to dominate, by attempting to take over and control their relationships to their own past. When the invading English rounded up the harpists of Ireland and burned their harps, it was partly for their function in carrying news and expressing public opinion, for their role as opposition media; but it was also because they were repositories of collective memory. When the Mayan codices were burned, it was the Mayan sense of identity, rooted in a culture with a past, that was assaulted. The prohibitions against enslaved peoples speaking their own languages, reading and writing, playing drums all had obvious uses in attempting to prevent organized resistance, but they were also ways of trying to control the story of who the enslaved thought they were.

One important way that power elites seek to disrupt the sense of historical identity of those they want to dominate is by taking over the transmission of culture to the young. Native American and Australian Aboriginal children were taken from their families by force and required to abandon the language, dress, customs, and spirituality of their own people. Irish and Welsh children in English-controlled schools and Puerto Rican, Mexican, Chinese, and many other nationalities of children in US public schools were punished and ridiculed for speaking their home languages.

Invading the historical identities of the subjugated is one part of the task of domination, accomplished through the destruction of records, oral traditions, cultural forms and through interfering with the education of the young. The other is to create an imperial version of our lives. When a controlling elite of any kind comes to power, it requires some kind of a replacement origin myth, a story that explains the new imbalances of power

as natural, inevitable, and permanent, as somehow inherent to the natures of enslaved and enslaver, invaded and invader, and therefore unchangeable; that explains changes imposed on gender relations, family structure, sexuality, land use, and other important aspects of people's lives as the way it always should have been. A substitute for the memories of the colonized. Official history is designed to make sense of oppression, to say that the oppressed are oppressed because it is their nature to be oppressed. A strong sense of their own history among the dominated undermines the project of domination. It provides an alternative story, one in which oppression is the result of human behavior, of historical events and choices, and not natural law.

Official histories also fulfill a vital role for those who rule. Those who dominate must justify themselves and find ways to see their own dominance as not only legitimate but the only acceptable option. So the founding fathers spoke of the need to control democracy so that only those fitted for rule by the experience of managing wealth would have the opportunity to hold public office; some slaveholders framed the kidnapping and enslavement of West Africans as beneficial to the enslaved, as offering them the blessings of a higher state of civilization; misogynist patriarchs speak of protecting woman from her own weak nature; and the colonized everywhere are defined as in need of improvement, which only a better management of their labor and resources can offer.

In his 1976 essay "Defensa de la palabra," Uruguayan writer Eduardo Galeano wrote, "What process of change can move a people that does not know who it is, nor where it came from? If it doesn't know who it is, how can it know what it deserves to be?" The role of a socially committed historian is to use history, not so much to document the past as to restore to the dehistoricized a sense of identity and possibility. Such "medicinal" histories seek to reestablish the connections between peoples and their histories, to reveal the mechanisms of power, the steps by which their current condition of oppression was achieved, through a series of decisions made by real people to dispossess them; but also to reveal the multiplicity, creativity, and persistence of their own resistance.

..................

History is the story we tell ourselves about how the past explains our present, and the ways in which we tell it are shaped by contemporary needs. When debates raged in 1992 about the quincentennial of Columbus's arrival in the Americas, what was most significant about all the voices in the controversy, the official pomp and ceremony, the outraged protests of Indigenous

and other colonized peoples of the Americas, and the counterattacking official responses, is that each of these positions had something vital to say about the nature of our contemporary lives and relationships, which our conflicting interpretations of the events of 1492 simply highlighted.

All historians have points of view. All of us use some process of selection through which we choose which stories we consider important and interesting. We do history from some perspective, within some particular worldview. Storytelling is not neutral. Curandera historians make this explicit, openly naming our partisanship, our intent to influence how people think.

Between 1991 and 1996 I researched and wrote *Remedios*, a medicinal version of Puerto Rican history told through the lives of women, not so much because the pasts of Puerto Rican women were inherently important to talk about but because I wanted to change the way Puerto Rican women think of ourselves historically. As a result, I did not attempt to write a comprehensive general history but rather to frame historic events in ways that would contribute to decolonizing the historical identities and imaginations of Puerto Rican women and to the creation of a culture of resistance.

Remedios is testimonio, both in the sense of a life story, an autobiography of my relationship to my past, and, like the testimonios of Latin American activists, many of them survivors of prison and torture, in bearing witness to a much larger history of abuse and resistance in which many women and men participated. One of the most significant ways in which *Remedios* differs from conventional historical writing is in how explicitly I proclaim that my interest in history lies in its medicinal uses, in the power of history to provide those healing stories that can restore the humanity of the traumatized, and not for any inherent interest in the past for its own sake. *Remedios* does not so much tell history as it interrogates it. It seeks to be provocative rather than comprehensive, looking for potency more than the accumulation of information.

In the writing, I chose to make myself visible as a historian with an agenda but also as a subject of this history and one of the traumatized seeking to recover herself. My work became less and less about creating a reconstructed historical record and more and more a use of my own relationship to history, my questions and challenges, my mapping of ignorance and contradiction, my anger and sorrow and exhilaration, to testify, through my personal responses to them, to how the official and renegade stories of the past impact Puerto Rican women. To explore, by sharing how I had done so in my own life, the ways that recaptured history could be used as a tool of recovery from a multitude of blows. In writing *Remedios*, I made myself

the site of experimentation and engaged in a process of decolonizing my own relationship to history as one model of what was possible.

As I did so, I evolved a set of understandings or instructions to myself about how to do this kind of work, a kind of curandera's handbook of historical practice. The rest of this essay is that handbook.

(1) TELL UNTOLD OR UNDERTOLD HISTORIES.

The first and most obvious choice is to seek out and tell those histories that have not been told or have not been told enough. If history books looked like the population of the world, they would be full of women, poor people, workers, children, people of color, slaves, the colonized. In the case of *Remedios*, where I had already chosen to tell Puerto Rican history through the lives of women, this meant continually seeking out and emphasizing the stories of women who were poor, African, Indigenous, mestiza and mulata, women enslaved and indentured, rural women, emigrant women in the United States.

(2) CENTERING WOMEN CHANGES THE LANDSCAPE.

Making truly medicinal history requires that we do more than just add women (or any other "disappeared" group of people) to the existing frameworks. We need to ask, "If women are assumed to be the most important people in this story, how will that change the questions we ask? How will it change our view of what events and processes are most important? How will it change the answers to questions that have already been asked and supposedly answered?

For example, if you ask, "Until what point did the Indigenous Arawak people of Puerto Rico have a significant impact on the society?" until recently most Puerto Rican historians would say that the Arawaks stopped playing a major part by around 1550 because they no longer existed as a people. But what no longer existed in 1550 were organized lowland villages, caciques, war bands—in other words, those aspects of social organization that European men would consider most important and be most likely to recognize. If we ask the same question centered on women, we would need to look at those areas of life in which women had the most influence. Evidence from other parts of the Americas shows that traditional cultures survived longest in those arenas controlled by nonelite women. If we put women at the center, it becomes clear

that Arawak culture continued to have a strong influence on rural Puerto Ricans until much later, in fact into the present, particularly in the practices of agriculture and medicine, spiritual practices, child rearing, food preparation, and in the production of cloth, pottery, and other material goods.

Similarly, in exploring when Puerto Ricans first began to have a distinct sense of nationality, the usual evidence considered is of the publication of newspapers or the formation of patriotic societies, activities dominated by men. How did women experience nationality? If, as José Luis González asserts, the first people to see themselves as Puerto Rican were Black because they lacked mobility and were, perforce, committed to Puerto Rico, what about the impact of women's mobility or lack of it? Did women experience a commitment to Puerto Rican identity as a result of childbearing and extended family ties? Did they feel Puerto Rican earlier or later than men? If women are at the center, how does that change the meaning of social movements like the strongly feminist Puerto Rican labor movement of the early twentieth century? Medicinal history does not just look for ways to "fit in" more biographies of people from underrepresented groups. It shifts the landscape in which the questions are asked and makes a different kind of sense out of existing information.

———

(3) IDENTIFY STRATEGIC PIECES OF MISINFORMATION AND CONTRADICT THEM.

In challenging imperial histories, some kinds of misinformation have more of an impact than others. Part of the task of a curandera historian is diagnosis. We need to ask ourselves what aspects of imperial history do the most harm, which lies are at the foundations of our disempowered sense of ourselves or of other people? Some of these strategic pieces of misinformation will be the same for all projects, and I name several below. Some will be of central importance only to specific histories. In the case of Puerto Rican history, examples of some of the specific lies I decided were important to debunk were the absence or downplaying of Africa and African people from official histories, the idea that there was such a thing as "pure" Spanish culture in 1492 or at any time since, and the invisibility of Puerto Ricans' relations with people from other countries, especially the French, English, and Dutch colonies of the Caribbean. The first is about erasure, the other two deal with ideas of national or cultural purity and also the myth of passivity, the lack of historical initiative in shaping our lives.

(4) MAKE ABSENCES VISIBLE.

The next three points deal with the nature and availability of historical evidence. When you are investigating and telling the history of disenfranchised people, you can't always find the kind and amount of written material you want. But in medicinal history the goal is as much to generate questions and show inconsistencies as it is to document people's lives.

For example, tracing absences can balance a picture, even when you are unable to fill in the blanks. Lack of evidence doesn't mean you can't name and describe what is missing. Tracing the outlines of a woman-shaped hole in the record, talking about the existence of women about whom we know only general information, can be a powerful way of correcting imperial history. I wrote one piece about the Indigenous women known to have been brought to Puerto Rico from other parts of Central, South, and North America who left no trace of their real names or even what nations they came from.

> We are your Indian grandmothers from Eastern America, stolen from our homes and shipped to wherever they needed our work. From Tierra Firme to the islands. From one island to another. From this side to that, each colony raiding for its own supply. . . . They have passenger lists with the names of those who came west over the ocean to take our lands, but our names are not recorded. . . . Some of us died so far from home we couldn't even imagine the way back: Cherokee in Italy, Tupi in Portugal, Inuit in Denmark. Many of us were fed into the insatiable gold mines of el imperio alongside the people of your island, and they called us simply indias. But we were as different from one another as Kongo from Wolof, Turk from Dane. . . . We are the ancestors of whom no record has been kept. We are trace elements in your bodies, minerals coloring your eyes, residue in your fingernails. You were not named for us. You don't know the places where our bones are, but we are in your bones. Because of us, you have relatives among the many tribes. You have cousins on the reservations. ("1534: Slave Mothers," in *Remedios*)

Such a piece makes clear the significance of people and events we know existed but have no details of. It marks the spot.

It is also possible to use fictitious characters to highlight an absence, as Virginia Woolf does in *A Room of One's Own* when she speaks of Shakespeare's talented and fictitious sister, for whom no opportunities were open. I wrote a similar piece about the invented sister of a Spanish chronicler who

visited Puerto Rico in the eighteenth century to make visible the absence of women chroniclers.

———

(5) ASKING QUESTIONS CAN BE AS GOOD AS ANSWERING THEM.

Another way of dealing with lost history is to ask speculative questions. "What if" is a legitimate tool of investigation, and the question can be as valuable as the answers. Proposing a radically different possible interpretation is a way of opening up how we think about events, even when there is no way to prove anything. It is useful to ask, "What would have to be different for us to understand this story in this other way?"

The chronicles of the Spanish conquest of Puerto Rico have relatively little to say about the cacica Guanina and her liaison with the Spaniard Cristóbal Sotomayor. The popularized version I grew up on goes something like this. Innocent Indian Maiden sees the most handsome man she's ever laid eyes on, far surpassing anyone in her whole culture. She falls in love with him, even though he has enslaved her community, whose members are dying like flies. She becomes his lover, and when her people plot an uprising, she runs to warn him. He doesn't take her seriously, not because he's an arrogant idiot but because he's brave, and promptly rides into an ambush and dies. Guanina is beside herself with grief and kills herself. Her brother, the chief, finds her dead body lying across her slain lover, the two are buried side by side, and the lilies of Spain entwine with the wildflowers of Puerto Rico upon their graves.

On the face of it this is an extremely unlikely tale. Guanina was the niece of the high cacique of Puerto Rico, in a matrilineal society in which sisters' children inherited power and wealth, and there were women who ruled as caciques in their own right. At eighteen she would have been considered a full adult, and a woman of influence and prestige. Puerto Rico, called Boríken by the Arawaks, was not permanently settled by European colonists until 1508, although the torture and killing of Native people had arrived with Columbus. By the time Sotomayor took control of the southwestern region of the island where Guanina's family ruled, the Arawaks of Boríken had had eighteen years of news from Hispaniola and had a pretty good idea of what was likely to happen to them.

In numerous works on Pocahontas, Mohawk writer Beth Brant points out that Indigenous women sometimes sought out liaisons with European

men as a way of creating ties of kinship, in the hope that such a bond would help them fend off the worst consequences of invasion. If all we do is assume, for a moment, that Guanina was not naive but was an intelligent woman, used to seeing herself as important, and that she was thinking about what she was doing and had more at stake than a cute boyfriend, the Spanish colonial story becomes completely implausible. My fictionalized reinterpretation of Guanina's story is based on that implausibility. It proposes another possible set of motives and understandings that could explain the known facts of her life and death, and leave us with a sense of her dignity and purpose. It is speculative, and without hard evidence, but it raises important questions about how to understand the actions of smart people in intolerable conditions.

(6) WHAT CONSTITUTES EVIDENCE?

Another issue to keep in mind is the biases built in to historical standards of evidence. Although there is an increasing acceptance of other forms of documentation, the reliance is still heavily on the written. Which means that we accept an immense body of experience as unavailable for historical discussion. The fact that something was written down does not make it true, as any critical consumer of the media knows. It simply means that someone with sufficient authority to write things down recorded their version of events or transactions while someone else did not. It is evidence of some of what they did, some of what they wanted others to think they did, and some of what they thought about it. No more. Of course even something as partial as this is a treasure trove, but when we rely on written records we need to continually ask ourselves what might be missing, what might have been recorded in order to manipulate events and in what direction, and in what ways we are allowing ourselves to assume objectivity is in any way connected with literacy. We need to remind ourselves that much of what we want to know wasn't written about and also think about ways to expand what we will consider as contributing to evidence. Is the oral tradition of a small town, handed down over fourteen generations, about the mass exodus of local men to the gold mines of Brazil really less reliable than what women tobacco workers charged with civil offenses deposed before a judge whose relatives owned tobacco fields? As historians of the underrepresented we need to question the invalidation of nonliterate mechanisms of memory.

(7) SHOW AGENCY.

One of the big lies of imperial history is that only members of the elite act, and everyone else is acted upon. In our attempts to expose the cruelty of slavery and conquest, market-driven famine or the ownership and subjugation of women and children by men, we sometimes portray the oppressed as nothing more than victims, and are unable to see the full range of responses that people always make to their circumstances. People who are being mistreated are always trying to figure out ways to end, avoid, or lessen that mistreatment. Their strategies may be shortsighted, opportunistic, ineffective, or involve the betrayal of others, but they nevertheless represent a form of resistance. For the sake of the planetary future, it's essential that we learn to develop strategies that hold out for real transformation and that take everyone's well-being into account. But in telling the history of our social relations with each other over time, it's important to recognize that resistance takes many forms. We need to continually challenge the myth of passive victimization, which leaves both the mistreated and the mistreaters, and their descendants, feeling ashamed and undeserving of unfettered lives. Even under the most brutal conditions, people find ways to assert their humanity. Medicinal history must show the continual exercise of choice by people who appear powerless.

(8) SHOW COMPLEXITY AND EMBRACE AMBIGUITY AND CONTRADICTION.

In order to do so, we must also give up the idea that people are 100 percent heroic or villainous. In searching out a history of resistance, the temptation is to find heroic figures and either overlook their failings or feel betrayed when we find that they have some. Human beings are not all resistance or collaboration and complicity. Popular official history tends to be simplistic, and ahistorical as regards individuals, focused on exceptional personalities instead of complex social processes. If we ignore what is contradictory about our own impulses toward solidarity or betrayal in an attempt to simplify history into good and evil, we will sacrifice some of the most important lessons to be gained from studying the past.

Important as they are, we need more than just the heroic stories of militant resistance—of suffragists chained to railings, slaves burning plantation

houses, armed revolts like that of John Brown. Stories of accommodation, collaboration, and outright defeat are just as important because they give us ways to understand our lives as caused rather than just existing. If we want to give people a sense of their own agency, of having always been actors as well as acted upon, we must be willing to tell stories full of contradiction that show the real complexity of the causes of their current conditions.

For example, Nzinga, born in 1585, was a queen among the Mbundu of what is now Angola. She was a fierce anti-colonial warrior, a militant fighter, a woman holding power in a male-dominated society, and she laid the basis for successful Angolan resistance to Portuguese colonialism all the way into the twentieth century. She was also an elite woman living from the labor of others, murdered her brother and his children, fought other African people on behalf of the Portuguese, and collaborated in the slave trade.

I tell her story in two different ways, once at the end of her life, celebrating courage and relentless defense of her people, and the power of her memory for Black women especially, and once from the point of view of the woman on whose back she literally sat as she negotiated with the Portuguese governor. It is in many ways more empowering when we tell the stories of our heroic figures as contradictory characters full of weaknesses and failures of insight. It enables us to see our own choices and potentials more clearly and to understand that imperfect people can have a powerful, liberating impact on the world.

––––––

(9) REVEAL HIDDEN POWER RELATIONSHIPS.

Imperial history obscures the power relations that underlie our daily lives. This is one of the ways that immense imbalances of power and resources are made to seem natural. In telling the history of any community, especially those targeted by some form of oppression, we need to expose those relationships of unequal power whether they come from outside our group or lie within it. Puerto Rican liberal feminists of the late nineteenth century, all those "firsts" in the arts and education, came primarily from an hacendado class made affluent by the slave-produced profits of the sugar industry. Many of the leaders of the 1868 Lares uprising against Spain were coffee planters angered by their growing dependence on newly arrived merchants and the credit they offered but perfectly willing to employ coffee workers at starvation wages.

Another way to expose unequal power is to reveal hidden economic relationships. One way I did this was by following the products of Puerto

Rican women's labor to their destinations and tracing the objects of their daily use to their sources. This shows both the degree of control exerted on our lives by the profit seeking of the wealthy and uncovers relationships we have with working people in other parts of the world. In the seventeenth century ginger grown by Puerto Rican women and men was sold to English smugglers from Jamaica and ended up spicing the daily gingerbread of London's working poor. One of the main items imported in exchange was used clothing made in the mills of England and the Low Countries. This reveals a different relationship between Puerto Ricans and English people than the "great civilization / insignificant primitive colony" story told in the 1923 *Encyclopedia Britannica* we had in my home, which described Puerto Rico merely as a small island with no natural resources. Telling Puerto Rican community college students that the stagehands for Shakespeare's productions probably ate Puerto Rican food on their lunch breaks changes their relationship to that body of "high culture."

Similarly, Puerto Rican women and children picked and processed coffee that was considered the best in the world at the turn of the century. Yauco coffee was served in the wealthiest homes of New York, Paris, and Vienna. Mrs. J. P. Morgan bought her personal supply from Yauco, and all those philosophers, poets, and painters drank it at their salons. Juxtaposing photographs of coffee workers who earned pennies for their labor with the silver coffeepots and reclining gentry who consumed the coffee restores Puerto Rican women's labor to its place in an international web of trade and profit.

I wrote one piece in which I described the lunch preparations of a rural Puerto Rican neighbor and showed how the food she set on the table was a map of the world, revealing her connections to people in Malaysia, Ethiopia, Portugal, and many other places. I describe the vegetables grown and canned in the Imperial and Salinas Valleys of California by Mexican and Filipina women and promoted as the "modern" replacement for fresh produce to Puerto Rican housewives of the late 1940s and 1950s. I read this piece as part of a talk I gave at a small college in Michigan, including a section about bacalao, the dry salt cod that is a staple protein of Puerto Rican cuisine.

The bacalao is the fin-tip of a vast movement in which the shadows of small fishing boats skim across the Grand Banks of Nova Scotia hauling cod from immense schools of feeding fish, salt it down in their holds and return with rumors of great lands to fourteenth century Basque fishing villages and Portuguese port towns. Return to Iceland, to New Brunswick and Nova Scotia, and to build up the great shipping fortunes of Massachusetts. The flaking

yellow flesh makes her part of a wide Atlantic net of people who live from the cod: catch the cod, salt the cod, pack and ship the cod, sell the cod, import and export the cod, stretch a piece of it into food for a family for a week.

After the talk, a man came up to me, deeply moved, to tell me that he had grown up in a Nova Scotia fishing village and his family had packed cod. I thanked him and told him we had eaten it for breakfast. "So did we!" he exclaimed. "We ate it with green bananas," I told him. "We ate it with potatoes," he replied, and we embraced. The last place he had expected to hear about his own life was in a talk on Puerto Rican women's history. Revealing this kind of connection increases our recognition of our common interests and uncovers the importance of our daily work, the way we and the people we know spend our days, in the international scheme of things.

———

(10) PERSONALIZE.

The majority of historical figures who are known by name are members of elite groups, while everyone else tends to be known en masse. However, there are quite a few places where the names of individual people who are poor, female, dark, etcetera, can be found in written records. Using the actual names of real individuals and any details of their lives we have, to dramatize and personalize the social condition of a group, makes those conditions far more real to us. When the disenfranchised appear only in crowd scenes, it reinforces a sense of their relative unimportance.

In writing about the lives of recently freed enslaved women in Puerto Rico, forced to contract themselves as laborers for two years after abolition, I used names of specific women found in a footnote in a book on slavery in San Juan. Many freedwomen fulfilled the requirement by finding and contracting themselves to relatives. These footnotes contained the details of which family members they sought out and what work they did. I wrote:

> The roots of the family tree go deeper than the cruel reach of slavery. Juana Gutierrez seeks out her granddaughters Josefa (28) and Matilde (32), the first liberated from the establishment of Sucesión Turull, the second from the grip of Teresa Amadeo. Juana Geigel, from Carolina, ex-slave of Teodoro Chevremont, presents herself in San Juan, in order to work for her father, Felix Angulo, "to provide him with the necessities of life." . . . Eustaquia Amigó works as a candymaker for her mother, María Luisa Amigó.

Her contract says she does not wish to be paid. Maria Narcisa, freed from Ysidro Cora, Yrene, freed from Rafael Cabrera, and Ventura, freed from Micaela Benisbeitía, fly like swift and hungry birds to their mothers, and work for them, provide for them, take up their loads. ("1873: The Freedwomen Contract Themselves")

This has an entirely different impact than writing "many freedwomen sought out their relatives and contracted to work for them."

The best-documented Arawak women are cacicas, members of the Indigenous ruling class known as nitainos. Most of the stories about Arawak women focus on cacicas like Guanina, Loiza, or Anacaona. But we know that the majority of Arawak women belonged to the naboria laborer class. I found a list of Indigenous women both from Borikén and from the smaller islands of the Eastern Caribbean who were being branded as slaves on one particular day in 1515. Many were given two names in the record, one Spanish and one Arawak or Carib, and many others were simply renamed María, Juana, or Catalina. By using names that were at least imposed on real women, and the few facts recorded about them, their anonymity in the records of their abusers is at least made visible and the realities of their lives during the conquest become more tangible. Here is an example from my poem "1515: Naborías":

> They were not cacicas.
> They were not heirs to yuca fields.
> There were no concessions made to their status.
> They were not "queens."
>
> Their names are recorded in the lists of work gangs
> sent to the mines, the conucos, the kitchens, the laundries
> of the Spanish invaders.
> Macaney, field hand.
> Francisquilla, cook.
> Ana, baker.
> Catalina, pig woman.
>
> They were the working women of Borikén.
> They were called out of their names.
> Casually recorded under the names of Catholic saints,
> or the queens of the myriad kingdoms of Spain, renamed
> after little sisters or mothers left behind in Estremadura,

Navarra, Castilla, Sevilla, León
or a favorite prostitute from a port town,
or a beauty out of some ballad of the old land.
They were not born Catalina, Ana, Francisquilla. . . .

The account books of the governor say herrose—
branded on this day—was Elvira Arumaita
from the island of Guadalupe
with a son they called Juanico.
herrose, a Carib called Beatriz, and her son, Juanico.
herrose, a Carib, Juana Cabarotaxa, from the island of Santa
 Cruz, and
herrose, a little girl called Anita, Carib,
from the aforementioned island
which we now call Guadalupe, and herrose,
also from Guadalupe, Magdalena Guavrama
Carib, and her child.

They were already here, enslaved, escaped,
and to their great misfortune, recaptured
and branded this day by Captain Juan Ponce de León,
Ana Taguas, Violante Ateyba
Leonor Yayguana written down as belonging
to the rebel cacique Abey,
and Isabel Guayuca with her son, once again Juanico,
once owing loyalty to the collaborator Cayey.
They were women under two masters,
the crumbling authority of the caciques
and the new and violent usage of the señores . . .

In cases where we really don't have names, documented elements in the
lives of a social group can still be personalized by writing a narrative that
conveys the details of such a life. I used figures on average wages of women
working in coffee, sugar, and garment work in the early twentieth century along
with a list of the prices of housing and essential foods to write an internal
monologue about the kinds of choices a single mother of several children has
to make during the dead season of the sugarcane industry when there is little
work and a lot of illness. Details like the difference between feeding your
children unbroken rice, broken rice, or cornmeal make the actual struggles
of such women visible and felt in a way that lists of wages paid alone cannot.

(11) SHOW CONNECTION AND CONTEXT.

One element of imperial history is that events tend to be seen as caused by extraordinary personalities acting on one another without showing us the social roots and contexts of those actions. For example, many of the great discoveries and inventions we are taught about in elementary and high school were being pursued by many people at once, but the individual who received the patent is described as a lone explorer rather than part of a group effort. Rosa Parks didn't "get tired" one day and start the Montgomery bus boycott. She was a trained organizer, and her role, as well as the time and place of the boycott, was the result of careful planning by a group of civil rights activists. Just as medicinal history must restore individuality to anonymous masses of people, it must also restore social context to individuals singled out as the actors of history.

(12) RESTORE GLOBAL MEANING.

One element of imperial history that is particularly strong in the United States is a sense that the rest of the world is irrelevant. Few USers are knowledgeable about the geography, politics, culture, and history of other countries. In 1968, when I was fourteen, I spent a summer in Cuba. One of the most striking things for me was opening the paper each day to find regular ongoing coverage of dozens of countries I had only heard of before as occasional "hot spots" or tourist destinations. Imperial history tends to talk about the world outside of imperial headquarters episodically, as if it existed only when the attention of the empire was upon it.

The way I was taught ancient history in school left me with an impression of a darkened world in which nothing happened until the lights of civilization were turned on, first in Mesopotamia, then in Ancient Greece, then Rome, and spreading northwestward into Europe. Only then, as European expansion took off, did the Americas, Asia, and Africa appear. It was at home, in bedtime stories my father told us, that I learned of Chinese merchants trading with East Africa in the twelfth century, the great university of Timbuktu, or the vast expanse and intellectual achievements of the Islamic world.

Another task of medicinal history is to show that all parts of the world coexist and always have. (Contrary to popular expressions like "Stone Age people" or "just entering the twentieth century," all people now alive are living

at the same time, whatever our technologies or forms of social organization.) We also need to show that complexity and change exist and always have existed in all parts of the world.

One of my current projects is a curriculum that starts from Shakespeare's England and connects his life and writings to events and people in the rest of the world. How many of us are ever asked to think about what was happening in China, Peru, and Mali while *Hamlet* was being written? What realities of North African history and politics hovered behind the scenes of *Othello*?

In *Remedios*, I included an ancient and a medieval section in which I showed the diversity and vitality of people's lives in the three regions from which Puerto Ricans originate: West Africa, the Mediterranean, and the Caribbean. I wanted to create a sense of balance between the regions long before 1492.

As a discipline, history is taught by regions and time periods, in ways that often make it difficult to focus on linkages. Medicinal history can restore a sense of the global to fragmented colonial histories. The arrival of the Spanish in the Caribbean is closely connected with the expulsions of Jews and Muslims from Spain, linking the history of San Juan with that of Constantinople and Marrakech. The upheavals that the slave trade brought to West Africa, and the conflicts between and within African nations have a direct bearing on who showed up in the slave markets of the island. The fact that General Nelson Miles, who led the US invasion of Puerto Rico in 1898, was also the most prominent military commander of the wars against the Plains Indians is not just biographical information about Miles's career. It connects the stories of peoples affected by US expansion from Puerto Rico to the Dakotas, from Idaho and Arizona to Hawai'i and the Philippines. Reestablishing a sense of the connectedness of world events to one another is a critical piece of the work of the activist historian.

———

(13) ACCESS AND DIGESTIBILITY.

If the purpose of medicinal history is to transform the way we see ourselves historically, to change our sense of what's possible, then making history available to those who need it most is not a separate process from the researching and interpreting. The task of the curandera historian includes delivery.

To do exciting empowering research and leave it in academic journals and university libraries is like manufacturing unaffordable medicines for deadly diseases. We need to take responsibility for sharing our work in ways that

people can assimilate, not in the private languages and forms of scholars. This is the difference between curanderas and pharmaceutical companies. Pharmaceutical companies notoriously go into Indigenous and other people of color communities worldwide, steal and patent traditional science, technology, and even the plants themselves, and produce medicines that are completely out of reach of the people who invented them. We need to be careful, in doing historical research about disenfranchised communities, to see that the active ingredients get back to the people whose ancestors generated our work.

A good medicine also includes a delivery system, something that gets it to the parts of your body that need it. Those who are hungriest for what we dig up don't read scholarly journals and shouldn't have to. As historians we need to either be artists and community educators or we need to find people who are and figure out how to collaborate with them.

We can work with community groups to create original public history projects that involve people in the creation. We can see to it that our work gets into at least local popular culture through theater, murals, historical novels, posters, films, children's books, radio documentaries, websites, or a hundred other art forms. We can work with elementary and high school teachers to create curricula. Medicinal history is a form of healing. Its purposes are conscious and overt—to improve the social health of all people. So it has to perform a network of community clinics, not a spa.

———

(14) SHOW YOURSELF IN YOUR WORK.

One of the pretenses of history is that being rigorous about research is the same as being objective. Since history is a collection of stories about people in conflict, and all our families were involved, it seems a ridiculous claim. Objectivity isn't all it's cracked up to be anyway. Being objective is often understood to mean not taking sides; but failing to take sides when someone is being hurt is immoral. In writing about the past, we are choosing to bear witness to the impact of that past on the people around us. We don't stand apart from history. We are in the midst of it right this minute and the stances we take matter. A committed moral stance does not mean that we cannot be rigorous. While the agenda of the activist historian is to restore a sense of historical and present worth to those from whom it's been robbed (and restore proportion to those whose importance has been artificially inflated), our ability to see worth in the contradictory and ambiguous means we welcome the full picture. We don't, in the narrow sense, have an axe to grind.

Part of what oppression tries to teach us is that as intellectuals we need not involve ourselves, and that it is undignified and undisciplined to do so. Certainly to talk and write openly about our personal, emotional, as well as intellectual stakes in our work is frowned on, and lets us in for ridicule and disrespect. Nevertheless, it's important for people's historians not to hide ourselves. Part of what keeps our work honest is acknowledging why we care about it and who we are in relationship to it. We often write the books we most need to read and do research that in some way touches on core issues in our lives. Revealing this is a way of shedding the cloak of apartness and revealing our humanity.

(15) CROSS BORDERS.

At a lecture I gave on my historical research, someone asked how I found all these myriad connections between seemingly unrelated topics. I realized, as I answered her, that the key thing had been allowing myself to be widely curious, across all boundaries of discipline, geography, and time. Academic training and the workings of the higher education marketplace exert powerful pressures on us to narrow our interests and not cross into unfamiliar territory. A commitment to the study of connections requires us to continually do so. The categories of discipline, geography, and historical period are themselves constructed in obedience to certain priorities that don't necessarily serve the projects of medicinal history. Borders are generally established in order to exercise control, and when we center our attention on the historical empowerment of the disempowered, we inevitably swim rivers, lift barbed wire, and violate no trespassing signs.

 From *Medicine Stories* (1998)

a poet on assignment

September 2001: I am in residence at Norcroft, a writing retreat for women on the north shore of Lake Superior. The beauty, the silence, the otters in the cove, the view of tree trunk and birds from my desk, the rule against speaking before 4 p.m.—are all elements in that stilling of the mind that lets my writing flow late into the night.

I'm deep in the nineteenth century, writing out the early chapters of a novel. The only public phone is two miles along the shore at the Lutsen Resort, a lovely walk at dusk. And there's an emergency line in the office. Tuesday morning I've arranged to go into town with the director, a woman I know from co-counseling, so that we share a language of mutual support and a set of active-listening practices for dealing with most things. But something has happened. There's an emergency message from my husband. I'm thinking of my daughter, who should have flown home to California the night before. We're hours away from the end of the talking ban. She looks at me and relents, handing me the phone.

He tells me there have been planes crashing into buildings, the entire air fleet of the country is grounded, a state of emergency, terrorist attack. I can see the blue-grey water of the lake, serene under the autumn sky. I think *This sounds like a movie trailer I saw*. He fantasizes about packing up the station wagon and his son, picking me up and heading for Canada. *And leave my daughter in California?* Sometime in the first few minutes I think *Please, God, let it not have been Palestinians. Let it be more white boys from Oklahoma*. I'm moving into organizer mode. What will we be facing? What work will we need to do? What poems will I need to write?

I get off the phone and we stare at each other. Silently get in the car. Drive off the property and pull over. You first, she says, or me? We sit there shaking, listening, comparing notes, deciding there will be a lot of other people who need listening to. The gas station, the grocery store, every place we stop the TV is on, showing the same clip over and over, and before long there's a clip of cheering Arabs. *Who are they setting up for retribution? Which target?*

A town meeting. The two of us decide to go. Our intention is to listen to people, help them process what has happened. But I can't. One after another

people say "why do they hate us" and answer, one way or another, "because we're the best." A woman says it's because this is the only free country in the world and they're jealous. Someone says that the pastor knows all about religion. He can explain what's wrong with Muslims. He says it's a religion of the sword, inherently violent. That's when I can't sit still any more. I speak in a reasonable tone. I say I'm a historian. I tell them Islam values integrity, values intellect, gave Europe science. I say every religion has its good and bad. For instance, I say, an outsider might even think, what with the Inquisition and the witch burnings and baptism on the hilt of a sword and massacres all over the Americas, might even think *Christianity* is a religion of violence. The pastor walks out. War is obviously gathering, ready to burst into the lives of people somewhere.

The thing that gets to me is the injured innocence, an outrage that someone could do this to "Americans"! Our flag, says someone, is a beacon of hope to people all over the world, and I think *How do I tell them that yanqui go home is written on walls all over the planet? How do I explain that US embassies direct assassins to eliminate union leaders and poets, journalists and presidents? That almost two hundred years ago Simón Bolívar was already saying, "The United States seem destined by Providence to plague America with misery in the name of freedom"?*

Then other voices emerge: The woman who talks about ostentatious wealth and world hunger. The World War II veteran who wants to understand the people who did this, not kill them, because he's had enough of war. September 12, I wake up at five in the morning with the first lines of a poem ringing in my ears, and muttering them over and over to myself so I don't forget, I pull on my pants and stumble out to the writing shed. Five hours later I have written "Shema," a 2,500-word outpouring. I stay at Norcroft, writing in the stillness, while the country shrieks and growls. I don't watch TV. At night I trek to the resort and make phone calls. When I hear that Congresswoman Barbara Lee has stood alone to oppose the war that is being brewed, I weep with pride that she is mine.

Two weeks later I am in the Twin Cities, reading "Shema" at a public library. I fly home to Berkeley. Within days my poem is all over the internet, and people are reading it at demonstrations and meetings. A gay couple in Minneapolis send me a check for $100 in appreciation. I forget to copy down their address before I cash the check, so I can't write back to thank them. Then Dennis Bernstein, producer of Pacifica Radio's *Flashpoints* news magazine, asks me to read it on the air.

The response is overwhelming. People call in to say they cried with relief. That they had to pull over. That they told their children to stop talking and

listen. *Flashpoints* rebroadcasts it again and again. What else do you have, he asks me, and that's how I become a poet on assignment. For three months I even get paid!

Every week I write poems in response to the news. I don't have time to polish them. They are not smooth and exquisite. They are sharp, rough, purposeful. Each day I ask myself, How can I make the news real? How can I keep people from going numb? How can I put a face on this story? How can I explain its history? *It's not whether the music's good,* says Pete Seeger, *but what it's good for.*

Think of these poems as graffiti on the wall of a certain historical moment. I wrote fast, on a short deadline. Each day I scanned the headlines online, looking for the stories that I could make into something useful. A short item about women in Baghdad inducing labor so as not to be caught out in the coming bombardment. The death of Lori Piestewa, a young Hopi woman billed as the first female Native American combat casualty of a foreign war. The White House appeal for contributions to drop food on Afghanistan. The posthumous granting of citizenship to dead Latino soldiers. I began asking organizers what poems they needed. Barbara Lubin of Middle East Children's Alliance said, *Write about how scared the children are.*

In the grocery store, at the doctor's office, walking down the street, people who knew me, people who saw me write down my name, told me how much the poems meant to them. I got masses of emails. The day I got my fiftieth-birthday colonoscopy, as I waited for my ride home, woozy with medication, a doctor with an Arab name came up to me, holding my chart, and asked, "Do you have something to do with the radio?" I started to say "Yes, I write poetry for . . ." and he dropped the chart on the floor and threw his arms around me. "Thank you," he said. So I abandoned my perfectionism and decided these rough constructions of spit and ideas were enough.

Each day I thought about what was missing from the conversation and how to add it: Hope, clarity, a sense of history. That we have to love our country with an accurate and radical love and not surrender it to warmongers. That radicals must have double vision, one eye on the muddy present, one eye on the future we build toward. If either one closes, we fall. That it's a long haul, and each step counts.

The pieces in *Poet on Assignment* were mostly written during the three years following 9/11. They include poems about Afghanistan and Iraq, Palestine/Israel, about Cuba, about union-busting and repression, about sustained radicalism. Writing under pressure, in direct response to immediate

political needs, with instant audience response in the form of calls to the station, was unlike any other writing experience I've had. It wasn't a sustainable way of life for me. I prefer to write slowly. I prefer to polish. I like to be sure of my words before I send them out in the world. But for a short while, putting everything I had into writing urgent-response poetry was my difficult joy.

Civil Disobedience

.....

for Condoleezza Rice

.....

1

I will not obey the loss of you. I will not agree to the bargain
which was the best blow your brave parents could strike.
I will not surrender you to Birmingham's hoses and dogs and bombs,
to centuries of Alabama on the necks of your people, trying to
bend their backs toward the ground, into the cotton, eyes on the dirt.
I am committing civil disobedience through time, sitting in at the
lunch counter of history, demanding a longer menu of choices than
this narrow road of beat-them-at-their-own-game obsession,
driven to the straight-A achievement of the enemy's idea of excellence.
I am demanding your release from the inner circle,
that cruel club of affable and vicious men for whom
you hold your brightness to the grindstone of insatiable greed. It is not
what you deserve. I am going back into the depths of Birmingham to find
the bloodied root of your ambition and insist that this poisoned power
 you wield
is a pittance, pennies on the dollar of what might have reached you in time
if we had linked arms around your childhood and refused to budge.

2

She was tired of tea parties, and her mother had just gotten divorced
so they went to Vienna, where she saw brown shirts marching.
She saw workers' cooperatives attacked by fascist gangs,
and she thought about sharecroppers and the Klan. She read
dangerous books about socialism and by the time she came home
she was thoroughly unsuitable. In this photograph
she stands in the doorway of the Jane Speed Bookstore,

the one place in Birmingham where your people and hers
could gather together to talk about what they were thinking.
The signs in the window say Italy Out of Abyssinia,
and FREE the SCOTTSBORO BOYS, and she is leaning
on the frame of the door.
To reach deep enough into this red soil I need Jane Speed, daughter
 of Dolly,
with her flaming hair and righteous anger, because
when they told her *keep speaking as long as you can*
up there in flagrant violation of the color bar, side by side with a man
who could have been your granddaddy,
speaking for the Southern Tenant Farmers' Union,
she did just that, talked while they hustled her off the platform,
talked while they handcuffed her, kept talking out the window of the
 paddy wagon
as they drove away, and sat in jail for two months refusing to be released
one minute sooner than the man arrested with her. I wrap myself
in her rough wool shawl embroidered with flowers in vivid red; I
wrap myself in her stubborn persistence and I reach
to where your grandfather is searching for an open door.

———

3

He was one of nine and his parents were house slaves
and then sharecroppers. He was from a small town
and he grew cotton. In 1918 he sold a crop and went
looking for book learning. He landed in Tuscaloosa
and gave a year of cotton to white missionaries
for a year at Stillman College, and became a Presbyterian
and a preacher, because that was how to get an education.
Education was his religion, every bit as much as church,
and you were raised on the gospel of self-improvement
because if you couldn't get a hamburger in Birmingham
you could still, and you promised yourself you would,
get in the door of the White House, and if girls like you
were shredded into the air in their best Sunday dresses
someday, if you didn't let up, the bomb would belong to you.

4

I know you are a peril to the breathing world. I know
you have been honed weapon sharp and you will continue
to draw your blade across the sinews of anyone left standing.
It doesn't matter whether you think *pax americana* is a noble quest
or just that it can make you rich and powerful beyond
the salt-stained dreams of your grandfather, arms full of cotton.
I am reaching back to the crossroads, to where the choice was made,
each time, steering you toward a different rebellion, putting your
child's hand in Jane's, giving you different books, plotting
a sharecropper's revolution that would let you stand,
laughing, among the poor of the earth,
watching the land deeds of cotton barons burn,
the doors of their white pillared mansions flung wide,
ready to become the schools of a new kind of peace.

Paris

The first time I had cramps was in Paris.
I was eighteen, on a delegation.
We had come to speak with the people we had
faced billy clubs, tear gas and secret agent files for;
the ones we dreamt about, whose lives we defended,
precious red blossoms amid the rice fields
facing weapons with names like "daisy cutter."

It was 1972 and might-makes-right was losing
badly enough to sit down with peasant warriors
and try to cut a deal. The invitation, when it came,
was to a quiet house in a Parisian suburb
full of flowers in delicate vases,
and the scent of tangerines and tea.
The diplomat was a soft-spoken woman,
hair twisted in an elegant knot,
but she had fought for years in the south,
wore the scars of tortured breasts
under a silk shirt.

The first time I had cramps
was that day she told us war stories
all the quiet grey afternoon
the words traveling from Vietnamese
into French, into English, first the sounds
then the meaning.

We no longer love blue skies, she said.
We love cloud cover.
We fear sunlight above our fields,
the clear gulf of air between the pilot and our skins,
the glint of metal overhead.
It's the other way around with bombs, she said.

You see the deadly meaning slant silently down.
It's only when it's too late that you hear the sound.

Then she gave me a ring carved with flowers
made from the wreckage of a US plane
shot down in the act.
Someone must have asked her about rape
about the things GIs had done.
Our women, she said, *take a piece of plastic tube,*
line the inside with bits of razors
pointed inward like the teeth of guard dogs
and wear them inside our bodies.
The man who rapes us never rapes again.

The first time I had cramps
I had been thinking about the details
of burying land mines in your own tenderest flesh,
wondering how they dug
those secret weapons out again
imagining band-aids on bloody fingers,
something small like paper cuts.

We were on the Metro, an hour gone, before I let myself know,
that any woman raped that way would not survive the rapists' rage.

The first time I had cramps, it was that same afternoon
only now we were tourists visiting museums.
We had paid our francs at the door of the Saint Chapelle
and stood in the whispering space
between gilded splendors of sacred art,

when I looked up into the glowing dome of blue
without a single cloud, only the burnished tips
of golden angels' wings, squadrons of them
glinting overhead: they had heaven surrounded.
Tiny metallic stars burst on the painted ceiling
without a sound. I didn't think of war, just *blue* and *wing*,

and then came the clutch and stab
of a thousand blades within my womb.

Baghdad Birthday

Someday a thousand children of Baghdad will ask
why they all have the same birthday, why
they all came into the world on the last day of peace,
and their mothers will tell how they raced
against the calendar of war,
how they crowded into hospitals demanding labor,
demanding to start the clocks of their bodies
as planes took off from bases half a world away.

They will say that they rode
wave after wave of contractions
as the targeting systems honed in on everyday life,
how they bore down and pushed while nurses and doctors
rushed around trying to prepare, empty-handed,
for shrapnel and burns,
for the shocked and wailing people who were next in line
to lie in these beds crowded into hallways.
How you crowned as the moon rose over the river.

You were born, they will say, in the last quiet hour,
such a small chest, such little legs,
arriving weeks before you were due,
and I hid your tiny face in my swollen breast
so the terrible fire wouldn't scorch your tender eyes.
For your first lullaby, I sang you my grandmother's song,
while missiles screeched low across the rooftops.
Then came the shock waves and everything was falling.
My darling, my dove, you were born in the nick of time.

We left the hospital to the wounded, the mothers will say,
to the little girl in her father's arms,
blood leaking from her ears,
to the woman and her son, bristling with shredded metal.

We walked until we found
our street with the houses still standing.
The walls shook around us, the windows exploded,
the dreadful wind knocked dishes from the shelves,
so we covered your ears against the roaring sky.
The first night of your lives
we lay down in our beds and held you,
a thousand moist sweet unfurling rosebuds
forced into early bloom,
a thousand passengers on a single rushing train
hurtling on its shuddering tracks,
on its timetable of splintered bone
set by men with empires in their eyes
in air-conditioned rooms where our cries
could not enter.

A thousand roses opening just before dawn,
a thousand infants born into the teeth of invasion,
a thousand thorny branches blossoming in the smoke.
Yes, we snatched you from the dark and the body counts
and pulled you into a world on fire and the smell of burning.
We were afraid, we were strong, we were trembling,
and all around us Baghdad was dying
but remember this: when you crowned between our legs
and the moon rose over the river
we were singing.

Guanakán

The body is a storyteller. Each act of illness is an epic tale about interactions of flesh, spirit, and environment, for which we have no language, since we have split existence into these three domains. Language, naming, is a way to make the overwhelming sensory flood of experience manageable, and for the sake of defining this against that, we distinguish things, separate them, hold them against each other, make culture and are made by it, and still the truth of our bodies lies in a realm language can't fully grasp, because to speak truly means surrendering the categories on which we have built our sense of reason and control, categories that are the tools of our daily work, as practical in their uses as scissors and hoe.

Consider skin: living in my skin, we say, jumping out of my skin, skin the boundary between us and not us, skin the receptacle of selfhood, the percentages and shades of melanin in skin, used to further shuffle and deal out the human deck, arrange us on a spectrum, dole out more and less of everything based on these degrees of difference in how we reflect light into each other's eyes. We think skin is like the walls of our houses, that only sharp objects, or very hot ones, can open it, but skin is permeable. It isn't the barrier between us and the world, it's a conversation, cells lined up in a smooth collaboration, a layered surface that is constantly exchanging molecules with everything else. What's more, a surface full of doors and windows, through which all kinds of wildlife passes. If skin is the wall of a house, that house is made of dried grass, is full of insects and small mammals and nesting birds, is its own habitat, constantly shedding stalks, or, to change the metaphor, is made of soft wood, growing mosses and mushrooms on its surface even as the shredded bark and wood fall away into the rich surrounding soil.

Like anyone whose life depends on being heard, our bodies tell their stories over and over and louder and louder until they are shouting, spewing symptoms. But wait. There's that word *body* again, with its lie of separation. And yet it's far too bulky to keep saying body-mind-nature-thing. So I am renaming it here and now. I will call it guanakán, which is constructed from Taíno language parts to mean "our center," that cloudy gathering of denser

particles and pulses in which our awareness exists. Our location. From now on, when I say guanakán speaks, when I hand it to you, take it to be a basket in which everything we think of as body and mind and spirit and ecosystem coexist, and often, but not always, are each other.

Well, then guanakán must tell its story. It does so without conscious decision. Storytelling is its being. When a hard object, denser than flesh, strikes flesh—a billy club, say—the strands of light and protein we call nerves begin winking and flashing their signal, telling receptors everywhere "something is harming us," which we call pain, and clusters of molecules rush out into the bloodstream, shouting at the legs to run, pulling blood away from its other work, away from gut and face and the many places of daily chores, into the trembling muscles of the thighs, and we call this fear. Coagulants crowd around the broken tissues, making bruises but preventing hemorrhage.

At the same time the synapses of memory summon up images of other beatings, layers of them: clubs that struck the same body, that struck the body before this one, since all cells except the brain shed over the course of seven years, like a slow forest where it is always autumn and spring together. Clubs that struck others in our sight, clubs we heard about, historical clubs, the memories of which coat the surfaces of strands of DNA like slick oil, epigenetically instructing the body that the club is always falling, because in some generation before us, neither fight nor flight was possible or complete, and an ancestral body remained flooded with cortisol, shuddering with it, subtly altering the methyl layers of its genes. So whether or not the club is still falling, parts of the guanakán still tremble with norepinephrine, images of past dangers still crowd what we call the inner eye, imagination and flesh collaborate to tell a story in which past and present are woven together into a composite, layered diagram of what is happening in the eternal now, and worst of all, what can be expected.

My guanakán suffered a series of invasions, which set up a repeating story of danger, which in turn shaped the behavior of the guanakán. My guanakán also inherited a huge stack of orders from the past, many of them meant to help with survival, the way sickle cells are meant to help with malaria but create so many other problems. Some of the orders are inexplicable. Random scramblings of genetic code. It's hard to tell, because they have been translated from the original, passed through many hands, become smudged. They are incomplete fragments of an indecipherable past, coded inheritances, made up of traumas and unpredictable changes and cross-pollinations.

Our guanakanes . . . Are you used to the word yet? Can I stop italicizing? Our guanakanes have cytochrome P450s, CYPs, which are proteins

with a job. They change things, start chemical cascades of transformation, convert substances into other substances, for the purposes of energy and nourishment and protection. A whole bunch of them work in the liver, taking apart poisons and flushing them down the gut. They have specific jobs. This one takes apart excess hormones. That one tackles ethanol. This other one is an expert on most prescription drugs. And like everything else, they evolve, they mutate, they respond, they have accidents. Whatever it is that is changing them, whole groups of guanakanes have CYP450s that are impaired. They're in charge of taking apart pesticides, burnt meat, stress hormones, and they just can't do it, or they can only do it slowly, or they do it with reckless speed and break things.

My guanakán, already attuned to danger by invasion, has been gifted with nine CYP450 polymorphisms, nine disturbances in the field of protection. Diesel fumes and tobacco, charred protein and estrogen, nonsteroidal anti-inflammatories and blood thinners, phenobarbital and bacon, all move differently through my guanakán, more slowly, leaving more damage in their wake. This is what I have inherited. Tiny broken places, gateways to change.

We are all of us full of unfinished stories, fragmented instructions, maps to places that may or may not exist any longer, new and ingenious responses to a changing environment, some of them lifesaving, some of them sickening, some of them fatal, life continually exploring new pathways in the guanakán. We have lost a great deal of early knowledge about how to guide those explorations and other knowledge we are only now seeing sprout above the soil line of our collective questions.

This I know: the arc of a story must be completed or it stays in the guanakán and becomes a disturbance. It grows hard and dense and begins to have more mass, or becomes louder, alters the chemistry of emotion, the bones of belief on which we hang our perceptions, starts sparking, fluctuating, crackling, depending on where it expresses itself between matter and energy, particle and wave. A story whose arc is interrupted causes detours, must be stepped around, begins changing everything near it, has its own gravitational pull.

Some of the unfinished stories we carry were forced on us: you are a person to whom it is right that these things be done. You are a person to be raped, to be paid less, to be made to live downwind from terrible smokestacks that corrode your lungs. You are a person who cannot think very well, who burdens the rest of us by existing. Broken stories like these make blood run the wrong way, make breath shallow, fill the arteries with plaque, distract the antibodies from devouring cancer cells before they can

form tumors and take over, cause the voice to shrivel, make the imagination flinch, generate heavy clouds of despair that reorganize our neurotransmitters. But the story of what is broken is itself something whole. These broken stories must be completed through our telling, our owning; like the roots of poisonous plants, they must be pulled up and laid in the sun to dry, so that by steeping, boiling, grinding, they can be made into medicine.

 ❧ First published in *nineteen sixty nine: an ethnic studies journal* (2013)

4 MAPPING WHERE IT HURTS

Part of the job of a socially committed poet is to tell the truth about what's wrong and how deep the roots of wrongness go. "Revision" is one of the opening pieces of my book *Remedios*, which retells the history of the Atlantic world through the lives of Puerto Rican women and our kin. "Revision" sets the stage for that larger project by centering the female, Indigenous, Black, and poor of Puerto Rico as the real protagonists of our history.

"Frontier Cooking" was my reaction to an actual collection of white settler recipes from Minnesota, a peeling away of the cheerful surfaces beneath which a story of genocide is concealed. "Brown Birds" takes on the sexism of a field guide to birds and how I, as a young, brown, female birdwatcher, felt erased. "Letter to a Compañero" expresses my rage and sorrow at the sexist dynamics of the Latin America solidarity movement but is also a passionate call for reciprocity.

The four remaining pieces, each in its own way, address the pain of how deeply undervalued our lives are by the "kings and corporations" that rule over us. "Endangered" speaks to the

value of one life, beloved gay Boricua poet Rane Arroyo. "Un-obituary" riffs on Nuyorican poet-prophet Pedro Pietri's famous poem "Puerto Rican Obituary" to talk about the deadly cruelty of neglect following the devastation Hurricane Maria left behind in Puerto Rico. "Questions for the Media," which got me thirty seconds on Al Jazeera, compared media coverage of two terrorist acts, mass murders that took place in the same week, one in Paris and one in Beirut. Finally, "Sacrifice Zones," from my book *Silt*, starts with an incident on the Mississippi River levees in 1912 and gathers up the threads of lives and places that are sacrificed to greed and extraction.

Revision

Let's get one thing straight. Puerto Rico was a women's country. Female head of household is not a new thing with us. The men left for Mexico and Venezuela and Peru. They left every which way they could, and they left us behind. We got our own rice and beans. Our own guineo verde and cornmeal. Whatever there was to be cooked, we cooked it. Whoever was born, we birthed and raised them. Whatever was to be washed, we washed it. We washed the ore the men dug from the mountains, rinsed a thousand baskets of crushed rock. We stood knee-deep in the rivers separating gold from sand, and still cooked supper. We washed cotton trousers and silk capes, diapers and menstrual cloths, dress shirts and cleaning rags. We squatted by the river and pounded clothing on rocks. Whatever was grown, we grew it. We planted the food and harvested it. We pushed the cane into the teeth of the trapiche, and stripped the tobacco leaf from its stem. We coaxed the berries from the coffee branch, and sorted them, washed them, dried them, shelled them, roasted them, ground them, made the coffee, and served it. We were never still, our hands were always busy. Making soap. Making candles. Holding children. Making bedding. Sewing clothing. Our stitches held sleeve to dress and soul to body. We stitched our families through the dead season of the cane, stitched them through lean times of bread and coffee. The seams we made kept us from freezing in the winters of New York, and put beans on the table in the years of soup kitchens. Puerto Rican women have always held up four-fifths of the sky. Ours is the work they decided to call unwork. The tasks as necessary as air. Not a single thing they did could have been done without us. Not a treasure taken. Not a crop brought in. Not a town built up around its plaza, not a fortress manned without our cooking, cleaning, sewing, laundering, childbearing. We have always been here, doing what had to be done. As reliable as furniture, as supportive as their favorite sillón. Who thanks his bed? But we are not furniture. We are full of fire, dreams, pain, subversive laughter. How could they not honor us? We were always here, working, eating, sleeping, singing, suffering, giving birth, dying. We were out of their sight, cutting wood, making fire, soaking beans, nursing babies. We were right there beside them digging, hoeing, weeding, picking,

cutting, stacking. Twisting wires, packing piña, shaping pills, filling ther-
mometers with poisonous metal, typing memo after memo. Not one meal
was ever eaten without our hand on the pot. Not one office ran for an hour
without our ear to the phone, our finger to the keyboard. Not one of those
books that ignore us could have been written without our shopping, baking,
mending, ironing, typing, making coffee, comforting. Without our caring for
the children, minding the store, getting in the crop, making their businesses
pay. This is *our* story, and the truth of our lives will overthrow them.

Let's get one thing straight. Puerto Rico was parda, negra, mulata, mes-
tiza. Not a country of Spaniards at all. We outnumbered them, year after
year, all of us who are written down: not white. We were everywhere. Not
just a few docile servants and the guava-eating ghosts of the dead. We are
in your bones, your hair, your teeth, your double helix. The Spanish men
left babies right and left. When most of the indias had given birth to mixed-
blood children, when all the lands had been divided, our labor shared out
in encomienda, and no more caciques went out to battle them, they said the
people were gone. How could we be gone? We were the brown and olive and
cream-colored children of our mothers, Arawak, Carib, Maya, Lucaya, stolen
women from all the shores of the sea. When we cooked it was the food our
mothers had always given us. We still pounded yuca and caught crabs. We
still seasoned our stews with ají and wore cotton skirts. When we burned
their fields, stole their cattle, set fire to their boats, they said we were tamed or
dead, that it must have been someone else. What was wrong with their eyes?
We mixed our blood together like sancocho, calalú. But the mother things
stayed with us. Two hundred and fifty years after they said "ya no hay indios,"
we had a town of two thousand who still remembered our names, and even
our neighbors called the place Indiera. When they wanted more enslaved
Africans, they complained that we had all died on them. They called us pardas
libres and stopped counting us. Invisibility is not a new thing with us. But
we have always been here, working, eating, sleeping, singing, suffering, giving
birth, dying. We are not a metaphor. We are not ghosts. We are still here.

Let's get one thing straight. We were everywhere. The Spanish, Dutch,
English, French, Genoese, Portuguese took captives up and down our coasts,
inland by river, overland on foot. They brought us here through every bay
deep enough to hold a slave ship. Legally, through the port of San Juan, all
registered in the royal books. And dozens more, unloaded at night, right
there in the harbor, sold but not written down. But that was the least of
it. We came through Añasco, Guánica, Arecibo, Salinas, San Germán. In
sloops from Jamaica, St. Christopher, Curaçao. We came by the thousands,

bound hand and foot, uncounted, unaccounted for, while official eyes looked the other way. And we came as fugitives from the other islands, because the Spanish let the slaves of their rivals live here free. From Saint Croix and Tortola, from Jamaica and the Virgins. There were many more of us than were written in their registers. Untaxed, unbaptized, hidden in the folds of the mountains, in the untilled lands. There were many more of us than the sugar planters knew or would say, always sobbing to the king about no one to do the work. We were here from the start, and we were here more often. They were always running away to seek better fortunes. We ran away too. We ran to the swamps and we ran to the cordillera. We ate their cattle and set fire to their cane fields. If they caught us, the judges were instructed to cut off our ears. (Police brutality is not a new thing with us.) Spanish men left babies right and left, café con leche children. But in their imaginations, they were all alone in their big white houses, dreaming of Peru or the voyage back to Spain, while on their threshold a new people was forming. How could they not see us, nursing their babies, cooking ñame, frying balls of cornmeal, banana, yuca; stewing up crabs and pork and guingambó. Wrapping cotton rags around our heads. Throwing white flowers into the sea. How could they not hear us, telling each other our stories with the soles of our feet on the clay; with the palms of our hands on tree trunks, on goat hides. Carrying their loads, laundering for strangers to earn them cash. We have always been here, longer and steadier, working, eating, sleeping, singing, suffering, giving birth, dying. We were not contented. We were not simple souls ready to dance and sing all day with innocent hearts. We were not lazy animals too dull-witted to understand orders. We were not hot-blooded savages, eager to be raped. We were not impervious to pain. We felt every blow they struck at our hearts. We were not happy to serve. We didn't love our masters. We were slaves. We were libertas. We were free mulatas. We were poor, and hungry and alive. When they needed hands, they brought us. When they needed jobs, they threw us on boats to New York and Hawai'i, threw us on food stamps, threw us drugs. But Puerto Rico is African. We made it from our own flesh.

Let's get one thing straight. Puerto Rico was a poor folks' country. There were many more poor than rich throughout its history. More naborías than caciques. More foot soldiers than aristocratic conquistadores. More servants than mistresses. More people wearing cotton and leather than people wearing silk and damask, velvet and cloth of gold. They did wear those things, and they ate off silver plates. But most of us ate off higüeras, or wooden trenchers, or common clay. There were more people who ate plátano and cornmeal and casabe every day of the week, with a little salt fish or pork now

and then, than those who had beef and turtle and chicken and fresh eggs and milk, with Canarias wine and Andalucían olive oil. Most of us had no money. Many of us were never paid for working. Those of us who owned the fruits of our labor traded it to the merchants for far less than it was worth, and bought on credit, and ended up in debt. We were the ones who cleared the land so it could be planted with sugarcanes from India, coffee bushes from Ethiopia, and bananas and plantains from Malaysia. We were the ones who grew food. We were the ones who were glad when a store came to the mountains, and then watched our future harvests promised for the sack of beans, the new blade, the bag of rice or cornmeal. We were the hands of Pietri and Castañer. We were the hands of Ferré and Muñoz. We washed and ironed the shirts of the politicians. We scrubbed the pots of the governors and their wives. We sewed those fine christening gowns for their babies and fetched the water for their baths. They said, this governor built a wall, and that one made a road. They said so-and-so founded a town, and this other one produced a newspaper. But the governor did not lift blocks of stone or dig through the thick clay. The capitanes pobladores didn't labor in child bed to populate their villas, or empty the chamber pots. The great men of letters didn't carry the bales of paper or scrub ink from piles of shirts and trousers. We have always been here. How could they not see us? We filled their plates and made their beds, washed their clothing and made them rich. We were not mindless, stupid, created for the tasks we were given. We were tired and angry and alive. How could they miss us? We were the horses they rode, we were the wheels of their family pride. We were the springs where they drank, and our lives went down their throats. Our touch was on every single thing they owned. Our voices were around them, humming, whispering, singing, telling riddles, making life in the dust and mud. We have always been here, doing what had to be done, working, eating, sleeping, singing, suffering, giving birth, dying. Dying of hunger and parasites, of cholera and tuberculosis. Dying of typhus and anemia and cirrhosis of the liver. Dying of heroin and crack and botched abortions, in childbirth and industrial accidents, and from not enough days off. This is our history. We met necessity every single day of our lives. Look wherever you like, it's our work you see.

 к From *Remedios* (1998)

Frontier Cooking

Take a country. Describe it as empty forests and prairies. Empty is in the eye of the settler, and it is your eye that is looking. Add one homestead act. Measure 160 acres and set aside. Get ready to impose your alien world onto a landscape full of its own being. Take a European farm from your memory, German, English, Czech, Swedish. Press firmly into native soil, until it takes the shape. Rub with butter and chill until firm.

To make into territory, add two good measures of settlers. Be sure to use only the whitest grade. Add eggs. The batter requires heavy beating. Wear an apron. This could be messy. The sponge will naturally ferment and rise. Don't let it spill outside the pan like Red River gunpowder blend, or you'll get an explosion of French breed hotcakes, and burn your tongue. Don't let it hiss with escaping fumes, or reach the other bank and set up camp in the grassland and raid your storehouse. Listen for horses out of the badlands. Punch down to size and cover with a white cloth.

Gather manomin and call it wild rice, because rice is known to you and manomin is not. Grind corn and call it Indian meal. Trade twenty bushels of cranberries for flour and sugar. Pickle nasturtium buds in brine to make imitation capers. Shoot a thousand pigeons in a day and sell them in St. Paul for calico. Uproot living trees that block the plow and plant hard spring wheat. Uproot Menominee and Anishinaabe and Dakota, and plant homesteads. This was a wasteland until you came. It was not owned. You make it valuable by grabbing it. Plant apples and plums. Pickle the small green plums and pretend they are olives. Pack pork into barrels of salt, and send the people of the wild rice packing. Hang hogs in the smokehouse for bacon, and thirty-eight Dakota men, the largest public execution in US history, on a Mankato gallows because they are neither white neighbors nor golden grain.

Cut down forests and villages and chop into little pieces, the size of a child's rattle, the size of a porcupine quill, the size of a bead. Put up fifty jars of cranberry relish. Fill the cellar with dried venison and salted pork, smoked fish and applesauce, oysters in brine, sauerkraut grown and fermented with cabbage seeds sent from Boston, a barrel of flour hauled fifty miles by wagon. Do not provision the people camped around the fort. They are spoiled and

must be discarded. Eat wild rice and pumpkins out of the empty landscape that nobody ever harvested or loved before you. Make soft shoes of deerskin, like the moccasins of people who don't exist. Bake nine pumpkin pies and put them in the pantry to cool. Serve cornmeal mush with maple syrup. Imagine you have always had these foods.

Build a new house out of cedar and pine. Clear another pasture. Raise cows and make cheese. Gather in the grain and grind it. Soak stale bread in apple cider and make stuffing. Render the fat from the land. Copy their canoes. Go hunting for ducks and geese. Kill hundreds and sell them in St. Paul. There are more where they came from. Send trees downriver for timber. They took eight hundred years to get that thick, so they will make magnificent tables, roof beams, ships' decks. Make coffee from chicory root. Smoke and chew tobacco without ceremony.

Boil prairie chickens and reserve the broth. Reserve White Earth. Reserve Red Lake. Reserve other lands to the west that are not yet needed. Add displaced people and set aside. Scrape meat from the bone. Keep straining the mixture through a fine cloth. It will get whiter. Clean and gut the Sauk at the river crossing. Rinse away the blood. Remove the connective tissue. Take out the spine. This is difficult. It will keep growing back. Divide the tribe into as many portions as necessary. Send to Kansas. Plant the new field in corn.

Brew beer. Make vinegar out of molasses, out of the dark sugary sweat of Louisiana. Bleach linens by laying them on new grass over mossy bones and yellow teeth. When you find arrowheads in the furrows, toss them in the creek. Make roads out of paths that someone else used before you, and name them after places on another continent. Cook squirrels and call it Brunswick Stew. Put up twenty jars of plum jam and ten of strawberry. Add wild onions to the pot. Add potatoes and a cup of legislation. Do not worry about stirring in too many treaties. They will break down easily during cooking.

Season with summer savory and winter starvation. This can simmer for centuries. It just gets richer. The cream rises and the bones sink. Make marble cake scented with clove. Make Prairie Teacakes. Make Indian Bannock. Let them eat frybread. Let them boil deer hide for the ghost of meat. Plant wheat. Plant corn. Plant sunflowers. Let them chew the wind.

Brown Birds

When I was a child, living in the wild, tangled beauty of Indiera, my world was full of wings. Tiny, jeweled hummingbirds, the little grey and yellow Reinitas, like Caribbean sparrows filling the bushes, the crisp silhouettes of Guaraguaos, Red-tailed Hawks, sun making their wings glow amber. The year I was eleven, my father's friend and colleague Robert MacArthur, an evolutionary biologist who specialized in birds, came to visit. I remember standing stock still under the Australian pine as he pointed out tiny vireos in the shifting shade.

We became passionate birdwatchers, my mother following up on the enthusiasm of the moment with bird books and binoculars. Soon my brother and I learned to stalk the woods identifying Bullfinches and Tanagers, hoping for a glimpse of a Lizard Cuckoo with its sinuous neck and dramatic black-and-white tail feathers, or the tiny round ball of green fluff known as a Medio Peso, and once, at night, we came on a whole family of little ground owls, Múcaros, sitting on a branch, blinking.

The field guides were difficult to decode, even with full-color plates. There were all the different shapes of tails, wings, and beaks, the minute differences between common locals and the rare visitor blown in from Africa or Mexico, and something I didn't realize until decades later. Ornithologists are human beings doing their work in societies riddled with bias and preconception, to which science has never been immune. Human constructions of gender and other social relations made to enforce domination get imposed onto other species as if they were the natural order of things, until someone bends down to look and realizes that the "raging bull" elephants are actually matriarchs defending their young, that the so-called law of the jungle is characterized more by collaboration than conquest, that nonhumans aren't "dumb beasts" but make language and tools and mourning rituals of their own.

So, one of the problems with the field guides we pored over was their focus on the males of the species. Of course, the bright coloring of male birds makes them easier to identify, and many of the female birds are brown, but a feminist ornithology might have taught me to pay attention to brown birds, to the slight rosy blush on the breast of this one, the dark ring around the

other one's eye, not to discard them as too boring and hard to understand. It might have spared me the mockery of my family, when, sometime in that last year in Puerto Rico, I came excitedly home claiming to have seen a rare Cuban Solitaire. Because it was one of the few brown birds in the book with its own name and a glossy color plate, and because no one had taught me how to distinguish the female tanager from the female thrush or the female thrasher, I was certain that I had found a rarity, a foreign male, not a local female. My parents made fun of me, seeing it as a bid for special attention, and instead of helping me explore the problems of identification of plain brown birds, made my claim into a cruel standing joke about pretentiousness.

It's ironic that my mother in particular should have responded that way. Perhaps a few years later, when a Puerto Rican working-class feminist intellectual was no longer such a rare species, and time and geography changed her from a solitaire to one in the immense collective flock of the women's movement, she might have said something different. One of her best-loved poems, "City Pigeons," proudly proclaims her allegiance to the common. Though she loved to wear bright colors, she never aspired to fancy social plumage, and despised elitism of every kind.

Then, instead of mockery, instead of communicating to me that for a little Puerto Rican girl to think she'd seen something rare was pretentious, we could have sat down together and studied the subtle markings of female birds, common and brown like us.

ꙮ First published in *Letters from Earth* (2016)

Letter to a Compañero

Dear Compañero:

Let's talk about solidarity, then. You name it in every tight spot, as if it were your credit card for drawing on The Revolution, a people's version of American Express. As if it were an endless obligation to surrender the goods. Now, when I confront you with having lied to me, once again you take solidarity's name in vain. As if it were a social obligation, like inviting the neighbors to dinner because our dog tore up their lawn. As if it were a tax on our progressiveness, to compensate for the blood tax our government levies to sink its iron claws into your people's backs. As if it were a duty, like giving a quarter to save a pagan baby.

I say solidarity is knowing the future is long and wide, with room for everyone on earth to enter. I say it's taking the long view of the job. Helping you onto the wall, so you can reach down and pull me up. Lifting you into the tree, so you can shake down peaches for two. That solidarity is a two-way street, fires burning at both ends, and the only well at the middle. I tell you my country . . . but you don't let me speak of my country. You tell me another piece of your story. You tell me your blood is burning and you have no time.

You have come here, men mostly, from the ironclad nations, exiled out of prison cells of torture, or living like you, in the nooks and crannies of your country, temporarily out on tour and going back to who knows what consequences. There are the ones like Paco, in jail at sixteen, exiled at nineteen, half his friends dead, now eight years later suddenly hurling a hamburger at the floor, yelling, "I hate this damn country!" There are the ones like you, temporarily out from under, whispering it's been a decade since I could walk down a street saying my own name, talking about politics. Even here, I can't stop myself from looking over my shoulder.

I think about what you carry through all the work, the benefits and speeches, the bulletins and campaigns: the people killed, the memory of torture and fear, the anguish of so much loss. I think of your desperation for someone to touch your wounds so you can finally scream, hold your sorrow, so you can shake and weep, and how you seek it the way you have

learned to, settling for another kind of touching, always disappointed, always looking for more.

I think about the word *solidarity* and who carries it, the day-to-day work of it. Women mostly. Here and now, mostly white women, many of them activists for the first time, their hearts flung wide open by these stories, crying over each bit you tell them, taking up your nightmares, wanting to heal you, free you, do anything to end the pain, comforting you in the way they have learned to, opening their arms and bodies. Falling in love with your history when they don't know or treasure their own. Intimidated by what you have survived, and minimizing their own survivals. The ones who are wracked with guilt when you accuse them of eating carrot cake while people are dying. Who decide to work harder when you declare you have not had a vacation since the coup and will not rest until liberation, even though they watch you collapse with the flu three times a year. Even when we know it's ridiculous, wracked with guilt, romanticizing the horrors, agreeing not to ask for anything.

So you write to me that I am the compañera of your dreams, the one you have been waiting for. You write the letter five times. You send it to me in Oakland and Amy in New York and Sally in Washington and Dana in San Diego, and you also recite it to Luz, the woman you have been secretly lovers with for the last two years of your marriage to Elena. Elena is the only one I know about. I write back to you asking about Elena, explaining how I feel about these situations, and you write back praising my honesty, which you tell me shines like a bright light through the page, saying you are divorced now because she was not a true revolutionary, not a New Woman like me, and that you want to walk beside me until death and even after. In triplicate. (Dana has lost interest. Amy is just after a fling.) Elated, I write that I will meet you in New York for the concert. There I learn about Amy. When I go to the airport to meet you, I learn about Luz, because she is with you. She and I talk. I show her my letter. She has heard the same words herself. You have assured her there is no one waiting for you here, even though she has known for months that you got letters from California. When we confront you, you say it hurts you more than it hurts us. I am not disarmed. I am mortified. I am furious. I am hurt beyond words. You are humble until I agree to continue my work for your tour. Then you act offended. You say personal problems should not be allowed to interfere with duty.

Now listen to me. I will not walk on one-way streets any longer. Your wound is my wound (though you don't know that mine is yours), and I do what I can, but the well will run dry. You will use us up. There are women whose first stretching across borders was into your lives. When they dis-

cover how you make use of their compassion, they will turn away heartsick, stricken, withering in the freshness of their hope. There are women who were leaders, who worked night and day, defeated not by foreign policy but by the sexual politics of solidarity, bitter now, unable to work anywhere near you. How dare you speak of the New Woman! We are your richest resource besides your endurance, and you use us like rags to wrap around your pain.

Listen to me. I, too, have a homeland to win. I love this second country of mine. It is more than the belly of a monster. It is more than the claws of an empire. More than Pentagons and CIAs. My country is a rug woven from the rebel threads of a hundred homelands. My country is rich with heroism and honesty. Rich with daring and defiance. Humming with song. No less precious under the weight of its evils than your own. Long after the dictator has fled and the streets are renamed, long after you have found the graves of your missing and taught the children to sing their names, we will be working to free ourselves from the shadows: your battle in this moment is bloodier, more urgent. Ours will be the longer and more difficult to win.

Take the name of solidarity from your lips, my brother, my compañero, until you can love each woman and man of my country the way you love the day of your freedom, or the wild flamingos on the salt flats of Antofagasta, or the light of your daughter's eyes. We are not the guilty ones, and we will not shoulder their burdens. Our government is not ours. We do not owe you for their actions. The work we do is for love. We are the light and hope of the United States of North America, and if you can hold our lives the way that we've held yours, then each and every one of us will get home.

&. From *Getting Home Alive* (1986)

Endangered

.....

For Rane Arroyo

.....

Someone is trying to decide whether my friend should continue to exist, whether a queer brown man who is a poet deserves to be put on the list next to the Primrose Violet, the Red-Cockaded Woodpecker, and the Little Blue Heron. I tell them the threat of extinction is specific. It is the Yellow-Headed Blackbird, and not the Red-Winged, that is endangered, that the Maidenhair fern hangs by the thousands in plastic pots in home and garden stores, but the Southern Grape Fern doesn't have much time.

Don't think, I say to them, that one thing replaces another. Each precious endangered creature is itself and no one else. The wet mammalian grace of the dugong is not the same as the grace of the humpback whale, which also rises dripping out of the sea. You can't say we already saved a sea mammal, a fern, a blackbird.

I tell them the right to live is indivisible. You can't prorate it. It isn't a dividend on investments. There are no actuarial tables to determine how worthwhile each unpredictable life will be, how much mileage the world will get from one good liver in this one ailing poet.

Look, I say, there are still six breeding pairs of Puerto Rican parrots living their rare, defended lives deep in a forest invaded by grabby, fugitive parakeets. Maybe they are the last generation. Maybe they will soon vanish forever from the world. We shelter them for the possibility that great clouds of green wings will once again rise over El Yunque but also because one short, dazzling flight, sun flashing through rain among the palm fruits, is reason enough.

And on this day of embattled laughter, this one man making poems in the middle of snowy nights, warm seas rising between his fingers and the stalks of corn, is the only reason you need.

Reading the articles on Puerto Rico that people post on Facebook is like having a subscription to a horror movie channel. It's hard to remember all the human and material support that's flowing toward exhausted organizers, who are trying to lay the groundwork for a shift that goes beyond immediate survival, into an alternative future of climate resilience, food security, and sovereignty.

I began this day filled with images of smallpox blankets being handed out by FEMA, of the locked warehouses of the Irish potato famine, full of grain that could have saved a million lives, of dystopian nightmares in which the desperate must fill out mountains of forms, and age and die while standing in line. I'm sure I will write about those things.

But then I started hearing the voice of Nuyorican poet Pedro Pietri, remembered him in his flapping black clothes, leaning into the microphone, ferociously detailing the everyday deadliness of our condition, and how we chanted along with him: *all died yesterday today and will die again tomorrow.*

"Puerto Rican Obituary," written by Pietri in 1969, is a kind of national anthem of the Puerto Rican diaspora, its names and refrains as familiar to us as any classic song, and many poets, following the communal musical traditions of our people, have sampled and riffed off it to write our own declarations. There are enough of them to fill a book. This one is mine.

Nothing in this poem is made up. People did stand in line all day in the hope of food and water, only to be handed mops and cleaning supplies. People going to emergency centers really are being given a phone number to call in a country without working phones. And I am as angry as Pietri. Sparks flying from my hair, my fingers, my tongue.

So, this isn't a fancy piece of literature. It isn't about the torn beauty of my native land. It doesn't say everything. In fact, it says hardly anything.

I didn't polish it into perfection, I hacked it out of the headlines, and threw it like a stone.

&❦ From *Silt: Prose Poems* (2019)

Unobituary

Juan Miguel Milagros Olga Manuel
All died yesterday today
And will die again tomorrow.

All died
waiting in line for a sip of water, waiting for arroz con algo
from benevolent rulers who gave them
mops and bottles of floor soap,
boxes of hot sauce, mayo, and ketchup,
as if to say we don't recognize you without a mop in your hands,
we gave you the condiments, now scrub for your bread.

All died
In a rain of insults and paper towels
And he said they were lazy, shiftless, nasty,
that their hunger was a hole in his pocket
that it wasn't a real disaster like the ones real people have
but he could spare them a trophy.

All died
Filling out forms that are the only dry things in their lives
Applying in triplicate for a piece of blue plastic to hang over the ruins
where they lie parched and sweating, holding each other close,
Proving their eligibility to receive a snack-sized bag of cheetohs
as a first installment on their malnutrition.

All died
Holding pieces of paper with the cruel joke of a phone number
In a country without phones.

All died
Waiting for the promises of colonial citizenship
To knock on their doors shouting *Mira! Mira!*

It was all a bad dream, we brought you real meals,
A million water trucks, all the packages
your familia worked so hard to send you,
And then they all died again from waking up empty-handed
day after day after day.

We interrupt this obituary to inform you
that Juan went door to door on the 13th floor
Checking on old people stranded by dead elevators
then he skipped the ATM line
went straight to the bank manager
and asked for a refund of the last 119 years.

Miguel shared his generator with the neighbors
so one of them could charge up the machine
that keeps his little girl breathing, and one of them
could keep her insulin cold, and one of them
could print out her manifesto on the power of people and sunlight
before the diesel ran out.

Milagros organized a brigade to open a mountain road
Collect broken green bananas from broken hillsides
and build an outdoor kitchen to boil them in a trickle of creek water
so her hungry neighbors could gather around one pot
for a bite of guineo and a feast of each other.

Olga has been climbing trees and mountainsides
Hunting for a signal, tossing her text message telegrams into the
 cyber-sea:
There is no food, no light, no water, no gas,
No FEMA, no políticos, no doctors, no help.
We've grown thin as stalks of cane,
And we're hoarse from shouting your names.
So if you hear me, she says, then listen up, world:
There is no good news story here but us, and we are learning
how to be each other's powerlines. How to be
houses and bread. Our thirst writes
banners into the air. We are becoming seed
of a different harvest.

Juan Miguel Milagros Olga Manuel
All fought back yesterday today
And we will fight again tomorrow.
This is the voice of Borikén
And we'll be back in the morning. Pass it on.

 ʕὁ From *Silt: Prose Poems* (2019)

Questions for the Media

If Beirut has been a city for thirty-seven centuries and Paris for twenty, why doesn't anyone refer to explosions in Beirut as attacks on music, culture, civilization? Why don't all the stories start with how ancient and rich with history it is, how in all those centuries of invasions, occupations, wars, it was never abandoned, how it keeps raising its head?

We know the name of the band and what song the band was playing in the concert hall in Paris when the gunmen opened fire. We know what teams were playing at the stadium, and how far along they were in the game. We know the names of the restaurants. What kind of food they served.

So why can't you tell me what Adel Termos and his little girl were buying in the open-air market in Beirut when he threw himself on the second bomber and saved hundreds of lives? Or who was buying bread at the bakery, or about the families walking home after work? What is the bakery called? Why haven't you profiled the mosque, told us how long it's been there, who goes there every Friday?

Why do you call that neighborhood of Bourj al-Barajneh, where people were filling bags with vegetables, walking hand in hand after a long day, thinking about dinner, "a Hezbollah stronghold" and describe the 10th arrondissement of Paris as "progressive, hip, diverse, vibrant"?

You tell us about a typical Friday night in eastern Paris, of groups of friends sitting in cafés. How they sip coffee by day and dance in clubs at night. You tell us it's a working-class place, just regular folks, about the Turkish kebab place and Vietnamese restaurant, the newly arrived and long-established immigrants. You don't mention the rise in anti-immigrant racism. You don't mention French colonialism. Its part in this. You tell us about the bullets in the pizzeria window. You interview residents by name. They say they were targeted for their civilized values. You tell us about innocence.

When it comes to Beirut, you go on and on about factions and offensives, and who claimed responsibility, and who is retaliating for what, and who swears revenge. You say the people there are Shia, as if that is enough, as if that's an explanation. You don't tell us what they do for a living, how they feel about their city. You don't tell us who has always shopped at that

market, who sells the best tomatoes, which businesses lost their windows, who lives just down the street, about the groups of friends sitting together, talking and laughing, about a typical Thursday evening, about neighbors, about long-established and newly arrived immigrants, about shell-shocked Syrian refugees, about the music, the flowers, the smell of cooking. You just repeat "stronghold," so we will stop thinking civilian, family, shopkeeper, innocent. So we'll think casualties, and not people.

This is what I want to know: can you tell me the names of the people? I need to know their names.

 ✌ From *Silt: Prose Poems* (2019)

Sacrifice Zones

Levee Camp, New Orleans, 1912: The river is in dangerous flood, lapping at the tops of the levees, so the white men who carry guns make the Black men who work their fields haul bags of sand onto the narrow ridge of the levee. This is the slavery of the convict gangs, men captured and jailed and brought to the edge of the flood to break their backs as they do in the cane. It's the servitude of sharecropping. But the water keeps rising, and there are gracious homes at risk behind the wall. The water drags at their knees as they throw the sacks of sand down and go back for another and another, but the engineers are running out of sand, so they make an offering to the god they worship, a sacrifice. They give the men one choice: lie down on the levee and make your own bodies into a wall to protect our property or be shot where you stand. So they lie down for the slim chance, as water fills their eyes, their mouths, their lungs, drags them from the high ground and away into the thick, brown, angry current as it fights its way out of the levees, silting the wide land beyond with mud and bone.

When I think of my own country left starving, thirsty, hot, when I think of water withheld and unrepaired wires dangling and no light, no fans, food gathering dust in locked warehouses, roads left buried in mud; when I think of unrepaired wires scattering sparks across dry California acres in a high wind, whole towns burned alive, vast plumes of suffocation, all to cut costs for the corporation that is demanding we the people dig them out of the pit of ash they made, I struggle to breathe. I feel the flood rising toward my mouth and I know they are laying all our lives on the levees, building them higher with our bodies, making reefs from our bones to hold back the sea, hoping to stay dry, cool, sated, behind this wall of sacrifice.

Three thousand acres an hour, the Amazonian lungs of the world are bulldozed into raw scar, into palm oil plantations, into miles and miles of soybeans fed to cattle and pigs in faraway feedlots for the sake of bacon burgers. Three thousand acres an hour fall, crushed, splintered, burned into the sky, and the people of the rainforest are crushed, splintered, burned, plowed under. The bad breath of oil plunder, the gunky pools of residue lie still, reflecting nothing. The new president of Brazil says if the people get in the

way of industry they will cease to exist. He burns the treaties, and already men with weapons are burning villages.

Meanwhile the people of the coasts, of the estuaries, of the salt marshes, of the atolls lie down at night and listen to the tide line creeping toward them, almost to their mouths. All the world is a sacrifice zone, dotted with enclaves for the rich, who imagine their money will keep the heat away. They abandon their beachfront properties and take over the once scorned ridges of the poor, while down in the bayou, St. James Parish is a village in a ring of poison factories, tethered in place as the giant, devouring snake draws near, belly filled with fuel for the flares that burn all night, for the leaky tanks, for the engines of commerce.

All the world is a sacrifice zone and among the first to go are most of the freshwater fish and frogs of the Americas, 70 percent of all vertebrates, the clouds of insects without whom nothing blooms. One by one the men lying on the levees blink out, eyes going dark in the muddy water, and one by one species flicker out while gazillionaires keep their eyes fixed on rising balance sheets, ignoring the oil slick waters around their ankles. They would rather destroy the world than share it.

So here I am, an organism long sickened by pesticides and the violence of extraction, unable to march with the chanting multitudes and drag my body to the doors of banks, to make part of a reef of bodies shouting in their lobbies, and so I split my tongue into a thousand voices and keep writing, sending out words like rope: hold here, hold tight, don't roll off the levee, don't drown, synchronize our heartbeats with song, refuse to be the burnt offering on the blood-soaked stone.

≈ From *Silt: Prose Poems* (2019)

5 MAKING MEDICINE

Mapping social pain raises questions about the meaning of healing, of how we attend to our individual bodyminds and those of our kin, our communities and our movements as an integral part of tending to the world. Medicine is created at many levels and in many forms. My book *Remedios* is an extended exploration of the "remedies" we have made over time, from the myriad ways we invented to resist harm to how we retell the stories of what has happened to us, from specific shifts of perspective to how we feed our physical bodies, souls, and culture by how we eat, from alliances with healing plants to coalitions against dehumanization.

This section is a medicine cabinet of specific remedies, the crafting of which forms a big part of my job. I move between genres and kinds of healing as I would between tinctures, salves, and teas. "Ecology Is Everything" is the cabinet that holds them, showing how ecology, justice, and health are inextricably intertwined.

"1515: Plátano," "Kitchens," and "Hold the Coffee" explore our complicated relationships with what we eat and drink—heritage and nourishment, culinary resistance, and substances that both give us endurance and addict us.

"Vivir Para Tí" and "A Remedy for Heartburn" are short fiction about resistance to male domination and the power of shifting the story. (For anyone who might be confused, the parents in "Remedy" are not mine. It's a fictional portrayal of people I knew growing up.)

"Prayer for White Allies," written at Standing Rock, and "Radical Inclusion," written for Reconstructing Judaism, are both specific prescriptions for building the integrity of our alliances. "Prayer for White Allies" was a rapid-response poem sparked by watching all the ways that well-intentioned white people reenacted centuries of taking—land, lives, cultures, attention, other people's labor—even as they were moved by the powerful acts of sovereignty happening all around them at Standing Rock, and the exhausting burden that was to the Native water protectors gathered there. I reached out to trusted movement veterans and this led to the creation of the Solidariteam, a gang of about ten people around the US who, in consultation with tribal elders and other Native leaders, created a required solidarity training for non-Native people arriving at Standing Rock. Roughly four thousand were trained in person and our materials were downloaded several hundred thousand times.

"Radical Inclusion" calls on white Jews and white Ashkenazi-dominated Jewish institutions in the US to abandon liberal ideas about inclusion and embrace a much deeper revision of their ideas about and relationships with Black Jews, Indigenous Jews, Jews of Color, Sephardic Jews, and Southwest Asia and North Africa (SWANA) Jews, often referred to as Mizrahi (BIJOCSM). I invite us to collectively embrace our true complexity and end "Radical Inclusion" by including "Racial Justice Invocation," written for my own synagogue's racial justice initiative. It is followed by "Land Days," part of *Rimonim: Ritual Poetry of Jewish Liberation*, my collection of radical Jewish liturgy. I wrestled for a long time with how to talk about being settlers, inspired by

Robin Wall Kimmerer's insights into naturalization as a third path between native and invasive. It came to me when I had given up and turned in the final manuscript of *Rimonim*, a tribute to the power of letting go.

"Transfusion" was written for Anishinaabe writer Marcie R. Rendon and offers the medicines of love and solidarity for ills that are rooted in the systemic assault on all our lives but expressed as concrete, measurable medical conditions.

"Exoskeleton" is a love poem to the wheelchair I used for more than two years, following my stroke. The technologies of access are complex, sometimes filling in gaps where community should be, sometimes frustrating, sometimes enormously liberating. I was a captive of isolation. My wheelchair was the medicine that set me free.

"Milk Thistle" is one of the many pieces in *Remedios* where plants speak as healers, teachers, and guides. Milk Thistle is an adaptogen, one of a class of plants that add resilience and adaptability to our bodyminds.

"Breath: 2020," in a quite different style from my usual work, and perhaps reflecting the state of mind of the seriously ill, is about having COVID in March 2020, and was written in response to two paintings, as part of the wonderful collaborative arts experiment the Telephone Game.

Ecology Is Everything

We live on a planet that has been changed by the actions of human beings to the point that it may not continue to support our existence. This planet we talk about so much isn't just a location. It's a biosphere, a living organism of which we are part, and on which we depend. I don't refer to our ecosystem as "the environment," because it implies that the biosphere is really a kind of stage for human activity, a backdrop, existing to support us. It also tends to segregate what we consider natural and not, to place the habitats we have engineered, and we ourselves, outside "nature."

The ecological crisis we find ourselves in is actually a crisis of human relations, with each other and with the entire planet. It is a crisis created by a set of false assumptions about reality, the same assumptions that drive all systems of oppression. That greed and domination are the inherent driving forces of human existence, and therefore, that warfare, conquest, enslavement, exploitation, the looting of other people and of the entire ecosystem are natural and inevitable, and therefore must be OK.

The intransigence of climate change deniers, their refusal to accept the scientific consensus, based on extensive and compelling evidence, that human activity is dramatically changing our ecosystem, their willingness to spend fortunes promoting conspiracy theories to account for and invalidate that consensus, is really a defense of the goodness of greed. In order to continue their plundering, they refuse to accept that there are limits to what can be extracted, from the physical planet or from other people. If we accept that the earth is becoming catastrophically less habitable for humans because of reckless extraction driven by avarice, then the founding myth of capitalism, that greed is a benign, creative force with tolerable costs, collapses.

It's heartbreaking that there are so many human beings who cling to the sinking ship of infinite piracy, unable to imagine a society of reciprocity, respect, and mutual care that would meet the needs of all, including them. They would rather accelerate their looting, hoping to amass as much wealth as possible before the ship founders, even though that ship is our entire world, and no amount of ownership will keep them from drowning.

But for those of us who are able to envision that society, it's essential that we understand this: every struggle is an ecological struggle.

The problems in our relationships with each other and with the so-called natural world are the same. If we understand ourselves as part of a living ecosystem continually being shaped by and shaping us, then everything we do has ecological implications.

For human society to be sustainable on earth, it must become inclusive, must take into account the well-being of each one of us.

For instance, much of the oxygen we breathe is made by plankton in our oceans, and the oceans are in grave danger. The only way we can stop, and reverse as much as we can, the extensive damage to our oceans—dangerous levels of acidification, oxygen-starved dead zones without any life at all, coral die-off, massive islands of garbage, and other threats to all marine life, including major sources of human food—is to have societies of people who think differently, who understand and practice interdependence, who are not pressed by poverty into overfishing, who understand the connection between burning coal and poisoning the sea, and have the power to do something about it. Only an interdependent humanity with the resources and power to make good ecological choices can act effectively on behalf of the seas or any other part of the world ecosystem essential for our lives.

That means that anything that threatens human interdependence is also an ecological threat. First among these is the existence of economic classes, the massive, worldwide exploitation of most people's work to pay for luxurious lives for a small minority, and the recruitment of a larger minority to participate in this system for more modest portions of the loot.

Every other system of oppression is at the service of this goal, the concentration of wealth. Every other systemic oppression exists to create and uphold that project: the attempts to exterminate Indigenous peoples in order to occupy and extract wealth from the land and water they live with; the enslavement of millions of African people whose forced, unpaid labor made it possible for European Americans to quickly amass fortunes, build roads and cities, dominate world markets for their crops, and the ongoing exploitation of their descendants; the immense and deeply rooted structures that violently control the reproductive abilities of female-bodied women, and the physical and emotional labor of all women; the commodifying of sex into an international commerce in rape, destroying lives, bodies, psyches, cultures in its wake; the discarding and often killing of people whose bodies and minds can't comply with the demands of profit-making work—people referred to as disabled; the violent enforcement of rigid categories of sexuality and gender,

the better to control us; the placement of artificial borders dividing up looting rights between different groups of owners and the enormous waste of lives and other resources spent in wars to guard or expand those looting rights.

We think about making cities more "livable" in terms of urban farms, restored streams, pedestrian zones, and cleaner and more efficient public transportation, but more than half of humanity lives in cities, often as the result of collapsing rural economies and wars. If human interdependence is essential for better ecological choices to be implemented, then every aspect of urban life is ecological: poverty, segregation, racist and sexist divisions of resources, the existence of food wastelands, inequitable and impoverished health services, the endless violence of the police toward Black people and other people of color, including Black and brown immigrants, the misman-agement of essential life supports such as clean water and air, the lack of basic safety, and all the ways we structure work, housing, transportation, neighborhoods, schools—these are all aspects of urban ecosystems. If we don't solve cities, we won't solve anything, and the only way to solve cities is to liberate the people in them.

When the basics of life are threatened by ecological harm, the conse-quences fall the hardest on people already systematically deprived of re-sources and self-determination. From the aftermaths of hurricanes to the deforestation of the tropics, from the depletion of fish to changes in tem-perature and rainfall that herald the collapse of coffee production, ecologi-cal disasters are inevitably disasters of social injustice that flow along the existing cracks in our world.

Eco-activism with a narrow focus on wildlife and wilderness that does not take into account the unequal impacts of ecological destruction on different groups of people, or the different relationships they may have to land, water, trees, and other species, ends up perpetuating the injustices that are block-ing our way toward lasting solutions. Wildlife advocacy groups attempting to protect tigers in India have unleashed state violence against Indigenous people for whom tiger hunting is culturally important, and could be sus-tainably managed. Middle-class urban activists trying to revive sustainable agriculture in Puerto Rico are becoming rural organic farmers but sometimes treat local growers of coffee and bananas, with a long and intimate knowledge of soil, rainfall, and pests, as ignorant or irresponsible for growing cash crops with pesticides, failing to understand how poverty drives their decisions.

My father used to pose this question to his students: What is the relation-ship between women's ownership of land and the nitrogen-fixing qualities of legumes? Because women have less access to capital, we tend to own smaller

farms. We also tend to plant more diverse crops, because a manageable scale and a variety of crops whose most intensive labor is spread out over the year are most compatible with childrearing and other domestic work, which is still overwhelmingly the responsibility of women. A small and diverse farm both allows and requires a more intimate knowledge of how plants, soil, insects, birds, and animals interact. It allows for and requires better management of the soil than plantation farming does, and close observation teaches us the importance of rotating crops, and planting legumes and other nitrogen fixers to maintain fertility where nitrogen-hungry crops grew the season before. Feminist land reform, increasing women's decision-making power about how land is farmed, is an essential component of protecting the soil that vast monocultures deplete.

At this point in our history, many of the most powerful fights against extractive economics are being led by Indigenous people whose deep cultural ties to specific ecosystems give them an understanding of our interdependence with earth, water, and other species, and a clear picture of the disastrous costs of extraction. In every case of Indigenous environmentalism, the defense of specific waters and lands are also fights for Indigenous sovereignty and resistance to multiple forms of genocide.

The peaceful, culturally rooted resistance of the Standing Rock Lakota water protectors and their Indigenous and non-Indigenous allies to the pipeline transport of some of the dirtiest petroleum in the world through their ancestral lands and rivers has grabbed the imaginations of people all over the world. Non-Indigenous people often frame it as a climate change fight and a fight for clean water, without understanding that it is, at its core, a battle for Indigenous survival, for the most basic of human rights, the right to exist.

"Water is life" doesn't just mean that we have to drink it to stay alive. It means water is alive, earth is alive, that these presences in our world are not inert "resources" to be claimed, packaged, and sold. They are bound by a billion strands into the fabric of the living world, and tearing them apart for profit cuts deep gashes into the biosphere, with consequences that spread far and wide. The failure to recognize this could destroy us all, beginning with the Indigenous peoples whose commitments to these truths stand in the way of the final extractions: the last oil, the last clean water, the last forests, the last uncontaminated stretches of ocean, the last great dammable rivers.

Liberal environmentalism talks about cultivating corporate responsibility, of "greening" the pursuit of profit without changing the fundamental social relations that profit-driven economies require. The pursuit of wealth for its own sake, and not for the common good, not to enhance the quality

of life on earth for all its living beings, inevitably leads those who pursue it to make decisions skewed by that goal, even if they practice some form of harm reduction. The underlying purposes of profit remain the same, and profit is built on inequality, which is incompatible with sustainability.

When power is in the hands of people whose driving desire is to accumulate as much wealth as they can, as quickly as possible, they will always choose short-term profit, no matter how destructive, over accountability to the rest of us. Underlying this drive, I believe, is a profound fear that those who don't dominate are doomed to be dominated, that the choice is between stealing what you can and starving. Part of our work, then, is to enrich the impoverished soil of the possible, to cultivate, through both our grand visions and our daily practices, the belief that we can create societies in which it makes sense to place our lives in each other's hands, neither exploiters nor exploited but simply kin.

We have the creativity and intelligence to solve the problems we face, but the majority of human ingenuity is tied up with just managing to survive oppression.

Nearly half the world's population, including 1 billion children, lives in poverty, and more than 1.3 billion people live in extreme poverty, defined as earning less than $1.25 a day. More than 750 million people don't have access to clean drinking water, which causes 2,300 deaths a day. One in nine people on earth are chronically undernourished. In 2011, 45 percent of all child deaths, nearly 1.4 million of them, were caused by lack of food. One in nine children is growing up in a war zone, and children make up half of all refugees. This is the context within which we must work our transformation.

Years ago, my colleague Victor Lewis said that the greatest untapped natural resource on earth is the human imagination but that if the cure for cancer lay in the mind of a starving child in a Brazilian favela, we were out of luck.

One of the things I love most about revolutionary Cuba is the perspective that each human's gifts are unique and irreplaceable and that all of those gifts are essential. Many of their social policies express the idea that the purpose of revolution is to nourish and free those gifts to fully function in the world. In order to tap the great hidden aquifers of human ingenuity and let them well up to meet our thirst, we must remove every obstacle to the flowing of human potential.

That flow is blocked by poverty, inequality, violence, the lack of sovereignty and self-determination, basic security and health, and the psychological rubble of massive collective traumas, reinforced by endless false narratives fed to us day and night, to explain why our suffering is our own fault.

In order to create ecologically viable societies and avoid our own extinction, we will have to build social movements that include all humans in our vision of environmentalism and our entire ecosystem in our vision of social justice.

Because every struggle is an ecological struggle and the only path forward is to create fully inclusive and interdependent societies, it follows that every ecological struggle must also be embedded in the call for universal social justice.

If we fall short, if we continue to build limited movements that treat the multitude of battles we face as separate and the work of full inclusion as a luxury, we will not be able to mobilize the power, resilience, clarity, and unity we need in order to win. I believe that we have it in us to rise to this moment, to end the failed experiment of greed, restore the streams of our creative power, and establish a global culture of reciprocity and generosity as the beating heart of human life on earth.

🌿 From *Medicine Stories* (2019)

1515: Plátano

Would you believe there was a time when we had no tostones? Plátano didn't start out being Puerto Rican any more than spaghetti was originally Italian! Marco Polo brought spaghetti home from China and plátano went from Malaysia to East Africa with the Indonesians and to West Africa with the Portuguese and when they found out how many slaves you could feed just enough to keep them going on guineo verde and plátano . . . ¡mija! Se lo trajeron enseguida. Fíjate. One of those traveling priests brought the first plátano to the banks of the Toa in 1515. You know they still grow plenty of it in the hills around Toa Alta, Orocovis, Naranjito. So who invented the first tostón? Slaves, por supuesto. The patrón throws down a sack of guineos y plátanos and says, "This is your food for the week." So the first day it's boiled. The second day it's boiled and mashed. The third day . . . boiled. One of the women says, ¡Basta ya! Gets a little grease from somewhere throws in a bit of garlic and fries it up—but the inside stays too raw, so she slams it with the palm of her hand, throws it back in the pot, y en un dos por tres everyone's eating tostones. On Saturday, the patrón brings them some salt pork for Sunday and someone invents mofongo. Soon they have a whole cuisine going. It doesn't win any prizes for good nutrition, because that's not a slaveholder thing, but making sabrosura out of empty calories is an act of resistance, and soul food is damn good medicine.

 From *Remedios* (1998)

Kitchens

I went into the kitchen just now to stir the black beans and rice, the shiny black beans floating over the smooth brown grains of rice and the zucchini turning black, too, in the ink of the beans. Mine is a California kitchen, full of fresh vegetables and whole grains, bottled spring water and yogurt in plastic pints, but when I lift the lid from that big black pot, my kitchen fills with the hands of women who came before me, washing rice, washing beans, picking through them so deftly, so swiftly, that I could never see what the defects were in the beans they threw quickly over one shoulder out the window. Some instinct of the fingertips after years of sorting to feel the rottenness of the bean with a worm in it or a chewed-out side. Standing here, I see the smooth red and brown and white and speckled beans sliding through their fingers into bowls of water, the gentle clicking rush of them being poured into the pot, hear the hiss of escaping steam, smell the bean scum floating on the surface under the lid. I see grains of rice settling in a basin on the counter, turning the water milky with rice polish and the talc they use to make the grains so smooth; fingers dipping, swimming through murky white water, feeling for the grain with the blackened tip, the brown stain.

From the corner of my eye, I see the knife blade flashing, reducing mounds of onions, garlic, cilantro, and green peppers into sofrito to be fried up and stored, and best of all is the pound and circular grind of the pilón: *pound, pound, thump, grind, pound, pound, thump, grind. Pound, pound* (the garlic and oregano mashed together). THUMP! (the mortar lifted and slammed down to loosen the crushed herbs and spices from the wooden bowl), *grind* (the slow rotation of the pestle smashing the oozing mash around and around, blending the juices, the green stain of cilantro and oregano, the sticky yellowing garlic, the grit of black pepper).

> It's the dance of the cocinera: to step outside
> fetch the bucket of water, turn,
> all muscular grace and striving,
> pour the water, light dancing in the pot,
> and set the pail down on the blackened wood.

The blue flame glitters in its dark corner,
and coffee steams in the small white pan.
Gnarled fingers, mondando ajo,
picando cebolla, cortando pan,
colando café,
stirring the rice with a big long spoon
filling ten bellies
out of one soot-black pot.

It's a magic, a power, a ritual of love and work that rises up in my kitchen, thousands of miles from those women in cotton dresses who twenty years ago taught the rules of its observance to me, the apprentice, the novice, the girl-child: "Don't go out without wrapping your head, child, you've been roasting coffee, y te va' a pa'mar!" "This much coffee in the colador, girl, or you'll be serving brown water." "Dip the basin in the river, so, to leave the mud behind," "Always peel the green bananas under cold water, mijita, or you'll cut your fingers and get mancha on yourself and the stain never comes out: that black sap stain of guineo verde and plátano, the stain that marks you forever."

So I peel my bananas under running water from the faucet, but the stain won't come out, and the subtle earthy green smell of that sap follows me, down from the mountains, into the cities, to places where banana groves are like a green dream, unimaginable by daylight: Chicago, New Hampshire, Oakland. So I travel miles on the bus to the immigrant markets of other people, coming home laden with bundles, and even, now and then, on the plastic frilled tables of the supermarket, I find a small curved green bunch to rush home, quick, before it ripens, to peel and boil, bathing in the scent of its cooking, bringing the river to flow through my own kitchen now, the river of my place on earth, the green and musty river of my grandmothers, dripping, trickling, tumbling down from the mountain kitchens of my people.

꧁ From *Getting Home Alive* (1986)

Hold the Coffee

I am the descendant of Taíno people whose tropical ecosystem allowed them to put in minimal work and reap abundant crops of carbohydrates, who could spend a modest number of hours fishing and gathering shellfish and have plenty of time to develop sophisticated art forms and elaborate rituals. Their culture honored artists and trees, created breathtaking carvings in wood and shell, invented hammocks knotted from the fiber of maguey, made polished rings of stone, ceramic pots and figures elaborately worked with earthen dyes, and dayslong festivals of poetry and song.

I am also the descendant of the Spanish colonizers who came and slaughtered, tortured, raped, and enslaved them; who came fresh from the famine-ridden lands of Europe, from rocky soil and harsh drought, and created a moral universe of harsh and virtuous labor to match.

Before they kidnapped, tortured, raped, and enslaved my African ancestors into the sugar fields of the Caribbean, they did their best to seize the labor of the Indigenous people of the islands and turn it to generating profit, which they believed in with frenzied devotion.

You can feel the hot outrage rising from the page where a conquistador reported to his queen that "neither threat of punishment nor promise of reward" could induce my Taíno people to work more than they had to for their survival. As yet untrammeled by avarice and ambition, I imagine them looking at each other, and back at the red-faced intruder with his odd ideas, and responding with one voice, "Duh!"

A few weeks ago my brother, Ricardo, published his weekly blog post, revealing his quiet rejection of sugar as a part of his diet, built on an earlier decision to stop drinking alcohol, and let slip that coffee is still a daily ritual for him. For me it was the other way around. Coffee was the first to go, and given my epilepsy and shattered adrenal function, that may have saved my life.

I grew up in a landscape entirely restructured to serve three great addictions of modern life: sugar, tobacco, and coffee. The sugar grown on our coastal lands, sucking nutrients from the soil and leaving it impoverished, was also converted into a fourth, rum.

I was born and raised at the boundary between the townships of Yauco and Maricao, in the very heart of coffee country. The smell of roasting beans and wood smoke still fills my heart with joy and longing. Everyone I knew drank a last cafecito before bed, and so saturated was the blood in their veins, their metabolisms so conditioned to the stimulation of those Ethiopian berries, that they slept like babies. (Oh yes, the babies had café con leche in their bottles.)

We didn't start drinking coffee until grade school, and as best I recall, only on special occasions, with a spoonful of sugar, and a floating dollop of cream cheese turning deliciously beige and cheesecakey.

I was born into a series of early traumas that predispose me to jitters and adrenal overreaction, and once I started independently consuming coffee, I very soon discovered that it made me tremble for hours and feel slightly sick, with that nauseated sensation you get after a sudden jolt of adrenaline. My body dished out the misery too soon for me to experience it as aftereffect.

It turned out to be the same with alcohol. For a few years I drank wine with my friends, and the occasional shot of Puerto Rican rum in Coke or coconut milk. But by the time I went to college, very small amounts would make the room spin, and I started passing out from half a glass of beer, so except for a few sips of champagne when Nixon resigned, I stopped.

My mother was a quiet but constant alcoholic, sipping sherry and vermouth, Barrilito rum and Gordon's gin, Benedictine and brandy, Kahlua and Grand Marnier. Alcoholism ran in her family, and I'm fairly certain the genetic variation that makes ethanol overwhelm my brain in seconds, and that has only recently become something you can be tested for, comes to me from her lineage.

I wonder if it was the hard-drinking Spaniards, the cohoba-snorting Taínos, or the palm wine imbibers of West Africa who bequeathed it to us, or whether it sprang into being from the confluence of those wildly disparate lives, violently clashing between the creak of the trapiche, extracting the juice from the cane stalk, and the thud of rum barrels being loaded into ships' holds to play their part in the triangle trade.

Although sugar wines have been fermented since ancient times, particularly in the South Asian lands where the sweet grass originated, rum was first distilled in the Caribbean by enslaved Africans experimenting with molasses, and then white slaveholders concentrating the alcohol until it burned.

Dulce caña me provoca, wrote Cuban national poet Nicolás Guillén, *con su jugo azucarado, el cual despues de probado, siempre es amargo en la boca.*

"Sweet cane provokes me with its sugared juice, which, after it's tasted, always turns bitter in the mouth." And he continued, "to cut the cane is my fate, but destiny is so cruel that when I wound it with my blade, it receives all the good, for from my blows, it lives, while I die from its blood." Addiction, like Christianity, came to the islands on the point of a sword, to the sound of shackles and whips.

The second crop was tobacco, wrested from its sacred place, promoted and commercialized into a necessary accessory of the good life, from the poor man's chaw through carved pipes and hand-rolled cigars, to the delicate pinch of snuff from an elegantly enameled box.

Tobacco covered part of the Morales family acreage, along with pasture for cattle and most likely some citrus, root vegetables, and maybe a patch of rice. They lived in the low hills of the northeast, along the Toa River, but my mother's aunt and uncle didn't die of lung cancer. It was liver failure.

Where my immediate family lived, in the heights of the cordillera, the cycles of coffee set the rhythms of people's lives. During the harvest, children went to the hillsides, not school. As teens, they courted to the gardenia scent of white coffee blossom, with its bewitching powers, and girls washed their faces in the petals to make themselves lovelier. Adults in their hard-working prime filled baskets, then sacks, then trucks, then warehouses with the red and green berries, raked the fermenting fruit till it fell from the pale seed within, husked, roasted, ground, and brewed it in their homes, and then celebrated the end of the harvest in wild festivals. Old women bent over metal cans of black beans and burnt sugar warned their descendants that the smoke could wither them.

In the famine years of the thirties, it was sometimes the only nourishment. Black coffee and a rind of green banana. Like Bolivian coca, it kept hungry people going through otherwise unbearable overwork and deprivation.

It still does. Every morning, millions of people get up and drink their coffee in order to meet the demands of capitalism on their tired bodies. Without it, they can't push past the exhaustion of the unreasonable work day, work week, work decade. Without coffee, we might have to notice how unreasonable those demands actually are. We might have to stop in the middle of sirens, deadlines, bells, conveyer belts, ringing phones, and take a nap.

I'm lucky. While my nostrils still flare with pleasure at the smell, and the other night I dreamed I was eating coffee ice cream, my body refuses to let me drink it. There's no struggle for me. Retribution is instantaneous, so it isn't willpower or virtue. That door is just closed to me. But imagine if

we all stopped revving our battered engines, if we could feel our tiredness beneath the pulse of caffeine and give it its due. If we defended our bodies' limits instead of violating them.

Imagine if neither threat of punishment nor promise of reward could make us work harder than we have to. Lying in our hammocks on a still evening, talking around the slow fire, what might we dream up then?

 ❧ From *Kindling: Writings on the Body* (2013)

Vivir Para Tí

The afternoon pressed into her like the palm of a huge hand, hot and damp against her thickening body. ¡Ay! Me sofoco. She stood in the doorway, her hand on her hip, watching two hens stalk the dirt, tipping their heads to look for stray kernels of corn. She reached into her pocket for a handful of grain and threw it to them. More chickens came scurrying out from under the bushes. Leaning against the wood, she looked out at the hills, falling away softly, stifled, too, by the dense air. The baby pressed relentlessly, hard as a green orange, against her breastbone, crushing her breath.

In the dim room behind her the television droned on to itself, casting a blue light into the corners. The passionate voices and shadowy faces were flattened by the brilliant light. She couldn't remember the characters' names. Was it the two o'clock novela or the three o'clock? You didn't remember the people, just the situations. The music rose and then changed abruptly. Luz glanced back over her shoulder into the dark room.

A cheerful young mother and her small daughter, in matching aprons, sat at a table in a brand-new kitchen, pouring the best-selling brand of tomato sauce into Papá's beans, stirring and singing a little song together. After a moment Papá walked in the door from work, wearing a shirt and tie, smiling and carrying a briefcase. He kissed the wife and child, sat down and tasted the beans, and smiled with satisfaction. Then a dancing tomato sauce can wiggled across the screen and the picture faded. Luz used a different brand.

She walked herself to the stove and lit the flame under a pot of peeled green bananas, then backed away, fanning herself with the flat of her hand. The children would be home from school soon. She heard the jeep pull in and stop beside the house. Her father was back early. She knew as soon as she heard him coughing and muttering that he'd been drinking. He snarled and kicked at one of the chickens, and it scurried, clacking, into the bushes. I wish, panic rising like the perpetual heartburn, making her gag, I wish I could disappear.

"Where the hell's my food!"

"It's not ready yet. I didn't expect you until later."

"So you think I should be out working in this hell-heat? Stupid girl. Look at you! What a mess!"

Think of a knife, she told herself slowly. Imagine a knife gutting him like a codfish that comes flattened, stiff, spread open, crusted with salt, packed in boxes. You rip the spines out with the edge of a blade. Her eyes went flat, trying to reflect nothing at all for his fury to latch onto. Once, when her belly was first showing, he had seen something stir in her eye and slammed her hard against the wall, making her teeth crack against each other. Her ribs had ached for days. He had tried to hit her in the stomach, but she'd curled herself tight, and spitting curses he'd gone back out, and come back too drunk for trouble.

Her father sat down on the vinyl couch and stared at the flickering screen where two lovers were kissing passionately. Stay tuned to this channel for more romance, said the announcer. In just a few moments María Estér stars in . . . and a husky woman's voice whispered, Vivir . . . Para Tí. To live . . . for you.

Down the road she could hear the children shouting and wanted to warn them, hush them, but they'd seen the jeep already, and slid into the house hugging books to their chests, and "Bendición, Papi," bless us, they beseeched. He looked them over. "Dios los bendiga y la Virgen," he muttered and turned back to gaze at the screen. Without looking up he told Papo to get out of his school clothes and get down to the plot and help Felo with the planting.

"But Papi . . ."

"Did you hear me? Don't argue, I'm warning you."

He tried to pull his belt out of his pants, still sitting down. Aurea, the youngest, giggled. He took off his shoe and threw it at her, and she ran to her big sister, clutching at her skirts, and crying, "Ay ay ay."

Irritated, Luz pushed the child off her.

"Ay, honey, it's too hot."

She smoothed her hair and told her to stop crying.

"You know it only makes him mad."

While Papo changed into the banana-stained pants he used for farmwork, Willie pulled a letter out of one of his schoolbooks and held it out to his father.

"Don Pepe said you forgot to bring the letter home."

"Oh, that's right. Papo!"

Papo came out of the back bedroom the boys shared with their father.

"Léeme esta carta."

Papo took the envelope and said, "It's from Eddie."

"You think you're so smart! Who else would it be from?"

"He says he's working at a new place where they pay better, and if Luz wants she can come stay with them, if she'll help with the children and the house. His wife is pregnant again and gets too tired." There was a small silence, then their father snorted. "A lot of help she'd be!" He ran his eyes over Luz's round body, and she turned away from him toward the stove.

"Then he says next year when I'm fourteen, he could get me some work as an errand boy if I want to come live with him, too." Papo looked up at his father's scowling face and quickly returned to the letter. "And that he knows times are hard here, so if we want to come, tell him a few months ahead and he'll send money for the tickets."

Their father stood up, shouting. "¡Coño! Does he think a farm runs itself? How the hell can I take care of my parcela if all you brats go running off to Nueva Yor? Your brother's a burro!" He looked around him at the roomful of apprehensive faces. "Papo, get the hell down to the parcela and help Felo plant bananas . . . and don't come back until you finish the first hillside!" Papo went silently out the door. Luz dished up a plate of reheated rice and beans and handed it to Aurea, who carried it carefully across the room to her father. Grumbling and muttering, he settled back onto the sofa and began to eat, gazing blankly at the television screen where the three o'clock novela was starting.

And now . . . Vivir . . . Para Tí. The hero, the handsome young painter, was sketching the beautiful wife of the patrón. There were long silences while he worked, and the woman watched him. Luz liked this novela. The young man was falling in love with the patrón's wife, but he was sworn to kill the patrón. Luz couldn't remember why. The young wife didn't love the patrón. Her family was rich and proud, and had forced her to marry him out of ambition. She and the painter went on walks and laughed a lot. Hitching herself up onto a stool by the stove, Luz began sopping up the juice from the beans with a piece of bread. It looked like pretty soon something was going to get started between the two of them. She watched absorbedly as the patrón told his young guest that he was going away on business for a few days. Now was their chance.

It was dark when it happened. When she thinks of it, she feels the child's small, firm body pressing against the walls of her stomach, and the nausea makes her head spin. Toño had promised to wait every night by the church until she could slip away to see him, and the night Papi went to town to see his brother about something, she'd gone, telling the others she was going to visit her godmother. In case someone checked, she stopped first by her godmother's on the way down.

Several of the neighbors were gathered on the porch. They had talked about the two o'clock novela, the one with the twin brothers, one good and one bad. The bad one was stealing the good one's sweetheart and they were trying to guess if she would believe his lies or not. Luz thought she wouldn't, but one of the other neighbors said she would, and then she'd find out her mistake and repent.

Luz spent half an hour on the porch, gossiping and sipping coffee. All the time she could feel Toño's cool shadow on the church wall, making her itch with impatience, but her face was placid, and she even asked to see the new embroidery her madrina had just finished. She knew how to hide even her smallest desires. She had always been able to do this, even when she was younger than Aurea.

Finally, she left her madrina's, asking for her blessing, and walked down the road, around the church corner, and straight into Toño's arms. His kisses had suffocated her even then. Even in the cool of the rainy season his hot breath on her face had made her dizzy with the longing to escape. But he smelled good, and he had sweet, dark eyes, and warm brown skin, and when he grazed his lips along her neck, she felt faint with excitement. In fact, his caresses were the only exciting thing that had ever happened. He had pulled her down into the grass, and she had followed him into the wet, green place, burying her face in his shoulder to get away from his lips. She loved his torso. It was the only part of him that didn't try to devour her. The only part she could approach at her own speed. She had placed her palms on his shoulder blades and kept them there until it was over.

When she got home, he was waiting behind the door with the belt in hand and he'd beat her around the house calling her a slut, saying you think I can't see the grass stains on your back? Your mother would get up out of her grave if she knew. I'll teach you to have respect. Then he had dragged her by the hair into the darkened bedroom, thrown her down on the bed, slapped his hard, stained hand over her mouth, and done it again.

Think of a knife. The blade ripping the ribs out, leaving him split like this dried fish, leather and salt. She hacked it up and threw it in a pot of water to soak. The baby swam up against her left side, poked a foot or elbow out, sank back into her flesh. Toño was in Connecticut and wrote all the time, through his sister Ana Teresa, but she hadn't answered him. He wanted her to come out and marry him. He knew about the baby from Ana Teresa.

She tried to imagine Connecticut. Rows of fruit trees in straight lines. Barracks with only cold water on an icy morning. Cold like ice cream eaten too fast and sticking in your throat. Cold too cold to touch getting into your

skin and bones. Cold enough to wipe out the hot breath smelling of rum that made her vomit, over and over, by the side of the house when he was finished and told her to clean herself up.

Sometimes she thought the baby was Toño's and would smile at her with his same, round freckled mulatto face, and out of sheer relief she would go to Connecticut and live in a tiny room with him and the child. But the nightmare came to her every night, the child with a drunkard's eyes, muddy brown, closed to slits, chewing at her breast, grunting over her in the dark. Her brothers' eyes slid away from her all the time now. Worst of all, what if the child looked like her and she grew to love him, not knowing, until one day her father stood out stark as lightning and she had to rip the boy out of her heart by a hundred tiny sucking roots.

He was whistling as he walked up the dirt road. He had planted a hillside of new bananas, and worked up an appetite. The sun was still cool, just barely warming the moist chill of the early air. As he turned toward the house, he met the children going to school. Willie was acting the fool, balancing his book bag on his head. They hesitated when they saw him and he grinned.

"If that thing falls in the mud, you'll have to do all that 'spiki eenglich' stuff again." Willie grinned back.

"No, Papi, I'll show Mr. Luna the muddy paper. He won't care."

"Bueno, you better run to school now, because you have Mr. Perez first and he'll smack your behind if you're late. Corre."

"Bendición, Papi," they yelled over their shoulders as they ran.

"Dios los bendiga," God bless you, he called after them. That Willie was a real clown.

He stamped his feet to loosen the mud, scraped it with a stick, and went in to breakfast. Luz had made surullos. She brought him a plateful, little fat cigars of cornmeal, fried crisp on the outside, moist and delicious inside. "They're good. You're getting to be as good a cook as your mother." Luz flushed a little at the compliment. "Titi Celita teaches me a little, and madrina." "That's good. When you marry, your husband will always be home for meals."

The comment was meant to be jovial, friendly, but the heaviness of her step moving around the kitchen made it fall flat. Silence fell between them again. He looked away from her, out the door where the chickens carried on their perpetual brooding search for food. He crumbled one of the surullos and threw the pieces out the door. In a moment it was covered by tiny scurrying black and white chicks, cheeping excitedly between the legs of the stolid hens.

Cooking beans, feeding chickens, fetching water, buying fish, washing clothes, making coffee, cutting bananas, sharpening the knife. One afternoon she got back from the store and Aurea handed her a note.

Querida Hermana Luz:

Nos fuimos a nueba Yor pa bibir con Eddie. Aquí ya no ce puede bibir. El nos mandó el pasaje, por eso tubimos que ir al pueblo el otro dia a recojerlo. No dijimo na pa que papi no supiera. que nos mata si llega a saber. Aquí ya no ce bibe. Dios te cuide y te guarde como dice madrina y que todo salga bien. Se despiden tus hermanos que te quieren.

Papo y Willie

[Dear Sister Luz:

We went to nueba Yor to live with Eddie. This is no life here. He sent us the tikets thats why we had to go to town the other day to get them. We didn't say nothing to Papi so he woodn't no. cuz he'd kill us if he new. This is no life. God bless and protec you like madrina says and that everything comes out OK. Goodbye from your brothers who love you.

Papo and Willie]

Spell out the words of the scrawled note. Scrub the iron pot with a fistful of steel wool. Grip the table against the pain of that goodbye. Nothing but a dullness left. Fetch water. Cook beans. Cut bread. Papo had always been her favorite, since she had brought him to sleep close to her after their mother's death. Aurea had been a newborn baby so her aunt Celita had taken her home for a while, but Papo, who was one and a half at the time, had crept in each night to sleep curled against her ribs. With the boys gone, it was so lonely that some days it was hard to breathe. One of those aching, monotonous mornings, she decided suddenly she would name the child Papo for that same caress of the ribs it gave her, and she felt the first stirring of a small, stubborn love.

Late in the night he came home, staggering a little, up the narrow road from the store where he had spent the evening buying twenty-five-cent shots of rum. A little rum made him want to fight, to give one of the kids a good whipping for lacking respect. A little rum made him mad. But a lot of rum made his heart turn to water.

It was very late. The moon had drenched the red soil with shadows. It looked almost purple. The small house was dark. He stepped toward it out of the darkness of the trees and blinked in the sudden light. Swaying a little, he stood looking at the shuttered windows. They gave the house a stupid, closed look, like a sleeping child. He pulled back, slipping on the wet ground, and caught at the heavy bushes that showered him with cold drops of water.

The air would be stuffy and still behind those shutters. Nothing had moved in the house since Ofelia had died. Now that the last of his sons were gone to the North, the house would be even quieter. His thoughts shied away from Luz, her swelling body. Shied and were pulled back. He had an image of Ofelia at sixteen, pregnant with their first child, her arms like smooth brown cream, her laughing face. She had been thin and faded at the end, but it had taken two of her brothers and his own sister Celita to pull him away from her body.

Some night bird dipped across the white air with a hoarse cry. Startled, his foot slid on the slick ground. He grabbed for Pancho, but Pancho had gone home, so he threw his arm around the limb of a tree to steady himself, then sagged against its rigid shoulder, and sobbed drunkenly. Across the gap of light, his house stood shuttered against him. Ofelia was buried. His sons were gone. He was afraid of Luz, with her growing heaviness and her silence. He was afraid of the still house where his daughters slept in the wooden dark, with their arms around each other. After a while he stumbled over to the jeep, crawled into the back, and slumped into a heavy sleep.

The rain fell so hard from the sky that it bounced halfway back again, and there was more water than air between the wet houses with their sodden planks of wood. Papi sat snarling at the television, and the humidity made the plastic sofa stick to his shirt back.

When Aurea sidled out of the bedroom, his eyes followed her. Está hecha una mujercita. Soon the neighborhood boys would be following her around.

"Ven acá," he barked.

Startled, she obeyed.

"Do any of the boys bother you?"

"No, Papi." She sounded puzzled.

"I better not hear about you going off with any boys and fooling around. You walk straight home from school, you hear me?"

"Sí, Papi."

"Dame un beso."

She looked at him.

"I'm your father and I said give me a kiss. You don't have any respect." Timidly she bent and pecked at his cheek.

He chuckled, held her chin with his rough fingers, and planted a mouthful of rum and cigarette fumes in a sloppy kiss on her lips. Aurea stood up, watching him with frightened eyes. He slapped at her behind.

"Vete y ayuda a tu hermana. Go on. Go help your sister."

He glanced up and saw Luz in the kitchen doorway, looking as stiff and hard as a stick of firewood.

"Vente, Aurea. Help me wash the dishes."

That afternoon the two daughters sat behind the house under the overhanging tin roof, scrubbing the stains from their father's pants. Their hands went round and round on the soapy cloth, grinding at the dirt with their sore knuckles. Slowly the water turned muddier and muddier. After a while the sun came out, and it got hot again. When they were finished, Luz wrung the pants out and hung them on a bush to dry, then she poured the dirty water out onto the steaming ground. In the late yellow light it seemed to smoke there for a while, before it soaked into the red earth.

It had happened. The young wife and the painter had become lovers. Madrina was scandalized. Luz's neighbor said it was only natural, with the patrón so old and mean, but madrina said it taught women bad habits. Luz went over to madrina's to watch. Her aunt Celita was up at the house doing the cooking and had sent her for some of madrina's oregano, telling her to take her time.

The wife had decided that she couldn't live in that house anymore, and she was going. Luz watched, wide-eyed, as the rich young woman stuffed her jewelry into her purse and hurriedly packed a bag. Suddenly a door opened and one of the servants came in and stared at the wife's suitcase. "Ay, Dios mío," gasped madrina, "now she's caught for sure." But the servant just said, "God bless you, señora." There were only two minutes left of the episode. The young wife looked around her beautiful home one more time, and then went out, closing the door behind her.

Luz and her madrina and the neighbor all let out their breath.

"Well, I hope she makes it," said the neighbor. "She deserves something better than that ugly old man."

"Hush, Luisa," said madrina. "She shouldn't have married him if she wasn't going to be faithful."

"Ay, mija, it isn't always that simple. She hadn't met the painter then."

Luz kissed her godmother and left. She could hear the women arguing as she walked slowly back up the hill.

> Dear Toño,
>
> God grant that this letter finds you well, as thank God it leaves me. This is to tell you that I am coming I am bringing Aurea because I can't leave her here alone with Papi the boys have gone north. We are coming Monday morning the eleventh. Ana Teresa got the ticket for me. Papi doesn't know anything.
>
> Your sincere friend,
> *Luz*

She dressed Aurea in the bedroom. In each of her shoes was a twenty-dollar bill stolen from Papi's pants. She tied their mother's wedding and engagement rings on a ribbon Ana Teresa had given her from her cousin's graduation and hung it around Aurea's neck, tucking it down under her collar so it wouldn't show. The tickets were folded up and pinned to the inside of her own blouse. Their father breathed heavily in the next room. Nothing would wake him now. Not for hours.

Last night she'd slipped out for a minute and hidden a plastic shopping bag of clothing for the two of them under an old rusted-out car that had sat at the edge of the road for fifteen years and six months. She knew exactly because Doña Luisa said some drunken idiot had driven it off the bank the same night Papi had driven her mother to the hospital in labor with her. Luisa had run out, afraid her pregnant friend had been hurt. "It sounded like his car, you know. If your father had been a single man I would have stayed in my kitchen and said God's will be done, but I really loved your mother, honey, and I was worried about her, since it was Saturday and I knew her pains had started. But when I went out it was some other drunk fool. The car was completely wrecked, so he just left it there and no one's figured out how to move it since. Way up here, it'd cost a fortune to have it towed to the dump in Yagrumo."

Yesterday she had stopped Mundín on his way back from the last run to town and asked him to pick her up by the church, an hour before Mass. "We're going to Ponce. Aurea has bad dreams. About Mami. I'm taking her to a lady who interprets them."

Luz knew Mundín was an espiritista. He'd nodded knowingly.

"I haven't told Papi, because he doesn't believe in that. He thinks we're going to see Titi Celita in Yagrumo." She had looked at him anxiously.

"Your father is going to get a big surprise when he dies, that's all. I won't say a word to him, mija. You're a good girl to take care of your sister like that."

.................

It was colder than she could imagine, even after all these months. The bus was always late. She was grateful for the small tropical sun that burned in her huge belly, but her hands turned red, then blue, and her lips got tiny cracks in them that stung when Toño kissed her.

It had been the ugliness that hurt when she first got off the plane, clutching Aurea's hand from the terror of that landing. The rows and rows of brown brick buildings with scrawny little trees here and there. She couldn't understand how people could live like that. Toño had been glad to see her. He'd kept patting her belly, and grinning, and trying to kiss her face in public, which made her uncomfortable. He'd been nice to Aurea, too, rumpling her hair and calling her little sister. He'd even stayed home the first few days, helping her get settled into the tiny one-bedroom apartment. It was as big as the house back home, but with no land around it, the rooms seemed cramped and airless. But she made the best of it, hanging her and Aurea's clothes in the little closet with Toño's shirts, stashing their underwear in a cardboard box under the bed. That's where she hid her money, too, under a flap of the cardboard box.

He hadn't let her take the job in the restaurant down the street, saying his woman had no need to work. But he was gone from late morning until late at night, so she took care of the neighbors' children and did a little sewing. After a while she made a few friends in the neighborhood, and it was one of them, a Dominican woman, who got her the housecleaning job. Slowly the crumpled bills accumulated.

In case he heard about her absences, she told Toño about her Dominican friend. Since he came home so late, she said, she liked to eat over there sometimes. For the company. At first Aurea went with her to her cleaning job and helped, but the señora didn't like it, and after a while Aurea went straight to the Dominicana's house to watch TV and wait for Luz.

There it was. The bus pulled up, hot, stinking, full of people hanging from the metal bar like clothes on a clothesline. She hauled herself up, trying to move fast, but as soon as she got onto the first step, the bus driver closed the door and lurched forward. She fell against the wall and hung on as hard

as she could, then she felt a deep twisting pain in her belly. She moaned, and gripped the rail so hard her fingers went white. A Black woman in the first seat took one look at her and yelled, "Stop the damn bus. This girl's in labor."

"Oh, shit!" The driver turned to look at her as he pulled over. "Can't you people do anything right?"

"How often are your contractions, hon? . . . how often . . . uuhh . . . Kay Mucho?"

"No onderstan Inglich."

"Hey, Sandy, send García up. Make it fast."

Once as a child, she had been at her aunt's house near the beach during a hurricane. Huddling in the Lion's Club, which was the strongest building around, she had seen the waves pick up pieces of wood and throw them into the air. She was the wave. She was the wood. Each time a wave hit, she felt herself flying up and out, into a thousand pieces. At first there were quiet spells where she floated, eyes closed, listening to the foreign voices speaking to each other around her bed, but after a while there was only the storm. At last she felt herself splitting open, her skin ripping like the peel of a mango torn to expose the dripping flesh. Then something slippery, hairy, hard-and-soft like a mango, pushed itself from her raw body and slithered onto the table.

"It's a girl. Tell her it's a little girl."

"Tienes una nena."

Fearfully, she looked down. The tiny face was the color of coffee with too much milk. She was waterlogged and swollen from the storm, and looked like no one Luz had ever seen before, but her hands were like tiny, perfect hermit crabs, clawing at the air.

That was all. There was not a single clue. The child's skin was like Luz's dead mother's, a creamy brown. She went over and over each miniature detail. The eyes, the chin, the wet black hair. She touched the crinkled mouth with her fingertip and the lips curled back like an opening bud of hibiscus, and then closed again, sucking tight. Luz watched in amazement. The child was new, as if she had been born that minute from the waves. Not one of them had left his mark on her. Looking down at the little cream face, she remembered the girl on the novela, the one who married the good twin. She had finally found out who her real father was, a kind old doctor who had been looking for her for years. No one would be looking for this daughter. No one had the answer.

The nurse held the dark, wet head to Luz's breast and after a moment the pink tongue touched her nipple and the tiny mouth fastened itself onto

her. Images drifted through her mind: a baby goat, a limpet clinging tight to a surf-washed rock. A shell found at the beach by her aunt's house after the big storm, pale brown and white on the outside, glowing smooth pink inside. A secret between her and the sea.

"What's her name, honey?"

"My neing ees Luz Rodriguez."

"No, no, the baby . . . uh . . . Too Bay-bay."

She stared at the nurse for a moment.

Luz y mar. Mar y Luz.

"Ponle Mariluz," she said. "Herr neing ees Mariluz."

She took the pencil from the nurse and wrote it down in a firm round hand.

The nurses were finally gone, and her baby drowsed across her belly, still latched on, sleepily pulling thin threads of milk from Luz's swollen breasts. The other bed in the room was empty, so it was quiet, the hospital noises muffled by the thick door. She closed her eyes and imagined hearing a rooster crowing in the late-night stillness. She still wasn't used to the night-time here, noisy and unnaturally quiet at the same time, with its grumbling traffic, but no tree frogs, or crickets, or dogs.

Toño had been and gone, storming out into the snow. Probably for good. Once he had been the only pleasure in her life. She was sorry to see him go, but not sad. She had train fare to New York, and Eddie and his wife were expecting her.

"Why didn't you wait for me, before you named her?" he'd asked. She had taken a deep breath, as deep as she could with the stitches burning and aching.

"She's not your child, Toño."

"What!"

"She's not your baby."

"¡Coño! Now you tell me? All this time living in my house and now you tell me it's not my baby?" He had raged up and down the room. Threatened to hit her, called her a cheat, a slut, a bad woman who had ruined his life. Cried because she wasn't his woman after all. Luz had watched him without blinking.

Was it Cheito's? Luis's? Miguel's? She shook her head tiredly.

"Who the hell's is it then?"

"Mine, Toño, no one else's."

"What are you? La Virgen María? ¡No jodes! Whose is it?"

"Mine."

She lay back on the pillows and thought of that last morning in the silent house, her father still snoring, sprawled across his bed. She had sharpened the knife till it gleamed even in the dark. It was like a razor blade, humming to her quiet breathing. She had stood looking down on him for a moment, the blade trembling in her hand. Then she had laid that thin, bitter steel on the pillow next to his face, so it would be the first thing he saw when he woke.

&♣ From *Cosecha and Other Stories* (2014)

Prayer for White Allies

WRITTEN AT STANDING ROCK, OCTOBER 2016

Great Spirit, in the names of our ancestors who,
long before their children became settlers,
were indigenous in their own lands, we pray.
In the names of our ancestors who were many things
before whiteness was invented to divide and oppress us all, we pray.
Because this is not our land, and we are not the leaders here,
because our task is to do what is needed, with humility and love,
to support the protectors of the water, we pray:

Help us to become true allies.
Help us to listen much more than we speak.
Help us learn to go last instead of first.
Help us to wait until native people who wish to speak have spoken.
If we speak, let it be briefly.
Help us to say only the words that are needed.
Help us to speak only from our hearts,
not because we want to feel necessary and important,
not because we hunger to belong,
not because we feel anxious and out of control,
not because we can't bear to keep our opinions to ourselves.
Help us to sit quietly with all these feelings, which we inherited,
Help us to breathe through any resistance we may feel to these words.
Help us to know that on the other side of discomfort lies peace.

Teach us to pay attention and learn by watching.
Teach us to hold our questions. They are not as urgent as they feel.
Teach us to hold our suggestions. They are not as necessary as they seem.

Great Spirit, teach us how to follow,
for we have been trained to think we know best.
Teach us to be patient. For we have been trained to hurry.

Teach us to sit comfortably at the edges,
for we have been trained to believe we belong at the center,
and we are not the center here.

Teach us to offer more resource than we consume.
Teach us to ask, how can I help, and wait for the answer.
Teach us to draw strength from our own roots, honor our own ancestors,
Grieve our own histories, and not seek to ease our wounds
by grabbing the cultures of others, which is theft.

Great Spirit, we ask your help
to become the allies our indigenous relatives need us to be
fierce, loving, and humble, as they lead us
in the work of protecting the waters
on which all our lives depend.

Transfusion

.....

for Marcie R. Rendon

.....

this is for the donors of blood, the ones
who transfuse the courage of their hearts into the faltering world
who tax the endurance of their bones
and farm their own marrow
for the sake of what everyone needs
until it cries out for a season of fallows—
but if the red cells fail,
who will carry this oxygen on their backs
so that the People continue to breathe?

this is to say that this morning, I will breathe words
mouth to mouth, into the lungs of the suffocating,
that I have no hands or feet or back to offer, but today
I will breathe for as many as I can
and you

lie still
let the earthworms make soil
out of fallen leaves and
broken limbs,
turn our beloved dead into rich dark cores of red
in the ivory hollows of your legs, ribs, shoulders.
let new blood well up
from the great aquifers of the earth,
and rise into your limbs, eyes, fingertips
like the green, sweet sap
no one can imagine in midwinter.
Be still. Make blood.
I will breathe.

From *Silt: Prose Poems* (2019)

Exoskeleton

My wheelchair is an exoskeleton protecting
the soft body of fatigue.
I get out of bed, walking slowly
on my curved foot and my overworked one;
the foot that cramps and aches and curls inward
onto its edge
trying to figure out where it is, to reconnect,
and the foot that does more than its share and gets tired,
the heroic and sullen foot that steps in to carry the limp.

My whole body aches and trembles with what people call fatigue
as if it had anything to do with a long work week,
a tiresome commute, the ordinary, "boy I'm bushed!"
of ordinarily tired people.
I carry the fatigue down the stairs to the shed,
unlock the shed, unlock the padlocks,
unplug the recharger cable, slide into the seat,
and suddenly I am uplifted and embraced.

Deep foam cushions me from below and behind.
I am surrounded by the yellow ribs of this new body,
rest my legs on new and stronger bones.
I relax into this enameled-steel-mid-wheeled
statement to the world
that I can't walk another step.
I no longer have to *tell* the people on the buses and trains to get up out of
 the specially marked blue symbol seats
because I belong there.
My new outer shell says it for me.
People step aside, apologize for being in my path,
stand without being asked
so I can be strapped into place for my bus ride.

The chair speaks for me,
a new and less exhausting form of speech.
It's the shiny carapace
that lets the world know my species.

I hear they call it being *confined* to a wheelchair.
Before it came, fatigue had me bound tightly to my bed.
When I say fatigue I mean a powdery white sensation,
like silently falling ashes.
I mean an odd, painful tightness all over
as if my skin were shrinking around me.
I mean when the plugs in the arches of my feet
are pulled out
and every ounce of fuel drains away.
I imagine it's my blood
that you can see me turning white as the level drops,
a sinking line of ordinary color like a receding tide.
I mean the fine almost imperceptible tremor of muscles that just can't.
Can't hold a book, lift a glass of water, pick myself up
I mean the trip to the bathroom is a marathon
something to summon up courage and strength for
and then crawl back onto the bed,
muscles cramping and shaking.

Long before the clenching of a blood vessel in my brain
left the right side of my body confused, noisy, silent, unattached, wracked
 with spasms and the searing touch
of nonexistent flame,
I *was* confined.

In the strange world of authorized and unauthorized illness, it was the
 stroke
that earned me the right to be believed,
the stroke that lifted me from the bed of exhaustion
into these metal arms, the stroke
that finally brought me the help I needed
to be carried through the world,
to move without moving,
to fly down the sidewalk the way I fly in dreams

weaving between people and trees.
I was a housebound invertebrate.
The stroke gave me the right
to purchase these bones.
The stroke set me free.

 ❧ From *Kindling: Writings on the Body* (2013)

A Remedy for Heartburn

.....

In memory of Doña Gina
Torres of Bartolo

.....

Our people have always been good at digesting even the most indigestible items on life's menu. Insults that would give a conquistador a heart attack—we have learned to wipe them off our faces and put the handkerchief away for later consideration. Sometimes our pockets bulge with insults, and personally, I have a little red leather coin purse that I had to quit using because it wouldn't close anymore. There were so many insults and so few coins that I was always turning up something nasty whenever I dug around for a subway token. When you run out of storage space, sometimes a hiss or sneer or some offhand and cheerful piece of disrespect goes down your throat and your stomach has to deal with it. It's not easy. It gives you heartburn like you wouldn't believe, but we can do it. All of us are experts.

As for this jaw-breaking language that gets pushed into our mouths every time we ask for a piece of bread, we're the best there is at digesting that. We roll it around in our sweet tropical saliva and spit it back, sweeter and sharper and altogether more sabroso. Everything they dish out to us, we soften and satirize with our acrobatic tongues. We wash with Palmolíveh and brush with superwhite Colgáteh. We rub Vicks Vaporú on our chests when we get a cold, and halfway through each day of hard work and boredom, we stop and have some lonche. Not at home on weekends. We never have lonche at home. But weekdays when we step into some hallway with a counter and six red stools and order a sánguich—that's lonche.

That's hard to digest, too—tasteless white bread, a smear of mayonnaise, a few wrinkled slices of ham or old-shoe beef, a square of what these people were actually not embarrassed to call American cheese, and some kind of a pale-green leaf. But our people have hard stomachs. Hunger makes people more like goats. I've known old men who lived for months on end on nothing but the malanga they dug out of other people's land. The USDA surplus lunches they served at our grade school comedor were excellent training for the immigrant eater's lonche break. The kids used to say the beans tasted of cucaracha, they'd been sitting in some warehouse so long. As

for the lukewarm powdered milk we gagged on, it was what each of us was told to be grateful for—it would make us strong and healthy—and, if we got good grades and had respect for our elders, it would make us worthy of our citizenship in that great nation los Estados Unidos, where everything good came from.

At home, there was a lot to swallow, too. The men swallowed the bad price of coffee and pocket-size bottles of rum and the women swallowed hunger and fear for their children, and the mean language and hard hands of their drunk husbands. There was boredom enough to make you go crazy looking for something to gossip about. Petty feuds between hard-up people who had to find someplace to put all the grief and desperation of watching poverty carve furrows in their lives as deep as the rains did in the hillsides. If you lacked the staying power for neighborly backbiting, you could join a religion, one of those fervent, severe, evangelical sects that were always holy rolling through the mountains in search of depressed and lonely people ready to try anything. Or you could drown yourself in illicit love affairs and star in your own novela, playing hourly in the patios and kitchens of your scandalized vecinas. Or if you were lucky, you had the gift of humor and could laugh hard and long at each of the slaps and cocotazos life dealt you.

I said before that hunger makes people more like goats, able to swallow tin cans and get something like nourishment from them. But sometimes hunger makes people fierce, like those wild dogs, left to starve by the humans, that go hunting in packs, stealing chickens and small pets and sometimes mauling people. Every so often, when they all band together, they do manage to maul some people. That kind of anger was hard to lay hands on where I grew up. Discouragement left us numb.

My mother said I was a very hungry child, always wanting more, which there wasn't much of because Papi would usually take his pay to the store and drink a few palitos and a few more before he turned the leftovers over to Mami. Then he would stay up all night giving crazy orders, like no one could sleep as long as he was awake. He would play the TV and the radio at the same time, and turn on all the lights, and go from room to room, banging pots together and dragging us out of bed to keep him company in his drunkard's nightmare. The rest of the time, when he was sober, he was a sweet enough guy, affectionate and funny. But as for me, I was always hungry and bad tempered.

Not Mami. At least not that anyone could tell. Everyone called her a saint. You know that way that Puerto Rican country women can look at a

woman's suffering and turn it into a kind of special attention from God? My mother was that kind of a saint. She worked twice as hard as Papi, in the house and on the farm; longer and harder than anyone else I knew. Her house was ramshackle but spotless, her food was exquisite, her garden plot was in order, and she always knew where a sweet orange tree was ready for picking or a bunch of the best cooking bananas had gotten big enough to cut. She was the one everyone came and asked for twigs of oregano and bits of geranium to plant. She was good-humored and generous, and several times a month my father threw her and all of us kids out of doors, tore up her meager belongings, raged and cursed at her, and hit her a few clumsy blows across the back and shoulders. Although she yelled at him to leave the kids alone, she never complained about his treatment of her. So they called her a saint.

The only thing to my knowledge that she actually longed for was a good house with a nice kitchen. But every day of her life she contrived and conspired for her children, and especially for me, her ravenous little goat. She saw to it that I stayed in high school by doing the extra work I would have done, and she picked coffee for don Luis three years in a row to send me to secretarial school in the city. I stayed with a cousin of hers who gave me room and board for helping out with the house and kids, and learned to type and answer telephones, and memorize all the correct formats for business letters.

I got a job in an office, with some nice people, and at first having even that small salary belong to me, in my own name, was enough to please me. After a while, seeing how little it really could buy made it less of a thrill, but sending some of it home to Mami, secretly, so Papi couldn't turn it into Palo Viejo, was satisfying.

After a couple of years I met Papo, and in not too long I married him and we went back to New York, where he'd been working the year before. He was a good dancer and a hard worker, and had to be because it turned out he was keeping three separate families of his own. One of them was a woman with two kids, who lived in the Bronx. She was under the impression that he'd been visiting a sick mother on the island and at the very moment that Doña Justa was kicking up her heels at my wedding, this woman, Sara, was lighting candles for her preservation from some kind of kidney disease. The other was Cindy (her mother had named her Lucinda), an eighteen-year-old he started in on about six months after we moved into our place in Brooklyn. By the time I found out about her she was very pregnant. She also lived only a block away from us, which was convenient for him. As soon as I had some steady work, I left him to his other families and moved in with my cousin Tinita. I had never actually mentioned to Papo that a little

outpatient surgery I'd had done a few years back had ensured that I would not end up like Cindy or Sara. Then again, he had never asked.

Well, about then I signed up for a class at City College. This girlfriend of mine at my job, Julia, told me about it. It was a class about history, our history. The man who taught it was smart. Puerto Rican, but brought up in los Nueva Yores. I love that expression. It's one of the ways we take something too big to swallow—a country as big as a continent, and all full of americanos—and make it bite-size. New York is about the limit of what we want to think about, so we wave a vague hand north, south, and west of it and call it all los Nueva Yores. I think this fellow grew up in Chicago.

Anyway, we learned all about the Conquistadores and the Taínos and the enslaved Africans. We learned about the Spanish governors who ran Puerto Rico like a boot camp, and about Betances and his buddies trying to get a fight going to kick them out, and then the way the Yanquis just helped themselves when Spain got old and weak and tired. Ricardo, that's our teacher, told us about the big strikes they had for better work and pay, and about this woman who went around reading speeches to the tobacco workers while the bosses thought she was reading them novels, and writing her own magazine called La mujer where she said that marriage was nothing but a pain and women should love whoever they wanted without any scandal, and leave them when they were ready to, without any fuss. I thought about that for a long time, and I finally told Julia maybe she wore boots and smoked cigars, but this Luisa Capetillo was right about one thing anyway. Marriage had not been set up for the benefit of any woman I had ever heard of. Taking this class was making me very hungry indeed. Not goat hungry. The wild dog kind. The kind where you only swallow what tastes good to you and spit the rest out, snarling.

I thought about Mami's life. I had been expecting for years to hear that Papi had driven the jeep over a cliff on his way home from the store, but by some kind of a miracle, Papi had suddenly decided not to drink anymore. He had given the old house to my brother Paquito and his family and had finally built Mami the house she always wanted. It was made of cement, with nothing a termite might fancy to eat. The rain stayed out, and so did the rats. It had a real kitchen with a Kenmore stove and a Whirlpool refrigerator. It even had a water heater, and with fifteen or twenty minutes' notice, it was possible to have a hot shower, something my mother had never had before in her long life of cold-water bucket baths at noon.

Then one day I got a letter from Paquito's wife, Migdalia. Mami had been saying lately that food just didn't agree with her. "You know how Mamá is—she never complains." But finally she had mentioned that her stomach hurt,

and one day Migdalia found her vomiting. They took her to the doctor in Ponce, and the whole way she kept telling them it was silly, she just had a flu—it was from the cold weather lately. But when they took some pictures, it turned out she had so much cancer in her stomach that nothing else fit. They said they had to operate immediately, then, when they had her open, they decided not to bother because there wasn't any good stomach left. So they sewed her up and sent her home with some pain pills, and three days later she died.

Now cancer isn't something that happens overnight. It must have been secretly growing in her, a thwarted appetite for flesh, for a long time. I've been sitting here thinking and I believe it was hunger that killed Mami. Not the times there wasn't enough to eat, because Mami always found ways to stretch a little bacalao a long way. I think it was the wild dog hunger in her that never had anything to feed on but the insults she swallowed, and those English brand names all full of corners, and the vicious retorts she never made to my father's abuse. Migdalia says they offered to drive to the farmácia and call me, but she wouldn't let them. She didn't send any special message, no last words for me, but I've been piecing together the clues.

The kind of hunger that ate Mami's stomach can't be kept in. It isn't housebroken, tame. It can go years looking like a farm animal, hauling water, carrying wood, cooking and digging and trying to stretch a handful of change into a living. It can even be hit with a stick and cursed for its lameness, but watch out. Sooner or later it gnaws at the rope that binds it, and if that rope is your own life, you die. That's the message she sent me. Her hungriest daughter. The one she managed to send away. I imagine her showing me her cancer-eaten belly, holding up the tumors the way she used to show me the yautía she pulled out of the ground. If you swallow bitterness, she says, you eat death.

Recently I don't eat death anymore, and I've been doing my piece to change the national diet of Puerto Rico. Death al escabeche, death al fricasé, death frito, and death con habichuelas. I've learned a lot of history by now, and I know that at least since Colón, we've always been hungry and dying. Some of us have gotten fierce enough to attack the ones who starve us, but mostly the wild dog kind just maul their neighbors and themselves. And the rest of us, we're good farm animals. We get milked all our lives, and then butchered for soup.

Instead of swallowing bitterness, I've been spitting it up. In a way it was Luisa Capetillo who gave me the idea. I got home from Mami's funeral and that Monday after work I began this book. Now it's done. It's a kind of cookbook I wrote for Mami. A different set of recipes than the ones she lived her life by, those poisonous brews of resignation and regret, those

soups of monotony and neighborly malice that only give you gas. Each recipe has a piece of what she gave me, though, nourishing as ñame, floating in a rich broth. It starts this way. *My mother taught me to cook. The name of the first dish was dutiful daughter, but she had a special way with it, so it turned out different from what her neighbors made.* There are recipes for Amores a la Capetillo (subtitled "for Papo"), and a Medianoche full of all my mother never screamed at my father. There's one called Secretarial Lonche that calls for a good stiff pinch of union wage. But my favorite recipe is the one at the very end. Remedy for Heartburn. *This is the most challenging recipe in my book, comadres. The ingredients? You already have them. In your pockets, in your purses, in your bellies and your bedrooms. For this kind of broth, there can't be too many cooks. Get together. Stir the stuff around. Listen to your hunger. Get ready. Get organized.*

 🌺 From *Cosecha and Other Stories* (2013)

Radical Inclusion

You asked me to write, recognizing the need to update the long-standing Reconstructionist understanding of inclusion, based, as it is, on the flawed assumption that Jewish identity will always trump all others, making a tent of unity, and that as long as all Jews are invited into that tent, the question of inclusion has been solved. And my first thought is: This is because whiteness is invisible to those who hold it.

Jewish inclusion has many borders to open—borders of gender, ability, class, political views, spiritual practices, and the very definition of who counts as Jewish—but what's grabbing my heart today is the ways that whiteness invalidates invitation and blocks the way in. The assumption that Jewishness is a kind of dominant gene of identity, always more significant in the lives of all Jews than any other, is historical. It has roots that can be traced, but it's utterly inaccurate for here and now, and in order to pose the alternative, I have to trace those roots.

There have been times and places, specifically in Christian-ruled Europe, when Jewishness was the primary location of our danger and therefore of communal mutual aid, although poverty and sexism were at the root of much of our people's daily suffering. Sometimes, Jews were racialized as "oriental" or "Semitic," but the core of our danger was our role as a pressure valve for class, used to misdirect the rage of the poor and working-class Christian majority away from the Christian aristocracy. Our day-to-day levels of insecurity rose and fell according to the needs of the rulers and how many social ills they had to find someone to blame for. For my shtetl ancestors who were subject, like all those around them, to the greed and arbitrary power of the rich, their Jewishness was what left them the most vulnerable to violence of every kind—not only from church and state but quite often from the neighbors with whom they shared the burden of carrying the aristocracy on their backs.

But when their children came to Turtle Island, mostly in the last 150 years, they stepped into a wildly different social landscape of ongoing Indigenous genocide and land seizures, of ferocious anti-Black racism and an abolition of slavery that only shifted the ground of an endlessly adaptable and infinitely

brutal exploitation, of anti-immigrant laws and bigotries targeting the many peoples displaced by European and US imperialist expansion into Asia, Africa, and the rest of the Americas.

Here, the pogroms burned through places like East St. Louis, where in 1917, rampaging white mobs dragged Black residents from their homes and murdered them or burned them alive inside those homes, places like Wounded Knee Creek, where in 1890, US soldiers massacred three hundred Lakota, hunting down the wounded, including children, because settlers wanted their land. From coast to coast and border to border, whiteness (and the impunity it conferred) was the coin of the realm. Jewishness was not exempt from harm, but it was very far from being the most dangerous identity.

I write these words as the granddaughter of a shtetl-born woman from Kherson province in Ukraine, who, following her father's earlier flight to the United States from the tsar's draft, came to New York City as a child, in 1906, with her mother, aunt, and uncle. They were garment workers, Socialists and Communists, feminists and organizers, who arrived in New York City to discover that they were no longer at the bottom of the heap. In spite of anti-Jewish slurs and exclusions, they found themselves in possession of a social currency that exists only in relation to those who are denied it: whiteness. Of course, not all the Jews arriving in New York Harbor and other ports were granted it, and not all its value was available right away. But the majority acquired and in time consolidated whiteness as part of their new identities in this place, while still navigating their worlds with a map whose compass points were the historic risks of Jewishness: bone-deep insecurity, and the sure knowledge that the Christian rulers of the US could still brush off and weaponize their antisemitism whenever it proved useful. So although the Wounded Knee massacre had been only sixteen years earlier, and a Missouri mob lynched and burned three Black men the spring of their arrival, my radical great-grandmother's question about most issues was "Is it good for the Jews?"

I also write as the granddaughter of two Puerto Ricans who left the island of my birth as impoverished minor landed gentry, who, in spite of the hidden Taíno and North and West African branches of the family tree, and persistent rumors that some of the family were "spoiling the race" with interracial reproduction, had resided in the white column of Caribbean racial accounting, and who, arriving in New York in 1929, promptly lost rather than gained whiteness, and went from being of the "buenas familias" of Naranjito to being Harlem spics. My wealthier but darker grandfather was hidden out of sight while my grandmother, her revealing bone structure hidden under pale skin, applied for apartments by pretending to be Italian.

The only work my grandfather, a licensed schoolteacher, could get in New York was as a janitor, and he got that because when a member of the small Puerto Rican community was promoted, they jointly decided that, because of my newborn mother, my grandfather should get the vacated job and so took him down at night to learn to use the industrial vacuum cleaner so he could apply in the morning. My grandmother entered the garment trade as my Jewish relatives were on their way out. My mother, who grew up in Harlem and the Bronx, was punished for speaking Spanish in school, and like many brown children, when she did well on a paper was accused of cheating. My two sets of grandparents passed each other going different directions on the ladders of class and race.

The goldeneh medina—the land of opportunity and upward mobility for migrant European peasants and workers—was also a land of lynching, Indian boarding schools, chain gangs, sharecropping, and urban slums with which the arriving Ashkenazim had to become complicit in order to rise. There is no need to bristle. We are all complicit with some kind of wrong. Complicity doesn't mean conscious collaboration. Mostly, it means accepting the way things are and not looking at what will make that difficult. The ideas of white supremacy completely saturate our society, and living by its terrible rules is at the core of assimilation for those permitted to join. This, and not some unique capacity for hard work, is the reason that my Jewish family went from sweatshop worker to university professor in two generations. They acquired whiteness.

The Europe from which our Ashkenazi ancestors came was the birthplace of those racist principles, but Europe's colonies were outside Europe, and most day-to-day European contact with people of color happened somewhere else. Certainly, our people absorbed the same racist, colonial ideas about people in Africa, Asia, and the Americas as their neighbors. We know this because early European Jewish settlers in Palestine openly expressed their contempt not only for the peoples of the region in general but also for Middle Eastern and North African Jews whom they regarded as uncivilized, and their dreams were also openly colonial. But for the Ashkenazim boarding ships to America in the ports of Europe, their lived experience of oppression was about class, gender, and Jewishness.

In the United States in a settler colonial society built on the extermination, dispossession, and enslavement of others, they were, however grudgingly, classified as white people and could cash in on the special privileges accorded to white people, a category of human that exists only by contrast. In reality, many Jews are excluded from that category—not only mixed-heritage Jews

like myself but also Jews of North Africa, the Middle East, Ethiopia, China, India, Uganda. The forging of a universalized white US Jewish identity erases the global nature of our people.

As European Jews—the majority of them from Eastern Europe—found their way into the American version of whiteness, they came to see themselves as the center of Jewish identity, to assume that if they were now white, all Jews were white and those who weren't, weren't really Jews—so much so that Black and brown Jewish friends of mine are continuously challenged in Jewish spaces, are assumed to be hired help. Recently, a Black Jewish man I know was set upon by a mob of white Jewish men for carrying a Torah scroll down the street after teaching a student, his life threatened under the assumption that if he was Black and carrying the Torah, then he must be a thief.

To assume that Jewishness is the one unifying identity, the primary common ground for all Jews, the place where we find safety together, is to take whiteness for granted. I am a Latin American, Caribbean Jew of Indigenous, African, and Iberian ancestry, and a direct colonial subject of the US from a country relentlessly looted for centuries. My Jewishness is precious to me, a deep root of my being, but for me, the threatened, those of my people who are dying for the enrichment and power of others, are not Jews. They die in Puerto Rico from deliberate, murderous neglect disguised as natural disaster. They die from death squads killing journalists, labor leaders, and largely Indigenous environmentalists across my continent. They die from a poverty that is, as Eduardo Galeano wrote, a direct result of the wealth of the land. They die from the actions of mega-farming, oil and mining companies, many of them made up of white US men, including Ashkenazi Jews.

Take the example of Schmuel Zmurri of Kishinev, who came to the US at fourteen, peddled bananas in New Orleans, and ended up ruling much of Central America through the United Fruit Company, financing and organizing his own military coups in Honduras and Guatemala. United Fruit was notorious for its ruthless interventions; for brutal anti-union repression throughout the region, including a massacre of banana workers in Colombia; for blocked land reforms that would have returned farmland to the mostly Indigenous poor, and for inflicting major ecological harm on the landscape, none of which is abstract for me. Those who suffer and die are my kin. Now known as Chiquita Brands, the company is currently financing death squads in Colombia who protect the company's interests by silencing labor organizers and intimidating farmers to sell only to Chiquita. My point is, the fact that Zmurri and I share Ashkenazi heritage means we are related, but it doesn't make us allies.

My home base, my community of necessity and hub of communal resistance, begins where the greatest harm is being done—not with white Jews but with the Black, brown, and Indigenous peoples of the Global South, including migrants and their descendants in the US. Identity roots where it must, where kinship is most urgent for survival. The only way to make a Jewish tent that is a true home for Jews of Color is by understanding and accepting this truth. Otherwise, the price of admission is to abandon ourselves and fake our belonging. Inclusion means learning all the reasons why opening the door isn't enough.

Real inclusion requires us to own all the ways that the immigrant survival strategies of most European Jews were built on joining whiteness, which means built on the pain of Indigenous people and people of color, including other Jews. Inclusion must take into account the high cost of that whiteness—for everyone, because assimilation into privilege is always paid for in deep losses.

Each one of us is weighed down by unearned punishments and unearned rewards, so that it seems natural to have more and better and easier, and we are oblivious to whole provinces of the social terrain where our own privileges settle like fog, to hide the landmarks of other people's suffering. But whatever our complicity in the deprivation of others, whatever we've allowed ourselves, in the name of comfort or fear, to accept instead of freedom, is not worth having. Injustice was already here when we were born, is much bigger and older than our mistakes, and claiming each other is much better than lying low.

The fact that white Jews remain vulnerable to antisemitism doesn't change the necessity of facing race. For there to be space in the heart of Jewish communal life for Jews of Color, Indigenous, Sephardi, and Mizrahi Jews, white Ashkenazim need to place themselves all the way into a US context and recognize that whatever their ancestors fled, here, they live within their whiteness (not conscious, not individual, not chosen, but deadly nonetheless), must recognize its unwitting impact on the rest of us, and consciously step away from the center they occupy to make room in that heart for us. This is the teshuvah of race. Not to forsake the richness of Ashkenazi culture (full as it is of the passion for justice) but to shift its dominant place and end its complicity with what kills the rest of my people.

Then the work of turning to face truth, of bringing our full selves into the commons, becomes joyful beyond measure. When the fog is burned off, what remains is an illuminated landscape, where the entire geology of our lives is laid bare, and we see how we are woven together, see the ground of

solidarity we must walk, to reach the future we love. How do we do it? I offer you this invocation, written for the racial justice initiative of my own synagogue:

Racial Justice Invocation

We who have hovered at the edges, with our bundles of silence, our cracked rage, our suitcases full of dispossession, our not rocking the boat for fear of drowning, our letting our white cousins massacre our names, our letting our white cousins ask if we are the help, aching to be known, aching to speak our Jewishness in accents you have never heard before, we who are called Indigenous, called Black and of color, we Jews beyond the Ashkenazi pale, will step, hobble, roll into the center, unassimilated, fiercely lovely in our unedited truths, bringing all our ancestors speaking all their languages into this room, saying we are not confusing, singing we Jews are a garment of a thousand threads, a coat of twenty million colors, for the heart of the Jewish world lives equally in every Jew, and no one is exotic, and every one of us is Jewish enough, and however we travel through the world is a Jewish path.

We who have held the center, raised the roof beams, wrestled old words into new melodies, carried our treasured scraps of Yiddishkeit next to our hearts, carried our shtetls, our Europe, our ship's passenger lists, our landings in the goldeneh medina, we who walked unknowing into the occupation of other people's worlds, walked unknowing into whiteness that coated us bit by bit like layers of shellac, deadening our senses, we who are etched with the pain of separation from all our others, we settlers hungry for unsettling, we will step, hobble, roll outward to the rim of the circle and hold space for our kin, will fast from speaking first, will fast from being the ones who know, will feast on listening, will let the varnish crack and peel, saying we will not be confused, singing the heart of the Jewish world lives equally in every Jew, and no one is the norm, and every one of us is a real Jew, and traveling together through the world is our Jewish path. And stepping in and stepping out, we will weave a dance of justice right here in this room. One two three, one two three, dance!

∜ First published in *Evolve* (March 12, 2021)

Land Days

Every day is a land day somewhere.
People land upon each other,
steal the way the light fell through
particular trees that are gone,
tear up villages and gardens
as if they were weeds, weed out
particular people who are gone
from land that no longer holds
the way their laughter drifted through
open doors along with the smells
of their cooking. We land and are
landed upon, so what

does the windblown milkweed
seed say to the field's edge, already filled
with fireflies and sassafras,
what does the tulipán say
shouldering in among roble blanco,
capá prieto? We choose, we

settlers in the grass, we
un-native to these fields,
these felled woods, these
cane fields and cafetales,
these houses built over graves,
we get to decide, we do not
have to be invasive

maybe the milkweed
rests lightly among the cattails
listening to the night

listening to how each part
sings, how the birches

and the earthworms
are speaking, we could
be like that, we could

listen, all our lives

be like the common
plantain, low to the
ground, rooting only
where there is room
between the conversations
of moss and stars,
join, not destroy, the ecosystems
join, not erase, the whole story

listen to the particular
crimes committed.
lean into their cold truth,
say yes this happened.
taste the ash of it, without
turning away, without lying about
any of it, yes we could

shred the deeds to
these houses built over graves
these manicured, gated
fictions about who
has the right to what, and tell

on ourselves, tell how our
family photographs, people
with our noses, eyes, hair
fleeing hunger, war, pogroms,
therefore always
one foot out the door,
tried to buy belonging, force
other people's land to be home.

we could stay, both feet here
we could change
ourselves, not the stolen land.
become something else.

not, no matter how long we stay,
not native, we could just
root where we are,
in the crux of history
in the truth of it all
not so the land will belong to us

it can never
it is full of other people's stories
we do not need to own their losses
or the way the light fell,
we do not need to
rename everything after
ourselves, piña is not an apple,
we lost the apples
we came across water in
leaky boats, we miss
a different light

but so that we can

not clear-cut history, not plow
the wildflowers of the prairie
into acreage, but lie down in it
and be stained, overgrown,
we could adapt, cross-pollinate, become
naturalized, become common,
be low to the ground, rest lightly
honor the people, still here,
long before us

belong to the land.

 From *Remedios* (1998)

Milk Thistle

Milk Thistle teaches guerrilla warfare. Adaptogen milagrosa, Milk Thistle works with what is here, the yellow layers of toxins, the charcoal grit, the green bile slow as crude oil pooling in the liver's reservoirs waiting to learn to flow. Milk Thistle says take what you are and use it.

She's a junkyard artist, crafting beauty out of the broken. She's a magician, melting scar tissue into silk. She's a miner, fingering greasy lumps of river clay for emeralds. She can enter the damaged cells of your life and re-create your liver from a memory of health. She can pass her hands over this torn and stained tapestry of memory and show us beauty, make the threads gleam with the promise of something precious gained.

She will not flinch from anything you have done to keep yourself alive. Give it to me, she will say. I will make it into something new. She will show you your courage, hammered to a dappled sheen by use. She will remind you that you took yourself over and over to the edge of what you knew. She will remind you that the world placed limits on your powers. That you were not omnipotent. That some of the choices you made were not choices. Use what you are, she says again and again, insistent. You are every step of your journey, you are everything that has touched you, you are organic and unexpected. Use what you are.

ॐ From *Remedios* (1998)

Breath: 2020

Inhale: The lungs unfold like wet buds revealing cavernous petal-draped tents. The lungs unfold like wetlands sucking in the tide and all it carries. It rushes in, awash with seeds and mollusks, dead twigs and sparkle, tiny crustaceans, flecks of metal, the rust of offshore oil rigs. It all pours through, saturated with sky, blushing the blood.

Pause:

Something nestles into the moist pink passages and takes root.

Exhale: Invisible dust storms. Floods of glittering plankton. Spinning moons. A red tide. Clouds of infinitesimal telegrams, flocks of speck-like origami birds, folded ribbons of code, invoices from the deep wild. The black wings of dread just beginning to flutter. Every mouth makes its wind. Every body is the root of a shared weather.

Pause: Microscopic rainstorms sweep across the plains between your mouth and my mouth, between syllables. It takes no time at all. Mats of water hyacinth drift and lodge and multiply.

Inhale: An explosion of stars spiraling across these small distances. I take in whole galaxies. My lungs become mossy, filled with spikes. The tiny barbs embed themselves in the core of what we take for granted. I am dizzy with it. I am felled.

Pause: A crackle of vessels branching out in supplication. Where did air go? How did I become a sodden sky?

Exhale: Dark wings pour from my mouth. Can we forgive this? Great flocks of sorrow migrate across the world. I cannot empty my chest and I cannot contain its spores. My mouth is a broken gate. My throat is a storm drain. My lungs are volcanos.

Pause: The delicacy of breath, the lacy possibility of it, throwing its birdlike shoulders against a door of stone for just a trickle of the essential.

Inhale: But I can't lift the mountain. But there is whistling and wheezing, an orchestra of half-choked instruments, shuddering reeds. But I am in a straightjacket made of muscle and wet sheets. A diver in the Dead Sea, I cannot go deep. Air runs over pebbles in shallow streams.

Pause: My bronchia are an undersea forest of swollen weeds. My heart, nestled between lobes, beats frantic wings against a cage of bone.

Exhale: Creaking of rusty hinges. A million caltrops whirling outward, snagged in nets. From this pillowed cotton to the white curve of the chamber pot is a journey of light-years. I will wake up old.

Pause: I remember immense cranes standing like steel horses around the Port of Oakland, ready to lift impossible weights off the decks of half-submerged freighters riding low beneath their cargo. I summon them to this effort.

Inhale: Five herbs send tendrils of steam into my crevices. It's raining outside. A tablespoon of breath, two tablespoons. I sleep and wake propped against a wall, and watch slow motions: shadows across the wall; milkweed leaving a thick-packed pod; melting snow sliding from bent boughs of fir; red clay settling down the mountainside; the lazy spinning universe of vertigo.

Pause: Fossilized air embedded in the walls of this year. Gasps and sobs turned into ammonites.

Exhale: There is a salt breeze on my breath. Oceans fill me. The distances are shrinking back into place. Damp shirts reeking of mineral sweat hang from the line through weeks of thunderstorms, slowly releasing molecules of pain. Elecampane left shadow leaf prints on my inner pavement. There is a new language of exhaustion in the world.

Pause: Sixty-six million mollusks open and close their shells in a staggered dance. Sixty-six million flowers open, spew pollen, and crumple shut. Sixty-six million forests spring up overnight and shed their leaves. There is no word big enough for the weariness.

Coda: When I was younger than school, my mother would buy them at the Japanese grocery at the corner of Broadway, smooth white clam shells sealed with little strips of colored paper we peeled away. When we dropped them into a glass of water, the white valves opened, and a paper flower, ruffled as a peony, unfurled from its cramped container and rose slowly, held by one thread, to float, swaying gently, among dozens of little bubbles.

I am the rigid shell clamped tight and the mercy of water. I am the tender bloom and the tethering strand. I am my mother's coin purse and the little shop smelling of plum blossom. I am gathering myself to take another breath.

🖋 First published in The Telephone Game (2021)

6 THE STORY OF WHAT IS BROKEN IS WHOLE

The title phrase came out of my mouth during an interview with Irene Perez about Latina spirituality. "The story of what is broken is whole." When we tell the stories of what has broken us, that in itself is an act of wholeness. As a researcher of stolen histories, sometimes all I can do is talk about what's missing, but that in itself becomes an artifact, a shard. By tracing the footsteps of that theft, we map what happened.

The writing in this section is about many kinds of breakage, from Nazi-occupied Eastern Europe ("Buried Poems" and "Eshú in Ukraine") to Afghanistan ("Mothers") and Gaza ("Gaza Nights: January 2009") to the revelations of child graveyards at Indian boarding schools in Canada and the US ("Lament"). "Histerimonia: Declarations of a Trafficked Girl, or Why I Couldn't Write This Essay" puts my history of being sex trafficked as a child into the context of rape and conquest in the Americas, "1919: Lost Bird: Western United States" tells the story of one Lakota woman stolen as an infant and exploited in multiple ways by her captors. "Plaza de Juárez" and "Historical Marker" link individual heartbreak to historical violence, and "Stroke" talks about the

erasure of disabled people's sexuality from the rehab process following a stroke, while "Salt," "Difficult Love," and "Metal to the Forge" dive into more personal loss. "Guerrilla Psych" is about how I built connections during an eleven-day stay in a psychiatric facility, and imagines alternatives to the pathologizing of emotional pain.

This is, at its heart, one of my main tasks, to tell the stories of how we are broken by injustice, and tell them in ways that mend us and make it possible to heal not only ourselves but the world.

From *Dark of the Year*

DARK OF THE YEAR IS AN UNPUBLISHED COLLECTION OF POETRY WRITTEN BETWEEN 2000 AND 2002, DURING THE DISINTEGRATION OF MY MARRIAGE, IN THE SAME TIME FRAME AS 9/11 AND ITS POLITICAL AFTERMATH.

SALT: FEBRUARY 2000

Your anger flares into the distance like a train.
Then dark peace rises, bitter and strong.
I stand alone among the cedars, in the scent of rain.

What is still here? In the pumphouse tanks,
water keeps rising from the earth,
piped to our throats, cool,
tasting of stone. My wedded heart still does its dance.

My hands want to trace your bones, the hollow of your temple,
stubborn jaw, the place where neck meets collarbone,
with rain on my fingers. Something that simple.

Something that obvious, inexplicable and pure.
To taste on your lips, without a word,
salt of the sorrow you endure.

———

DIFFICULT LOVE: MARCH 2000

One winter in New Hampshire,
the snow fell so thick the branches bent themselves,
mute, all the way to the ground.
They didn't break, but neither
did they sway or crackle. They never made a sound.

Let me be. I am stunned with grief.
I need my winter, my cold, silent season.
Don't say *love*, expecting kisses.
This isn't springtime. Just love me. Just wait.
The way I loved and waited for those trees,
bent to earth by what they willed themselves to bear,
kept from breaking by their own green, dormant wood,
day after day in the white forest where nothing moved.

I do not believe in spring tonight. I didn't then.
But the bent branch of the cherry tree, stiff and stark
through ice-bound nights, and grey thaw, and green rain
did soften to the sun one day. Sobbing and creaking
the drenched wood opened
into sweet white fire that set the hills ablaze.

———

HISTORICAL MARKER: MAY 2002

She says she doesn't want the baggage of my crumbling marriage,
that any land she enters with my love will be new land, a clean slate.
She believes there are places outside history,
that the dips in the ground are not the ruts of wagon wheels,
axles groaning, that traveled this road before her.
The new settlers in occupied lands always sing this song:
empty, fruitful, virgin. They say that because the houses
are made of deerskin, or birch, or mud
they are not really houses,
because the rain will wash out the stains of blood on the stones
that no one was here. Don't believe it, I tell her.
Five hundred years after the slaughters,
the names of those whose history
shaped the bed you lie in
still bleed through.

———

METAL TO THE FORGE

You said you were iron
walking by choice

into the white heart of the forge,
ready, willing, eager
to burn away dross, to come clean.
Metal to the forge, you said,
this is how I come to you,

You said you thirsted
for transformation
as the downtrodden thirst for justice,
to be taken to the unbearable limits of heat,
hammered, beaten into thin, silken sheets of steel
on the anvil of this love.
Take me there, you said.
No matter what you do,
don't let go.

Imagine me then
lifting your molten heart
from its bed of embers,
laying my soft blows
to this lump of slag
that will not crack
that cannot shatter
can never show me its lovely, liquid, cooling core,
pure untouchable metal
gleaming in its husk of cinders.

Imagine me stoking the fire
blistered fingers, scorched hair,
feeding whole forests
and my crackling fear
to the furnace of my intent,
holding myself steadily in the flame,
singing *come*,

and in the shimmering air
glimpsing again and again
the sweet mirage of you
The promise of a horizon
that never changes, or fades,
or draws near.

PLAZA DE JUÁREZ

It was in the years of the Revolution. Her husband was a gunsmith.
She had seen her twin sons murdered, and soldiers drag her love away.
Her name was Mercedes. Her granddaughter told me this.
There was a place to go, then, when you had lost

the heart of your life: son, husband, brother, father, stolen for war.
To the plaza in Juarez where the hopeful bereaved
circulated asking *Have you seen him? Has anybody*
seen him?

I also ask among the living, but there is no trace of you.
I glimpse you only in dreams and even there, you are missing.
Each day beloveds die in the wars of others, bodies broken and buried.
And each day in their millions, people we have loved
fall under the wheels of their despair, use sex
or whiskey or cocaine to deaden it
and are torn away from our lives.
Morning and afternoon, for six years, like me
Mercedes Esqueda went to the plaza
remembering that last meeting of their eyes,
unwilling to believe it was all she would ever have of him.
Once, someone told her he'd seen him, in a camp,
years earlier, far away.
Morning and night and morning she looked for him,
not yet a widow, not yet.

Then one day she folded away her hope
and stopped looking for his eyes in the faces of strangers.
She crossed the border and stepped on a train
headed for the rest of her life.

Stroke

WRITTEN FOR SINS INVALID PERFORMANCE PROJECT AND USED
AS THE SOUNDTRACK OF A DANCE I PERFORMED.

Stroke

stroke
stroke

when it happened the right side of my body disappeared from the map
left only tangled lines. everything dragged down toward earth
except for my pinkie that curled up and out like a twig.

when it happened my foot was pierced with fire, but cold and swollen
as waterlogged wood. my skin couldn't bear the weight of my sheets.
touch made me scream and weep.

when it happened my hand was scalded, wracked with spasms,
a dense slab of pain. five fingers set adrift from my brain
couldn't cup, grip, press, pinch.

therapy began with holding my right foot in my left hand and squeezing
so it would know where it was. so the crazy screaming nerves would
calm down and remember to be foot.

therapy was holding my runaway fingers together
reuniting the pinkie with the ring finger, teaching them to be hand.
therapy was stepping on needles, on burning asphalt, on
glaciers. ten steps. fifteen. try again.
start rubbing the skin with silk, they said,
with wool
with terry cloth
put sandpaper on the toilet seat.
apply texture to the hypersensitive and the dulled.
the arm, the hand, the leg, the foot, the face

no one asked, no one ever asked
about inner skin
about silk and touch and stiff
uno dos tres cuatro cinco
all summer at the gym in Havana
all day every day step, step, step
up down open close
my hand clenching, spreading, uncurling
my foot stepping, bending, arching
walking
strongly
on the earth
but no one asked, no one ever asked
do you feel this?

the injured brain forgets the places it's lost connection with
blank spaces in the atlas, unexplored oceans
find your missing continents, they said
grasp with your hand, put weight on your foot, touch your face
use it or lose it
but no one asked
do you feel this?
or this?
no one said,

pleasure is a lost continent
touch yourself with silk
how is your clitoris today?
use it or lose it.
stroke, stroke, stroke

no one helps me.
I explore the dry places and the wetlands.
struggle to clench and release muscles that forgot how.
rub dry sticks trying to raise a spark.

open, close, open,close
tracing the tips of nerves that have been sleeping
hoping they will wake up and remember to be delicious
the hand that dives in is still thick as a novocained cheek.
it cramps on the vibrator.

how do I tell which is numb,
the slick, ridged wall or the finger.
clench and release, clench and release

breath takes me down
breath is a bridge across numbness
closing gaps in the circuits
streaming past burnt neurons
chi dancing naked in the dead places
becomes my instructor

exercise imagination she murmurs,
remember
wet tongue, long finger, velvet cock.

breathe them into bound muscle
conjure sensation out of thin air.
the imprint of memory
begins restoring the coastline of pleasure
mirages shimmer in the air, forgotten peaks
floating above flesh
breathe them in
breathe them out
become what I have lost
until nothing is missing
stroke
stroke
stroke
stroke
stroke

 From *Kindling: Writings on the Body* (2013)

1919: Lost Bird: Western United States

She was found under the stiff and bloody body of her mother, in the bitter cold of winter on the slaughter fields of Wounded Knee, and from that moment she became a souvenir. The soldiers would not allow her people to retain her, such a luscious little lump of sugar, such a black-eyed trophy, such an adorable symbol of conquest, little Zintka, the Lost Bird of the Lakota.

Leonard Colby was a brigadier general, with first dibs, a man of devious mind and ruthless appetite. With great fanfare and flag waving, he adopted Zintka and exhibited her to the world. Two thousand paraded by her in the first weeks, until she grew ill from their gazes and their withering breath. Clara Colby, a suffragist and a good-hearted woman, cared for Lost Bird as best she could, but never understood that pit of sorrow within her, full of deerskin and dried blood.

Leonard understood it and relished it. It was for the wound, for the helplessness, that he took her from the frozen ground. It was for the helplessness that he kept her, and as she ripened toward womanhood, would enter her room at night and take the field, and watch a people fall to earth again and again. Separated from Clara, Leonard had all the power. Pregnant, despairing, imprisoned by her "father" in a boarding school where any disobedience was punished with the leather straightjacket, Zintka gave birth to a stillborn son. Clara, demonstrating beside Emmeline Pankhurst in London for the suffrage of women, never heard her silence until it was too late.

Look at her now, her face distorted by syphilis, a bequest from her husband, Zintka of the Lakota dances in buckskin and beads as the mascot of a sportsman's club offering the illusion of exotic worlds to jaded white men hungry for what they had tried to destroy. Lost Bird, she flies through the silent films as a beautiful "Indian maiden" and into the noise and tobacco smells of Buffalo Bill Cody's Wild West Show. She tries to go home, but her

relatives don't know how to claim her, the city girl with flashy ways. Look at her now, on a rainy day in February, gasping for breath as her heart, squeezed tight by the disease of conquest, succumbs to the flu that is killing hundreds of thousands. She is the lost child, the wounded wing, the broken song, the stolen girl, the invaded land. She died of syphilis, she died of grief, she died of contempt, she died of costume, she died of ignorance, she died of theft, she died of her missing name.

 ❧ From *Remedios* (1998)

Lament

INTRODUCTION

It is not the work of artists to respond to every emergency, each headline, to repeat what is already being said, to declare each outrage, even though we often feel as if it is. The news drags at my heart, but I wait. I cultivate hope and possibility, and let the terrible move through me until they, the terrible and the hopeful, can speak in me together. Often it's the accumulation of the terrible that pushes me to reach for a place outside the normalized, numbing awfulness of oppression. In my poem "V'ahavta," I wrote about the responsibility to imagine winning, six weeks after the Pulse massacre of mostly Puerto Rican queer young adults left me unable to lift my heart from the floor.

This morning, I was reading about the 215 small bodies found buried on the grounds of the Kamloops Indian Residential School, another 91 dead Palestinians from 19 families, including children, and 150 young students abducted from a school in Nigeria, in a week in which I had been looking at artwork I made a few years ago about a mass grave of murdered Jews, including 19 "mischling" children in my grandmother's village in Ukraine. Then I read Rebecca Foust's wonderful poem "and for a time we lived," describing our times as if reporting to future generations, and was reminded of Bertolt Brecht's "To Posterity":

> You, who shall emerge from the flood
> In which we are sinking,
> Think—
> When you speak of our weaknesses,
> Also of the dark time
> That brought them forth.

And in the company of poets, I felt the stirring of my own words and wrote this poem.

LAMENT

Everywhere the earth is planted with small bones.
What will the archeologists of a distant time imagine of us,
unearthing our stories, delicately wielding brushes
made from the last feathers of the last crows
carefully preserved for the purpose? Will they remember,
tell each other, sitting quietly amidst their flowering fields,
about the terrible ages when children
were mowed like corn? Or will they stand,
in somber amazement around these graves,
squat over the fossils of our anguish, dark feathers
brushing across ivory ulna, puzzling

unable to comprehend
a world studded with crime scenes

asking what extinct rivers could have made
such odd accretions, trembling and aghast
at the dawning realization of the crimes?

Maybe they will find, deep underground,
frozen deposits of briny grief,
our numbness melting
in their compassionate hands,
as they gather, arms around each other in the dusk
and weep.

Eshú in Ukraine

I am in a field in the Ukraine, at a place where roads fork, carrying a dark bundle on my back. Part of my heart has been buried in these fields, and I am drawing it up, calling it by name to rise up the way buried grain rises, red winter wheat of the steppes, Mandinka rice, Mesoamerican maize, a fat green malanga sprout unfurling a tropical green flag among the apple trees. I have come to turn ash into food.

Eleggua stands in front of me, scuffing the dust of choices, a small dark-eyed Jewish child with a red and black cap, tossing coins in the air. Eagles and crowns rise and tumble, flashing golden threats and possibilities, inscribed with lessons and consequences. I ask him to open the way.

This is the road to my grandmother's village, to the old house where she was born more than a hundred years ago as Riva Sakhnin, in the agricultural kolonia of Israelovka. I am walking backward, from the urn of ashes on my cousin's bookshelf, to this point of decision, where the road splits and the red tracks of war must be reckoned with, where I must choose my own Jewish name.

I am traveling across centuries of massacres, stepping through the burned villages of the Caribbean, navigating over the salt bones of West African kin, working my way through a minefield of contemporary killing, to come to this one site, a pit dug into the edge of a Ukrainian forest, where nineteen mischling children were shot dead and thrown across their neighbors' bodies in the late spring of 1942. Eleggua tosses the coins and I smell the soft wind across the wheat fields. From this point on, there are two roads, two ways to enter the village, two names to call as I knock, two ways to leave.

The last stage of my family's journey to this place begins in 1807. Two hundred and fifty Jewish households from the crowded cities to the north accept the imperial offer of land, houses, tools, seeds, and draft exemption, in exchange for which they must settle this border land, plant their bodies here as a hedge against Ottoman Turkish armies and dispossessed Tatars, and grow wheat for the bakeries of Moscow. They climb into their heavily loaded wagons and, wheels creaking, begin driving south, until they arrive

at their designated site, in the guberniya of Kherson, near the Ingulits River, just southeast of Elisabetgrad and the ironworking city of Krivoy Rog.

They were Jews under Russia, using multiple names, public and private, gentile and Jewish, accepting their recently required surnames for official use. They spoke Yiddish, Ukrainian, Russian, German, and Lithuanian, and the men had Hebrew for their prayers. The name they chose for their town was Yazer, from a root meaning strength and healing, sometimes translated as a gathering of priests. The name they were given was Israelovka, Jew Town. The two names twine through the pages of official records and personal letters like different colored threads, printed and handwritten in Russian and Yiddish.

Was it from Jewtown or from Yazer that my great-grandparents departed in 1904 and 1906, respectively? Probably both. I cannot read my great-grandmother's diary, written in almost totally faded pencil, in Yiddish, in a small black notebook. In the margins she has copied out an address in Canada, another in New York, and the one word, practiced over and over again, Amerika, in Russian script. On the page beside this is a shopping list, rubles needed and spent, quantities of fish and grain. How can I tell what she dreamed of? Pogroms burn at the edges of our family stories, never in our direct gaze. 1905 was a bad year, and Kherson was at the eye of the storm. Apples, she wrote. Soap. Salt.

They were long gone, my great-grandparents Leah and Abraham, their daughter Riva, Leah's sister Rivieka and brother Samuel, all living in Brooklyn and speaking English, buying fish with dollars, eating store-bought bread, when the Einsatzgruppen roared into the village in armored trucks and ordered the people of Israelovka to dig.

Cousin Basi was in Moscow. In photo postcards taken in the 1920s, she and her sisters bloom like extravagant sunflowers, some blond, some black haired, all direct of gaze with beautiful wide faces, long necks, strong noses, big bones.

When the war is over, all I know is that Basya was alive. Of the other swan-necked wild-haired women smiling into the camera's light, I know nothing. Still less about the black-eyed girl of seven or eight, her snapshot labeled only "Bella, Esther's daughter, 1922." She would have been in her late twenties when German armies laid siege to Stalingrad, captured Smolensk, tried to take Moscow. I don't know where she was when the soldiers rounded up her cousins and herded them to the edge of the woods.

Gitl, the baby born when my great-grandfather Abe was a half-grown boy, had married Shabsel Loshkin, a tailor. They had a daughter Fira and

a son Boris, and traveled more than five thousand miles to Birobidjan, the experiment in Jewish autonomy way out there on the Chinese border in the remote east. I don't know why they were in Yazer when the Nazis came. My father had a story of relatives missing the last train to Siberia because of a sick child. Was it them? Had they moved back, come to visit, returning like salmon to their birthplaces to die? Hershel, the brother, was also there, with his wife Perl, and their daughter Musia. He was a tailor. She was a seamstress. Musia was a teacher. They died on May 19, 1942. I don't know the time of day, but it was light. Their bones are in a trench on the lee of a hill, under the mischlings.

Of the Shevelevs, Zasloffs, Loshkins, and other kin who were left behind when Mom and Pop each steamed away from Odessa on their separate journeys, there is no word. There has been no accounting. There is silence.

I am not just here for the names of the dead, my particular relatives, the bits of shared ancestral DNA sticking to the tools of the forensics team, as they collect fragments of cloth, hair, teeth, for war crimes prosecutions that never come to trial.

I am here to excavate possibilities, to find out what it means to carry a suitcase full of unfinished stories, broken midsentence, from country to country, so heavy they make us lean to one side like a tree that grows in the path of a prevailing wind.

Eshú stands at the X where West Africa crosses Arawak, Catholic Spain crosses Muslim Spain, conquering Christians and secret Jews emigrate to the Indies together, and together slaughter and burn, rape and enslave, love and befriend, plant, harvest, and exploit, have children and are buried. At the little crossroads where the Yauco, Maricao, and Lares roads meet, and one road leads to Castañer, where my mother's legs part to push forth a mischling, a mestiza child with ancestors sprawled all across the atlas, who has come here searching for one grave among millions.

Eshú winks and the coins fly from his fingers, return to his palms, like the golden shower of kopkes my great-grandfather's religious schoolteacher dropped on the desks of students who knew the answers.

The place where I was born is called Indiera, Indiantown. No hint of its real and hidden name remains. But there were polished grinding stones in the river, shards of pots dragged into the open by rain on clay, and the green guava smell of something missing. The rain and smoke smell of a world that is gone. The something under our fingernails that says *you mean almost gone.*

Each point of suffering shatters into a thousand roads we could take. Each time the death of a people is attempted, paths spin out in every di-

rection. I came here to ask this one question. Which is the path that leads away from war?

I am a many-spirited Caribbean Jewish child on my way to a grave in a village. One road always leads to Indiantown, Jewtown, Spictown, Trashtown. I am looking for the road to Yazer, for a way to choose that name again, a way to let the burdens of history return to the soil and be made fertile, to be a gathering of people burning with our own clear light.

Buried Poems

All through the late summer
as they laid lines of steel,
cold bars of hard labor
across the mountains of Serbia,

Miklós Radnóti snatched poetry from the air
and stuffed it in his pocket.
Beautiful as a shadow, beautiful as light
he wrote to his wife, *beyond three wild frontiers.*

Farms burned over the hill,
the unwashed men stank and bled
and were left by the roadside
shot impatiently in the head. Where
did he find a pencil? From
what smoke did he make ink?
How did he keep the little notebook
hidden on the forced march?

As he walked, his hair grew back
from the rough shaving of the camp.
Bruises occupied his skin. He wrote
I am alive, I will come back,
I will find my way to you.

November, 1944, the black limbs of ash and oak
stretched, in supplication, toward the sky.
Stripped of every leaf, Miklós
and three thousand other exhausted men
stumble from one thicket of guns to another
toward a dark hole in Hungary.
I will be as resilient as the bark on trees
he promised her, the poems
still in his pocket,

when she turned his earth-damp coat
brushed soil from his mouth, pulled forth
the mildewed pages buried and exhumed,
and found the poetry grown in rings around him,
peeling from his bones, tender and green.

By the vast grave she read
how he had picked himself up, turned
from the ditch of death,
moving through the terrible days
toward everything that matters:
the plum trees, the garden, her hair,
words hidden everywhere, in each fold
of ragged cloth, insisting to the hollow-eyed moon,
there must still be a way home.

 From *19 Questions on the Yazer Road* (unpublished)

Mothers

I am of the generation of red diaper children that was raised on the songs of the Spanish Civil War, that brave international effort to stop the spread of fascism in Europe. As a six-year-old, my father had gone door to door collecting coins to support the International Brigades, units of mostly communist volunteers from Europe and North America, many of them Jews. It was one of the heroic stories of my childhood.

So, when, at the age of twelve, I began translating poetry from Spanish, I started with Pablo Neruda's Spanish Civil War poems, *España en el corazon*, and the first poem I chose was "Explico algunas cosas."

You will ask, says Neruda, *where are the lilacs, and the metaphysical blanket of poppies and the rain that often struck your words, filling them with pinholes and birds. I will tell you everything that has happened to me.* Then he describes the neighborhood of Madrid where he lived, his house, brimming with geraniums, the marketplace with its heaps of bread, rows of fishes and ladles of olive oil, a city alive with the drumming of hands and feet, and beyond it, the dry, leathery face of Castile.

And one morning, everything was burning, and one morning, the bonfires leapt from the earth devouring beings, and since then fire, gunpowder since then, since then blood.

Eighty years ago this month, German planes bombed the Basque town of Guernica, the northernmost stronghold of the Iberian anti-fascist resistance, and an important cultural center for the Indigenous Basque people. It was early evening, on a market day. Most of the men were away fighting, so the crowd gathered in the town square was made up of women and children, trapped there because the roads and bridges out of the town had been hit first and turned into barriers of rubble.

I thought of them today, the people whose deaths Pablo Picasso brought to world attention with his most famous painting, and of Neruda's poem about the bombing of Madrid. *Traitor generals,* he cried, *look at my dead house, look at broken Spain.*

I had been reading about towering flames rising over Nangarhar, about the ground shaking as if in an earthquake, of people at a distance knocked

unconscious by the force of the blast. I was reading about impoverished tribal people whose fields were just destroyed, about high maternal and infant death rates and no medical care, about a border slashed through the land by British invaders, and a government that provides nothing but decade after decade of war.

The US military men who dropped this gigantic weapon onto the homeland of Pashtun farmers in a show of strength meant to intimidate the world called it the mother of all bombs. Bombs are not mothers.

The actual mothers of this beautiful, wounded world are taking one step at a time, trying to protect our children from an all-out war on life, and all too often are forced to grieve them. I think of the mothers of Guernica, the mothers of Vietnam and Palestine and Syria and the Congo, the mothers of Buenos Aires and Detroit, Chicago and Ayotzinapa, Indigenous mothers like Berta Cáceres, mothers protecting rivers from Amazonas to Standing Rock, real mothers.

I have no punchline or moral to end this with. Neruda's poem was a defense of political art, a declaration of conscience. He writes, *You will ask why my poetry doesn't speak of sleep, of leaves, of the great volcanos of my native land.* And he answers, *Come and see the blood in the streets.* Like Bertolt Brecht, who wrote, "What a time it is when to speak of trees is almost a crime, for it is a kind of silence about injustice," Neruda seems to be saying that blood makes leaves and land irrelevant. But today we know that trees and rivers, land and sky are all swept up into the same struggle, between the cultivation of life and its destruction, between the practice of mothering this living planet and all its beings, a practice rooted in the heart, with or without a womb, and the so-called mother of all bombs.

And then words of a song begin to run like a thread of water through all this trouble, and I find an ending after all. It's the rich, jazzy voice of vocalist Linda Tillery filling the sanctuary at my synagogue with her rendition of an Eric Bibb blues song: *Time has come, enough is enough, got to move aside, let the mothers step up.*

 ↝ First published in *Letters from Earth*

Gaza Nights: January 2009

On the first day the earth shook all the time, a constant trembling underfoot. I was in the forest, watching Ruby-Crowned Kinglets in the underbrush, sitting still in the presence of trees that were seedlings when the Ottoman Turks took Palestine. When I came home, the roof of tranquility was gone.

On the second day the journalist on the radio said there were old men sitting in the street weeping. He held the phone out his window so we could hear the whisper of limbs trying to find each other.

On the third day I am trying to write about Gaza, but in my mind's eye is a silver-toned photograph of Wounded Knee, 118 years ago today. I want to write about the dead of the last half hour, of the last five minutes, about the mosque the police station the children walking home from school, but what fills my inner eye is cannon tearing through buffalo hide to where families lie wrapped in fur, and afterward silence, torn edges hanging still in the bitter winter air.

On the fourth day I say Gaza and my mouth fills with rivers of blood: Sand Creek of the Cheyenne, Bear River of the Shoshone, Mystic River of the Pequot, Red Bank of the Sauk and Fox, the Coayuco and Loiza and Yagüez of the Taíno.

On the fifth day I think about the concept of retaliation. I remember that when the Sauk returned to their village by the great river, the white general said it was an invasion and ordered a massacre. To conquerors, every act of resistance is an atrocity. Surviving is provocation enough. Among the occupied, not even babies are civilians.

On the sixth day and every day after, I think of tight spaces: the holds of slave ships, cattle cars, canyons, London bomb shelters during World War II. I think of the most densely populated place on earth on fire with the doors locked.

On the seventh day I realize I haven't been sleeping. When I lie down I see pictures, so I get up and turn on the lights. My stomach hurts all the time. I watch a mouth say the words "there is no humanitarian crisis in Gaza," and I realize that she means there are no humans there.

Days eight, nine, and ten I am organizing poets, collecting a sheaf of voices so we can begin tearing and mending the story.

Today one of the poets says her whole family, gathered in a basement in Gaza, almost died last night. I learn about laser weapons that explode people from the inside, depleted uranium shells, something that's shredding people's limbs much more than the "usual" bombings. Suddenly I am sixteen reading about "daisy cutters" and other devices meant to tear apart the bodies of all the families in Vietnam, because the maimed and agonizingly wounded will heap greater suffering on the so-called enemy than the merely dead. I am sixteen reading about napalm, etched, like all my generation, with the photograph of the naked girl running down a road from a village in flames.

On the eleventh day I dream I am one of a multitude walking without legs. On the twelfth day I recognize the smell of these weapons, the stench of them drifting across the beaches and hills of my country, playground of armies, where every nightmare device, every terrible substance, has its trial run and incubates tiny wars in the cells of everybody downwind.

I stop writing. I can't write. I sleep a few hours in the dawn. At night I am wide-eyed, listening to a silent movie. The news has edited out the voices I most want to hear. The murderous assault dies down below the tideline of the nightly news, back to the slower grinding to death of a people, but I still can't sleep.

I don't sleep until I arrive in Cuba, the leading exporter of hope, until the Jewish neurologist holds my hand, says he, too, is the descendant of Ukrainian migrants, says his son is in Israel and thank God, he says, not in the army, nowhere near Gaza, not part of it, and I ask how it's been for him, how he feels, not knowing what he believes, and he says *I had a heart attack* and I look at him and say *That's when I stopped sleeping.* We stand there for a moment, holding hands, and in the morning, I begin to write.

Guerrilla Psych

June 2002. I was in the depths of a very bad breakup and I wasn't eating or sleeping much. Two months earlier, my partner of six years had left without saying goodbye, committing a series of betrayals on his way out that devastated my trust in others and in my own judgment. I felt desperate to escape my overwhelming emotional pain. I'd just returned from a major academic conference, where I'd had two seizures in a single night, each time waking to ask where he was, my missing husband. One nurse said doubtfully that I had no ring and no tan line. In the two sunny months since his departure, it had faded.

Now I was back home and it was late at night and I couldn't feel my feet. I didn't know what was happening to me, didn't know my shallow breathing had deprived my extremities of oxygen, so I went to the ER, thinking about my numbed arches and toes, not my broken heart. I don't really remember the full sequence of events. I was exhausted, it was one in the morning, and they had only one option on offer. Either I got in an ambulance and went to a suburban psych ward, or I went home to the same hyperventilation that had made my legs vanish out from under me, back to single parenting through alternating bloody anguish and black despair. I wanted something, anything, to change, and I was too tired to think, so I let them put me in the ambulance. When I got to the facility, they said I had to take a massive dose of Remeron or go back home. I slept for three days, the heavy hand of the medication forcing my eyelids back down each time I struggled toward alertness.

But on Day 4, I woke up and started talking to my neighbors, and because I'm an organizer and a healer, I listened to their stories and I organized, doing what I do with all my struggles, trying to find ways to collectivize them in a world of privatized pain. What I saw all around me were emergencies that never needed to have gone this far. We were all of us imprisoned for lack of community.

There was the young, white, devoutly evangelical Christian woman who had become pregnant while at college, whose lover was East Indian, and whose mother, also devout, had forced her to have an abortion, which they both believed was a mortal sin. She was brought home to live with her par-

ents and forbidden to ever mention the pregnancy or the abortion again. Her mother's racism and fear of scandal in their congregation had taken precedence over what she'd always been told was God's irrevocable law. Imposed silence and the spiritual abyss that opened up inside of her sent her reeling into a so-called psychotic break. When I met her, she was loaded to the gills with lithium, and unable to cry. She needed help to integrate the immense moral contradictions, grieve her lost child, and build a sense of sovereignty from the ruins of what felt like the ultimate violation.

There was the young Latino man, a first-generation child of immigrant parents who worked themselves ragged to build a business he could inherit, their whole lives pinned on making him a successful small businessman or even a professional. But he was an artist, and the weight of their expectation, their complete incomprehension of his passion for applying inks to paper, and his inability to disappoint them and tell them his truth felt like such a tiny, no-exit room to him that he'd attempted suicide five times. The staff was jittery around him, eyeing him sideways, and he liked to yank their chains with offhand comments about sudden death.

And lastly, the new mother, bedridden with postpartum depression, made deeper and more complex by her husband's affair while she was pregnant. On top of which, on September 10 he'd been on a business trip to New York, and they had stayed up half the night talking on the phone, trying to mend, so he overslept and missed his flight, which ended up hijacked and crashed in a field in Pennsylvania. In the face of massive death, personal betrayals had seemed suddenly small, but still, she couldn't get out from under her heavy heart.

All of us were there because our most intimate relationships had been damaged, and there was nowhere else to take the intensity of our pain. And the new mother and I were also there because we needed someone else to take care of our children while we caught our breath, and an emergency was the only way to get access to respite parenting.

All of us needed for there to be thickly planted networks of neighborhood healing houses, places of crisis care, with an abundance of peer support, soothing teas, people to listen, and help finding ways to change and mend our relationships or let them go. We needed acknowledgment of the depth and importance of our losses. A friend of mine whose husband had also disappeared said, if they had died, people would bring us casseroles and not expect us to function, but heartbreak gets no respect.

The first rule of this place we were in was *take your meds*. The second rule was *no physical contact with other patients*. It was forbidden to hold a hand or

offer a hug. That was my starting point. Part sabotage, part guerrilla theater, I sidled up to my new friends and with exaggeratedly furtive whispers out of the side of my mouth asked two of them to stand guard because I was going to hug the third. Throughout the day, I got them to join my conspiracy of contact, and it started to knit us into a band.

Rule number 3 was *food may not be brought back from the cafeteria*. New Mama couldn't drag herself out of bed to go to meals. The only thing she could stomach, anyway, was chocolate milk, but the rules required her to go sit among the noisy crowds to get it. I started smuggling pints to her room in my pockets, and got some of the others to help. Each small carton was a declaration of kinship, proof that she was not alone, that we were on her side. Her wan smiles grew wider.

Although I still spent a lot of time sleeping off my exhaustion, and they made us go to silly, busywork activity groups, where we had to circle the stick-figure faces that matched our emotional states, I sought out the people I'd connected with and kept trading stories. I validated the Christian girl's sense of betrayal, said anyone would be upset. You don't need lithium, I told her, you need respect and room to mourn. Her parents wanted her to live with them when she was released, and the thought made her spiral down toward a desire to die. I told her she didn't have to go home. She was over twenty-one. She could defy them. She started talking with another inmate who was due to get out around the same time about getting an apartment together.

The Latino artist was the one I talked with longest. He liked to muse out loud about his next suicide attempt, partly defiant attempt to shock, partly his way of shouting pain without betraying vulnerability. Next time, he said, he was going to try an electric hair dryer in the bathtub. Most people reacted with tension, so I joked.

In a relaxed and interested tone of voice I'd ask him how he would kill himself with different assortments of objects—an apple, a paper clip, and a rubber band? A toothbrush and an envelope? He started seeking me out. When he frightened the art therapist with his comments about scissors, we laughed together. One time he called me aside and showed me a broken plastic knife. He said the staff wouldn't let him have a dull butter knife but loaded him up with plastic, which, when broken, had a razor-sharp edge.

His parents were due to visit in a few days, and he became increasingly anxious and seemed more serious about self-harm. I told him that being an artist was really important, one of the most important things he could choose to do with his life. I told him his parents had worked that hard so that he would have a choice. I said he needed to tell them that he was an

artist, that that was what he wanted to do with his life, not run the family business, and trying to please them was killing him. That they might not support him right away, but they would come around, that they loved him and wanted him to live and be happy.

Then I got him to promise he wouldn't try to kill or injure himself for the next forty-eight hours, that he could come to me to talk at any time during that period, but he couldn't hurt himself. I said it mattered to me that he be OK, and that he live the life he wanted. He tested the seriousness of my intention a little but saw that I meant it, and I think he was shaking when he agreed. He kept his deal, and I think being asked to make that promise by a stranger who was only invested in his happiness was a kind of talisman to him. I was sent home before the visit, so I don't know how it went with his parents, but I told him he could keep talking to me in his mind, that I'd be his guardian angel, and any time he wanted to hurt himself, he should tell his imaginary me about it instead.

It was all so simple, what I offered. Contact, respect, and kindness. And in the offering, I found some equilibrium for myself. It's funny, I was in such agony, but what I remember most from those eleven days is the people I reached out to. They remain vivid to me while the pain has long since faded. Because the reaching itself was an act of healing, an act of self-worth and hope. All of us were wounded in the place of bonding, of knowing our well-being mattered to those we loved. I left that sterile place, full of sledgehammer drugs, rigid authoritarianism, and cheerful disrespect, much stronger than when I came, because I found a way to build a tiny island of what we all needed, however temporary: brief ties of mutual care, and that overused, tattered, and resilient word, community.

 ❧ First published in *Alternatives to EMS Anthology* (2014)

Histerimonia: Declarations of a Trafficked Girl, or Why I Couldn't Write This Essay

Because when I set myself to write what I call a histerimony of my own sexual exploitation within the immense and malevolent traffic in raped girls and women, the project poisoned me with nightmares and I could not maintain residence in my own flesh.

Because since the day I announced my intentions, I haven't eaten or slept well, always watching the darkness, waiting for them to appear, as they promised, those men with knife eyes who threatened me with torture and death if I talked. Because I am never at a loss for words, and yet I feel mute, because for this, we have to invent languages, and I don't know how to draw the map of this crime, explain its dimension—global in width, ancient in depth, a distanced international enterprise and at the same time the most intimate massacre of personal sovereignty.

Fragment one:

I was born in Barrio Indiera Baja in the town of Maricao, in the highlands of western Puerto Rico. Indiera, one of the last refuges of the Indigenous people of my land, and Maricao, which means the suffering or sacrifice, the *cao*, of Mari, an Indigenous woman who was most certainly not named Maria. The legend says that she betrayed her people for love of a Spaniard, and that they killed her for the crime, but that's how the legends of conquerors go. We don't know what she suffered, nor at whose hands, but we know what native women tend to suffer at the hands of the invading soldiers of foreign empires. Maricao is also the name of a tree of our cordillera forests, on the road to extinction, with yellow flowers and bitter, juicy fruits. It's the place where I collided with two violences, the ecological and the sexual.

In the imagination of the invaders, women, our peoples, and nature share a rapeable femininity, created by divine mandate for the enjoyment of privileged man. Women and trees suffer the blows of a single ideology.

Because it nauseates me to read and translate these quotes from rapist conquerors, because rage sickens me, and I get headaches, because my pacifism runs away howling, because while I jot down the words of men who've been dead for centuries, I know that more than a million girls and boys enter into slavery every year, in other words, in the twenty minutes in which I take my turn here, 46 minors will be enslaved, that there are more enslaved people now than at the height of the African slave trade to the Americas, and every day, in the name of commerce, 20,000 hectares of tropical forests, the lungs of the world, are destroyed, along with 135 species of plants, insects, and animals, our necessary kin.

Because as Andrea Smith writes, rape is not a casual or marginal effect of conquest; it's a fundamental strategy of domination. Sexual violence seeks to destroy our most basic sovereignty. It invades us beyond our skin and marks us as territory. Its intent is to ruin whatever position of respect and authority we may hold in our own societies, rip the fabric of communal kinship, and rename us as property, without a will of our own.

Because even if I limit myself to my small and unique island, you will see that rape has been, from the very first moments of the European invasion of the Caribbean, a systematic practice and central metaphor of our domination. Listen:

Fragment two:

An Italian aristocrat by the name of Cuneo, who sailed with Columbus, wrote: "I captured a very beautiful Carib woman, whom the said Lord Admiral [Columbus] gave to me and with whom . . . I conceived the desire to take pleasure. I wanted to put my desire into execution but she did not want it and treated me with her fingernails in such a manner that I wished I had never begun. But seeing that, I took a rope and thrashed her well. . . . Finally, we came to an agreement." Well do I know that kind of agreement.

Chroniclers of the US invasion of 1898 describe the landscape itself as voluptuous and fertile, "yielding herself to our virile marines."

In his Pulitzer-winning biography of Columbus, *Admiral of the Ocean Sea* (1942), US Rear Admiral Samuel Eliot Morison wrote: "In the Bahamas, Cuba and Hispaniola they found young and beautiful women, who everywhere were naked, in most places accessible, and presumably complaisant." Presumed by whom? Echoing the writers of 1898, he, too, describes the conquest of the Americas in sexual terms: "Never again may mortal men hope to recapture the amazement, the wonder, the delight of those October

days in 1492, when the new world gracefully yielded her virginity to the conquering Castilians." Gracefully.

In the romance of conquest, the land and its people are equally subject to sexual assault, imagined as welcome rape, and the right the invaders felt to the bodies of Indigenous women and, later, African women, is echoed in their entitlement to use the land as they please, which has led to the no-less-violent degradation of our ecosystem, the island habitat with which our Taíno ancestors lived sustainably for two thousand years. In the sixteenth century, the forests of Puerto Rico reached all the way to the beaches and covered 90 percent of the terrain. By 1900 it was only 10 percent. Today the ever scarcer rains carry away the soil of the cordillera, leaving behind the scars of erosion, because deforestation has left us without roots.

Because this is not an academic exercise. Because I also carry scars.

Fragment three:

Taken in this context, the violent production of pornography as a cottage industry of the Puerto Rican countryside has a certain historical logic. Systematic rape for profit, the sale and rental of girls and women for sexual exploitation, is a predictable extension of the sociosexual relations of imperialism in our region. The international and local trade in women and girls is nothing new.

At the beginning of the 1960s, I was one of those girls. My fourth-grade teacher was the leader of a pornography enterprise with perhaps a dozen managers and a line of clients who came up from the coast to enjoy the merchandise. He threatened me with the death of my family, a family already sufficiently threatened as communists under surveillance during a time of repression. My *cao* began with a drugged can of peach nectar and lasted almost five years.

Because I feel lightning strike when I speak. Because rage consumes me. Because rage can be a wildfire, incinerating the inner landscape, leaving only coals and ash, a savage current that erupts in sparks of fury that burn everything they touch. But suppressed, it turns into inflammations that sicken us, smoke that deprives us of oxygen. In order to be of use, it must be concentrated, focused, turned into a blowtorch that can melt obstacles and solder visions, made to illuminate—and I only know how to do this with art, but it's not yet within my reach.

Fragment four:

The human trafficking industry is the third-largest criminal enterprise in the world, after drugs and arms. One writer on the subject, who exposed a network of traffickers in the town closest to my own, thinks it's a sign of the moral decadence of our times, and blames the mothers and food stamps. There's no question that it's moral decadence, but it's not recent, nor does it have anything to do with the brave mothers of my country, or the crumbs of food the government tosses us to keep us on our feet and working. It's a global decadence, a criminality closely tied to those other worldwide crimes: empire, poverty, racism, sexism, war.

But its face is local. I have seen the consumers of my suffering, men with thick fingers, heavy gold rings, avid faces, and blurred eyes, and I recognize them. Whether on a coffee farm in Yauco, a hotel in San Juan or Bangkok, or a basement full of chains and beds in San Francisco or New York, the faces are local. In every part of the market, there are those who eat their young with the same fervor with which corporations eat the planet, in a fever that is both suicidal and murderous.

Because when I talk about women and ecology, the ethical principles that nature imposes, of the communal, horizontal, strategic skills women have cultivated out of necessity over thousands of years of work, our talents for thinking collectively, not inherent, but drawn from a long experience of labor, I do not want to be confused with bourgeois essentialist ecofeminists, expropriators of Indigenous cultures, romanticizing lands and people with the same enthusiasm with which their ancestors pillaged them.

Because I don't want to be misinterpreted when I speak of the infinite web of relationships that bind the beings, seas, minerals of our planet, millions and millions of threads that form a dense and living fabric, the entity we are, because it is neither metaphor nor mysticism but the autumn rains on the hard red clay of Indiera, up there in the lap of the sky, falling on that flowering, devastated, poisoned, living mountain with its strong and desperate people, that taught it to me.

Because it's not liberalism but a hard-won truth when I say that the addicts of domination are orphans, that they recognize no kinship, that they bleed from where the threads bound them to the universe, driven mad by the wounds of disconnection.

Fragment five:

I have just read this about trauma: what happens in our bodies when we can neither defend ourselves nor flee, like me. The delicate, complex systems of our immunity unravel, and that moment of powerlessness, of finding ourselves defenseless in the face of the terrible, extends itself, becomes a permanent condition. With no other choice, the body, in a state of panic, turns against its own cells. What happens, I ask myself, when an entire people is captive? We can't flee, and all our fierce resistance hasn't protected us. We suffer from a social autoimmunity in which the infinite violence and dehumanization of the last five centuries, the internalization of a merciless oppression, has left us inflamed with rage, witnessing how our wounded society devours itself.

I am an artist of needle and thread, looking for ways to mend this battered fabric. I am a curandera opening paths to use our rage and rebuild our resilience. The struggle for the integrity of our bodies is the ground from which we fight for everything else.

Because I bled for a week, and dreamt of a girl with dark eyes whom I, single, sick, poor, could not take care of, and I chose my voice, my vocation, my own life, and the other lives I helped to save, and of the six countries in the world in which I could not have made this decision, even if those who raped me had left me pregnant at the age of twelve, not even to save my physical and literal life, four are in Latin America, and among them are those who defend their economies and territories from imperialism but not my body.

Fragment six:

We who dream, imagine, struggle, and work for a liberated world live between two realities, the possible and the actual, with one foot in each. Here in the actual, we can't have everything. We have to choose. But we have to choose what will offer us the most future, what gives us the greatest possibility of having it all when another time comes. I am not one of those who say that fetuses are not lives, but between those precious, unripe buds, and the sovereignty and potential of their mothers, I choose the women. We are the most committed, the only ones capable of building societies in which no woman has to risk poverty, exhaustion, isolation, and the sacrifice of every other dream in order to raise the next generation, almost always in a state of psychic malnutrition.

A century ago, Puerto Rican feminist Luisa Capetillo said, "If you don't want women to sell themselves for bread, give them bread." Instead of crimi-

nalizing and punishing the woman who tries, painfully, and at great personal cost, to save herself, and perhaps other members of her family, by means of abortion, make it unnecessary. Develop safe, effective, free, and available contraceptive technologies, and abundant economic, social, and cultural support for the work of childrearing.

The girls and boys of the world who live in poverty, the displaced, the orphaned, the abandoned, the homeless, are the most vulnerable to trafficking, my little sisters and brothers who right now, and now, and now, are suffering what I suffered. For me that nightmare ended. I don't know why. They stopped coming for me. But for the forty-six children captured while I've been standing here reading this to you, it's only just begun.

Why is it that governments are so concerned with innocent lives (as if there were such a thing as guilty lives, lives we could condemn to suffering without sinning), and only until they are born? And if more are born than a family can take good care of, and no one has an eye on them, if they are born in slums and war zones and these girls, these boys, disappear, carried away by the current of the rape industry, politicians don't take to the streets, indignant, or promise to resign their offices if the traffic doesn't end.[1]

Because I can't do it alone. Because to heal the girl I was, I must fight for the woman I am, and that can only be done among sisters. Because we are the majority, women and children, and sovereign, powerful, healed, we could change even the orbit of the earth; because we don't yet know it, because to understand it, we must be together.

Last word:

Nowadays there is a lot of talk of the *patria grande*, the greater American homeland, and the unifying dreams of Bolívar, but I have never trusted that word *patria*. Nations emerged when the obedience and loyalty once sworn to individual aristocrats had to be transferred to an entire class, and it's not a coincidence that *patria* comes from the same root as *patriarch, patrimony, patriarchy*. The loyalty I swear is not to nations or governments. My loyalty is to a far broader and deeper integration. I am faithful to the web of vital connections between all that lives, and being faithful to that web requires practicing ecological ethics, requires defending whoever needs it, requires interweaving intimate and communal sovereignties in what could perhaps be called the *matria*, from the same root as *matriz*, womb, the reestablishment of kinship. Only so, spinning and weaving that fine, strong, relational

gauze, will we be able to bind our wounds, mine, those of my people, and those of my planet.

🐚 From *Medicine Stories* (2019)

.

Note

1 In 2013, President Rafael Correa of Ecuador threatened to resign if the country's strict abortion laws were liberalized.

7 ANCESTORS

We are made of those who came before us, ancestors of blood and spirit, and when we acknowledge them, we are made stronger.

Here, I name ancient ancestors like the African woman whose DNA we all share, and the earliest occupants of the Americas, the voices of the dead that underlie the last five hundred years of Boricua history, and specific groups of people who I claim, like the freedwomen of Puerto Rico, Jewish and Puerto Rican garment workers of New York, the Puerto Rican and Mexican waterfront workers of the San Francisco Bay, and the murdered children of Nazi-occupied Ukraine and Israeli-occupied Palestine. I have pieces about Sor Juana Inés de la Cruz, Muna Lee, Fidel Castro, and Filiberto Ojeda Ríos, one each about my mother, Rosario Morales, and my father, Richard Levins, and one about them both.

The first five pieces in this section are from *Remedios*, the prose poetry work that was the core of my doctoral dissertation in women's studies. I set out to tell what I think of as a "medicinal history" centering Puerto Rican women, our ancestors in the societies of the ancient Americas, West and North Africa and

Southern Europe, and the peoples to whom we have been tied through trade and migration. The last two pieces are from *Silt*, my tracing of stories along the waterways of the Mississippi and the Caribbean.

First Mother: Maghreb (–300,000)

We began in her shade, running at her callused heel, strapped to her strong back, the first mother, the one woman we all hold in common out of that band of a thousand ancestors from whom humanity came, rising like a dust storm out of the heart of Africa.

First Mother was never the golden-haired Eve in Renaissance paintings whose flowing locks fall across perky breasts, munching apples with the snake. She was walnut-skinned, with hair like a thundercloud, and her breasts hung long and slack and leathery from nursing many babies. She lived at the rim of the wide and green Sahara, a land of many rivers and flowering meadows, and she did not eat apples. She ate dates from the palms, and sweet berries from shrubs. She ate nuts and seeds, wild grubs and honey. She had antelope when she could get it. Fish when she could catch it. She did not live in a garden, alone with a man. She lived with a band of kin, and they walked wherever they pleased on the green and yellow and brown earth, gathering, and dropping seeds, hunting and scattering bones, drinking and going dry, growing older and bearing young.

Her children spread outward like a fan of fingers, filling up continents. Some lived at the edge of the sky, in high cloudy valleys among snowy peaks, and their chests grew broader and deeper in the thin air, their blood richer. Some lived in dense, dimly lit forests, where warm rain dripped from a canopy full of the swinging shadows of monkeys, and these became quick and light on their feet, small and compact, with smooth and hairless skin, the better to stay cool. Some lived in places of long winter and few plants, of mammoth Arctic nights and blazing days, and they padded themselves with fat against the bone-cracking cold, and learned to eat the oily flesh of whales. Some lived inland, houses pitched against the winds of winter sweeping the plains and steppes for endless months of darkness, far from the fish oils that could strengthen their bones, and these grew pale, translucent skin, made to suck up the meager daylight. Some stayed in the latitudes of the sun and gathered up even more of the darkness of earth to keep them

from burning. They were tall and thin, arms long enough to pick fruit off savanna trees, legs swift enough to follow the distant herds, with a blue-black sheen that gave their bodies shade.

But everyone in the menagerie came from the same litter, suckled at the same brown breast, and in every one of her daughters, unchanged through the generations, a tiny fragment of her flesh persists, a mitochondrial speck, a grain of earth she gave us in the wide Saharan garden, at the beginning of human time.

⥟ From *Remedios* (1998)

Old World: –100,000

The diggers among old bones have an axe to grind, a stone to chip. Archaeology is a child of conquest, a follower of armies, conceived in the looting of treasures from other people's graves, born under colonial flags, with a story to tell. The archaeology of colonial masters finds evidence to put us in our places, to put them on their thrones. If what they find contradicts the story of their unique superiority, then the evidence is wrong. How can it be that the people they have enslaved built cities, studied the stars, were scientists and artists? How can it be that the empty lands they imagine have been waiting to be claimed were not empty at all? They insist that Turtle Island is a new world, that human cultures barely scratched the wild surface of all that real estate. That it is all raw material. They have an official account and they're sticking to it. The bones and stones keep talking back, but anyone who listens is ridiculed. They have to keep saying it was simple, it was recent. No matter that humans have been settling continents, walking over isthmuses for hundreds of thousands of years, traveling oceans for at least forty thousand, the experts keep saying it couldn't have happened here, not in America, the source of so much wealth. They say we stumbled across the land bridge at the worst possible time, a single culture with a single style of tool making, 13,500 years ago, which in the world of old things is just the other day. But there are hundreds of mouths scattered across this earth, all speaking, all saying *older, older, older*. Saying it could have been a hundred thousand years ago, it could have been sixty thousand, but it was very much longer ago than that, when we climbed up out of a hole in the ground, left a cave, emerged from a shell, fell out of the sky, and began to shape this old American world.

&❧ From *Remedios*, 2nd ed. (forthcoming)

Guakía Yahabo

Toa is mother. Aracoel is grandmother. Makurí is foreigner. Macana is a war club. Daca, I am. Guakía, we are. Yahabo, still here. I sit on the iron-rich, red, red clay, surrounded by trees: guayacán, coabo, ausubo, yagrumo. Colibrí is hummingbird, Guaraguao is red-tailed hawk. Bejuco is vine. My roots in this place are thousands of years old. I string the ancient beads of our language onto brand-new nylon fishing line, a necklace for perilous times. We have words without grammar, stories changed almost beyond recognition after passing through so many other mouths, broken axe heads lying in the beds of streams, walls of stone 528 years thick, plastering memory over with lime, and still, Daca, I am. Guakía, we are. Yahabo, still here.

The old ones told these stories to the priests, and now we take them back. Put them in our mouths, roll them around on our tongues. Earth is our grandmother on our father's side. Our mother's mother came from the sea. Somewhere in the deep, green heart of the great southern rainforest across the sea, Grandmother Earth gave birth to four sons. One day they stole casabe, the bread of life, from their grandfather's house while he was sleeping, but he woke up and roared in anger, and they ran for their lives. As they ran, their grandfather spit on them, and his sacred spittle, the stuff of visions, landed on the back of Deminán Caracaracol, and where it landed, a great lump appeared, and grew and grew as they paddled frantically north along the chain of islands, until at last it split open in a gush of sea water, and our mother, with her gleaming ivory belly, green and brown carapace, yellow-lidded eyes, fell out onto the burnt wood of their canoa and took their breath away.

She was not the tiny painted turtle they sell at pet stores, not the snapper turtle of freshwater ponds, but the great green turtle of the seas, whose shell is covered with whorls that map the universe. Her name was Carey. The four sons of Grandmother Earth fell into her embrace, spilling their river mud seed, smelling of yuca, into her salty flesh. Her belly filled with a hundred orbs of light, and when they came to shore on the beaches of our home, she dug a deep hole in the wet sand and laid them there. The moon went light and dark and light and dark, and then we hatched and became island people, people of sea and clay, the Taíno people of Borikén.

There is another story, a later one, a second creation. That somehow, between the reefs and the cloudy mountains, between the hurricanes and the sun, many of the women of Borikén disappeared, and when the others went looking for us, they found new people shining among the trees, creatures as supple as saplings, glowing red brown under our bark, but without genitals. That it was the pájaro carpintero, the woodpecker, who came in a flurry of red and black and white plumage, with its beak like an awl, and carved new places, tender and pink, for our touch. That it made us flower, wider and wider, until from the sap-filled crevices of our bodies, from the sticky pleasures we took together, a people was born, made of sea water and earth, feathers and shells and trees.

I sit on this clay, wondering how many times we women of this land have re-created ourselves from whatever was to hand, made a new story so we could begin again. Born out of our journeying, carved by circumstance, mixed up from the market stalls of all our far-flung ancestors, handfuls of fragrant leaves, gritty pepper, pungent garlic, pounded into the savory stuff of life. But whatever spices from other continents we throw into the mix, the pilón is made from the darkly gleaming and nearly indestructible wood of guayacán, and every story we tell about how we came to exist says Daca, I am. Guakía, we are. Yahabo, still here.

 ☙ From *Remedios*, 2nd ed. (forthcoming)

1695: News of Sor Juana

Juana de Asbaje is an illegitimate child, born in a village near Mexico City. But she has found a place for herself at the Viceroy's court. She is intelligent and beautiful. Reading and writing by the age of three, at eleven she debates with philosophers and mathematicians, physicists and musicologists, and is a favorite with the Viceroy's family. At eighteen she is especially and passionately attached to the Viceroy's wife. There are no diaries, no snapshots taken together, no friends to be interviewed about this passion.

At nineteen she joins a convent, first the Barefoot Carmelites, which she finds too severe, and then, when she is twenty-one, the Order of St. Jerome. There she becomes Sor Juana Inés de la Cruz. Her library, the most extensive in the Americas, has four thousand volumes, and her cell is full of scientific equipment with which she conducts experiments. She is an acclaimed poet. She writes *hombres necios que acusais a la mujer sin razón*—"Stupid men who accuse woman without cause." Men who seduce women and then blame us for being loose, who say they want us to be pure and chaste as lilies and then hit on us.

The Bishop of Puebla writing as Sor Filotea condemns her unwomanly interest in science and literature and her presumption in seeking to know about the world. In a brilliantly argued essay, Juana turns the very same biblical authorities he cites against him, with deceptive humility, in unabashed and skillful defense of the right of women to think. In 1693 "Reply to Sor Filotea" becomes the first feminist essay published in the Americas. Copies appear throughout the Spanish empire. Perhaps, late in the year 1694, a copy comes to San Juan, to the Carmelite convent, and the nuns gather around it and whisper and frown and question and maybe a few eyes sparkle with excitement. Maybe one of the nuns undertakes to write to her illustrious sister, but the letter takes many months to compose and many more to find its way to Mexico. Meanwhile, there has been yet another epidemic, and Sor Juana, who has sold her books and equipment, as ordered, to help the poor, has been tending the sick, and fallen ill herself, and at the age of forty-seven, has died. Maybe, in the delirium of her deathbed, she imagined

you—brown skinned, poor, female, sitting in a college classroom, reading about her, choosing among books, picking up a pen. Then her spirit flew into the sky over Mexico, bursting into hundreds of fragments of brilliant light, and became a new constellation.

 € From *Remedios* (1998)

1873: The Freedwomen Contract Themselves

In the year of abolition, the old slaveholders try to drag the institution a few tottering steps farther and require every freed slave to contract with an employer for another two years. If they don't, they will be forced to join public works projects. However, the newly freed don't have to work for their former captors. They can choose anyone.

They choose their families. They cross the island in search of parents and children, spouses and grandparents for whom they have longed. They walk for days to find ancestors and babies long divided from them but never forgotten. They no longer risk the lash or other tortures for a glimpse of kin.

The roots of the family tree go deeper than the cruel reach of slavery. Juana Gutierrez seeks out her granddaughters Josefa (28) and Matilde (32), the first liberated from the establishment of Sucesión Turull, the second from the grip of Teresa Amadeo. Juana Geigel, from Carolina, ex-slave of Teodoro Chevremont, presents herself in San Juan, in order to work for her father, Felix Angulo, "to provide him with the necessities of life." Also from the Chevremont place, Felícita and Guadalupe come looking for their fathers and find them and contract themselves, Felícita as a domestic servant, Guadalupe to help in the fields.

In slavery most children are parted from their parents by the age of eight. By the time they are eleven, only a few live with kin, usually siblings. Now the freedwomen of Puerto Rico go looking for their mothers. The new liberta Francisca, age fifty-four, formerly held by Ruperta Gomez, binds herself to her mother, María Rosario Acosta, in order, she says, to help her in all things. The lost daughters go barefoot along the coast roads, their skirts gathering dust, returning to the women who gave them life.

Eustaquia Amigó works as a candymaker for her mother, María Luisa Amigó. Her contract says she does not wish to be paid. Maria Narcisa, freed from Ysidro Cora, Yrene, freed from Rafael Cabrera, and Ventura, freed

from Micaela Benisbeitía, fly like swift and hungry birds to their mothers and work for them, provide for them, take up their loads. For the first time in their lives, they can choose their labor. They sit down and wash their mothers' hard brown feet and the daughters sing at their work.

From *Remedios* (1998)

Tsu Got Vel Ikh Veynen

Tsu got vel ikh veynen [To God I cry out
Mit a groys geveyn with a great cry,
Tsu vos bin ikh geboyren "Why was I born
A neyterin tsu zein? to be a seamstress?"]

David Edelstadt

1

Six years at Melody Bra and Girdle Company, sewing corsets and girdles. Another year at the Donel Foundation until it folded. Four years at Imperial Brassiere Corporation, traveling two hours each way, working the three-stitch machine for ninety-five dollars a week. This is the work history on a job application of my grandmother's that my mother found in a drawer, dating from sometime in the early sixties.

Women in Puerto Rico had been doing home-based needlework for garment companies since the beginning of the century, and especially after the start of World War I, when supplies of embroidered work from Europe were cut off, leaving the department stores high and dry. By the 1930s, sewing was Puerto Rico's second-largest industry, but it was hidden away in women's homes, so economists and historians called it "marginal." In 1921, when my great-grandfather Don Ramón Morales died of pernicious anemia in his forties and left his wife, Doña Rosario, with a property in Naranjito and twelve children to raise, there was nothing marginal about it. The older boys worked the tobacco and pasture land, and Doña Rosario turned the big Morales family house into a garment workshop, attaching piles of bodices to skirts to make nurses' uniforms, and turning out miles of lace tablecloths, acres of embroidery, every kind of fancywork she and her young daughters-in-law could contrive.

In the 1950s, when my parents moved to the remote mountain community of Indiera Baja, women still traveled down to Yauco and Maricao to pick up handkerchiefs and precut pieces of blouses and shirts and dresses,

which they took home to sew and embroider, and then exchanged for new sleeves and collars and handkerchiefs, and a thin sheaf of dollars. It was one of the few ways rural women could get their hands on cash. The men went in and out of the infernos of the cane fields and spent half the year sharpening their machetes for the next harvest, or hacking at weeds while they waited anxiously for the coffee berries to form and ripen, but women could ply their needles year-round, at any time of day or night, and still cook, and wash, and sweep, and nurse, and raise food on the family plot.

For my grandmother's generation of migrants, it was still the best option. You could wash clothes for a hospital or a laundry company—my grandmother did that, too—or be a maid. Or you could sew. Garment work, piece work, at the minimum wage. Her longest stint at one place was at Melody Bra and Girdle, between 1950 and 1956. It was the flood period of Puerto Rican migration. Thousands of women who had been doing piecework in their wooden houses in the countryside of the island poured into the sweatshops of the New York garment industry. They sat at rows of noisy machines, doing the same thing over and over and over, needle points flashing a fraction of an inch from their fingers. *Feather stitch machine. Three stitch machine.* The needles whirr, pierce the fabric, rip along seams with a deafening clatter. As each piece is finished, it's tossed into a bin. No time to glance at it. The next one is already pushing under the devouring flood, guided by their hands.

During those same years that my grandmother, Lola Morales by nickname and marriage, guided millions of elastic undergarments through her machine, Lolita Lebron was also working in the New York City garment trade. How much did that harsh labor intensify her patriotic fury? In 1954 she led three men of the Nationalist Party in a guerrilla action against the US Congress. The intent was not assassination. On the floor of the chamber, pompous men were attempting to ensure that the United Nations did not meddle with their colony, by declaring in tones of outraged sovereignty that Puerto Rico's affairs were purely internal and nobody's business. In that deafening silence in which her life and the lives of all the people she knew and loved were casually erased, Lolita and her companions fired guns into the air and unfurled the flag of their nationhood, as proof that we did, in fact, exist. I say "we" because six days earlier, I had been born into that same dispossession. Lolita and her three companions spent the next twenty-five years in prison for that outcry, while the needles continued to rise and fall over the hands of her sisters and cousins and nieces and neighbors.

My grandmother hated it. Even her irrepressible urge to laugh became muted there. She hated the pressure of keeping up to speed, doing the same deadly work over and over at breakneck pace. She hated the displaced hostility of the women, screaming their frustrations at each other, their anger erupting into slaps and curses. She hated the danger. Once, preoccupied with her troubled and troubling younger daughter, her hand was caught in the machine, and a needle went all the way through her finger. I imagine her pinned there, struggling for flight like one of those tropical butterflies with pollen-dusted wings whose labor brings blossom to fruit, trapped for some collector's use. She hated the danger and the long commutes and the low pay, and the insulting attitudes of the bosses, and she went on hating it for twenty years.

———

2

> The needles break, fifteen a minute
> and from my fingers the blood spurts out.
> To God I cry out, with a great cry,
> Why was I born to be a seamstress?

Those words were written by David Edelstadt, a Jewish poet of the New York garment sweatshops of an earlier generation of underpaid and exploited pieceworkers. Workers like my great-grandmother Leah Shevelev and her little sister Betty, once Rivieka. Betty was in her early teens when she arrived from a country village in the Ukraine and went in to the shops to sew for ten hours or more a day.

> I've hardly fallen asleep before I wake again
> And with my tired bones,
> I drag myself back to work . . .
> Mit meine kranke beyner.

Workers like my step-grandpa Abe's sister, who died in the Triangle Shirtwaist fire. The Triangle Shirtwaist company locked its employees into an upper room. Presumably so they wouldn't slip away early. Presumably to extract the last penny's worth of value from them before they were released, limp with exhaustion, at the end of the day. When the building caught fire, they burned among the shirtwaists, or leapt to their deaths in the street

below. *Tsu got vel ikh veynen, mit a groys geveyn, tzo vos bin ikh geboyren a neyterin tsu zein?*

Men also worked in the needle trades. For years my great-grandfather Abe lived in Bridgeport, Connecticut, during the week and came home to see his family in Brooklyn on weekends. He was a foreman at a factory that made nurses' uniforms and so received enough pay to make the weekly trip. The workers under him didn't. They lived in boardinghouses and sent their paychecks home without the gift of seeing their loved ones' faces, smelling their skin, touching their hands.

At one time, during the early years, he was also foreman of a small shop where Leah and Betty worked. The story is that the women went out on strike against the management he represented. It would certainly have been in their character. They were women not easily intimidated by authority. In a 1931 article, written for the unemployed women's circle she led, my great-grandmother wrote of her own grandmother, the one who "instilled the revolutionary spark in me." She was a rabbi's wife, and lived in the city of Kremechug, on the Dnieper River. The rebbetsin was highly respected, the local arbiter of disputes, and a better scholar than her husband, but Jewish law proclaimed she could not become a rabbi herself. "This is God's law," the men told her. So she stood up in shul, said, "Your God is a man," and walked out, taking her husband with her. The oldest family photograph I have is of her daughter Henke, and the most striking things I see there are her steady gaze, and the way her hands, at rest in her lap, look just like mine.

3

I learned to sew from my mother, on an old treadle Singer set up in the hallway of our house in Indiera Baja. Although both my mother's grandmothers were skilled needlewomen, my mother grew up Harlem and the Bronx, separated from that tradition. There must have been a sewing machine, because she remembers riding the pedal, but her mother had no interest in voluntary sewing, and more than enough of the compulsory kind. What clothing they had, they bought.

Instead, my mother learned to sew in the public schools of New York in the 1930s and 1940s. She loved physics and theater and literature. She loved learning with a passionate hunger, as she loved whatever took her from the airless, violent pressure cooker at home. In school they knitted socks for soldiers, and she learned to embroider, read patterns, and assemble

garments with a marvelous stitch, half running half backstitch, the fastest and easiest for hand-sewing long seams, which she taught me as a child— "See, the backstitch anchors, the running stitch flies!"

Today that love of craft and color has made my mother a quilter. Her walls dazzle the eye with original, brilliantly colored creations full of tropical foliage and lizards, sun and visible wind. She took the needle from her mother's tired hands and made it sing. These are not the incongruous yoyo quilts of my childhood and hers, a net of squashed cloth bags, stitched together at the edges: lacy, delicate, and useless, made only to drape over things and satisfy the Puerto Rican passion for covering up furniture with everything from doilies to fringed mats. Hers are well stitched and solid, full of the world she sees, like the piece I saw at the Oakland Museum, by an African American woman who had embroidered the constellations as seen from her front porch, then quilted in each field of the plantation, with the lines of the plowing to show the contours of the hills. It was her view, a map of the place where she had lived her life.

For my wedding, my mother made me a wall quilt, which became the cover of our first book together. There are three horizontal panels. Each one has a small house, with a corrugated roof, shaded by banana leaves. The miracle is the light. The houses rise, one above the other—at dusk with gleaming windows, in dizzying midday blue, in the flooding yellow of a tropical morning—like a tower perched over the coastal waters, like the slums of La Perla hanging off the walls of Old San Juan, precarious and resilient, drenched in sea spray.

Along that surf-washed northern coast of Puerto Rico they still make mundillo, a craft brought by the lacemakers of southern Spain. Women sit wrapping white threads around an elaborate arrangement of pins stuck into a little pillow, then rearranging them according to a pattern. Out of the thicket of silver pins flow rivers of flowers and fans, panels of knots and bows, dense medallions and airy borders. This is the work my aunts labored at under the stern eye of their mother-in-law: tablecloths, christening gowns, wedding dresses, and mantillas. This is the work my great-grandmother Leah did when she made the now fragile piece, cross-stitched with Russian letters, part of the household goods she brought with her when she boarded the ship in Odessa bound for Ellis Island and the rows of sewing machines. Each minute woven square is surrounded by knotted space, a record of her days, of hours spent tying delicate threads into little bunches. For love and for bread, the women who came before me worked needle and thread.

4

When I was a child, you went to Doña Tata to have your school uniforms made up, or to Doña Luisa in town for a wedding dress or a gown for a quinceañera. But the days of neighborhood seamstresses and tailors are long over. Most of our clothing is made in the new garment districts of our country in Bangkok and Manila, in Taipei and a hundred maquiladoras strung along the Mexican border the way the old sweatshops once lined the streets of the Lower East Side. Which is not to say that the sweatshops are gone from the US, or even from New York. Walking along a street right here in Oakland, I got a glimpse once, through an open door, of three dozen Asian women making men's blue work shirts in a dusty, noisy room without windows. Then a white man came and closed the door in my face.

The pants I bought yesterday say on the label, Crafted with Pride in the USA. Probably in the South. I imagine the tired woman who zipped this black cotton along a guide, under a gigantic machine, and then did another, and another, and another. The room is full of cotton dust and the roaring of machinery, and when she gets home, she's sore in every muscle. Her ears ring from the battering noise, and she coughs up threads and motes of cotton that make her chest ache. But she fixes dinner for her kids, and whoever else lives there. She does the laundry and sets out clothing for all of them to put on in the morning, and then lies in bed, wound up by the tension of boredom, with her *kranke beyner*, waiting to drag them back again in the morning. Not that much has changed.

What happened to all the bras and girdles my grandmother made? Or the shirtwaists and uniforms my great-grandparents sweated over? Most of them are probably landfill by now, all that nylon and elastic worn out by hardworking women and thrown in among the rubbish heaps of the fifties. Landfill, or smoke, incinerated as rags and thrown up into the atmosphere. But maybe some of the shirts are still around, cut into patches to mend a hole in someone's pants. Used to line a pillowcase. Perhaps the unworn bits embroidered and put away in a chest for a grandchild, or placed at the pale heart of a quilt.

Or maybe it's all gone, all those threads unraveled. But thousands of people went to work each day in the garments my people made. Ladies served tea and learned to type in those shirtwaists Abe's sister died for. Nurses saved and lost lives in the uniforms my great-grandfather and his

coworkers missed their families for. Generations of people were clothed and kept from cold. Women strapped themselves into undergarments that reshaped their bodies and then went out and found work that bought the beans, or stayed home and cooked the beans, or both. They went on their way, did their work, told their stories. In the ordinary lives of millions of people, the work of those hands still holds.

⁊ From *Cosecha and Other Stories* (2014)

Prologue to *Filigree*

FILIGREE IS A MYSTERY NOVEL SET IN PUERTO RICO IN 1897.

At the edge of the lower pasture, where it slopes toward the river that was once called the Toa, there is a place where the bones of slaves turn slowly to limestone under the lush grass. No one has broken the roots with a shovel for thirty years. There are no stone markers to tell a stranger who is buried here. Their names are in the parish books, but no one reads them. Those who would can't read. No one visits the graves. Those who would, live now on the newer haciendas of the Family's next generation, or have found work as servants or craftspeople in the city.

It is an old city, one of the oldest in the Americas, but it wears a new face these days, so full of bustle it's bursting at the seams, desperate to expand. The flickering light of gas lamps is giving way to the steady glare of electricity. There is a telegraph office where you can read cables all the way from London, by way of Jamaica and Havana. A person can ride a train from the foot of Martin Peña Bridge, west along the coast, between pastures of red cattle and fields of sugarcane, past strange white hills full of fossils and bats, all the way to Arecibo and beyond.

These days there is a lot of argument about progress and tradition, freedom and the responsibilities of civilization, a lot of warm moist air being expelled from a great many lungs under white starched shirts and elegant waistcoats. New cabinets of distinguished sons of this and that wait breathlessly to take office, pacing up and down in spacious, well-furnished rooms, practicing their acceptance speeches.

Talk of freedom or obedience is also moistening the air in less refined places. In the tobacco shops where deft-handed men strip the big leaves and roll them into cigars, where tuberculosis and socialism travel from mouth to mouth on a breath. In the plazas where women sit cross-legged behind their wares, white and brown coconut sweets and pots of steaming tripe stew, among the porters who carry goods and news to and from steamships

and sailing ships tied up to the docks. It gathers in the yard where a young servant named Luisa, too big with child by the patrón's son to squat with the other laundresses and beat those white shirts against washboards anymore, has started on her journey toward the soapbox. Soon she will unfold the secrets of sex for young women, ignorant about what awaits them, so they may choose, and will insist on overturning the order of things, equating salvation and liberation, Christianity and anarchism. Talk hums in the girls' school where Doña Ana Roque has been training young women to be printers, and swirls round the desk where she edits the feminist journal *La mujer*. It crouches in the hiding places of exiles preparing to slip away to the rebel swamps of Cuba, and in back rooms where seditious journalists pen outlawed commentaries for yet another banned newspaper.

Talk fills the parlors where the members of ladies' charitable societies agree that working women are not yet fit for self-rule and need instruction in morality and hygiene. Talk fills the private rooms of royalists shuddering at the specter of criollo government, and the verandas of well-bred families of every stripe, aghast at the ever-present possibility that the African taint will enter their pure bloodstreams through the daughter or son who, swept up in a fever of liberal ideals and unruly passion, will cross the wall that separates caste from caste.

They have buried the unspeakable past, the thick twining mat of tangled stems, dank roots, and swollen tubers, and turned their eyes toward a promise of brilliant scentless blossoms that spring from the air, seedless and rootless, miraculous and immaculate.

But under the rioting colors and noise, the bones by the river speak. Underground, through the web of filaments beneath the grass, seeping along the secret pathways of water, the murmur of the bones never stops. At night, when the bustle of the living grows still, you can hear them: in the ripe shadow of the mango trees, under the blue cobbled streets, in the grey clumps of dried palm fronds. By the docks where the ships unloaded, and the plaza where the sales were made. In the courtyards where they boiled piles of dirty sheets, and the sheds, still stinking of sweetness, where they lifted razor-edged cane to the teeth of the mill. In the field where María fainted from exhaustion and heat, at the wall where Antonio was whipped, in the bed where the child Ana was raped.

In the old crevices of the city and the shadowed expanses of whispering cane, where the brilliant new lights don't reach and the song of progress is just a distant noise, the fingers and shinbones of the enslaved gleam like

old ivory, clicking and sighing and trading their stories in the dark. It is San Juan de Puerto Rico in the hopeful year of 1897. Each night the children and grandchildren of slaves and slaveholders dream their inheritance of blood, but in the morning, they cannot remember their dreams.

 🐦 From *Filigree: A Norma Morales Mystery* (forthcoming)

Voices of the Dead

THESE PIECES END EACH CHAPTER OF *FILIGREE*, A NOVEL IN
WHICH THE IMPACT OF THE DEAD ON THE STORY'S PRESENT
PLAYS AN IMPORTANT PART. IN THEM I DRAW FROM TAÍNO BE-
LIEFS ABOUT THE AFTERLIFE AND THE HISTORIES OF AFRICAN,
INDIGENOUS, AND EUROPEAN PEOPLE IN THE CARIBBEAN.

*i am a throat full of cotton thread fingers made of pins my bones are made
of aching back pulled by fourteen children i was a second wife of three
the first choked and gasped spat out her life in red rags the third died with
the last son lodged between her hips swamp fever came for me in the
night robbed and burned left only pirate ruins other women raised my
babies only the three girls I buried bright as the sun flicker and shine beside
me the living children were told to stop crying to stop dwelling on sorrows
soon they didn't speak of me they grew up and made generations with the
names of saints and virtues children who eat their fill none of them sickly
none of them barefoot none of them carry my name*

———

–0–

*semillita de papaya that's what she used seeds the size of my tiny black
eyes and te de ruda to unmake my slender tangled veins dislodge my hairy
little body, like a root of malanga tugged from the earth that made it and here
I lie a bundle of tiny bones teeth like grains of rice, the grit of those shiny
seeds she dug out of the sweet, ripe orange flesh chewing their bitter
venom all night long until the cramping began and she cut me free my
mother murdered me to save my life. I am a fistful of seed beneath the ceiba
tree, I am a chill breeze down the backs of the women's necks as they hurry
past a blood-stained rag turned dark with time but I am not I never
was a slave.*

we hang upside down in clumps like bats waiting in the darkness wait-
ing inside a seed to come back. long narrow thorns of steel went through our
necks and bellies so we died in bunches we rattle the pods of flamboyanes
we make the shhhrr shhhrr of the palm leaves we dropped so many teeth
out of our broken heads like a sack of seed corn split still spilling heaps
of hard kernels onto the ground like fish skeletons like sea urchin spines
after the worst storm our needle thin bones are everywhere underfoot
along the salty line we wait in the world of wet limestone or walk barefoot,
like cloud shadow behind our people eat fruit and drop the rinds lay
our smooth skinned bodies beside the living no birth button on our fronts
not yet born laughing we melt away from their pleasure waiting for
the mother who can bear us for the time that will receive us for the ripe
moist place where we enter

The old Señora used to pull me to the floor to pray, sometimes half a dozen times
in a day. Prayer struck her like an attack of dysentery. She would crumple to
her knees wherever she happened to be, fingering her rosaries and dragging me
down beside her. I was her witness. I would kneel next to her with the hard floor
hurting my knees and while she demanded to be blessed, and that her children,
and especially her son be blessed, I would listen to the sound of blood moving
inside my head, a humming sound, like an old song, quieter than breath, and I
would curse her. Every prayer she hurled up to heaven, I would snatch out of
the air and grind into the dust with my curse. The blood that moved inside me
could do that. It was my only religion.

i never got rid of the salt. it seeped in through the wood, out of the ocean that
crashed against the hull where I lay bound. it climbed onto my fingers, like an
invasion of tiny white ants and moved into my joints. it crept up my nose, into
the tunnels of bone, so the smell filled my head and left no room for the stink
of shit and rotting hopes, and the disturbing dreams of the half dead but still

breathing, visions that filled them with ghosts and fire. salt still crusts the rims of my eye sockets. it has worked its way so far into them that they cannot decay. it burns on the tongues of the little creatures who lick the cracks in my jaw, hoping for some tiny taste of long gone meat. how precious those grey-white crystals were, when they arrived in hard flat blocks, brought from the dry heart of the desert. how much these bones would be worth to my people, if any of them were left in that green place. they would weigh my skeleton, and traders would offer gold of songhay, and lengths of good cloth. but I am here, biting the roots of the sugarcane, souring the grass of the pastures so the milk of the cows tastes of the minerals of pain, and their hides are stained with mysterious maps.

———

=0=

of the roses in my coffin nothing is left. the wood itself is eaten away by insects and worms that move quietly in the earth. they don't disturb me. why shouldn't they eat? we all eat where we can. in the dusty dark, much of me has fallen into powder, but there are the thin spokes of my hands. there is the arc of a cheekbone, the fine slope of my brow all the beauties. still, they would not caress me now, the men who owned me.

come, I laugh. come kiss this. lift the scrap of rotten skirt and feel for sweet moist delights.

may the rusty nails of my burial box pierce your nasty hands, and poison your blood. may tétanos clamp your jaws, tighter than your triple locked, rusty hearts. may your backs become hoops of pain, arched over your beds. there is a gold ring slipped sideways on a joint of my left hand, and a silver band wrapped round the scattering of white that was my other wrist. they left the hair clasp of polished shell in my long gone hair, and the little cross of rosewood, but there's only a loop of chain, now, and a pinch of rosy termite dust. I was a perfumed captive of many men's cravings, mulata de oro, cinnamon skin, my taste of honey. come, I say, laughing. come taste me now.

———

=0=

me and my kind streak the earth with our small mineral stains our soft, barely formed bones hardly disturb the soil we lie among the seed pods and rootlets, discarded seeds broken hulled wrapped in a rough sack a bit of rag a smear of rust red a crumble of chalky white the tiny pearls of what could one day

have been teeth our prehistoric lizard tails and the loose skein of blood vessels
spinal cord insect fingers fungal lungs a drift of black downy hairs we are
the indiscretions untied from our mothers' solid flesh and let to float away
like dreams our only sign the pallid veins that lace the clay

———

=**0**=

i always longed for the horizon that milky blue line like the rim of a blind
man's eye like a door cracked open that i could slip through if only I could
get there whenever i climbed the hill to catch that pregnant goat who liked to
run away or pick anones to be served in blue and white dishes with lime juice
and sugar i would shade my face with my hand and stare so hard at that
pale edge of the world that it left a thin bar of shadow across my eyes as i
walked back down i would close my eyelids and stumble on the path clutch-
ing my basket gripping the rope that leads the goat just so i could watch
it until it faded sometimes the edge changed was as closed as a secretive
mouth lips firm and teeth clenched tight behind and i knew i would never
escape but when next i climbed the hill, it would beckon again a melting,
tender blue, a promise, a chance
 the cholera came for me one morning when i was in the yard killing hens
for an asopao my insides twisted into a knot and brown water ran down
my legs they laid me on some sacks behind the hen house while my
tripas emptied i was wracked with thirst but whatever i drank came right
back out my eyes fell into my head my lips cracked my voice turned as
thin as a child's and by afternoon i was dead they buried us all in a place
apart as close as possible to the edge of the sea as far as they could from
where people lived i have no eyes now to watch for the line to open but
i watch with my spirit eyes i have no ears, but i listen for that one note
of silence in the roaring of the sea where it pounds with its fists on the land
i know there must be the thinnest possible slit between the clouds and the
foam a place i could slide through if I could only find it the place
where everything blue condenses, thick and sweet between the midnight blue
of the water and the clear, bright blue of the sky.

 ➢ From *Filigree: A Norma Morales Mystery* (forthcoming)

Water Front

All the men this side of the Bay, people tell me, worked the docks, packed salmon
or went to sea, everybody one time or another, they say, shipped out.
In each family, two, five, a dozen men heaved crates and barrels,
stoked boilers, swabbed decks, worked the ocean and all its messy rim.
Their names are not found in any records: Alfonso, Esteban, Manuel,
Gustavo, Juan, Domingo, Isidoro, Pedro, Miguel, Séptimo, José.
Their now greying children, nieces, nephews remember them
marching down Market Street arm in arm with
Irish, Black, Jewish, Italian, Swede: general strike, 1934,
filling the avenue with defiance, department store to department store.
She tells me she was a child, watching from the sidewalk as each local
went by, the stevedores, and longshoremen, and boiler tenders,
in their crisp uniforms and caps, banners flapping.
Union, she says. *We were always union.* After '34,
wages were good. They grew old on decent pensions, grandfather, vecino, primo.
Do you mean to tell me their names aren't written down anywhere?

How can history have forgotten so many men from Zacatecas and Guadalajara,
so many men from Yauco and Peñuelas and Arecibo,
our cousins who died at sea,
our uncles who closed the waterfront to scabs, our fathers who shipped out
for months at a time and brought back carved ivory tigers,
seashells made into combs and dancing wooden monkeys?

This is 2002 and the king of bandits says war is permanently declared.
Wartime measures apply, and he'll put soldiers on the docks if he has to,
to crack the backs of those unions our grandparents wore like the dignity
of fresh gardenias in the women's hair, starched blouses and shirts,
and carefully pressed secondhand coats with impeccable hats,
fingers flying on guitarras, cuatros, saxophones.

Dignidad, cultura y sindicato, swept into the disposal bins of our times,
just so the Gap can import sweatshop sweatshirts cheaper than cheap,
made by cousins, sisters, tías, madres,
Ana, María, Elvira, Graciela, Elva, Cristina
working overtime, pocketing pennies, dying young; and now soldiers to
 load ships
in defense of a corporate country that steals the savings accounts of
 braceros,
told they could bank their lives on the democracy they laid track
and picked peaches for, left empty handed,
gnawing on their fingers fifty years later with nothing to eat.

This is the rim of the ocean, this place made of fire and continental shifts
made out of the pounding of wave after wave on stone,
as relentless as those people,
each generation has them, who do not give up their bread and voices.
Who keep slapping their hands on the tables of bad faith and takebacks,
shouting *who do you think I am, maldito sea,*
people are not pigs, while the bandits fill our barrios
with toxic dumps, freeways and pepper spray chokeholds,
and give our livelihoods to computers a thousand miles
from the smell of salt and fish.
Who say, *oígame sinvergüenza,* we've been shipping out from this
 waterfront
four generations, and it's been some kind of war or another
for as long as any of us can remember.
Even if you haven't written down our names,
we know they were Rafael, Enrique, Saturnino, Apolinario,
Francisco, Anastasio, Antonio, Israel, Romero, Ariel,
who have never had statues put up for them
anywhere along the Embarcadero. We know all about bandidos, and wave
after wave of us, we scour the bay each and every high tide of rebellion,
shake the pilings of concrete piers stacked with container traffic, and gnaw
at the rock beneath your fancy glass houses trembling on the eroding cliffs,
where landslides and the evening news expose those de-fault-lines,
cracks made by the heavy overhang of your appetites.
Do you think we can't bring you down?
We have seen soldados before. We know what a war is and what a union is,
we know the names of the people who worked here before us.

We are the most undercounted and underestimated force
that was left out of your calculations
and when you come to take away what the viejos marched for,
we will be waiting here
on the last dry piece of land in America
with the biggest ocean in the world at our backs.

Memorial

In my grandmother's village there were no olive groves.
When the soldiers came, it was through fields of wheat
that the children ran, and my young cousins bloomed
like a sudden crop of red poppies among the pale stalks. May, 1942.
Among the crimes of war, what a tiny handful of deaths that was,
nineteen children of Israelovka, murdered by Ukrainian men
in a wheat field, on a summer day, their eyes open, looking,
the way children look.
I carry their wide gazes like a pocketful of pebbles,
small stones of grief snatched from an avalanche of suffering.

But my cousins keep multiplying on the stony ground,
while crazed men, hoarse from shouting at each other
pretend it is safety they are buying in the marketplace of slaughter.
My cousins lie in bruised heaps like roughly handled plums,
shatter on ordinary street corners, are shot, just like that,
simply for being, bleed to death slowly, thirsty, barricaded from help.

My throat fills with the cries of Rivka, Avram, Gitl
falling in the blonde grass of more than half a century ago,
wide eyes gazing across time, watching their own deaths repeated,
their anguished voices calling *help them!* and seeing stones
in the eyes of their could have been sons, the same brutal gestures
the same crumpled dress, stained shirt, small corpse.

Shake out the pebbles from your pockets, they tell me. Grief is grief.
The earth is littered with it. Each child lying in her blood
is a universe ended. Hassan, Salah, Jameel.
They were galaxies that will not return.

Hope is always ridiculous, say the murdered children.
Don't be reasonable anymore, they shout, angrily.
Don't just stand there grieving.
Your heart is still beating.
it's not too late.

Muna Lee

What I keep thinking is: why didn't I know about you? I have needed you and I didn't know. I grew up in the Puerto Rican independence movement, in a home full of books, speaking English and knowing other families who did, pacifists, university people, circles you would have moved through. I am a poet, a translator, a feminist historian studying women's resistance, women's voices, and I never heard that Luis Muñoz Marín had a first wife, far less one like you.

But of course I know the answer. I understand how we are disappeared from history, from literature, from print. It fills me with fear, with rage, with grief, with a righteous fury of intent that you be known. Your life is too close to mine for this to be some academic exercise, a cool assessment of your place in the various scales of importance. You are important to me. That is the story I am going to tell.

———

People who are intending praise say that you became Puerto Rican, that you were Puerto Rican in your heart, that you were, for all practical purposes, native, but I know you are something more rare. There are people who move into the cultures of others with such grace and respect that the friction of foreignness virtually disappears, who can unselfconsciously love the unfamiliar as if it were the most natural thing in the world. It is clear in the way people speak of you, and in the tracks of the life you lived, that you were one of them. You entered Latin America this way again and again, through political action, through marriage, through poetry, through the paid work of communication. It is a gift of relationship that requires a certain boldness of affection, and a generosity and curiosity toward the variety of humankind.

I grew up embedded in two entwined stories of "Americans" who also had this gift, who married into Puerto Rican politics, and made children,

richly woven lives, deep-rooted alliances. The first, Jane Speed, was a white woman and radical from Alabama who married communist labor leader and journalist César Andreu Iglesias, and came to Puerto Rico with her mother, Mary Craik Speed, in 1937. She had long red hair that she wore in a braided crown on her head, straightforward strong good sense, and she was an organizer with the originality and nerve to become a Tampax sales rep because the moment she mentioned her reason for visiting a working-class household, the men disappeared and she could talk to the women alone.

The second was my Brooklyn Jewish father, Richard Levins, who married my Spanish-Harlem-and-the-Bronx Puerto Rican mother in 1950, and came to the island the following year, where Jane and César became their close friends and political comrades. And my father, who knew only a few words of Spanish, decided that his high school Latin would be close enough, and unabashedly blundered his way into fluency, drinking unbelievable amounts of coffee in the cause of organizing coffee workers and small-scale farmers in the wilds of Yauco and Maricao.

I grew up in the house Jane and her family had built on our farm, and because she and her mother loved flowers as you did, I grew up among the forget-me-nots and gladioli they planted, which persisted among the upthrusting spears of ginger and tangled hibiscus, decades after they were gone. But most of all, I grew up within a legacy of joyous border crossings, of knowing we have the right to love anyone, to learn any language and speak it, to offer ourselves wherever we choose. And this makes you my kin.

––––––––

–3–

I also grew up in a house full of books, with parents who read poetry aloud, in English and Spanish, and those rhythms saturated my earliest sense of language. Most of them were men, but men of many countries, writing in many languages, translated into our reach. I read Bertolt Brecht and Nazim Hikmet, Pablo Neruda, Antonio Machado, and the Eighteen Laments of Tsai Wen Chi. Bad translations irritated me almost physically. I was still a child when I began revising the English versions of Neruda in the bilingual editions we owned, and ached to know what might have vanished from the German of Brecht's poems in order to preserve their rhythm and rhyme. I recognize your need. You had entered our world. Once you had read and loved the poems, the itch to make them audible to others, to bring something back, must have been irresistible. I remember vividly my discovery,

in college, of the first good translations of Neruda, my relief that someone had done the work, that I could share the beloved poems unfrustrated, and that I didn't have to learn the difficult art myself.

I know what it takes. That talent for relationship, akin to listening. A keen awareness of subtlety in language. A touch that is sensitive and bold. Respect for the poet, honest intent, meticulous faithfulness, reckless daring, acknowledgment that the task is ultimately impossible, and joyous in the attempt. You wrote of translating from the Portuguese that poetry "is only partially translatable—that is, so much of its beauty depends upon intricately braided jet and silver of its cadences that a great deal is necessarily lost by translation into a less liquid tongue," both accepting and refusing defeat. Your work is exquisite, your translations breathtaking in their own right, each one a pleasure, another aspect of your talent for love.

You were always hungry to know more, share more, kindle excitement in others. You describe your anthology of Latin American poets as a cage full of birds from every climate, a mere suggestion of the vast richness you found in the poetry of a language you acquired in two weeks in order to get a government job as a translator (which turned out to be censoring letters), and came to know as intimately as your own skin. I am full of gratitude for your skill and dedication, for the way you loved our poets and took them home with you, for doing what I lack the patience for, for using yourself to open the border wider, to make gates and doorways and windows through which sounds and images of these other lives could flow. To listen to the other is the beginning of possibility.

–4–

Like you I devoured books and was devoured by them, scribbled poems from an early age, was encouraged by my parents, struggled for belief in myself, translated the poems of others, was a passionate feminist, disrupted congresses and conventions to make a collective voice heard, loved men who could not rise to the occasion and broke my heart, kept writing anyway, kept finding ways into the work, not only wanted the peace of nations but believed it possible. I look at the good strong bones of your face in these photographs and wish you had been my teacher, wish I had not been eleven when you died, wish we were friends and I could call you, any one of those hundred times a day when I go out against despair with only poetry, personal joy, and collective faith, and find them too small for the task. So I invoke you instead.

–5–

I am standing beside you. It is Havana, 1928, the Sixth Pan American Congress at which the men of the Americas have gathered to make policies and deals, thinking about the fact that you, a white girl born in Mississippi, raised in Oklahoma, are here representing Puerto Rican women, your arms locked with those of Cuban, Peruvian, Brazilian, Costa Rican, Mexican, Argentinean women, all of you insisting on a place at the podium. I can imagine the elation, the rage, the energy, knowing the balconies above, the streets outside, were crowded with Cuban women. Arguing, holding out, pushing harder, finally after a month of agitation, winning the chance to speak, and a mandate to study the legal condition of women in every member state. I remember what it's like. Walking out of the endless monologues of men, teaching birth control in our living rooms to the outrage of male medical monopolies, shouting out loud with thousands of other women filling up hitherto off-limits public space, seeing our own words roll off hand-run printing presses. I am with you, eating together afterward, laughing, talking fast, exhausted.

I am thinking of the year I tried to teach the history of Western feminism on a North-South axis, US, Latin American, and Caribbean feminism, not US and Europe, and first heard the names of these women you rubbed shoulders with, Bertha Lutz, Clara Gonzalez, Elena Torres, Minerva Bernardino, Amalia de Castilla Ledón, Paca Navas, Irma de Alvarado. No one in my class had ever heard of any of them, not a single one. Not the Latin American delegates who put women into the UN Charter and saw to the creation of the Commission on the Status of Women, not the women who openly balked at the militarization of the continent in 1947, not any of the writers, thinkers, agitators who had struggled not only for suffrage, which came far later to them than to women in the US, and kept them militant through the lull between our first and second waves, but for divorce and child custody, nationality independent of a husband's, national self-determination and living wages, against dictatorships and fascism and the arming of the Americas.

But you knew. You had become part of this transnational agitation of women whose loyalties were to each other and not to borders, who were cynical about the political conduct of even their nations' most progressive men, who held meetings, drafted proposals, created commissions, traveled all over the continent, worked out of offices from which hostile men kept stealing the furniture. Who raided scientific conventions, political congresses, the

MUNA LEE · 301

League of Nations, shoving their way into the places where treaties were being made, because they believed this was their best shot at shaming and pressuring governments into making women citizens of their own countries, full human beings under the law, with human rights.

This was not some exotic side trip you made. You were right in the center of something most US women knew nothing about, laying foundations for what we were to inherit, for labor laws that were not passed until the year of your death, for the long, unended struggle for the Equal Rights Amendment, for legal and economic rights established after you were gone. You stood in that meeting hall in the spring of 1928 and said, "Every enlightened woman of this hemisphere desires for her sister of another country, the same good which she craves for herself." Your ardent band of delegates to Havana planted the seeds of the UN Decade of Women, of Mexico City and Beijing, of global alliances beyond your reach but within your vision. There is nothing as sustaining as legacy, as foremothers on whose lives we can build. I understand your life. I understand what you made of it. It gives me another place to stand.

———

–6–

Then there is the mirror of sorrow. Of being bright, creative, strong-minded, generous-hearted women in love with men who are first entranced by and then cannot tolerate our brightness, who treat us badly, for whom we grieve in spite of ourselves, for whom we are heartsick. It only takes a glance at the outlines to guess that he must have been unable to handle your independence of thought and action, the fact that you had your own priorities, and didn't follow him, were never his shadow. That you went to Washington for the summer to work for the Inter-American Commission of Women, your feminism carrying you into different spheres of politics than his, instead of being the handmaiden to his destiny. I reconstruct from long, bitter memory the sulkiness of offended male ego, the souring of your passion in contempt for his personal smallness, writing to you from New York asking for money when you are scraping to feed the children in San Juan, the ache for the sweet lost bond, the small reconciliations and spurts of hope, the certain knowledge of the other woman, the unbearable pain that you nevertheless bear, first loneliness and then solitude, the putting of one foot in front of the other, the moments of ferocious joy: "I wake to exult that the world is changed—is vivid and salt because we are estranged." I can imagine each

gesture of it, the slow earthquake you wrote of, tilting your bedrock into the abyss. I am weathering my own cataclysmic rupture of the heart.

The history of strong women, of writers and revolutionaries, is full of these shattered places made by loving men incapable of loving us as we are. The women I look to most are often heartbroken. It's a condition of history, a moment in evolution, that those of us who act most powerfully, who are artists and activists, who take up space and show ourselves to the world, and whose lovers are men, rarely find loves who can stand to be our matches. Emma, Rose, Luisa, Alexandra, Rosa, Jane—when I look at the lives of the women before me who give me strength, I see them mostly torn with grief or stoically alone, powerful and articulate and in pain, unable to have it all.

But you didn't die of it. You didn't join the ranks of our suicides or start drinking or stop writing poems or shrivel away into obscurity. You wrote and translated and organized and worked for a living, and went on alone.

> Since this hour is the worst, since I have found
>> The doom long-dreaded, and found it can be borne,
> For all that hope is trampled to the ground
>> And the force in which I trusted fled and torn:
> Why, I am still what I was one hour ago;
>> What I was then, with this knowledge for new power—
> Though ruin is swift and resurrection slow,
>> This hour being worst, I shall be better in an hour!

—MUNA LEE, "Dies Irae"

So I have mounted your photographs on a thin piece of wood, with a print of wildflowers, and set you to watch over my desk, because you denied neither love nor pain, neither politics nor poetry, and I am still reeling from my own recent losses, trying to remain whole. So I will learn from you the slow resurrection, the strength in solitude, the writing through, and remember that you were not defeated. We have the poems to prove it.

———

–7–

Meadowsweet, Verbena, Spiderwort, Johnny-Jump-Up, Foxglove, Lavender, Columbine, Wild Rose. Choctaw, Creek, Arapaho, Cheyenne, Wichita, Caddo, Ponca, Pawnee, Seminole, Kiowa, Apache, Ottawa, Shawnee,

Comanche, Chickasaw, Potawatomi. You grew up reciting the names of Oklahoma wildflowers, but if you spoke of the nations being destroyed around you, no one has recorded it. It was Indian Territory the year your family came, the most Indian place in the country, full of exiles from the southeast, refugees from the northern forests and lakes, people of the plains. It was the year the railroad came, and behind it the flood of white settlers pouring into "empty" lands. I know that you saw Choctaw faces in the streets of Hugo every day, but I don't know what that meant to you. The nations don't appear in your poems, but the flowers do.

> Uninventive child of dust,
> The flower, responding as it must,
> Even under skies of doom
> Finds no other way than bloom . . .
>
> —MUNA LEE, "Apology for All That Blooms in Time of Crisis"

Fierce organizer, tireless in the cause, it was poetry, after all, that meant most to you. The delicate shade of rose among the tall grass. The startle of blue. The violets of a first love betrayed. The flamboyánes of San Juan, blazing against the sea. You didn't write agitprop. You wrote about love and heartache and blossom, the early sentiment ripening into a clear, strong voice, acquiring edges, an iron tang. You fought for laws as concrete and mundane as soup on the table or not, and you wrote of the roses, of acacia, of trinitaria against a wall. You said that poetry was as much the daily bread as the white hyacinths of life, insisting that it was necessary, not a luxury, more powerful, in its electric spark, leaping across the gaps between us, than any other form of speech. You used it to heal your broken heart, and to make bridges and pathways between peoples, and it was as essential to you as breath.

———

−8−

"Even those whose lives have touched mine most nearly have thought last, if at all, of my poetry."

Oh, this is the place I can least bear to meet you, the place I dread in myself. That what meant most to you was least thought of. That you could write to your mentor, H. L. Mencken, "You are, I think, the only person who has ever considered my verse seriously." The more I talk with other women

who write, the more I know what that deprivation costs us, the leaching of spirit, the way malnourishment leaches minerals from our bones and teeth and makes them brittle.

"I do not think it would have changed the aspect of the world for anyone else if I had not written," you told him, although you knew it would have changed it for you. Yes, I know you loved the work of translation and saw its importance as a different kind of political action. Yes, I know you published your poems in many periodicals that were widely read, that you got good reviews, that reviews you wrote were published in prestigious places, that you made a living writing, editing, reviewing, working as a cultural diplomat, a woman with children, on her own in the 1940s and 1950s. All of this matters.

But I also know the corrosive, intruding, deadly voice that whispers in the ear of every woman writer I know, belittling, criticizing, stripping, mocking, poisoning the creative moment. You published one book. In 1923. And lamented when it was out of print. You could see to it that Andrade was known, that Storni was recognized, that Mistral was revered, and write, of your own work, to Mencken: " I can only add my hope that you find it worthwhile."

This is not a society that honors poets or respects women. I must celebrate that you had the recognition you did, that you survived your battles, that you were not poverty-stricken to the point of silence, that your poetry is there to be found, that this book is possible. But I cannot find it enough.

Sitting alone with my writer's block and the rent due, my email box and date book filled with the endless clamor of obligation, of invitations to give away my time or sell it cheap, with the urgent disasters of the world crying out for eloquence and spirit, it takes a strength I don't always have to let myself bloom in a time of crisis and do what means most to me. I am a different poet than you. The flowers and politics coexist in my poems. I write of war and heartbreak, blossom and atrocity, and I take my poems to the street as often as I speak them from a lecture hall podium. But my struggle is no different from yours. I have not published the half of what I've written, or written a fraction of what I could. It is far easier for me to fight for the voices of others than for my own. I am underpaid and tired, and though I can raise the hairs on people's arms with the passion of my defense of poetry and of hope, I don't always believe it matters that I write.

This is the final gift of this encounter. What is not enough for you is not enough for me. I have needed you as another Anglo-rican living in the tidal zone between cultures, and as a foremother to my radicalism, my Latina feminism, another strand to add to my sustaining sense of history. I have needed you as a woman surviving the loss of love through her own

strength of spirit, and a woman artist carving a public place for herself in an earlier time, when fewer of us did. I have needed your mix of militancy and prairie wildflowers, your defense of simple blossomings, your willingness to engage the intricacies of love and keep stealing back the desk and chairs from which you agitate for women's lives within the law. I have needed your expansive sense of "we," so desperately absent from the evening news, the Pan-Americanism of your day that would have been a global web of mutual responsibility today. I have needed this sense of companionship across time. And I have needed what I know right now, writing of you at two in the morning while rain drums on the roof.

I hope that future generations of women writers will have lives so much easier than mine that they will instantly perceive barbarities of my situation I don't see, because I can't imagine their absence. Perhaps it will be inevitable that some future woman, writing of me after I am dead, will feel the grief for me I feel for you, and be angry that I didn't have more. But I am looking back at you, and thinking that this is how I will honor you. I will say that my writing matters, and I will write, before laundry, before phone calls, before editing jobs and lectures, through grief and worry and distraction, whether I am intimately loved or not, and I will publish every way I can, so no one will have to hunt through out-of-print periodicals and attics full of boxes to find me. Militance is easy for me, but blooming without apology is hard. The world is full of opportunities to be of use, but I believe with you that poetry has a special power to reconnect our severed bonds, and I will practice it, because for myself and also for the world, you have reminded me that poetry is bread.

꙳ First published in *A Pan-American Life: Selected Poetry and Prose of Muna Lee* (2004)

Fidel

One of my favorite songwriters, Cuban Pablo Milanes, wrote: *Lo que brilla con luz propia, nadie lo puede apagar, su brillo puede alcanzar la oscuridad de otras costas. What shines with its own light, no one can extinguish, its brilliance reaches the darkness of other shores.* I was born on one of those other shores, in what one Cuban revolutionary recently described as "grey times."

I never saw Havana in those years. I only knew by rumor that it was a playground for the rich and corrupt, run by the US mob and the CIA, a place where children begged in the streets and shined the shoes of foreigners for a bite of bread, where Black Cubans couldn't go in the front doors of nightclubs that served up their music to white Cubans and foreign tourists. My friends who were children then remember the tortured bodies of union organizers, student activists, anyone who dared to protest, dumped late at night in the quiet streets of the suburbs, remember their terror of the police. Across Latin America, dictatorships flourished, and even the most basic striving, for enough to eat, for a roof overhead, were met with gunfire, disappearance, beatings, people dragged into jail cells buried so far out of sight that no one ever saw them again. When I was young, these stories floated above my head, spoken among adults who met in our living room, between my parents. The names of overthrown presidents, assassinated leaders, and massacres hung in the air, while anti-colonial movements erupted and were suppressed, erupted and were suppressed. Young Cubans rose up to take the Moncada barracks and were killed, tortured, exiled, and a young lawyer promised that history would absolve him. A handful of small victories and a litany of defeats, of broken branches piled high, waiting for a spark.

I was born in early 1954, in a tiny, homemade hospital built by pacifists, in the western mountains of Puerto Rico. In those coffee-region barrios, children grew up hungry and parasite-infested, without running water or indoor bathrooms, their parents couldn't read, wages were abysmally low, and young men were being drafted to die in Korea and then Vietnam for an empire that stole our natural resources, exported our unemployed to the slums of US cities, and conducted horrible experiments on our bodies without our knowledge.

It was the year the CIA, on behalf of United Fruit, overthrew the government of Jacobo Arbenz for daring to commit agrarian reform and defend the right of workers to organize into unions. It was the year four Puerto Rican nationalists fired shots in the US House of Representatives, where Congress was busy telling the United Nations that our suffering and lack of sovereignty was an internal matter and none of their business. In the roundups that followed, my father was arrested and then released, and my parents had papers made out for my adoption by pacifist friends in case anything happened to them.

I was two when an overloaded cabin cruiser called the *Granma* carried eighty-two revolutionaries from Mexico to the south coast of Cuba, and almost five when the guerrilla movement they ignited and the parallel urban insurgency of workers and students brought down the Batista dictatorship and ended US control of Cuba. They sang: *Se acabó la diversion, llegó el comandante y mandó a parar. The party's over. The comandante came and said stop*, and a tidal wave of hope swept through Latin America and the Caribbean, raising surf as far as Africa, across Asia, all the way to the Pacific's western rim, igniting some of that piled-up tinder. Within weeks, new revolutionary parties and movements sprang up all over Latin America like the little purple day lilies that shoot up after it rains. By May, Cuba's first law of agrarian reform went into effect and large plantations were seized and distributed to campesinos. Like the Haitian Revolution before it, the Cuban Revolution changed the definition of the possible, and the grey and bloodstained social landscape of the Americas began to show some color.

I grew up among the children of poor coffee laborers, their bellies swollen with malnutrition and worms, for whom meat was mostly a seasoning for starch, whose water had to be fetched by hand in buckets from often distant springs, while at the nearby hospital old men on benches spat blood from tubercular lungs.

But just over the horizon a million Cubans, including 100,000 children, fanned out into the countryside and taught their elders to read and write, wiping out illiteracy in a year. Country clubs and mansions were becoming schools, and all of a sudden everyone had access to food, education, medicine, and the arts. Nicolás Guillén, home from his long exile, wrote, *I Juan with nothing, yesterday with nothing, and today with everything.*

If we got up early, when the first light was just spilling across the coffee farms of the cordillera, and the CIA jamming station in Monte del Estado hadn't kicked in yet, we could listen to Radio Havana reporting on how many acres of land were in the hands of the poor, how many fields planted

with food instead of cash crops, how many children had fresh milk, the diseases eliminated, infant mortality falling and life expectancy rising, all those mundane numbers that added up to a hurricane of change, to landslides and uprooted fences and the first unfurling leaves of a new society built for the benefit of its own people. *I have*, sang Guillén, *what I had to have.*

Between our mountain farm and closest edge of Cuba was an island of pain, was Papa Doc and Trujillo, armed thugs and torture cells, secrets and whispers and underground organizing. Between Cuba and Puerto Rico, Dominican Juan Bosch was elected president, and overthrown, and US planes flew over our farm to make sure he didn't come back.

One day in 1964, my father came back from his weekly trip to the university where he taught, with a letter that made my mother light up and clap her hands. It invited my father to come to Cuba to help reshape the University of Havana's Department of Biology into an incubator for a new kind of science. My brother and I were packed off to one colleague and two sets of grandparents for a month, and my parents flew off, by way of Prague, to see the brave experiment for themselves. Four years later, we all went together, and I got to walk the streets of Havana for the first time, and breathe a different air, filled with enthusiastic struggles, laughter, and hard work.

It was 1968, the year of the Tet offensive, of Martin Luther King Jr. murdered in Memphis and cities on fire, Red May in France, the Chicago Democratic convention, the Soviet invasion of Czechoslovakia, and the Tlatelolco massacre of students in Mexico City. I was fourteen, and people my age were drilling in the streets of Cuba to protect their country from the next Bay of Pigs, were veterans of the literacy campaigns, studying ways to build a country. We rode around Havana on buses, lined up for ice cream at Copelia, listened to vigorous discussions of public policy and international affairs, and met Boris, a nineteen-year-old who took us under his wing and took us seriously, probed our ideas and encouraged us to see ourselves not just as children of radicals but as radicals in our own right. I read *Granma* and discovered a whole world of people trying to build human lives in places that never showed up in the US media except as hot spots, flaring into public view for a few seconds and then sinking back into invisibility.

In Cuba, adults asked me what I thought LBJ would do next in Vietnam, about the potential of the Black Panthers, about Black liberation movement discussions over the strategies of nonviolence versus armed self-defense. It was a country full of people who knew they were in it together and rejoiced. When we returned to Chicago, where we lived at the time, a city under the rule of Mayor Richard Daly and his violent and corrupt police force, Cuba

had spoiled me for the tedium, pointless regulations, and punishments of high school. That inextinguishable shared sense of purpose that shines so powerfully had blazed up inside me. Within two years I had a radio show, a box of poems, and had left school to take part in the social movements of my time. I felt like a time traveler returning from the future with news from a less barbaric age.

Each time I travel to Cuba, some large piece of my life shifts on my return. I become unable to tolerate some inhumanity of daily existence that had become normalized. My standards go up and I rebel. I demand more from my life. Cuba is a bright spark of navigation in my sky.

The next lines in Pablo's song are *Bolívar launched a star, that shone next to Martí, Fidel exalted it to travel through these lands*. Pundits will argue about Fidel forever, weighing up facts and rumors, influences and mistakes, braiding and unbraiding his personal story from the story of his people and the revolution they made together, but for me, a Latin American Caribbean child growing up in the deep shadow of US colonial rule, Fidel was a man who sowed stars across my continent, a whole milky way of constellations that still burn above our grim times, pointing the way toward a different future, in which each one of us shines with our own light, and together, we are as bright as the sun.

 ૏ First published in *Letters from Earth*

A Boricua Speaks of Rivers

.....

For Filiberto Ojeda Ríos, hero of the
Puerto Rican resistance, assassinated
by the FBI on September 23,
2005, while playing his trumpet
and left to bleed to death.

.....

I've known rivers. . . .
My soul has grown deep like the rivers.

Langston Hughes, "The Negro Speaks of Rivers"

I've known rivers ancient as the ocean floor,
secret upwelling waters from the chasms of night
where the earth divides, slashed into airless depths;
known rivers without banks or beds, warm streams
where turtles travel under round dark moons,
to lay a hundred eggs in the sand, rivers
older than language, red tributaries cradling our hearts,
blue riachuelos gathered in our wrists,
tiny capillaries like creeks
buried in translucent Boricua flesh.
My spirit has learned to circle, branch, return
like the rivers.

I rise from many aquifers,
through sand and mud and stone.
I am a rainfall blown crosswise by the wind.
I came by many roads.

I washed my cooking pots in the Orinoco
when dawns were fresh and green, white winged
over the dark bank; rinsed bowls of casabe
as thunder gathered in the mountains,

and rolled brown waters down
through lakes of flooded reeds
out the great wide mouth, uncoiling like a tongue
into the blue-green sea.

I gathered red rice in the Niger delta,
filled baskets to feed a village, made cloth
from the bark of mighty trees whose leaves
reflected light of Kongo currents,
molded river clay into bowls I carved and cut
with marks of kinship and courage,
a mirror of my face.

I hunted red Iberian deer
along the Al Wadi al Kabir, lay down
in the juniper and thyme, swam with otters
and pastured sheep in its rich meadows,
watched summer's electric dance
set the pine woods ablaze,
and winter choke the canyons with snow.
I have known rivers of distant continents
washed together in the soft damp marrow of my bones.
I have grown rich with the blended mineral wealth
of their resourceful ways, whispered conspiracies
lapping at my shore. I have learned to mingle waters
and take winding paths
like rivers.

I sifted golden grains from the Toa and Manatuabón
saw the first blood of conquest stain the Loiza and Yaguez.
watched the flooded Guamaní steal into the cane,
to drench and rot the calloused feet of field hands,
saw the dark arc of machetes in the smoke
chop at slavery's rope, and part the strands.

I watched grey dawn break over the East River, dark with oil,
lit by shipyard welders' flares, sewed elastic into
waistbands in airless sweatshops by the Hudson,
let my trumpet echo from the red iron walkways
of the George Washington Bridge.

I have been fugitive at the cold edge of the Connecticut,
where maples burned their sharp song into the coal smoke wind,
left anonymous winter coats on the doorsteps of my shivering neighbors,
took seven million bits of paper from a cash box on wheels
to buy them food and rebellion, arm consciences,
slip hope through a cracked window,
into a worn shoe, a threadbare pocket, to buy us time.

I have known rivers of laughter carve beauty
into the sooty canyons of heartless cities,
rivers of courage break through the sandbars of despair.
Heard music spill out into the windy street
to steal back smiles pilfered during the long, dull day.
I have learned a robber's quick fingers from the flood.
I have kissed the wild and stolen waters
of my own Río Blanco poured into a trough for soldiers,
watched children splash in the shadows of factories
full of broken thermometers, leftover poisons,
the sewage of greed, seen credits flow into far away accounts
while mercury made fingers tremble, kidneys falter,
minds grow slow.

I have known arroyos de la sierra, like Martí,
bright streams of joy tumbling from sweet cordilleras,
filling cisterns and buckets, washing the roots of yautías,
with enough left over to water my roses
in the secret garden everyone protected;

and I've seen the clear arteries of my island drained,
piped into the pockets of strangers
who want every river on earth to bear their trademark,
the privateers of thirst, eager to sell
each quenching mouthful to people
born in the river's embrace, left licking the dust
of its dry, empty course.

I know the places where rivers branch,
the moments of choice. I know
a life can become a spring.

That morning I sang *Despierta boricua,*
defiende tus ríos while G-men wriggled
in for the kill, flat on their bellies, infrared scopes
the reporters far away, behind barricades,
and then a flash flood of bullets
through the doors of my house: I've seen that
high water coming all the years since I chose.

I died in the scarlet watershed of my lungs
and was buried in Río Blanco under a white stone
and while the roses I once tended tangle overhead
I listen to waters gather, pool and rise
in their secret places underground
and here in my dry and narrow bed,
I am not thirsty
I am not alone.

 ❧ From *Silt: Prose Poems* (2019)

Memoir of a Collaboration

Dear Mami,

 I write these words from your room in Massachusetts, the same one in which you stopped breathing almost a year ago, and in a minute I'll send them by email to your granddaughter, so she can read them in Havana, among Latina women, writers, fighters like you, because I want them to recognize you, because they are the ones who should receive this *testimonio* of what you and I did.

 Our collaboration began one afternoon in New York, when I was five. You were teaching me to read, and suddenly, something magical happened. The lines and curves on the page became a word, and I understood that I could mark a piece of paper with the signs for "cat," send that paper to the other side of the world, and make another human being, utterly unknown to me, think of a cat. In that instant I found my vocation. You gave me the alphabet, mysterious, potent, and mine.

 You, Rosario Morales, known as Sari, were the daughter of migrants who arrived from their small island town on a steamship, in September 1929, just in time for the crash on Wall Street. You were born hungry and grew up in Harlem and the Bronx, among other scraps of displaced nations, and at thirteen you made a pact with your best friend to read every book in the little neighborhood library, starting with A, because for you, too, the alphabet was magic.

 At eighteen, at the height of McCarthyism, you became a communist, joining the party as so many were leaving it, and it was at an evening of music and discussion that you met a young Jewish scientist from a revolutionary family, who tells me he fell in love with your ever so sharp questions, with your intelligence and critical capacity, and I say, "Yes, Papi, but also with her radiant beauty, right?" "Of course," he says. At any rate, you married, and when the Korean War broke out, you decided to go to Puerto Rico, and when Papi couldn't get a job, because the FBI followed him everywhere he applied, you followed a comrade's advice and bought a half-abandoned coffee farm, where you raised chickens and children, growing vegetables and consciousness for the neighbors.

You two, with four or five others, were the Party nucleus for the whole coffee region. Papi drank beers with coffee workers and talked about better wages, and with the small farmers talked about cooperatives, and you organized a women's group, sponsored by the agricultural extension, to teach them various practical things, but most of all, to get them out of their houses and talking about how hard their lives were.

In that mountain barrio, away in *el jurutungo*, as we say, I grew up in a house brimming, from floor to ceiling, with books. Among the poetry and novels, Marxist philosophy and scientific books, you began collecting anthropology texts, inspired by a group of young radical academics you had met in New York. When they finally kicked my father out of the University of Puerto Rico, you wanted to go where you could study anthropology, make it your own, use it to change the world. You also wanted to get me out of that countryside where thirteen-year-old girls were getting pregnant and the only model of how to be a woman was to have six children and put up with domestic abuse. So we went to Chicago in the so-called Summer of Love of 1967.

How can I explain to our sisters what it was like then, in those years of the late 1960s in the United States, so full of rage and hope? Between the battles for civil rights and against poverty, racist violence and the war in Vietnam, feminism erupted, and on every side, poetry burst from mouths silenced until then. I, adolescent, furious, confused by the culture shock of migration, intoxicated with struggle; and you, almost forty, confronting the arrogant white male elites of anthropology who despised you for being a woman, a faculty wife, a fierce working-class Puerto Rican intellectual—we both took pen in hand and began to write, in notebooks, on bits of napkins, on the walls, anywhere.

We would leave the house fuming over the most recent of those classic fights between mothers and daughters, and arrive together at the meeting where we were allies, comrades, I, at fifteen, the youngest in the room, and you among the oldest, both of us insisting that racism, that the privileges of class, that homophobia not contaminate the project of our liberation as women, that we would not tolerate that in the name of convenience or urgency a single woman be left behind. We put the *revolú* in revolution.[1]

I occupied buildings, made guerrilla theater in the streets, was expelled from high school, filled notebook after notebook with anguish and longing, went to my consciousness-raising group, wrote scripts for a feminist radio show I produced with another teenager, was part of a collective that infiltrated the medical school library to learn about our own bodies and

facilitated illegal abortions, and traveled to Paris with a delegation, to meet with representatives of the Vietnamese liberation front.

You led mass protest gatherings, went to meetings and coalitions, formed collectives and study groups, and at the University of Chicago, conservative bastion, researched the genocides of Indigenous peoples and in spite of the warnings of your professors, threw yourself into battle, so that your master's thesis was a condemnation of the racist colonialism of that god of anthropology, Claude Lévi-Strauss himself, and in mockery of his famous book *Triste Tropique*, entitled your manifesto *Tropes Tipique*.

I grew up, went to college, and we called each other on the phone to read each other drafts of poems and essays. I moved to California and you to Boston and we both began to do readings and to publish, and when you read, you read my poems with yours, and when I spoke, I spoke your words and mine, and one day in June 1981 we stood with eight other women in a church in Boston to present the fierce anthology *This Bridge Called My Back*, a bridge made of our own backs, over which the whole world crossed, we, Black, Latina, Asian, Indigenous women, struggling in ten directions at once. The first edition sold out in three weeks and suddenly we were experts. I was the one who began to travel from university to university to speak of our feminism, that of so-called women of color. You didn't like that. You liked to stay home, read your work at the corner bookstore, or at the nearby campuses of the academic world, and enjoy my wanderings at second hand.

One day you called me from the doorway of your house, with your coat still on and a letter in your hand, to tell me that we'd been invited to write a book together, about everything we were most interested in. In those days you could count the number of books in English by Puerto Rican women on so few fingers that you could eat tostones with the other hand. We wrote, over the next three years, the book we longed for. *Getting Home Alive* was a multiple challenge to convention—in its content, its form, and in the identities of its authors.

We mixed poems, prose poetry, and personal narratives with wild abandon, a collage of genres. We celebrated the identity and culture of the diaspora at the same time that we denounced the racism that saturated everything, the pressures of assimilation, and the almost impenetrable chill of individualism. We celebrated our love for the island of our roots with nostalgia but without romanticism, also declaring our opposition to the virulent sexism,

to what colonialism has done to us, against the mythology of a Boricua paradise, cultivated from afar.

They called it a landmark in Puerto Rican diaspora literature in the US, selections from the book appeared in dozens of anthologies and academic texts and were translated into seven languages, but what always pleased us much more than good reviews was when people came up to us with personal stories of revelation, because they had never before seen themselves reflected in the pages of a book, and we had made them a mirror: the student who wrote lines of our poetry in the bathroom stalls of her university in protest because all the books she was assigned were by white men; the woman who told me her mother was a heroin addict, and the only thing, she said, that they could share was our book, which they read out loud together; the teacher in Kansas who had his students write their own versions of my poem and sent me an envelope full of vulnerability and beauty that made me weep; the ones who wrote to us to say that the book had given them the courage to persist, to pursue their dreams; the rumors that fragments of what we had written had been turned into dances, posters, graffiti.

I don't say this to brag about our literary talents but rather to say that it was our great honor to give voice to something our people needed, that in the passion we expressed, they saw their own power and beauty, and that this was our greatest reward and satisfaction.

We were never very interested in the world of professional authors, with its contests and tours, multibook contracts, and the desperate self-promotion required to live from writing in the capitalist literary marketplace, nor the search for more fame than came to us without effort. Our artistic passions, in spite of their sensuality, had always and fundamentally been political and our deepest loyalty to a different definition of success.

Between your work and mine, there are two poems that are the most reproduced, the most famous. Mine, "Child of the Americas" and yours, "I Am What I Am," are, more than anything, declarations of self, of existing in the face of everything that despises us, in all the glorious complexity of who we are.

I am a child of many diaspora, I wrote, born into this continent at a crossroads. I speak English. It's the tongue of my consciousness, a flashing knife blade of crystal, my tool, my craft. I am Caribeña, island grown. Spanish is in my flesh, the language of garlic and mangoes, the singing in my poetry, the flying gestures of my hands. I am of Latinoamerica. I speak from that body. I am not African. Africa is in me, but I cannot return. I am not Taíno. Taíno is in me, but there is no way back. I am not European. Europe lives in me, but I have no home there.

I am new. History made me. My first language was spanglish. I was born at the crossroads and I am whole.

I am what I am and I am, you said, US American I haven't wanted to say it because if I did you'd take away the Puerto Rican but now I say go to hell I am what I am and you can't take it away with all the words and sneers at your command. . . . I am Boricua as Boricuas come from the isle of Manhattan and I croon sentimental tangos in my sleep and Afro-Cuban beats in my blood and Xavier Cugat's lukewarm Latin is so familiar and dear sneer dear but he's familiar and dear . . .

And someone who did languages for a living stopped me in the subway because how I spoke was a linguist's treat I mean there it was Yiddish and Spanish and fine refined college educated English and Irish which I mainly keep in my prayers It's dusty now I haven't said my prayers in decades but try my Hail Marrrry full of grrrace with the nun's burr with the nun's disdain. Do you know I got an English accent from the BBC For years in the mountains of Puerto Rico when I was twenty-two and twenty-four and twenty-six all those young years I listened to the BBC and Radio Moscow's English English announcers announce and I love too the singing of yiddish sentences that go with shrugs and hands and arms doing melancholy or lively dances I love those words hundreds of them dotting the english language like raisins in the bread shnook and shlemiel zoftik tush shmata all those soft sweet sounds saying sharp sharp things . . . I am what I am. Take it or leave me alone.

We were born together at the crossroads—of roads, nationalities, social movements that tried to fundamentally change society and in the process erupted into a fiery abundance of poetry. You taught me to favor the democratic, the accessible. There is no question that I am an intellectual, and I was a traveling lecturer through the universities of this country for thirty years, accompanied by my doctorate and my publications, but my intellectual life has been carried out in the reading rooms of public libraries, in radical cultural centers, around tables in kitchens and cafés, in women's groups and artists' collectives, on the radio and in used book stores. You gave me this, supremely organic intellectual that you were. You taught me to write, and together we became socially committed writers.

All my life has been a conversation with you. You were my best friend, my closest colleague, my most trusted political comrade. For forty years, together we wrote a new version of what it was to be Puerto Rican women. That 3 a.m. in which you left, my world changed forever. A thousand times

a day I turn toward your last known location to share a story, a hopeful bit of news, a delicious phrase. Although there is no longer any telephone that you will answer, I keep talking to you, and it's no surprise that we continue to collaborate. While I edit your stories and mine for our last book, *Cosecha and Other Stories*, while I organize your papers for the archives, crafting a memoir of your life, I feel you here with me, settling into my bones, giving weight to my intentions. You keep creating our shared history with me.

May it continue to be of use.

.............

Note

1 *Revolú* is Puerto Rican slang for chaos, disorder, disruption.

My Father's Hand

The first thing I remember is the big, warm wall of your chest, breath rising, falling rising falling reliable as an ocean and how I stretched my toes to reach the crook of your arm, then I remember the weight of your hand on my head, like a roof.

There are photos: my plump self among the bananas, your hand on my hand guiding a pencil, as Lenin and the outlawed flag of my country look on. Shown so often, they've lost the shine of remembrance and become landmarks, milestones to visit, but this is not that poem.

The next thing I remember is the plane to New York, the roar of propellers, the sparkle of mica in the sidewalks, the record player high above my head playing drama and defiance: "Petroushka" and "There once was a union maid."

This is where the whole stories begin. Where we walk together, my small hand in yours, to the lab at Columbia, the high stools and shining microscopes, the tall woman in the white coat. By the age of four I know there are women scientists. It is 1958. The old women on the boardwalk called me sheyne maydele, but you filled my head with finches' wings, sequences of numbers, bacteria swimming under glass.

You and I go to Riverside Park, where you sit on the bench reading a book whose title I can sound out. Who is Jim Crow, I ask, and now I know about dogs, ropes, hoses, riots, barricades, children forbidden to go to school. Enough so that when we join the picket outside the Woolworth's lunch counter sit-in, I know why I'm there, holding my corner of the sign. From that moment on, I know why I'm there.

Each time you take me to Uncle Fidd for dental work, my reward is a trip to polished wood, towering bones, tiny dioramas. We discuss dinosaurs and the evolutionary purposes of their shapes. You tell me the story of the six birds and the archeopteryx. You bring me to windows behind which are miniature tundras, savannahs, rainforests. I begin making my own tiny worlds, in matchbooks, on shelves. I begin modeling possibility. I begin looking for windows into other people and places.

On the long drive between Rochester and New York City you offer us puzzles: Why does the radio go silent in tunnels? How do the speed limit signs change by themselves at dusk? How do you know when the light is about to turn green? You tell us stories about your adventures with medieval Chinese navigators and Arabian bandits, full of call-and-response. You sing to us about Joe Hill and Pretty Boy Floyd and we sing along. We understand that we are actors in history, not spectators.

You recite Gilbert and Sullivan and read us the nonsense poems of Edward Lear and parodies of famous poems, and also the famous poems so that even though I know I must never, ever write with my pencil in a book, I understand that I can change the story, make fun of it, bend it to my purpose, that anyone can compose a birthday poem full of silliness, a new verse to an old song: this land's not your land, this land's not my land, from Mayagüez to Vieques Island . . . You and Mami saturate us with poetry, fill our heads with rhythms and cadences. We know how to rhyme in two languages.

You leave windows open everywhere: the microscope on the kitchen table, the encyclopedia on the bottom shelf, the questions you dangle. Peering through your lens, I discover the pomegranate eye of the fruit fly, the exact location of color in a petal, in a leaf. One pinch of the uniformly golden beach explodes into specificities of coral, bottle glass, shells. From now on I know the scale of the question determines what you see.

Even then, when we are still small, you are talking about parts and wholes, uncertainties and oscillations, the delicious complexities of islands and societies, contradictions and principles, the big long view and the inevitability of surprise.

I remember the moment when I realize how you remember a million details, of history, of science, of my mother's family tree—by connecting them! From now on I follow threads, tend the net of my mind, winding strands, tying knots. You teach me to watch for patterns and make them.

You spin equations and I spin metaphors, my tool of analysis.

I remember the moment when you say there are no bad people, only bad choices. The possible bursts wide open, pollen flying everywhere. If there are no bad people, everything can change.

You talk about your grandmother, raising you to be a good radical, about Bad Bishop Brown and garment worker strikes, about the Lincoln Brigade and the Warsaw Ghetto Uprising, about the long march across China, about imprisoned writers and exiled poets. You read us Brecht, Hikmet, Neruda. I begin translating the Spanish Civil War poems. I know who I am a part of. You tell us about the Moncada, the *Granma*, Fidel. Then you take us to Cuba.

By now I am fourteen, and while all my mother's poems and stories and questions have been making constellations in my head all my life, this is your poem. The day we arrive in Havana the rain piles up in thick brown curves at every street corner and there is the smell of my damp wool poncho and that distinctive odor of Cuban newsprint, crates of guanábana yogurt delivered to our door, and the surprising fact that adults keep asking us children what we think. So while you do your mysterious grown-up business at the university, I begin taking ownership of revolution, and when we return to Chicago, I can no longer obey. I leave high school. I leave home. I travel and march and scribble furiously in notebooks, on napkins, everywhere, knowing why I'm there, who I am part of, how to change stories, find windows and look through them, participate in history, make webs of connection, follow threads, think big, own my revolution, watch for patterns, ask the right questions and leave them open, on the table, dance with uncertainty, write new verses to old songs, place my hands on the heads of the young, and when I am inevitably surprised, I know how to be delighted, and laugh, and begin again.

 From *Silt: Prose Poems* (2019)

Introduction: New Orleans

I came to a city at the crossroad of earth and water, where the Great River fans out in a thousand fingers to meet the small bright Sea. I came carrying my own dead. Mis muertxs.

There is an open pit mine in this place, where stories are shoveled out of the half-flooded soil and taken away, to shine in private collections housed on solid ground. I didn't bring a shovel. I came with my own stories, my handful of seashells, my granito de arroz, my island eyes, to find the confluence of our lives. I came to Bulbancha, where many words meet, to add my story to the shell mound.

I came carrying my drowned country in my hands. I came in the wake of storms that were not brewed at sea. I came from a land on fire. I did not come to sit shiva. I did not come to sit at the wake. I came to add my song to the weave.

I came carrying my mother, Sari, who taught me the brujería of her life, buzzing with questions: taught me how to hold a pencil and lay words onto paper, how to track the course of a hurricane across a map by lamplight, how to brew tea from night blossoming jasmine, to know the names of all the colors (cerulean, veridian, umber) and make them my compass, to turn toward difficulty and chart my course, to sew a swift, well-anchored seam, to smell the flaw in the argument, the problem with the plan, the name of the dust brushed under the rug, but also to smell the first hint of dawn, and the promise of rain.

I came carrying my father, Dick, who taught me the ciencia of his life, drawing equations in wet sand and illustrated birthday books in rhyme: who taught me endless webs of connection, and all the words of "Solidarity Forever," who showed me the wings of fruit flies, their ruby eyes, the banded shells of snails, the poetry of imprisoned radicals—impossible blooming, who laid his hand on my head and said think, trust your mind, who told me there are no bad people, only bad decisions and chanted complexity, complexity, the truth is the whole.

I carry my mother in my bones, my father in the chambers of my heart, though she died of cancer-riddled bone marrow and he died of a muscle that could barely move his blood.

I came to let this place rise through the soles of my feet, through my bones and my heart, and turn into the water songs of a traveling Caribbean Jew.

From *Silt: Prose Poems* (2019)

8 CEREMONY

I grew up in an atheist home, in a countryside full of the rituals of multiple ancestral streams. Candles lit in corners, bargains made with saints, offerings left at creeks and crossroads, visitations from the dead. As I played in the woods, I made my own minute altars, arrangements of pebbles and flowers and snail shells around tiny ferns, petal-stained rocks, tiny twig houses, and I composed mysterious chants in made-up languages that were part of my deep partnership with the wild.

Although my parents were not religious, they had a great sense of occasion. We ate Red Flannel Hash, a fry-up of beets, onions, and potatoes, and sang "The Internationale" to celebrate May Day. Mother's Day involved breakfast in bed, borne on a flower-laden tray while my father recited his latest humorous poem, and Sunday afternoon tea, a gift from Alabama aristocratic communists and Anglophile scientific colleagues, was a table laden with small dishes: anchovy paste, guava jelly, three kinds of crackers, an array of flavored cream cheeses, a huge brown pot of imported tea, and my father's Ashkenazi version of guacamole that replaced chiles and garlic with hard-boiled eggs, the whole feast always accompanied by a Gilbert and Sullivan operetta played on the old Victrola. Our walls displayed a series

of Cuban posters declaring a multitude of international days of solidarity and historical commemorations. There were days for countries and revolutionary leaders, movements and moments. Ritual and ceremony were woven into my psyche early and from many directions.

As a young adult, I encountered traditional Jewish holidays through the mostly lesbian Jewish feminists who were excitedly rewriting it, creating liberation seders, alternate versions of new moons and new years, working from texts that were unfamiliar to me but echoed in my bones. I began writing dramatic scripts for Latin American exiles performing the resistance stories of the Southern Cone and radical dedications of the Passover cups at the same time, and they came together beautifully in a Haggadah for a Latin America solidarity seder.

The writing in this section has served as ceremony, as ritual, as prayer, as lament, as invocation. "Tashlich" refers to the Jewish Rosh Hashana (New Year) ritual in which Jews release burdens, mistakes, and sorrows into water. "Dark of the Year: December 2002" was written in the aftermath of a terrible breakup that had deep roots but was also impacted by the eruption of war. "Shema: September 12, 2001" came out in one great flood of words the day after 9/11 and went viral, was broadcast on national radio, and began a stint for me as a paid radio poet. "Grave Song for Immigrant Soldiers" was sparked by the deaths of three US soldiers, immigrants from Latin America, denied citizenship in life and granted it as a reward for dying, and invokes a different future for the Americas than borders and wars. "Silt of Each Other" speaks back to a moment of US imperialist pseudoscience that was the inspiration for my book *Silt*, and declares a different kind of manifest destiny.

"Rain," "Vena Cava," and "Baño" are a triptych of related pieces from *Silt: Prose Poems*, following threads of water and history as

they weave between the Mississippi River and the Caribbean. "Bees" is about solidarity across species and "Resurrection" draws strength from the strategies of a Louisiana fern. "Slichah for a Shmita Year" is my reworking of a communal Yom Kippur prayer of release and mending. "A Sweet Year of Struggle" was a Rosh Hashana blessing during the hard year of 2020. "Braided Prayer" is about learning to listen to the world, and "Water Road" describes my experience of being called home to Puerto Rico.

Tashlich

I give the stones of my grief away,
let them slip like pebbles into the stream bed
into shallows where minnows flicker
I hurl them into the salty crash of wave on reef
as crabs scuttle into crevices.

My tiredness I surrender to the rain
to the tropical downpour, to the drawn out drizzle,
to the puddles after, to the percussion
of water drops on tin, pounding away at things,
to the shiny new leaves of the wild ginger
and the thirst-quenched ferns.

The ache of my body, the sickness, the scars
I lay out for the dew to spangle,
for condensation's slow caress to ease them
from my tight grip, away.
I must don high boots and heavy gear
to lay my jagged angers at the waterfall's foot
for the jackhammer of the torrent to unmake
and pound into gravel, into sand.

Empty handed I climb the bank
like ancient life emerging from the sea
dripping with possibility, evolving,
learning again, again, again,
to live on land.

Dark of the Year:
December 2002

1

We drove to the edge of the river and I dipped my hands into that dark
 water,
brown with silt, and she sang *the water is wide, I cannot cross over*
while the last geese made their way south above us.
I was there to gather stones,
nine dark, nine light, for ceremony, for magic, pulling power
out of the dark of the year, up the roots of the moment,
to mend my broken heart and grow strong.
Her voice blended with the wind and the shouting of the crows,
and neither have I wings to fly,
all around us the air full of wings, black and white,
the iridescent purple and green of mallards' necks
as vivid as pain, wings all around me,
wings everywhere, while I stood at the river's rim,
hands full of stones, as earthbound as I have ever been.

———

2

My brother is drawing what I asked for, a map of war, roads that split and
 curve,
a heart in flames, rivers meeting that have never met, the Jordan and
 Mississippi
and the *vena cava*. I move across this dark bare earth
through which rivers twist like veins,
the Crow and the Sauk and Finn Creek, threading their way, ice edged,
from pearl blue ponds, along a cheek-soft curve of the coffee colored fallows,
and into the wind burnt husks of a field of standing corn. I am listening

to the memory of war buried under the plow. I am following an imagi-
 nary map
into the heartland. I am writing poems with my fingers in the dirt.

————

3

Maybe courage is the one red feather in the dark wing of this year.
Maybe I am stitching a single crimson bead into a tapestry of jet.
Maybe my heart is the one unforgettable thing you cannot cut away.
I am sitting in a field at midnight cupping my hands around this flame
as it bends and flares in a deadly wind, feeding it splinters, seeing
 sparks
fly whirling into the black space beyond my tiny circle of light.

————

4

The voices of men I love collect at the edges of this night,
crows flocking to glean corn from an empty field.
They come for my small grains of truth, for the word I speak
that drives back the chill of amnesia,
for the way their names glitter in my eyes.
They are too cold to know if they are wounded.
I tell them yes and no, yes and no. You can still fly.
They make dark circles around the eye of the moon,
shadows of grief around the songs of women. I alone
stand in the stubble and the frost and say I need your sorrow,
tell me the truth of what you are grieving.
When the sun breaks over the blade of the horizon
I am wearing a cloak of black feathers and a crown of antlers,
and then I wake again, naked skin wrapped in white linens, and alone.

————

5

I am calling magic out of the snowy air along the train tracks and above
 the silos.
I am calling magic out of the river stones and the dark of the year.

I am kindling magic from a dream of an old woman and a silver cup of
 deep red wine.
I am drawing it up through the floors of this little house, out of the poi-
 soned aquifers
that coil beneath the crumbling brown earth, sucking venom from my
 wounds
and the earth's wounds, and spitting it out. I am trying to wake myself
 from a long dream.
I am summoning who I was before so much loss. Before I forgot myself
 and fell
into the wake of your suffering, the undertow of your stuttering faith. I
 am calling up
the brown-eyed child who could call owls and lizards and rain. I am
 dowsing this earth
for my own blood, filling my veins with remembering.
I am remaking myself from the seed
that lies buried in the ground.

6

Give me a boat that can carry two, and both shall row, and both shall row . . .
I am at the river crossing between the worlds, on the banks of the Ohio,
at the border between freedom and death, slavery and life, singing *both
 shall row*
while you turn heavily in your sleep. I am at the place where the waters part
and some walk through to what was promised,
and some are swept away on a red tide.
I am making a bargain for your life. I will not give my own. I will not go
 crazy.
I will not pay in blood. I shout to the boatman that my only coin is truth.
I will tell the story and leave nothing out.

7

Sitting in a circle of flames and painted stones, I speak with my ancestors.
They come from four directions, six continents, many centuries,
out of my flesh and the memories of flesh, and a dust far older.

They are many and strange. They fill my head with dreaming.
They tell me: do not be afraid. They bless me again and again.
I tell them my sorrow is deep and I am weary and the water is wide.

8

I confess that I have ridden the tide of panic into battle.
I confess I have been afraid to love myself, and have teetered
in the high wind of your misdirected rage. I confess that I took false
 coin,
accepted romantic homage that was only an old longing
wrapped around your fear that nothing real would ever be enough.
That I threw stones and bared my teeth at the vast shadows
your small, scared gestures cast on the walls of our rooms
in the crooked light of my history.
That there were times I dissected every word you spoke
desperate for escape from a past that was over, looking for a key
to a door that was open, trying to find the way back to our delight.
That I wanted you to heal and sometimes could not bear to see your
 wounds.
I was relentless in my grief and hope. I confess I did not let you sleep.
I confess I took your bitter words and scornful looks too much to heart,
and was infected with shame, to think perhaps I was as wrongheaded
and misshapen as you said. I will tell the whole truth. I was afraid,
and the words rushed and tumbled from my mouth in a fury I could not
 control.
I was afraid and closed my eyes and let you get away with lies. I was
 afraid
and accommodated your injustices, hoping you would become merciful.
I admit that I tried to pass impossible tests. I will tell the whole truth.
I refused to give up. I would not accept this defeat, I would not reclaim
 my heart
when you left it on the table, I made my stand at the far edge of loving,
at the dark riverside, in a torrent of sorrow. I would not
surrender the one true thing. I did not let the cavernous
past derange me utterly. When you fought me, I fought back.
I wanted my heart in your hands to be safe forever.
I wanted you to lay down the shields and come to me.

I wanted my faith to be enough for us both.
I would have burned a city to win you. Perhaps I did.
I drop the golden fiery coins of my story
into the boatman's withered hand.

———

9

The oracle has told me in its voice of cowrie shells and stones
that I am not to doubt this: you are my love.
But you are in a trouble you cannot name,
a dream you cannot wake from, a mistake that cleaves your senses.
Your power slides from between your fingers, and you clutch at nothing.
You are stumbling on a narrow road, without elders to guide you, in a place
where not even my prayers can go. I am told I am like the mother of myth
searching the barren winter earth for the piece of her heart
that wanders in the underworld, eating pomegranate seeds and forgetting
 the sun.
No matter how many times the shells fall, she says there is no open path.
I cannot be Orpheus and bring you back from hell. You must die your
 death
down to the bitter root, to cold ash, to the last burning, acrid drop,
before your hunger for what is real overpowers your dread,
before you part the drenched soil with your tight bound hands,
and your fingers open to push up a thousand shoots of new-made green.

———

10

I am not the plow for this furrow. I am not the corn for this planting.
I am not the axe for this firewood. I am not the basket for these apples.
I am not the shoe for this foot. I am not the bandage for this bleeding.
I am not the walking stick for this journey. I am not the cup for this thirst.
I am not the doorknob that will turn. I am not the rose in the briar.
But I am the one among all others who knows your secret name
and I am the one who writes these poems when you are sleeping
and I am the one who will be waiting when you arrive, soaked and
 gasping,
at the far shores of the night.

11

I am told the only gift I can give you is my people.
I make them offerings of cornbread
hot from the oven, dripping with honey, and dark red wine,
and for my handsome Jewish grandfather, whose honor was straight as a
 reed,
who laughed like you, who respected himself and everyone,
I lay out braided Finnish bread, as close to challah as one can get
in this windswept Lutheran corner of the world. They promise not to
 leave your side.
They promise to teach you, if you will be taught, how to honor yourself.
From this night you will not stir without a flock of my kin around you.
My people enter and leave your dreams like rooms in their own houses.
When you reach for one thing, they give you another. When you turn
in circles in the dark, they glimmer like lanterns and make paths.
They are hawks circling your confusion.
They will feed your courage and starve your misery. If there is a way
out of shame, they will show it to you. Each time you drop your stick,
they will shake rattles, blow in your ear, stub your toes until you pick it up.
You said you didn't know how to be my lover and believed it.
My people know everything there is to know about the matter.
They scorn duplicity and scoff at self-pity.
They will feed your trust and starve your terror.
They will enlarge your spirit and shrivel your worry.
My people have fought terrible battles and won them.
My people have been bound hand and foot with the cords of despair.
My people have made peace from a pinch of salt and intentions.
My people know how to love me. They know what you are made of.
They know what the lesson is and where it will take you.
My people will make themselves into a road and invite you to walk it.
The rest is up to you.

12

This is the cold heart of winter from which fire springs back into the sky.
I am a kindler, rubbing sticks and chanting spells. I write poems

that flutter in the dark like moths searching for whatever is bright.
I am a red thorn in a black wood. I am the bird that did not fly south.
I circle above your burial place, writing your name with my shadow on
 the snow.
War blows like smoke across the moon. There is fear in every throat.
I must concentrate if I am to make this dry wood crackle with life.
There are other lives to save besides our own.
I am a matchstick in a pile of coal. I make fire out of a wish.
Soon the sun will be born out of the black mouth of solstice
and start its slow journey.
I will be a blazing prayer flag fluttering from the wheel of the year.
I will be the red bud on the black branch when the wild birds return.
I will stitch my bright red love with this silver needle tongue, like silk
 thread,
in and out and in and out, binding light into dark, and darkness into day.

Shema: September 12, 2001

Hear this: while the generals, panting, peruse their lists of countries to
 bomb
in the sacred cause of reestablishing that their collective dick is bigger
than that of any pissant, terrorist-wielding, dark-faced dictator in a tent;
while the same men who have plotted invasion after invasion of sovereign
 lands,
bombed cities into rubble on every inhabited continent, called the deaths
 of children
an acceptable sacrifice, kidnapped, killed, and replaced the leaders of
 other countries
with nothing but admiration for their own maneuvers,
Hear this! while these men diagram the next war into which they will
 drag us
using our fear as gasoline, using our grief as lubricant—
wake up!
America the dutiful, wake up from the mall-driven dream of snug
 security,
the fraudulent, flag-wrapped lifetime warranty of the good life
just out of reach but surely coming to us all, even the ragged homeless in
 our streets,

American ragged, in American streets, surely more pure in poverty,
more blessed than the beggars of Bangkok or Bombay.
Wake up and see the shocked eyes of a hundred thousand dead Iraqi
 children watch
as the fiery birds of war come home to roost.
Hear, oh people. The warriors are many.
War is one.

There is nothing to separate this fiery falling of buildings
from the buildings that have fallen in flame
under the weight of ordnance made in factories just down the road from
 each of us;

the jets filled with ordinary people turned into unwilling missiles were
 forged,
rolled, cut, riveted, welded in the same factories,
by the same billionaire wing-makers
whose jets burned the sky over Baghdad, Panama City, Grenada, the
 Mekong.
What should surprise us? That other residents of soot choked cities,
other heart-ripped mourners of civilian dead, other anguished, enraged
 people
should be swept up in a whirlwind of revenge? What have they done to us
that so many hateful, hysterical voices blare over the radios of our nation
as if we were the only human beings on earth
and we alone, when we are burned, scream?

Never forget: we were taxpayers in Egypt.[1]
Imagine if we, his armies, his consenting majority, had said to Pharaoh
we will not be wielded against any more enslaved people,
any more unwilling subjects, any more laborers of the pyramid maquiladoras
in the name of your golden sarcophagus. You have put us in harm's way.
The angry gods of the conquered do not distinguish
between kings and their subjects. We will not drown for you.

Hear, oh people, the man on television surprised by devastation into saying
that Manhattan looked to him that night just like Beirut, as if only Beirut
is supposed to look that way.
Imagine Beirut is your home
and it has looked like this for as long as you can remember.
Imagine you know that untouchable nation across the sea
has everything to do with your ruined city and then look again,
from the other side of the table, at Manhattan streets full of rubble,
Manhattan sending up plumes of smoke
and imagine what you might feel. Listen
to the indignant woman from Pennsylvania who wants to know
why she was not protected from this? Who fell down on the job?
Who demands to know why the people of the greatest nation on earth
 are not immune
from the tragedies spawned in the ready rooms of our leaders?

Hear the call of the ram's horn and rouse yourselves from the dream of
 comfort

into the cold light of day. It is better to be awake than comfortable.
The illusion was bought on credit
and the street children of Brazil are our creditors.
Our creditors are the elders of Nigerian villages
bulldozed by Chevron's private armies,
Colombian coal miners gunned down for saying "union"
to Drummond Co. Inc., coal kings of Alabama, by thugs
paid for in the name of a fictitious war on drugs,
our creditors are the drowning island nations of the Pacific
disappearing in a warm and rising sea begging us to stop using
so much more energy than we need, inching their houses
closer together on their vanishing land
while Disney's Electric Circus sparkles and dazzles
to the delight of shrieking children,
sticky with candy and ignorance, and late night television hawkers
peddle gadget after gadget that does with electricity what,
for the sake of our suffering neighbors, we could do with our hands.
Our creditors are the millions of oil dead, ravaged nations of refugees
whose lives stood in the path of insatiable greed,
who were considered collateral damage, cost of production,
to expand the already swollen bank accounts of the obscenely rich.
Do people burn villages for profit and then buy television moments
to tell us their compassionate corporate nature
has saved a tiny butterfly called a Mission Blue? People do.
We did not sign these mortgages on our futures,
but our names were placed on the deeds
and we will be asked to pay.
Hear, oh bystanders certain of your innocence,
not one of the passengers, flight crew, office workers, firefighters deserved
 to die
and neither are we innocent.
We have inherited the hatred of whole continents of the hungry,
been persuaded to accept the leftovers of their looted wealth as our civi-
 lized due,
taught to think of it as just a higher standard of living,
as if our shrinking ability to pay $35 for blue jeans made by a girl in Hon-
 duras for 85¢
was the result of a better upbringing, of our impeccable taste,
and not the random fortune of being born under the coattails of empire.

We are the heirs to the hatred our corporate masters earn faster than
 interest,
the invisible column in their quarterly reports,
and upon us will fall the fiery hand of the desperate.
Hear this: the lost humanity of the hijackers and the blazing deaths of
 the hijacked
have already been calculated into the annual overheads,
figured into the budgets of business as usual
and boards of directors have said amen.

Wake up, oh people, to the voices of our missing kin.
We have been lulled into forgetting them.
We are the grandchildren of starving Irish tenants,
kidnapped Senegalese teenagers and Ghanaian farmers,
refugees from wars between petty fiefdoms and principalities of Europe
and the drafts of the Tsar's armies.
We are the descendants of English serfs and sheep shearers
fled from the pillage of the common lands.
We are the children of daughters sold to traders for food
and sold again to strangers, dead of syphilis at twenty;
the children of Cantonese stowaways and Swedish orphans, of sailors
 pressed into service
and servants oppressed and indentured, of children wasted into pale
 shreds at the loom,
of foot weary Neapolitan fruit vendors and raw knuckled Polish laundresses,
Puerto Rican seamstresses and shtetl shirtmakers from Byelarus.
We are the children of Norwegian and Bavarian loggers
clear-cutting white pine from the landscape for a pittance
and Portuguese cod fishers emptying the Grand Banks for a crust,
of Cornish colliers coughing up blood in Sierra Nevada mines
and Scots Cherokee miners buried alive in Kentucky coal shafts.
We are the offspring of French fur trappers and Huron leatherworkers,
 smallpox survivors
and relocated Choctaw singers, Mexican war widows who walked to El Paso
one step ahead of the armies and Vietnamese families forever missing
 their children dead
along the long way out of horror.
If we are also the children of slaveholders and Indian agents,
factory overseers, paper mill millionaires and railroad robber barons,

then we are the long sleeping conscience that can wake and shake the
 family tree.

Hear, oh people. This is the now. This is the day our ancestors dreamed
they would be the ancestors of. Our ancestors who are the cause of the
 eight hour day,
of social security and workers' compensation, of public libraries and
 cooperatives,
of weekends and sick leave and the right to bargain,
of there being anywhere to turn and of the vestiges of a free press still
 speaking
in the nooks and crannies of the corporate monotone drone they call
 news.
The freedom we have pledged our allegiance to does not yet exist,
and wherever the seedlings of it are green it is because we the people
 planted.
We are the custodians of freedom, not the barking voices of war makers.
The safety they tell us we have lost because of maniacal Muslims from a
 far away land
was never real; most of the people in this country are not safe.
Many cannot walk down the street without being pulled over for being
 brown
and perhaps shot. Cannot open the window without breathing cancer.
 Cannot go to work
without soaking up birth defects. Cannot turn on the television
without being lied to. Cannot get healing when they are sick, no matter
 how sick they are.
Cannot do work that makes them proud to do it because all they can get
 paid for
is taking out the trash of others and making the parts that keep the ma-
 chines of others running.
Can expect no destination except prison
because that is the only space that has been left vacant for them.
Liberty and justice for all is a rag shot full of exceptions.

We children of a thousand nations gathered in this homeland of hope
 and horror,
bribed with hot and cold running water, electric pencil sharpeners
and the prerecorded cheerleader's chant that we are the best, best, best in
 the world,

we have been hypnotized by the fantasy that we are the freest of all people
to quietly accept the coup of the unelected, and the ravaging of the planet;
we are passengers in a car driven by men drunk with plunder,
ricocheting through the world leaving trails of devastation:
we are the ones who must take the wheel,
stop this hurtling death ride, downshift into decency, not because we are
 wiser
than the crushed and bleeding in the streets, but because we are here.
We are not the designated drivers of the world:
but we are designated to stop what we can reach.

Right now, as the men in the soundproof rooms demand war,
demand retaliation against insolent unknowns
who dare to boomerang bloodshed back into their spanking clean board-
 rooms, now,
while the networks juxtapose burning buildings and smiling Muslim
 faces
getting us ready to accept whichever Middle Eastern war target they choose
to be their nation of expendable accomplices to crime; this is the moment
to ask these men who finance death squads around the world
and stand in the floodlights declaring they will not tolerate terrorism:
What have you done in our name that anyone should wish us such harm?

If we have not known, this is the time to know. If we have been unwitting,
this is the time to gather our wits. If we have allowed ourselves to be
 overwhelmed
by the delusion that we are helpless, the machine all powerful
and the state of the world best left to others, most of them unborn,
if we have fallen into the blank narcotic dream of our insignificance,
settled for the late night promise of an exciting career
in dental hygiene or the thrill of a nicely packed 401(k) and a remodeled
 kitchen,
if we have fallen to our knees under the blows of complacency and ridicule,
it is not too late to forgive ourselves and rise.

Now is the time to quit the comforting drug of *let it be* cold turkey
and rise up shaking from the floors of our spirits with all of our ancestors
 around us.
Today is the day to insist that this nation rooted in conquest and slavery,
rooted in rebellion and righteousness, renew the meaning of our union

and become what we have never been except in the speeches of
 politicians.
Make true the proclamations of the senators and let us serve notice upon
the duly incorporated, legally registered, true and trademarked terrorists
who, to our undying outrage, have launched themselves from US soil,
protected by US armies, backed by US money and US law.
Cut their budget of tolerance and cash, for they have embezzled our
 honor
to finance a wave of crime against humanity.
Hogtie the global bullies
who have raised such hatred by their acts
that this tsunami of helpless rage has been hurled
against the members of our families.
Hold the bandits responsible for each beloved face gone
in the backlash of international loathing.
We do not absolve those desperate men of the murders of our people,
but we also name the killers of their peace; we know who it was
that robbed them of everything but desperation, who taught them
to trust weaponry, who treated their lives with such contempt
that they grew contemptuous of ours.

Shema, people of the United States of America,
infinitely divisible under their thumbs,
infinitely courageous, humble and just within our hearts
heirs to struggles of a hundred thousand righteous ordinary people
what peace will we make and with whom?

There is untold wealth hidden among us.
Wally, who is having bad dreams of Pearl Harbor
and is wrestling to find compassion for people he doesn't understand
and doesn't want them dead before he finds it, who says out loud
"I have fought in three wars and I don't want this one."
Lucille, who lost her husband under rubble, a firefighter,
and wants no fires set in his name to ravage any other life.
Jules, who survived the deaths of six million of his relatives
and has gone to stand in front of a mosque and prevent harm.
Kim, who says I don't know much but I know this,
those towers were golden symbols of wealth in a hungry world
and I won't wave a flag till everyone has eaten.

Eric, who had a brother on that planeload of people who refused to be
 used as weapons
and says if he can be that brave so can I. I will not be hurled at anyone's
 home.

A murdered poet in a land of volcanoes has told us
All together, they have more death than we,
but all together
every single heart beating in every time zone
desiring more than anything if the truth be told
the shared bread of justice, and the laughter of the ones we love
all together he said before he died, one and one and one and one
we have more life, more life, more life than they.
Hear, oh people, this is our hope
and our hope is one.

.............

Note

1 This reference is to the traditional Passover command never to forget that we
 were slaves in Egypt thousands of years ago and does not in any way allude to the
 modern Egyptian state or people. The traditional wording in the Haggadah is to
 not forget "we were slaves in Egypt." We are referring to ourselves.

Grave Song for Immigrant Soldiers

JOSÉ GUTIERREZ, JOSÉ GARIBAY, DIEGO RINCON, AND JESÚS ALBERTO
SUAREZ WERE "GREEN-CARD SOLDIERS" WHO DIED IN IRAQ AND WERE
GIVEN POSTHUMOUS CITIZENSHIP. EZEQUIEL HERNÁNDEZ WAS SHOT
IN THE BACK WHILE HERDING HIS FAMILY'S GOATS NEAR HIS HOME IN
TEXAS, BY MARINES TAKING PART IN BORDER MANEUVERS.

PART I

I am sitting right here in California this
occupied land ripped with borders,
borders running like red scars
under the city limits and county lines
stitched into our hearts with crimson threads
a thick embroidery of grief
welts of damage crisscrossing
the everyday landscape of ignorance.

The wealth of the world may enter
but its people may not.
Industrial strength needles rise and fall
setting barbed wire stitches,
doing the meaty business of empire,
upon the hacked and reassembled body of the planet
drawing a bloody string through lives
that people living inside the gates
are instructed to forget.
I am sitting here thinking Flor,
Germán, Lola, Manuel, Claudio,
Mercedita, Ricardo, Cristina, Ramón,

the stained gauze of foreignness
binding their fluid caribe tongues.
I think, how many Chinese women
were sent back yesterday morning
wrong papers start over
go back to sewing American flags
for six noodles a day
in mainland sweatshops
waiting for something new to happen.
I think Haitian bodies
dark driftwood on Florida beaches.
I think how many miles
from San Miguel to Tombstone
if you go on foot.
They are playing taps
for José, Diego, Jesús Alberto, and José
sworn in with their mouths taped shut,
obscenely wrapped in the prize
they could only win by
going in front, falling first, dying fast.
They have been given their citizenship
in the cemetery of the star-spangled dead,
and their officers do not expect any trouble.
I tell them I cannot mourn you
in the small space they have set aside
in the margins of their blood road.
I must carry you with me.

I am thinking about Basra and the Alamo
about mayflowers and leaky boats capsizing
downstream from Port-au-Prince, not pilgrims.
about Arizona vigilantes with assault rifles
patrolling an invisible line at the edge of their fear
that runs right through our living rooms,
terrified that Michoacán will conquer Colorado
that bloodbath and bankruptcy will come home to roost
trying to hold their own history at bay with equipment.
I am trying to see the faces of the

ten thousand unnamed bodies
fallen into the gullies and canyons
of the crossing, the ones that are never found
and the two bodies a day they do find
strange fruit of the Mexican desert.

My great-grandmothers made lace,
twisting white cotton strands around pins
until the web could catch the sun, catch
a fall of jasmine down a wall,
delicate and tough, one thread bound into another,
spreading out across their beds and tables.
My great-grandmothers wound pain
around pins and fingers.
They made lace out of suffering
and I am unraveling bandages,
pulling weft from the fabric of lies.
I am trying to twist this savage thread
around the pins of what I know,
fastening this to that,
fraying the edges of nations
to make a blanket.

I am making a shroud for immigrant soldiers,
knotting and tying a thousand
journeys to locked gates,
going under and around,
doubling back, knowing that someone
traveled by night,
wore a disguise,
carried false papers
swam the Ohio, the Mississippi, el Río Grande,
jumped a train,
crept through the sewers.
I am untwisting the sharp teeth of borders,
knitting rivers and veins in a fabric
as rough and fertile as earth,
the only cloth I can use
to bury you.

Someday the river
will be no more than a river
nothing but water
carving its way through earth.
Not a line drawn through our hearts,
not a place of execution, not
a floodground of smothered cries.
And those bones, those
ten thousand chunks of rough ivory

tumbling restlessly along the course of history,
will settle into the riverbed.
They will become the fossils
of an age that has ended. No one will remember
where the fences were
in what strange place the scorched
landing strips of an ancient ruthless war
were brought back
from the deserts of Kuwait
to make a deadly wall against which
people broke trying to reach bread.
Schoolchildren will pause,
somber, trying to imagine what difference
there could ever have been
between one rough mountainside
full of snakes and coyotes,
and another, between your hunger and mine.

Listen, José, someday jaguar will move like living flame
from Quetzaltenango to Yellowstone without hiding
in freight trains, without dodging guns, someday
America will stretch from Inuit dreams of
whales arched and gleaming under northern lights
and the crackle of shifting ice, uninterrupted plains
where blue shadows chase each other across the wheat fields,
through red stone and grey-green brush smelling of sage

between volcanoes like a string of coral ember beads spanning the
night
to where water spills down mountains, air thick and moist
with the smell of leaves opening, and the crimson slash of parrots'
wings
copal rising, rain falling, river after river, grasslands again
to the last cracked rocks and icy seas of Tierra del Fuego
and there will not be one strand of wire, not one
hole filled with massacres, torn shirts bullets burned faces shoes
nowhere on the earth the boot marks of soldiers trained to make
orphans,
no one alive who remembers what it was to eat garbage
in the streets of Guatemala City.

Listen, Ezequiel, herding
the ghosts of goats before the crossed hairs
of men devoured by their own weapons
until they see nothing but target,
bleeding slowly to death not
three hundred yards from your door, cooling
under the infrared eyes
of twenty-first-century marksmanship;

Listen, Diego, wrapped in an imperial advertising banner
halfway around the world from Colombia,
lying in your box between streets as shattered as
the world your family escaped,
where it is easier to buy bullets than beans,
and the most corrupt people in the world
the same ones setting up regimes
and toppling them with your broken youth
give lessons in assassination
and money laundering
to anyone who will deal in white powder,
for the wholesalers of desperation
pumping crack into the gaps
between be all you can be
and twenty years to life
making plastic chairs for twenty-five
cents an hour in California prisons.

Imported liberation or a war on drugs,
it's all the same, because
in your country, the dead
are the only ones who can object
without being gunned down.
Listen, citizens of the countries of breath
all of us illegal alien foreign uncivilized
savage beyond control
someday it will be enough to have been born.

But today,
while the world is still
a maze of borders and fences,
I will not mourn them with this blue
quarter acre of gated stars, this
harrowing of red and white
scratch marks on the face of our continent. No,

in order to drape the graves
of four immigrant soldiers
shoveled in through the service door
while their starving relatives
stand outside the gates calling for food,

I must imagine an infinite river
of brown smiling children
who do not need documents
and a flag
of six billion stars.

Silt of Each Other

It doesn't matter what his name was. He could have been any one of the white, propertied men who were the muscle of that fast-beating heart of US expansionism in the late nineteenth century, full of the exhilarating conviction that they were manifestly destined to rule, were the pinnacle of creation, and that anything that did not belong to them was wasted. To dominate nature was to do God's unfinished work, to straighten out His crooked rivers and put them to lighting bulbs and watering crops, to plow up His useless prairies and irrigate His unproductive deserts so they could be planted with mathematically designed, maximum-yield rows of highly marketable crops, to the enrichment of His chosen creatures, the banker, the agribusinessman, and the railroad baron. God and natural law stood united behind him and his kind, in support of American Empire.

The internal frontier had been abolished and every nook and cranny of arable Indian land had been stolen. (Who was to know those barren reservation wastes would turn out to have coal and oil and uranium under their rough dry exteriors?) The glittering oceans beckoned east and west with their delectable morsels of tropical conquest. Today it was Cuba on the menu, and the men of means were salivating. It was one of the last gems in the Spanish Crown, and they wanted it, they needed it, they must have it as soon as possible. So, they drafted reasons for seizing it.

The man in the waistcoat said that the reason was mud. He said that the great river carried silt from American fields, American rocks, American leaves and twigs, far out of its muddy mouth, deep into the Caribbean sea, and that it was these chips of Minnesota granite, fallen pine debris of Wisconsin and Illinois, white kaolin and black shale of Montana, crumbled river bluff from Iowa and Missouri, red clay and sand of Mississippi, Arkansas, and Louisiana, sludge of long-dead catfish and northern pike that had piled up over the eons and made Cuba, literally, into US soil.

The islands where I was born rose in fire, out of a place of tilt and slip, strike and jolt, a crack of transformation in the great plates of the earth's skin; a place where one slab of rock shoves its way under another, heaving

immense angles of thick, wet limestone into undersea mountain ranges whose crowns rise up in foam and salt, to be decked with palms and egrets.

They rose in serpentine and basalt, and the slowly built sedimentary stripes of compressed ocean bed; in the bones of billions of tiny coral creatures, pressed by the weight of water into banks of dolomite that the surf wore smooth, that the sun heated and cracked, that rainwater carved full of caves, seeping through the filtering porous beds to make deep sweet aquifers and habitat for seed and spore. They rose in the slow conversion of plant matter to clay, and clay back into plants, into airy bromeliads, towering trunks with splendid crowns, tiny mosses, extravagant bloom, rattling seed pods, fruits and tubers searingly poisonous, exquisitely flavored, earthily nourishing.

These islands did not rise from the trash heaps of the continental river, were not made out of leftover Midwest. They are their own creation, dripping with salt water and honeysuckle.

And sediment has no nationality. Sediment drifts from place to place, on currents of water and air, on muskrat fur and the feathers of Indigo Buntings. It travels without passports, visas, or allegiances. If there is Minnesota dust ground into fine powder by its long journey through wild currents and sandbars; fragments of Canadian glacial rock whirled along the bed of the Missouri into the common flood; grains of ancient lake bottom that have been swept out to sea and fallen at last into drifts of silken mud, pressed into shale when our ancestors were still tree rats, and in an age long before borders, lifted and tipped into the side of some Caribbean valley, why, each one of us walks through the day with miniscule bits of old African DNA twirling in the mitochondria that fuel our cells. Caribbean pollen of tropical forests brushed from the feathers of migratory birds has also sifted down through the fragrance of fermenting pine needles, into the lake bed of the River's source, mingling, under the rose-green flickering of the northern lights, with the ashes of volcanic eruptions half a world away.

What are we all but the silt of each other? Every molecule of oxygen we breathe has been breathed a billion times before by every other set of human lungs, has crossed the panting tongues of dogs and leopards and small jeweled snakes, fueled the tiny hearts of hummingbirds and the large hearts of gorillas, been transformed in the green veins of plants, passed in and out of clouds and rain and waterfalls, risen up from oceans into the planetary sky. To whom does it belong?

We are the mineral residues of distant stars, carbons formed within their blazing cores, continually rearranging ourselves in an endless genetic shuffle

of dazzling forms. Microscopic flakes of our skin lie scattered on Himalayan snow and in the bed of the Amazon.

We cannot be owned. We cannot own each other. And there is no such thing as a particle of US soil.

But there *is* the root web of ecohistory, a dense mat of relations thick as mangrove, between the great inland river and the islands that girdle the small, bright sea.

Birds and pebbles, seeds and sorrows, languages and tools, trees and music, bloodshed and rebellion, sugar and iron, people and their stories have traveled the waters upriver and down, windward and leeward, and left their mark.

These are poems drawn from the real story of river and island silt, the residues of landscapes and peoples, species and cultures, that shift and change and charge each other with minerals and meaning, moving along a pathway made out of water and mud and our own feet walking. I dip my fingers in its rich colors and paint my face. I dip my fingers and write my own manifest destiny: we are meant to be fearless, we are meant to recognize each other and rejoice, we are meant to be free.

 From *Silt: Prose Poems* (2019)

Silt Sequence

THESE THREE PIECES MAKE A TRIPTYCH OF WATER POEMS IN MY
COLLECTION *SILT: PROSE POEMS*, WHICH TRACES CONNECTIONS
BETWEEN THE MISSISSIPPI RIVER SYSTEM AND THE CARIBBEAN.

RAIN

1 · There is no beginning to this story. We begin midstream. We begin in a gush of water from our mother's bodies. In our first moist breath. The makers of landmarks and destinations, the holders of deeds, argue about where the River is born. In what exact spot does it really begin, which trickle into which stream, into which tributary, how many gallons, how fast, how wide, how deep? They say it begins in a clear, cold northern lake, Omashkoozozaaga'igan, a shallow glacial hollow in the bedrock, and travels this course or that along the ancient claw marks of ice. But it is rain that gathers there and begins to flow. It is the snow that fell in drifts from heavy clouds and melted in the sun. The headwaters of the Mississippi River are in the sky.

The sea has no headwater. It is all belly. The sun beats down until the surface of the salt water turns into dimpled gold. It steams up into the sky, becoming low, white clouds of the Caribbean, held close because the layers of air keep them so, or is swept into the great spiral storms that come spinning in herds across the ocean from Africa, or is blown northward in streamers and rags of vapor, on the arc of the winds. Steam meets the chill upper air, meets the cool shadowy breath of trees, tumbles and darkens and condenses, and the water in the sky returns in spatters, sheets, pillars of rain, pouring sweet into salt, pockmarking endless miles of rolling waves, and blows ashore, drenching the islands, drenching the continent, returning, always returning.

Water flows in and out of red veins and green, making a tracery of drops spangling the globe, this wet planet, this single organism we are. We are made of water's dance. Everything else is residue, molecules of matter and spirit moving from place to place. Everything else is silt.

2 · Windblown water beats on the metal roof of the house where I am still a child, drumming so loud we have to shout. It comes on the vientos alisios, the sea winds, the trade winds, always blowing from the northeast. The sea winds shepherd the great storms with their trailing whips of dark cloud, their spinning hearts, their debris of broken branches, torn paper, pieces of houses. They bring red dust of Mali, blow tiny particulate matter into our lungs, sticky traces of pesticides and truck exhaust into the crevices of living reefs. They bring invaders blown off course from Iberia, lost in a dream of India and Cathay, hacking our worlds apart like the husk around a kernel of gold. Not corn, but money.

The winds that run low, closest to the moist earth and the crested sea, blow toward the equator. The winds that run high in the upper air race away toward the poles. The winds of the islands come slant across the map and bring water. Billions of tiny tree frogs call out as the humidity rises. The old ones say they are calling for their lost mothers, *toa toa*, and their cries reach up into the dark clouds and pull down the rain.

3 · In the glacial north, made by ice moving across rock and grinding it into soil, rain comes from the northwest, in the summer, and falls from towering thunderheads, dark grey mountains of steam, crackling with electric tension, loosing their bright, hot current in forked rivulets down upon the wide brown earth. Winter winds turn vapor to clouds of crystals that bury furrow and field and sheath the rivers in thin blue ice for dark months on end. But water is water and spring comes and everything melts and rises and flows and changes, crystal clear ice-melt into blue flood into Mississippi River dark with mud.

4 · Rain blows sideways over slow blue marshes of manoomin and water lilies where little fish dart through forests of reeds. Rain falls slant across wide brown muscular reaches, hiding the far shore, the barges and docks, water like biceps, currents strong enough to take us by the unwary foot and drag our bodies from Hannibal to Ferguson, Cape Girardeau to Osceola, born on undercurrents that make the surface boil. Rain drenches the fishers on the banks, women singing praise songs and scattering tobacco, scientists dipping samples, catching crawfish to study, drenches the paddlers in canoes downstream from Clarksdale, falls wide over the wide delta, over looping oxbows, over the fork of the Atchafalaya, over the border where cotton gives way to cane, drums on the roofs of sharecrop shacks and the cabins of lift boats chugging along channels choked with water hyacinth, falls through

the leafless branches of grey ghost oaks murdered by creeping salt water at their roots.

5 · There is no end to the story, but the river opens itself into this vast estuary fan, and everything lands here, a silted geography made by whatever is light enough to carry: soil, stories, industrial effluent, feathers, petals, blood, the most delicate windblown seeds of hope.

———

VENA CAVA

The vena cava, the hollow vessel, carries spent blood to the heart to be refueled. It carries weariness into the red pumphouse of love, where oxygen crosses membrane. The renewed blood is bright red, but the tired blood isn't blue. It's the color of wine, of mulberries, of dusk. It is the waves of light passing into and reflecting back from skin and glistening layers of fat that make our veins look azure at one depth, crimson at another.

How deep will we go, one stream into another, current below current, to the bedrock and bone of what we need to know?

Adivinanza de la esperanza: here is the riddle of hope. Lo mío es tuyo, lo tuyo es mío, yours and mine and mine and yours, toda la sangre formando un río.[1]

Kitípikwitana means buffalo fish in Myaamiaki-Illiniwek. Nothing to do with tipping a canoe. Tecumseh, the Sha'wano'ki weaver of peoples, and his prophet brother made warp and weft right here, at the fork of the Waapaahšiiki, which means water over white stones, the Wabash, which runs into the Good River of the Seneca, the Ohi-yo, which runs into the Misiziibi of the Anishinaabe, the runoff of Prophetstown flowing downstream.

There is the Upper Vena Cava that flows down from the headwaters, from our eyes and necks, from the rivers of our speaking faces and gesturing hands, from the many small streams that gather in our arms, to join just below the throat, just beneath voice, mulberry, dusky, dark, tired, pouring into the right side of the churning, muscular heart. The dark blood passes through chamber upon chamber, then washes out into the great marshes of the lungs, where gases bubble into the tiny creeks of capillaries, and the blood turns red, red, red.

Wounded Knee Creek of the Lakota runs into the White River, which runs into the great Wimihsúrita, the wide Missouri. Sand Creek of the

Inunina and the Tistsistas, renamed Arapaho and Cheyenne, runs into the Akansa, which runs into the Misi-ziibi, the aorta.

The lower Vena Cava has tributaries and confluences just like the River. The blood pumps uphill through a thousand locks and valves, resisting gravity, climbing from our feet into our thighs, into the deep pools of the pelvis. It comes from the purple hills of the liver and the twin mounds of the kidneys. It comes from belly and womb, climbing up into the right atrium, the small sea, the tidal whirlpool of life, and flows out into the floodplains of breath.

There is the Little Minnesota and the Minnesota, the Little Bighorn and Bighorn, the Small Cardiac Vein and the Great Cardiac Vein, toda la sangre formando un río.

The Ets-pot-agie-cate runs into the Bighorn, which runs into the Mi tse a da zi, which means Yellow Stone River in Hidatsa, which pours into the Missouri, which flows, dark, dusky, tired, into the Mississippi, at a place far downstream from Sand Creek and Powder River, downstream from Crazy Horse and Red Cloud, south of the Great Sioux War, just upriver from East St. Louis in the summer of 1917, and what was called the bloody outrage: fifteen dozen Black people dead, and six thousand burned out of their homes by shrieking vigilantes, while anyone who could, slipped across to St. Louis on rafts by night in the red glow of arson, and ten thousand marched in silent vigil in Harlem.

The swamp fed oxygenated red red blood flows back into the heart on the left side, into the drumbeat of the ventricle, into the main channel, the deep course, the longest river of the flesh, the Aorta, which means to raise, to lift, to carry, to carry word from upstream, lantern light from across the Ohio, carry the churning tides of the heart, carry the opening of our eyes to see in the dark, carry the legends of the liver, leaching poison, dredging sludge, healing damage, means to carry the in-spiration, the deep breath, the mouth-to-mouth resuscitation of hope. *Swamp fed, oxygenated, red.*

Listen. The Allegheny is the Oolikhanna, the beautiful stream of the Lenape. The Monongahela means the place of falling banks, and it springs from the ridges and hollows where the people grew corn long before foreigners called it Apalachee. The little rivers pour their hearts into the green Ohio, the meeting place of roads, where the Trail of Tears crosses the Underground Railroad, where inhale crosses exhale, toda la sangre formando un rio.

Listen. The Artibonite of Haiti once ran down River Road, a river of feet, a river of no, a river of big houses burning, and in the smoke, shadowy shapes of the possible. Met the slow-spreading pools of marronage in St. Maló,

seeped into the wetlands, estuaries, shallow shifting lace of bayous, lakes, spits of earth, scarred with channels, and out the wide throat of mud into the deep, out past the dead zone, the depleted waters, weary, airless, full of nitrogen, and into the roads of the living gulf, into the taste of salt, into the song of my people, guakía yahabo, we are still here.

Drum of my heart, push the red flood into the most delicate veins and capillaries of my extremities and let me be full. Drum of the world, in a time of extremities, fill us with red, this praise song to circulation.

Adivinanza de la esperanza, here is the riddle of hope, swamp fed, oxygenated, red as day, todos los ríos formando su sangre, all of the rivers making one blood.

———

BAÑO

We enter the water singing, weeping, praying. We slide down into the healing bath. We run into the water to escape the soldiers. Singing, weeping, praying. We walk into the water to find the way home. Brucha at shekhina eloteinu malkat ha olam asher kid-shatnu bi-tevilah b'mayyin hayyim. Blessed are you, spirit of the universe, who makes us holy by embracing us in the living waters.

This is the Ohio by starlight, the creaking of oarlocks, the glittering constellation hanging like a compass over the low hills, and five hundred miles is a million steps, a million choices to go on, though dogs though guns though manacles though torture though fever though hunger, though thirsty always thirsty, one step after a million steps to the other side, to the safe haven, to the warm bed, to the northern lights, to the land border and the smell of maple on the wind.

This is the water of Igbo Landing, a different kind of freedom, singing the water spirits brought us here and they will carry us home, all the way, all the way home, walking into Dunbar Creek through stands of cordgrass, singing their mouths full of seawater, opening their lungs, surrendering breath to become spirits wheeling over the salt marsh, arrowing east against the wind, stolen bodies left behind like sodden logs because freedom is that precious.

This is the mouth of the Bad Axe River, the ambush, the gunboat, the desperate people running into the Mississippi, blooming into red clouds in the current, swept away downstream, children, grandmothers, women carrying babies: the plaque says this riverbank ended a war. Clots of their blood still lodge in the roots of bayou sawgrass.

This is the Río Bravo, the border, the fierce water, the place of infrared scopes and helicopters. Two thousand miles is four million steps. Four million times of one foot before the other in Lenca, K'iche', Zapoteca, Nahua, Mixteca, Tzotzil, from one nest of guns to another, slipping down side streets, down furrows, into fields, shacks, contaminated faucets, or into jails, camps, cages, deportations, start all over again. Unless you can't. Unless your bones become white stones in the riverbed, fossils of a long war that doesn't end at the riverbank, that doesn't end.

This is the river clogged with oil, where we wade in in our thigh boots gathering drowned birds with their beseeching cries. These are the rainforest pools of Amazonas, poison rainbows shimmering over black sludge. These are the bathtubs of Flint, water as brown as any swamp, carrying all the muck of industry, infusions of rust and lead. These are the waters of St. James Parish, trapped between leaky factories dripping cancer into the groundwater, chemical plants and refineries with their burning flares day and night, pipelines ready to crack and spill, and nowhere to run.

This is the river that storm surge made of our roads, brown swirl of broken things, floating trash, shuddering people wading toward higher ground towing the sick and old and injured on rafts made of doors, their houses roofless, filled to the windowsills with flood, climbing stairs to missing upper stories trying to get dry, working from first light to last dragging debris out of the streets while faraway pundits debate whether we're human enough to be helped and a thousand bottles of water sit on a runway for a year.

Ah, but this is the mikvah of healing where we steep fistfuls of truth in living water to brew a medicine deep enough for this wounding. Blessed are you, oh breath of the universe, that embraces us in waters that still live and makes us holy again, for we were born holy, from the inner oceans of our mothers, we were born human, and we step singing into the water because freedom is that precious, we are that precious, so we submerge and rise, submerge and rise, and pull the ache of breath into our grieving lungs with all the power of our love.

This is el baño, la limpieza, sacred herbs floating on the wet skin of steaming water in a deep tub, powdered eggshell dissolved into milky blessing, the cup of spirits, the petals of roses, the handful of honey, the whisper of song.

This is the ceremony of our cells, each one a sip of water, a tiny ocean, a bubble on the bloodstream, inside our skins, beading up on our faces, trickling down our sweaty backs, dripping from our weeping eyes, offerings to the world. Then let the water in you call to the water in me. Let the water in

our veins call to the water in the world, one river, one ocean, one rainstorm gathering over the dry places, ready to pour down quenching relief for the thirsty, and we are all of us thirsty.

Then as we gather ourselves in prayerful determination on the edges of endangered pools and streams, look out over the peril and grief of dead zones that should teem with life, let the water in me call to the water in you, and from the deepest waters of our beings all of us feel the pull of a single moon bright with reflected light, and we all move together, inhale, exhale, ebb tide, flow, singing shehechianu, oh what a blessing, that we have come to this time, this place, this day, knowing that the rivers are ancient, but this moment is new.

 🐚 From *Silt: Prose Poems* (2019)

.............

Note

1 All Spanish quotes are from "Son número 6" by Nicolás Guillén.

Bees

When I was twenty, I spent several weeks of my poetic translation tutorial wrestling a Neruda poem into English, a word at a time. "Abejas II" begins, "There is a cemetery of bees . . ." and ends,

> there they arrive one by one,
> a million with another million,
> all the bees arrive to die
> until the earth is covered
> in great yellow mountains.
> I will never forget their fragrance.

In 1974, thinking about mountains of dead bees in their millions was a metaphor, devoid of horror. In Neruda's imagination, they were dying of sweetness, not neonicotinoids. Gigantic corporations didn't call them thieves for gathering their yellow grains of genetic code, in violation of trade monopolies, and scattering them across property lines in violation of privatization.

Their fragrant expiring didn't signal the fracture of the natural world, famines, crop failures, barren gardens. This summer the squashes in my garden bloomed but never made fruit. I saw only one large bumblebee all summer, in spite of all the offerings we planted, and their absence filled me with fear.

My brother, Ricardo, has pointed out how so many of the online campaigns to save the bees focus on the work they do for us, as if we were the privileged rich and they were an exploited immigrant nation, toiling in our fields to fertilize the dinner table, worthy of saving only so that we can eat.

But the bees are their own golden beings, orbiting their flowering planet. I remember them, traveling the paths of the air, spiraling in slow grace through the pollen-dusted petals of nasturtiums, hibiscus, gladioli, or in bullet-fast furious beeline, spending their rough bright bodies in defense of the hive. How the intricate calligraphy of their dancing unfurled across the morning like a scroll, how they were not there *for* us, but *with* us, how

they spread fertility to orchards, wildflowers, and inedible shrubs, without regard for our hungers.

They are a shining strand in the web of ecology, whose unraveling dooms us. They are sovereign nations facing extinction, and we have been here before. We must be their underground railroad, their sanctuary movement, their solidarity committee, blocking the roads that lead to their massacre, not because they could make the squash blossoms bear fruit, though that is part of their beauty, but because they exist, and like us, are being driven unjustly to their deaths.

 ∾ First published in *Letters from Earth*

Resurrection

.....

for Kerry St. Pé after Katrina

.....

Polypodia, the many-footed fern
stands on the broad limbs of the live oaks
like armies, like breadlines
waiting for rain.
Bent, brown, dead-looking,
thirsty at the side of the road,
no one looks at them.

But when the rain comes,
resurrection fern
springs up in a green mass
of strong backs and arched fronds
making leaf out of water
and the reservoirs of hope
hidden in their wiry roots.
They crowd the riverbanks of the trees
in the moist morning of their unfurling,
holding their revival, lifting their arms.
If you listen you can hear them singing
the gospel of life's stubborn return.

Slichah for a Shmita Year

let them go like birds released from cages
let them go like fruit rinds giving themselves to the soil
let them go like pebbles rolling away underfoot on a steep trail
let them go like crumbs scattered for pigeons
let them go like sweat dripping from our brows

If we have messed up, let it go into the great compost heap
and become the nutrients for new seeds, intentions, blessings
pink blossomed, azure, ripe with tender food.
If others have hurt us, let clean water irrigate the wounds
and let the runoff water effortless gardens
that spring up between the furrows of sleeping fields
between the cracks of unswept sidewalks,
take over the untended lawns.

Let grudges crumble to dust.
Let shame dissolve into loam.
Let each harsh word we hurl at ourselves
be turned into petals before they land.
Let everything, all of it, be recycled.
Let the trash become jewels we string into necklaces
and drape around each other's necks.

Let us enter the year of fallows
Burdenless, loose-limbed,
lie down on the dark earth,
do nothing,
let tiny rootlets emerge from our fingers
let ourselves be covered with moss
and instead of doing
become the sapling students of the elder trees, and
be ourselves into the new year

and *be* ourselves toward the new world that waits
like an autumn bulb packed with unimagined colors
ready to wake and bloom
just under the skin of what is.

Braided Prayer

1

Some of us want to burn up the world sooner than share it, in the ironclad belief that there is not enough of anything, hoarding up life that withers when it's pulled apart like that, cursed to never feel sated, continuing to insist there is no consequence, even as it knocks on the door.

Some of us are all awake, feel each blow, our hearts like drums beating hard day and night, putting bodies and words in the path of unthinking greed, singing keep it in the ground, singing water is life, water is really truly life, singing life, painted banners flying.

Some of us doze in the shallows of comfort, unable to open our eyes, listening to the same song over and over, unable to make ourselves look on a future of smoking ruin, and so we never see the gardens in the smoke, putting one foot in front of the other, planning as if there is no precipice, because we can't imagine there is anything to be done.

———

2

There is the land where the water rises right to the edges of our mouths and we either flee or become amphibious, and there is the land where the leaves parch into tinder, waiting for the spark and the offshore winds to blow through miles of dry underbrush and turn trees into torches, houses into charcoal skeletons, and there is the land of spinning storms that can shatter cement, blow blunt objects right through walls, and drive the sea all the way to the foothills.

In one place the people pray for rain. In another they pray for dry land. In a third they pray for still skies and a different storm path. What if we could braid our prayers? Not my drought, your flood. Not let this storm curve into your part of the map, not mine.

What if all the prayers became breath, became the one word: *listen*.

What if the engineers listen to the river, and not what they wish the river to do in the name of commerce? What if they listened to the whisper of water creeping beneath their ever taller walls? What if they opened the gates of spring flood and let the river spread the nourishment of its sediment over the wide miles of swamp and let land rise up again out of the swirling waters?

What if the foresters listened to the first people who listen to the land and learned to set small fires against big ones, to make meadows for deer and burn away the kindling under the trees? What if they made a friend of fire?

What if we learned the best way to bend with the wind, listened to the trees that survive, deep roots, flexible trunks, and studied them, built roofs like the wings of gulls, went into the ground like malanga roots and let the great swirls of weather wash over us?

What if we listened to the earth itself, not the desperations of ownership, that fever that is never still? What if we listened to the drowning men on the crowns of the levees, and the women wading rivers bristling with guns, and the children of Amazonas watching the tree of life fall into the chipper?

What if we dig in deeper into the soil beneath our feet, and even when we stand on pavement grey, let ourselves hear lake water lapping with low sounds by the shore, what if we hear it in the deep heart's core?[1]

3

I am writing these words from the bed of an ancient sea, white expanses of dry salt, the fumes of copper smelters in the air, imaging how much listening would be enough to tip the balance, imagining what it would be like, a world of people who can feel the veins of copper in the earth, who hang prisms over the graves of plankton and do not disturb their oily rest, who hear the wind rising and know which note means time to take shelter, who make commerce change its course, not the river.

One of our teachers says to learn the grammar of animacy, to know the aliveness of everything and speak to this quality by name.[2] To know the water is being a bay, being a creek, being a rainstorm, is always being, that it was never, even in the dead of winter, an inanimate thing.

I am writing these words from a nest of bruises, the lightning in my head having hurled me at the steps and broken bone.

What if all the prayers became the one word: *listen.*

———

4

I hear the crows in the budding willow. I hear the guaraguao unfurl its high hawk's cry over the grassy slopes, I hear the water drift very slowly down the estuary toward the sandbar, and a big fly explore the crevices of the doorway, while cattle low across the water. I hear my heart lubdub lubdub. I hear moss growing on willow stump. I hear the water in the wet ground under the dead leaves. I hear beetles. I hear fluids creaking through my bruises. I hear my belly trying to digest the world. I hear oil rigs and trees falling and gunfire and the shuffling of paper designed for theft, but I listen deeper, deeper. I hear the heart of the world, its molten core, and all the seas washing all the shores.

———

5

We are the people of the tipping point, where the river meets the sea, where the rubber meets the road, and we could all die of habit while everything spins away, where life and death have we set before us and every single inhaled breath says *choose life* and every exhale grips tight to the usual and says *not yet.*

So what if we braid our prayers into the one word *listen,* and as we listen, bending toward the earth, waves of listening move outward like rings on water. What if people everywhere stop in their tracks and feel deep into the sound waves of the living world, and we see how the harm in our mindbodies echoes the harm in the world, sludge caking the vena cava and the Yazoo, feverish imbalance, immunity vanishing, cities and cells growing out of control, the cravings that devour us. What if the beauty of the world takes our breath and restores it, and we see with the inner eye of the heart how precious, how brief, how easily broken, follow each drop of water that circles the globe, in and out of rivers, in and out of lungs, in and out of bloodstreams, toda la sangre formando un río, making us one.

6

This is where the river meets the sea. Hush now. Hush. Listen.

 🐦 From *Silt: Prose Poems* (2019)

.............

Notes

1 From W. B. Yeats, "The Lake Isle of Innisfree."

2 Robin Wall Kimmerer, *Braiding Sweetgrass.*

Water Road

1

The Río Cubuy runs over huge white, water-carved stones between steep, rainforested slopes in the sacred mountains of Yocahú, renamed El Yunque, the Anvil, by men used to beating steel into swords.

I am sitting in a shallow pool of the river, water like silk flowing around me, dissolving barriers. Birds cartwheel in the air above. Clouds gather around the green peaks. A distant waterfall moves silently down a gleaming rock face.

In the deep stillness, their voices well up. *Come home.*

Suddenly it seems obvious. The questions that have been beating their wings in my face for months, years, *where to be, where to be,* where can I find clean air, peace, wild lands, brown people, community, all that turbulence settles onto the water like a great white bird and floats, making ripples that move outward toward the river's edge and disappear. Everything around me and within me says *come home.*

———

2

There are people who write articles identifying the safest places to be as the world comes apart. They say to settle on the continental bedrock, away from the coasts, closer to the poles. Someone tells me that Duluth, Minnesota, is a prime spot for climate refuge. Someone else says people in the hot and humid US South should turn their eyes toward Canada.

This morning the news is full of Canadian flood waters, thousands evacuated from four provinces, two of them solidly inland, states of emergency in Montreal and Ottawa. Meanwhile, the tidal people of Bengal, where snowmelt meets sea rise and islands appear and vanish every few years, are building farms on rafts made of plastic debris, lashed together and heaped with fertile soil. Meanwhile in my own Caribbean homeland, people are planting root crops, experimenting with earth ship houses made of tires and

dirt with round roofs that deflect hurricane winds. Meanwhile the storm and pillage-driven exodus from Borikén is contradicted by a small, steady flow we call *rematriation*. Across the vast diaspora of our people, some of us are being called home. We come with seeds, tools, the street skills and friendships we acquired in those northern cities. We come packed with intent.

———

3

This piece of land where my heart unfurls has had many names. I only know a few. My young parents, blacklisted city kids turned farmers by necessity, married less than three weeks when US troops entered Korea, called it Finca La Paz, a place of peace. A decade later, Lencho Perez, the person whose hands go deepest into the soil, who cuts and clears and plants for my parents, calls it Monte Bravo, fierce mountain, and he should know. But Lencho is long buried, and the land has eaten our house, leaving only a faded tile floor, a water tank. The forest has reclaimed the tilled acres, making an island of trees between clear-cut slopes of banana and short, sun-grown coffee bushes, scored with eroded gullies that wash the soil downhill toward the sea. The cool air that rises from among the leaves precipitates rain, calling it down from the clouds that blow over and through the cordillera. Their roots bind water into soil. Neither fierce nor peaceful, these thirty-three acres, these trees, insects, ferns, birds, orchids, flowering herbs, have become a sanctuary, an encampment of nonhuman water protectors calling us to join them. We rename the land Finca La Lluvia, Rain Farm. As moisture gathers in the air, the little coquis, tiny tan frogs hidden in the cups of bromeliads and the mossy crevices of fallen logs, begin their chorus, which the ancients tell us is the word *toa*, mother, endlessly repeated. They call for the mother and are answered with rain.

———

4

My dreams are full of yautía, malanga, the root foods of the islands, tasting of earth, full of nutrients, harbored in the rich soil, out of reach of storms. Pumpkin vines wind through and around their stems. Words fly from my mouth in flocks of endangered butterflies, of cucuyos, the little fireflies, winking off and on in the dusk.

If the *patria* is defined by ownership, by flags and borders and treaties of states, then the *matria* is this: the densely woven kinships of the land, this

single organism of roots and fungi, mist and pollen, anthills and circling red-tailed hawks, their feathers turned amber in the sun, centipedes and berries and the billions of microbes unmaking the dead in the soil. All this matted interdependence is made of water, the one liquid being to which we belong, and all the molecular codes of creation it carries.

———

5

The water I carry is also made of language, the stories we humans make the way plants make chlorophyll, because story is our nature. But the path of sunshine into leaf has no dead ends or detours. The water of our mouths can be tainted. Our rivers move across battlefields and wastelands, are rainstorms passing through sulfurous clouds of smoke. Like the privatized water of mountain springs, they have been bottled in plastic, diverted into rusted pipes that leach lead. I must let the wellsprings of story that rise up in me pass through beds of limestone, be filtered through the bones of a billion tiny ancestors, evaporate in the heat of this warming world, be drawn back to earth by the cries of tree frogs and kinfolk. I must call out in my own voice, toa, toa, for my words to rain down, sweet and clean.

———

6

Everywhere on earth the matria cries out to us to come home, to weave ourselves back into a fabric that is torn, fraying, falling into pieces, dying of separation. Everywhere on earth, molecules of water move though skin and sky, tracing the flows that bind us, teaching us to be woven. As I turn toward the high cordillera, toward the teal and turquoise sea that crashes in white foam against the reefs and rocks of my archipelago, my dreams follow the infinite paths of water.

It is no longer intellect that makes the maps. I can taste traces of Mesabi iron in tropical rain, feel the thinnest possible film of slick river mud between my toes as black ferrous sand scrubs my toenails pink, just east of Cueva del Indio. I feel the movement of all these currents in the veins and pools of the earth and in my own watery body. From the River's northernmost rootlets to the cloud valleys of Maricao, from the vast estuaries of South Louisiana to the moonless beaches of Borikén where sea turtles nest, the path of water tugs and pushes at my heart, a living rope, a story in endless motion, or so we pray. The more I give way to its pull and let it carry me,

the more I know myself to be silt, just a fistful of mud, a scoop of nutrients the current brought to shore, here for a moment, soon to wash away. I am the residues of every choice I made, of all my ancestors, their triumphs and defeats, carried by currents that circle the world again and again. How do I end a story of water that doesn't end? Like this.

I set out from Minnesota asking only to listen to the River and let it tell me where to go, and the River took me in its grip and sent me south and farther south until it brought me here. I set out to listen, and the River brought me home.

) From *Silt: Prose Poems* (2019)

9 PROPHECY

Prophecy is often misunderstood to mean the ability to predict, but the real work of prophets isn't to see the future but the present. To perceive, with as much clarity as possible, the complexity of the present moment, with all its tangled roots, to hold and articulate visions that do not wince from the bitter truths of our moment but tally up our true capacity, and keep their eyes on a far and shining horizon.

The pieces in this section are ones that others have identified and I have owned as having prophetic voice. They were drawn from me by necessity, by my own needs and those of others. "Awake" is a poem from *Rimonim: Ritual Poetry of Jewish Liberation*, a song of praise for a state of consciousness from which we can begin.

"1954: Transition" is about being born, again and again, into possibility, and was the final piece in the first edition of *Remedios*.

An earlier version of "Speaking of Antisemitism" appeared in an anthology produced by Jewish Voice for Peace and was revised for inclusion in *Medicine Stories*; and speaks to a widespread collective confusion about how antisemitism works and why.

In the fall of 2017, I was asked to speak about spiritual audacity for my synagogue's Yom Kippur morning service just after Hurricane Maria had devastated my homeland—a moment when I drew deeply on my Taíno ancestry to speak as an Indigenous heritage Jew. The result was "Tai: A Yom Kippur Sermon 5778/2017," which uses hurricane metaphors to talk about the imperative to anchor activism in joy.

I wrote "V'ahavta," a poetic echo of a traditional Jewish prayer, to lift myself from the aftermath of the Pulse nightclub massacre in Florida. The piece has since become a staple of progressive Jewish community events, from demonstrations to weddings, shabbat services to conference openings.

I end this collection with "Will We?," a poem from my book *Silt: Prose Poems* that asks the question, what if we win? Imagining what winning could be like is, in my mind, one of the most important tasks of prophecy. It's far easier to detail the horrors of what injustice and greed have wrought, but if we don't have a dream of possibility, a detailed imagining of the world we want, we can't build it. We may not be able to dismantle the forces that are ripping our ecosystem apart in time to remake the world . . . but what if we are? What if we do?

Awake

There is a pink light at dawn, in spring
that signals the trees to bloom
because this is the moment for blossoming so that
there will be seeds nestled in the fruits of summer.

There are cells in the bodies of caterpillars
that wake when the worm has outgrown the cocoon
singing dissolve, unmake yourself, it's time
to become something winged, beyond your imagining.

There is a medicine in the bodies of willows
that calls forth roots from the broken twigs
and says to the cuttings, each wound is full of possibility,
let your torn edges tingle, and start again.

I am awake now to the promise of this day,
to push out buds, to be wide petaled,
to welcome pollen, set fruit. I am awake now,
to the unmaking that comes before transformation,
awake to becoming new and improbable.

I am awake now,
in all my torn and splintered glory,
ready to root into the soil and heal.

Bless me, for this is the time and I am awake.

 ›☎ From *Rimonim: Ritual Poetry of Jewish Liberation* (forthcoming)

1954: Transition

I am leaving the comfort and constriction of my mother's womb. This is the turbulent passageway of birth. Ancestors crowd around me, giving me advice, shouting last-minute instructions about life on earth. I am being pressed, squeezed, strangled with the old things that once nourished me, shedding my skin of watery membrane, pushing through an endless place of panic toward something bright.

Are you with me? We are being pushed forward into power we do not think we know how to use. We are strangling on the old comforts, the contradictory messages, feeling skins that once held us in a moist embrace rip away, leaving our tender surfaces exposed, nerves tingling. We are erupting into our lives, uncertain what we must do there, listening for whatever inside us says yes.

I am being born into the lunch hour of a February day in the year nineteen hundred and fifty-four, into the heart of a century both grim and dazzling. I burst into a room so filled with sound and light that I am temporarily made deaf, my pupils tight against the blaze of sun. Shaken by the world that rushes in on me, at last my ears open and the first sound I hear is water trickling into a metal basin.

Are you here? We are being cut off from the old sources of certainty, watching them shrivel into shreds of rag. We do not bury the birth cord under the house to keep us from wandering. We carry it under our hearts as warning and direction, as company in dark. The noise around us is tremendous. Sometimes we have no idea what we are listening to. Sometimes there is the gift of quiet, and we hear the thin fall of water from a hidden spring. We are messy, we are covered with blood. We want to bathe in that water, but we cannot always find it.

I am being born on an autumn afternoon in nineteen sixty-four in the tangerine grove of Don Modesto and Doña María where Tita and I have been stealing tangerines. We hold our skirts full of fruit gathered in one hand and with the other, each tries to hold the strands of barbed wire apart so we can pass through. We can hear that we have been discovered and Don

Modesto is growling threats. Tita is on the outside and I am still in the green shade, heart pounding, my cotton clothing catching on the barbs. "Hurry," I whisper, frantically, and Tita, still clutching her skirt full of harvest, pulls the strands wider, and pulls me through, and we run, breathless and laughing, up the hill to eat tangerines in the sun.

We pull each other through. We steal sweetness and feed each other segments of our lives, sections of orange flesh bursting with what we are learning how to name. We tell each other stories, lift the strands of wire apart, whispering, "Hurry, you will be captured." We clutch the gatherings in our skirts and don't surrender them even when we have to run. We make sunlit moments of laughter.

I am being born, and giving birth, on a scalding hot morning in July of nineteen eighty-eight. I expected to do this and that other sweet and sustaining thing, but birth is raw and unexpected. My mind steps into a blaze of light and I am convulsing on the floor, being whisked to a hospital, wake up strapped and wired to everything in the room. And I rise, plant my naked feet on the slick linoleum floor and my palms on the walls and summon up power, more naked and unashamed than I have ever known.

We are all laboring. We plan every safeguard for our passage and all of them are useless. We cannot know until we know, what it is we need. We learn that listening to our hungers, each other's and our own, is the only preparation. There is no way to stop it once we begin. We strain and struggle and ask if we can go home now, change our minds. We bear down on possibility and are startled at what we find that we can do.

I am being born on a late summer day in nineteen ninety-six, pushing myself forward through the narrow opening carrying all these voices I have called to me, wrapped in my skirts. Carrying my own voice, leaving behind skins that only hamper me now. I am in transition, pushing myself out of myself. I have left behind the garments of shame. The camouflage of fear. I have taken my hands back from my tormentors. I have stolen as many of our names as I could carry from the orchards of the hacendados. My head is crowning. Can you see me coming? Are you with me?

Our voices pour like waters breaking, gushing from our vientres. Like the tough and nourishing roots of dandelions shoving stalks upward through cracks in pavement, we push our stubborn heads through the small spaces of windows barely ajar. We find our way into rooms that were always reserved for others and pick up everything we can use. Our loudness echoes off the walls. We pull each other past the sharp teeth of danger, lift each other's

faces into the light. We break the membrane over our mouths and begin to breathe on our own. We are pushing into history, we are coming out of the corners, we are gathering our spirits, we are taking up the challenge, we are living in this heartbeat, we are deciding (are you ready?), venga lo que venga, to be born.

&ew; From *Remedios* (1998)

Speaking of Antisemitism

I am a child of two oppressed peoples, a New York Puerto Rican mother, raised Catholic, and a New York Ukrainian Ashkenazi Jew, raised communist, the grandchild and great-grandchild of people displaced by war and economic hardship, the thread of my life descended through many generations that faced all the abuses humankind inflicts.

I was born and grew up in rural Puerto Rico, where my radical parents survived the McCarthy years of blacklisting by growing vegetables on an abandoned coffee farm. I was born into a Latin American and Caribbean world dominated by military dictatorships, CIA coups, and US invasions. I have relatives in mass graves on three continents, and my African and Indigenous dead weigh as heavily as my Jewish dead.

Who am I to speak? A colonial subject, a woman of color, an immigrant, disabled and chronically ill, of mixed class, with personal experience of both poverty and middle-class privilege, and a Jew. I am targeted by many oppressions, which has taught me to sift and compare, braid and unbraid them.

My father's family lived in a small southern Ukrainian village where each spring, the Easter sermons sent their neighbors rampaging against the Jewish farmers and craftspeople who lived among them. For centuries, Jews had been forbidden to own land, but in the early 1800s, as the Russian Empire was pushing up against the Ottoman Turks, they started settling Jews and other people they didn't mind sacrificing on the newly conquered lands of southern Ukraine as a kind of buffer, in case the Turks pushed back. In 1807 my family climbed onto a wagon and drove south from the overcrowded northern city of Gomel to become part of that buffer in the brand-new agricultural settlement of Israelovka (Jew Town), in the province of Kherson. They were given farms, seeds, tools, and draft exemption, and ordered to grow wheat, which had to be sent to northern bakeries to provide bread. Jewish farmers could not travel without permission or pursue any other occupation until they had farmed as ordered for twenty years and gotten written permission from the authorities.

By the time my great-grandparents were born, in the 1880s, the draft exemption had been canceled, and Jews did other kinds of work, but travel was still difficult. My great-grandfather Abraham, known as Pop, had to bribe a guard at a checkpoint to go to his job in a town where Jews were not allowed. Once, when a different guard was on duty, he was beaten instead, and jailed. When war broke out with Japan in 1904, he left for the United States to avoid military conscription. Two years later his wife and my young grandmother followed with other relatives, so they were not in Israelovka when the Nazi Einsatzgruppen murdered several hundred Jews, including Pop's sister and brother, their spouses and their children, on a single day in May 1942.

One reason I say all this is because in the public discourses of antisemitism, losing relatives to the Nazis is often wielded as a kind of moral authority that exempts us from the challenge to think critically. I have been accused of betraying the Jews who died at the hands of the Nazis because, like the last six generations of my family, I believe our safety lies in the solidarity of working people, and not in a Zionist state. I have been accused of being a retroactive Nazi collaborator by people who claim that dead children accuse me. I am at peace with my ghosts. In none of my lineages do my ancestors demand that I build gated homelands. They say protect all the people, cherish every land, build freedom for everyone.

But I am also saying that Jewish oppression is real, that it goes underground and emerges again like an indestructible weed, that this is its nature, to lie dormant, its roots intact beneath the ground, and when conditions are ripe, to burst up through the well-manicured lawns and do its job. That it does not need to be in rampant flaming flower to be a threat. That my father was fearless as a communist, in spite of repression, because it brought him joy and hope and comradeship, because revolution really was his homeland. But he was frightened as a Jew. He was born in 1930, and was a child and teen during World War II, a highly politicized child who followed the details of the situation in Europe, who knew when his mother's village was destroyed, who wept with pride at news of the Warsaw Ghetto Uprising. The horrors of the attempted genocide against European and some North African and Middle Eastern Jews didn't turn him inward, toward an exclusive concern with Jewish survival. It made it even clearer that human solidarity was the only force capable of dismantling such suffering—that we had to make it bigger, deeper, more comprehensive. Never for a moment did he consider joining or supporting a nationalist movement willing to take part in a colonial conquest and build into it privilege for Jews, constructing a state on the plunder of other people's lives.

I have not, in my lifetime, faced such an annihilating disaster as the extermination of a large part of European Jewry, although my lost cousins, the village that is gone, the thriving cultures I will never visit, are in my bones. But I know what antisemitism is for, that its purpose is to protect the Christian elites from the outrage of the oppressed by throwing Jews under the bus, by redirecting their rage toward Jews, and you never know when it will come in handy to someone. Like the Republicans in the New York State Senate who cut $500 million from the budget of City University of New York, slashing at the educational resources of working-class students who are overwhelmingly people of color, because that's what they do, but saying it's because Jews need protection from antisemitism, because Jews are upset, that this is why capitalism is closing schools for working people, amplifying the Jew-blaming that was already in place, ready to flare up from ember into conflagration, and hiding the perpetrators behind a screen of smoke.

WHAT ARE WE TALKING ABOUT?

The oppression of Jews as Jews, as a racialized people believed to possess inherited inferior or immoral traits that justify our mistreatment, is a thoroughly European Christian phenomenon, and as such, has been carried throughout the world as part of the conquering ideology of European colonialism. It arrived in Puerto Rico with the Spanish, and a woman of my name was burned at the stake in 1520 under suspicion of being a secret Jew and desecrating a crucifix. It arrived in New York City long before my great-grandparents made their way through Ellis Island. It arrived in North Africa and the Middle East with the British, French, German, and Spanish colonizers and landed on people who had suffered Ottoman despotism, and discrimination as non-Muslims, but had by and large not been systematically singled out for persecution as Jews. It arrived as part of an arsenal of domination because it was every bit as useful as racism but a lot sneakier.

Because I have sifted and compared my own experiences as a mixed-heritage Jew of Color, it's more than an intellectual exercise when I hold racism and anti-Jewish oppression, one in each hand, and weigh them, when I watch them move through the world, distorting the air around them, and I recognize their behaviors, their camouflages. Racism is like a millstone, a crushing weight that relentlessly presses down on people intended to be a permanent underclass. Its purpose is to press profit from us, right to the edge of extermination and beyond. The oppression of Jews is a conjuring

trick, a pressure valve, a shunt that redirects the rage of working people away from the 1 percent, a hidden mechanism, a setup that works through misdirection, that uses privilege to hide the gears.

Unlike racism, at least some of its targets must be seen to prosper, must be well paid and highly visible. The goal is not to crush us, it's to have us available for crushing. Christian rulers use us to administer their power, to manage for them, and set us up in the window displays of capitalism for the next time the poor pick up stones to throw. What is hard for the angry multitudes to see is that Jews don't succeed *in spite* of our oppression. We are kept insecure by our history of sudden assaults, and some of us, a minority of us, are offered the uncertain bribes of privilege and protection. Privilege for a visible sample of us is the only way to make the whole tricky business work. Then, when the wrath of the most oppressed, whether Russian peasants starving on potatoes or urban US people of color pressed to the wall, reaches a boiling point, there we are: the tsar's tax collector, the shopkeeper and the pawnbroker, the landlord and the lawyer, the social worker and the school administrator. And whether it's a Polish aristocrat watching the torches go by on pogrom or the Episcopalian banker discreetly out of sight while working-class people tell each other that Jews control the economy, the trick works. Agent of the rulers, scapegoat for their crimes. This was our history in Europe.

When European Jews began arriving in the US in large numbers, none of us were considered white. We were poor tenement dwellers, and the demagogues of the day said we brought disease, immorality, crime, and sedition in our tattered pockets. But after World War II and the GI bill, with the slow end to anti-Jewish quotas and redlining, we got some traction and began climbing right back into those middle-agent roles, buying the package of assimilation, which, this time, surely, would protect us and establish us firmly in the safe zone. So the digestible Jews began moving to suburbs and renting our old homes to the Great Migration and the Guagua Aerea, Black and Puerto Rican migrants filling the cities we had also landed in, my Puerto Rican grandmother entering the garment work my Jewish great-grandmother was just leaving.

And in order to be middle agents again, in order to be buffers between the ruling class and the poor and working classes where most people of color were concentrated, those Jews who could do so had to take on white identity. It was part of the job description. The ones who could were offered the same old deal. The ones who could not, the ones who were too dark and foreign, became unimaginable as Jews and weren't offered anything. In the US, the Jews in the display window are light of skin, assimilated, and have money.

I am not a student of Zionist history, not a scholar of Middle East colonialism, or the Nakba, or the evolution of the state of Israel, but I am an anti-imperialist Latin American, a colonial subject who understands what happened when the British decided that breaking up the Ottoman Empire would help them defeat the Germans in their bloody competition to own more of the world, when arrogant British officials put themselves in charge of those lands, and then promised them to Arab nationalists seeking independence, Zionist Jews seeking a territory, and the French, seeking control.

I am a native of an occupied colony being systematically stripped of everything that supports life, and I know exactly what I am looking at in Palestine. I too am a thirsty resident in a land of privatized water, of massive land grabs, toxic waste disposal, a majority of my people unable to live in my country, citizen of a continent famous for invasions, occupations, death squads. I am familiar with the pornographic distortions of marketing through which oppression is sanitized, with shiny brochures that proclaim Puerto Rico to be paradise and Israel the home and hearth of freedom. I am a Latin American, so when I see soldiers shooting at children and calling them terrorists, I know what that is. I once wrote: "I am a colonial subject with a stone in my hand when I watch the news. I am a fierce Puerto Rican Jew holding out a rose to Palestine."

I am also a Jew who knows the deadliness of that middle-agent role. I recognize empire's habit of using proxies, understand and am enraged by the deathtrap that is built when the powerful protect their domination by bestowing guns and money and titles to expropriated land on marginalized and fearful colonizers who take up the whole hideous arsenal of Orientalist racism and embrace imperialist aspirations in the hope of finally becoming "real" Europeans.

Jews fleeing the hardships of Christian Europe could have built something quite different in a place with centuries of coexistence, could have come as respectful migrants, to be neighbors, not conquerors. But whatever it could have been, what we have now is this devastation, which, along with everything else, is also bloody reenactment: the grandchildren of ghettoized Jews patrol the borders of Gaza, descendants of pogrom survivors carry out collective punishments and random executions, and Jews privileged by what they have built speak of "dirty Arabs" with the exact same tone of voice in which the Christians of Europe said "dirty Jews."

In my grandmother's village there was a three-cornered argument about what, if anything, would save the Jews. The Orthodox said it was in God's hands. The Zionists said only Jews could be counted on to stand by Jews, and we needed a defensible territory of our own where we called the shots. The communists and socialists and anarchists who slipped in and out of the shtetls, handing out precious pamphlets to be passed around and hidden, said only an alliance of all the working people can dismantle our oppression and everyone else's. As a boy, my father took part in that identical debate on the Boardwalk in Brooklyn. But after the Holocaust, after the Nazis destroyed so much of the world of European Jews, after the solidarity that existed was not enough, and the old Russian antisemitism that had been punished as a crime against socialism became a part of Soviet policy, after all that, the three-cornered debate went lopsided with despair, and the Zionist minority of my father's childhood has grown to dominate all debate, aggressively silencing dissent.

The overwhelmingly US Jews who write to tell me that I should have died in a camp before living to denounce the crimes of Israel believe with all their hearts that their only possible safety in the world is a state where Jews dominate society and have protected privileges. They believe this is so essential to our survival as a people that we can't afford to consider the most basic human rights of Muslim and Christian Palestinians. They think that requiring accountability is an injustice to Jews, that it threatens our existence, that if we stop for a moment, the Holocaust will catch up with us, and therefore any means that will give Jews more control are justified, and anyone who disagrees wants us dead.

Some of the Jews who think this openly justify the horrific abuses required to hold such absolute power, spewing extreme racism, and utterly dehumanizing non-Jewish Palestinians, demanding their expulsion and slaughter as a right. Some say violence has been forced on them by violence, that resistance is aggression, that the anger of dispossessed Palestine is rooted not in rage over colonialism but in hatred of Jews, and that all the armed paraphernalia of a brutal and brutalizing Israeli state is the necessary self-defense of innocent people simply occupying their ordinary privileges. That there was no Nakba, just voluntary departure by people who didn't happen to want to live in those villages under continual assault. They dig in stubbornly, claiming the right to an unthreatened existence they believe

they have earned through suffering, while those they have displaced have not. It's the common narrative of people determined to do the wrong thing because they think the right thing will kill them.

Many more are in denial about the human cost of exclusive Jewish rule of a multireligious homeland (and Ashkenazi rule over Mizrahi and other African and Asian Jews), claiming that it's not as bad as people say, that as usual, everyone is picking on the Jews, that other countries in the region treat people worse, that all countries start with invasions and slaughters and expropriated lands and it's unfair to criticize Israel for what everybody does. After all, they say, the United States was founded on genocide against Native Americans, as if one bad history licenses another, as if the genocidal plot against Indigenous North America was long over, and Indigenous life some quaint fossil underfoot, and not in blazing resistance at Standing Rock, in Idle No More, in five hundred years of refusing to give up and die.

A lot of US Jews are deeply uneasy about Israel's treatment of Palestinians but believe the suppression of Palestinian society is an unfortunate necessity, or tell themselves, as many white people in the US do, that atrocities are committed by a few bad apples in a basically sound barrel. These don't write to wish me dead. But they don't want me to speak. They think I have betrayed them, that a Jewish-dominated Israeli state is our best, our only, shot at long-term survival, and any protest, criticism, or challenge to that state, if not an outright act of attempted genocide, gives aid to our enemies, always waiting to fall upon us once more. These are the people who shout antisemitism at any whisper of dissent. It's not exactly crying wolf because unlike the fabled shepherd they really do believe the wolf is there in the underbrush, but they cry it so often that when the real scapegoating nastiness takes place, no one believes it's there.

———

WHAT I WANT

I said I was not a student of Zionism, but I am a student of historical trauma, and I know that the cyclical nature of anti-Jewish oppression has proven over and over that the violent scapegoating of Jews can erupt in the midst of the most apparent security (Spain in the 1400s, Germany in the 1920s), that this fear is not unjustified, that it is not paranoia to think it could all happen again. But I am also a student of how such trauma is recycled, reenacted, how the determination to prevent what has already happened, to never again be victims, justifies everything from domestic

violence to wholesale slaughter. The oppression of European Jews, entangled with imperialist manipulation and profound racism, has all enmeshed to create the nightmare, and I want all my peoples to be free of it. In the face of a widespread belief that domination is the most trustworthy answer to fear, I am fighting for both the freedom of Palestine and the souls of Jews.

I am a child of two traumatized tribes and when I fight for justice in Palestine, when I reject the premise that criticism of Israeli crimes is antisemitic, I am not supporting a faraway people out of an abstract and benevolent idea of doing the right thing for someone else.

I am fighting for myself, a Puerto Rican Jew who does not exist within the American Dream of Jewish whiteness, the same dream of "real European" Jewishness that forced Mizrahi children into the equivalent of Native American boarding schools, to remake them, or stole them from their families and gave them away for adoption by Ashkenazi parents, and throws away the generously donated blood of Ethiopian Jews as "tainted" by their Blackness.

I am fighting for an end to the recycling of pain. I am fighting for my own deepest source of hope, the belief in human solidarity, in our ability to decide that we will expand our hearts and our sense of kinship to include each other, and resist the urge to contract in fear, to huddle and bare our teeth and lash out. When I speak out for the humanity of Palestine, I am defending the humanity of everyone, including all Jews. When I stand firmly against the hidden reservoirs of antisemitism that bubble up when the ruling class needs them to, when I tell my gentile friends not to get distracted from the white Christian male 1 percent, to stay the course and stay clear, I am standing for accuracy, for clarity, for revealing the structures of domination that crush our world, including the people of Palestine.

When I keep saying that Israel's war against Palestinians only multiplies danger and pain for all of us, when I denounce and chant and recite and sing back against this injustice, when I say I will have no part of it and I am accused of denying Jews a future, I know that I am fighting for the only real future there is.

When I insist that we can be on each other's sides, that we can make sure everyone has enough allies to be safe, that this is the only work that matters, I am pushing back against despair, tipping my corner of that three-sided fight toward a justice big and beautiful enough for us all.

෨෩ From *Medicine Stories* (2019)

Tai: A Yom Kippur Sermon 5778/2017

THE THEME OF KEHILLA COMMUNITY SYNAGOGUE'S HIGH
HOLY DAYS THAT YEAR WAS "SPIRITUAL AUDACITY," DRAWN
FROM THESE WORDS BY ABRAHAM JOSHUA HESCHEL, WRIT-
TEN IN 1963: "THE HOUR CALLS FOR MORAL GRANDEUR AND
SPIRITUAL AUDACITY." THE TORAH PORTION PRECEDING THIS
SERMON DESCRIBES THE SCOUTS MOSES SENT INTO CAANAN
COMING BACK TO REPORT THAT THE PEOPLE LIVING THERE
WERE GIANTS, MAKING THEM FEEL AS SMALL AND INSIGNIFI-
CANT AS GRASSHOPPERS.

I am from a land of hurricanes, a place where the wind can rip off your roof and send it hurtling through the air to embed pieces of it in the trunks of distant trees. So, I know that at the very heart of the biggest, most danger-ous storm, there is a place of absolute calm, where the air is still. All around it are walls of wind, full of torn leaves and branches, tin cans and bits of paper. The wind nearest the core is the deadliest, but inside that circle at the center, the sky is blue and the sun shines. Once when we were children, huddled around kerosene lamps inside our shuttered house, tuned into the shortwave radio so we could plot its course, our mother took my brother and me outside, hands held tight, into the eye of a hurricane. We saw great arms of cloud stretching out in an arc a hundred miles wide, saw grey walls of storm, miles high, all around us, while we stood under clear, sunlit skies. My mother was nothing if not audacious, and in the middle of a raging hurricane, she took us to see the sun.

Tai guay nanichino. In the language of my Caribbean Indigenous ances-tors, these words could simply mean good morning, friends. *Nanichi* means heart and *no* makes it plural. *Guay* is the sun, and the Catholic priests who came to Borikén, renamed Puerto Rico, men who accompanied and assisted in the conquest and slaughter of my people, wrote down in their chronicles

that *tai* means good. But these were men fresh from the bonfires of the Inquisition, ready to impose their own ideas of good and evil on everyone they met, at sword point if necessary. From what I know of my ancestral culture, and by the poetic license of my own heart, I have come to believe that *tai* means that state of knowing ourselves to be connected, in reciprocity and gratitude, through the deepest ties of kinship, to everything that exists.

Tai guay nanichino: we are one with everything under the sun, dear hearts.

Ever since I learned that this year's High Holy Days theme was spiritual audacity, I've been thinking about the source of audacity and how we find it. I believe the answer is *tai*, the joy that comes from being fully present, here and now, with what is.

To be clear, when I say joy, I don't mean happiness, or optimism, or contentment. You can turn your back on the world and find all those things. When I say that joy is the source of my audacity, I am speaking in the midst of heart-wrenching grief and anger for my country, in the midst of my own struggles with depression and loneliness, anxiety and overwhelm.

Joy is to mood as stars are to the weather, a constant to steer by, sometimes hidden by storm clouds, but high above them, untouched by wind or rain. This is not to say that the weather of the world isn't violent, drenching, harsh. We could spin forever from emergency to emergency, shouting no to each new crime—but that would be steering by chasing clouds. If we are to live audaciously, we need to step into the calm eye of the storm, and steer by the stars, to imagine in rich detail, the biggest, most delicious, satisfying, inclusive future that we can, a great flowering of human potential and well-being, project our hearts and minds into that future, and then spend our lives walking toward it, and each time the weather buffets us, wait for a glimpse of sky, find that bright point of light, and adjust our course.

But in order for that dream to be accurate, to burn bright enough for navigation, it needs to be rooted in the reality of here and now, all of it. This is how we turn trauma into light. Trauma is not the opposite of joy, it's the husk around its seed. The more we face into the world, the more we let ourselves know how other people live, the more we learn not only about their pain and rage but also their love and resilience, their defiance and hope, and it's from that full spectrum of knowing that we fill in the details and colors of the world we want. There is a joy that rises from being with what's true, even when that truth includes the terrible.

We live in a society that tries to reduce our biggest dreams to marketable packets of distraction or comfort, as if that were the most we could hope for, but comfort and distraction are not the wellsprings of joy. We live in

a society that tries to control us through bribery and threat, hoping we'll decide to live small lives that won't upset the way things are. We are not grasshoppers. Grasshoppers are fine. They are here to live grasshopper lives. But we are people, with the gifts of both memory and imagination, able to learn from our many histories, and create what does not yet exist. It makes it possible to face the terrible with joy.

We don't need to spend every moment of the day shouting no. We can learn to sing a thousand-voiced harmony of yes. In 1993, I visited the National School of Music in Havana, and while our group waited for the bus to pick us up, a group of teenage boys, two of them Black, three of them white, played guitar for us. It took a few minutes to realize what it was that moved me to the edge of sobbing. Then it hit me. It was the first time I had ever seen young Black men whose body language held no trace of the fear of violence. Whenever I go out into the streets to express my rage and grief over yet another Black or brown death at the hands of the police, I carry those boys with me. They are my yes. Yes is what keeps me going.

And I carry MPD150, a hope-based, grassroots organizing project in Minneapolis, in which the communities most affected by policing researched and evaluated the performance of the Minneapolis Police Department over the last hundred and fifty years, concluded that they are best served by a future that is police free, and are charting a path to make it so.

It's true that audacity can arise from crisis, and courage can spring from fear. Emergencies can draw more from us than we ever thought possible, but that kind of boldness runs on adrenaline. It doesn't have the horsepower for the long haul. When the crisis passes, we settle back, exhausted, into our accustomed lives.

To live a lifetime of audacity, dwelling in the place where joy meets justice, year after year, can only be sustained by being so in love with a vision of what's possible that we no longer flirt with despair.

The world is full of weather, full of all the urgency and danger of the present moment, but the work of social justice has always been urgent, and if we let that drive us, we'll never make the time and space to dream together, dream big, and set a real course toward our dreaming.

Imagine this, that each one of us is weighed down by unearned punishments and unearned rewards, that when we are punished, not for what we do but just for existing, it's like being wounded, so that we guard our injuries, and they become easily inflamed, making us lash out or turn in; and when we are rewarded, not for what we do but just for existing, it's like being drugged, so that it seems natural to have more and better and easier,

and we are oblivious to whole provinces of the social terrain where our own privileges settle like fog, to hide the landmarks of other people's suffering.

Imagine, then, that seeking the sources of audacity in our lives, choosing to know whatever we must to find it, we discover that there is nothing to defend. Whatever the harm done to us and the real wounds of it, our scars are not treasures to be hoarded. Whatever our complicity in the deprivation of others, whatever we've allowed ourselves, in the name of comfort or fear, to accept instead of freedom, is not worth having, that injustice was already here when we were born, that it's much bigger and older than our mistakes, that claiming each other is much better than lying low.

Then the work of turning to face truth, of bringing our full selves into the commons, becomes joyful beyond measure. When the fog is burned off, what remains is an illuminated landscape, where the entire geology of our lives is laid bare, and we see how we are woven together, see the ground of solidarity we must walk, to reach the future we love.

Tai guay nanichino: we are one with each other, lit by hope, ablaze with love.

Today, with Puerto Rico torn apart by climate violence disguised as natural disaster, burdened by manufactured debt, when it is we who have been robbed and are owed, I am imagining all that is possible when people stand among the ruins of a colonial misery they can't bear the thought of rebuilding, and ask, what could we do instead?

When the people of Minneapolis stop talking about bad apples and police reforms and ask, what could we do instead?

Ninety-eight years ago today, more than a hundred Black sharecroppers in Elaine, Arkansas, had the audacity to organize themselves to demand better pay from plantation owners. White mobs responded with a state-sanctioned rampage, massacring between 100 and 240 Black people. Returning Black veterans of World War I, no longer willing to tolerate the violation of their most basic rights, also began demanding justice, and faced the same murderous mobs. A wave of lynchings and race riots swept through dozens of cities in what came to be known as the Red Summer of 1919. None of the attackers went to jail.

Right now, as we pray for the spiritual audacity we need in these times in order to do the work of tikkun, tens of thousands are honoring those dead tenant farmers and drawing from their courage, as they pray with their feet in Washington, DC, and in sister marches around the country, saying no to the killing and systematic abuse of Black and Indigenous people, saying

yes to a world in which their full humanity is celebrated and safe. Here and there, two breaths of a single prayer.

So right now, rise in spirit and intention, and if you can, and choose to, with your body, and let's turn our faces toward the truth of their vision, and add our yes to theirs: Say after me *tai guay nanichino*. Or in the words of Argentinian singer Fito Páez:

> "Who says that everything is lost? I come to offer you my heart."
> ¿Quién dijo que todo está perdido?
> Yo vengo a ofrecer mi corazón.
> Tanta sangre que se llevó el río.
> Yo vengo a ofrecer mi corazón.

ᘔ From *Medicine Stories* (2019)

V'ahavta

WHEN FORTY-NINE MOSTLY QUEER PEOPLE WERE MURDERED
AT THE PULSE NIGHTCLUB IN ORLANDO ON JUNE 12, 2016, PART
OF WHAT BROKE MY HEART WAS THAT HALF OF THEM WERE
YOUNG PUERTO RICANS, ECONOMIC EXILES FROM MY HOME-
LAND, RAVAGED BY COLONIALISM. THEY WERE FAMILY. IT WAS
A BLOW THAT HIT SO CLOSE TO HOME THAT I REELED. I HAD
TO LOOK HARD TO FIND MY STARS. I FOUND THEM BY WRITING
THIS POEM.

Say these words when you lie down and when you rise up,
when you go out and when you return. In times of mourning
and in times of joy. Inscribe them on your doorposts,
embroider them on your garments, tattoo them on your shoulders,
teach them to your children, your neighbors, your enemies,
recite them in your sleep, here in the cruel shadow of empire:
Another world is possible.

Thus spoke the prophet Roque Dalton:
All together they have more death than we,
but all together, we have more life than they.
There is more bloody death in their hands
than we could ever wield, unless
we lay down our souls to become them,
and then we will lose everything. So instead,

imagine winning. This is your sacred task.
This is your power. Imagine
every detail of winning, the exact smell of the summer streets
in which no one has been shot, the muscles you have never
unclenched from worry, gone soft as newborn skin,
the sparkling taste of food when we know
that no one on earth is hungry, that the beggars are fed,
that the old man under the bridge and the woman

wrapping herself in thin sheets in the back seat of a car,
and the children who suck on stones,
nest under a flock of roofs that keep multiplying their shelter.
Lean with all your being toward that day
when the poor of the world shake down a rain of good fortune
out of the heavy clouds, and justice rolls down like waters.

Defend the world in which we win as if it were your child.
It is your child.
Defend it as if it were your lover.
It is your lover.
When you inhale and when you exhale
breathe the possibility of another world
into the 37.2 trillion cells of your body
until it shines with hope.
Then imagine more.
Imagine rape is unimaginable. Imagine war is a scarcely credible rumor,
that the crimes of our age, the grotesque inhumanities of greed,
the sheer and astounding shamelessness of it, the vast fortunes
made by stealing lives, the horrible normalcy it came to have,
is unimaginable to our heirs, the generations of the free.

Don't waver. Don't let despair sink its sharp teeth
into the throat with which you sing. Escalate your dreams.
Make them burn so fiercely that you can follow them down
any dark alleyway of history and not lose your way.
Make them burn clear as a starry drinking gourd
over the grim fog of exhaustion, and keep walking.
Hold hands. Share water. Keep imagining.
So that we, and the children of our children's children
may live.

 🙶 From *Rimonim: Ritual Poetry of Jewish Liberation* (forthcoming)

Will We?

What if we all become apprentice islanders, and learn the things that island people know? What if we learn to be flotsam, to be buoyant? What if we learn to wear tall boots and stay dry? Maybe there will be more ocean and less rain, or maybe the rain will just shift away. Will we become rain nomads, following the clouds like herds? Will we make dryland terraces held in place with old fishing nets and head scarves until the roots take hold? Will we carry water a bucket at a time to sun-bleached industrial tanks and make aquaponic gardens full of fish and water lilies that bloom under desert stars?

What if the people of the tidal zones, the floodplains, the estuaries and archipelagoes expand the ancient arts of rafting? What if we build towns that move with the swells and follow sea turtles along their sea roads? What if we move aside from the paths of hurricanes, anchoring far to the south until they pass, and return to gather the wood of fallen trees and dig our root crops from the muddy ground?

White men who claim to know things say we must abandon the water worlds and move to the polar continental bedrock, but what if we don't? What if we turn back toward the ancient salty home of all life? What if we move toward the rising water instead of running away? What if we lose our cities of steel and stone and become people who live in baskets? What if to save ourselves we float on baskets woven from the leftovers of extraction, plastic drums, polyester shirts, styrofoam coolers, nylon ropes, piled high with compost, and heavy with green growing corn, tomatoes, melons, morning glories?

What if the people of the plains make dreamcatchers that harvest water from the wind? What if we make windmills, dew traps, sun ovens from junkyard cars, tin cans, broken appliances? What if the people of the great inland prairies learn to call rainstorms, make basins and chutes and cisterns, and cherish every drop, lean into the prevailing weather, collect their snowmelt, and in the scorching sun of summer, make islands of shade that rise out of a sea of grass?

What if the people of the high mountains grow quinoa to trade for fish and what if we turn flooded basements into fish ponds and ask mushrooms

and sunflowers to help us clean the soil? *They say that we could hang turbines in the sky, kite-balloons lifting light petals of some sturdy substance that could turn wind, turn jet stream, turn spin into electricity, turn wheels, turn engines. No fossils. Only breath.* What if we did?

What if we befriend pond scum and make our fuels our plastics our waterproof boots from things that grow, and leave the ancient dead to dream in their fossil beds? What if we make our meatloaves from algae and wild leeks?

When the coastal cities begin to drown, will we turn the lower stories of skyscrapers into oyster beds and clam farms, seed coral onto steel frames, make offices into greenhouses, roof gardens into farms, and paddle our boats between towers? Will we make airy bridges between blocks of apartment buildings and live like spiders? Will we grow bee balm and hyssop in every crevice of the cracked concrete and tenderly restore the hives?

What if we never drown in despair, but learn to float?

What if here and now in the death throes of the age of greed, in the fevered ramping up of extraction, with our people falling around us, we crouch around the fire we keep making in a bed of shredded headlines, from the friction of our hopes rubbed like prayer beads between our palms until they spark, and tell each other these stories. What if here and now as the brute force of taking throws us up against the border wall of impossible, we use these stories like chisels to pry apart the stones?

What if these stories are paleochannels running wild under levees and borders, under the fields of monocultured, genetically modified, pesticided industrial crops, maroon rivers full of secret nutrients spilling into the sea of us to feed our plankton, and exhale waves of oxygen so we can breathe. What if these stories steam up from our mouths as we talk, and make big puffy clouds of possibility circling the globe and falling as sweet rain into our upturned thirsty mouths?

Everybody says what if we don't win, what if we don't stop the war in time, what if we can't save each other's lives, what if we can't flip the situation, what if we can't climb the hill of time and roll down the other side, what if we don't make it? Drum of my heart, drum of the world, nothing is lost, water returning, swamp fed, red blooded, shehechianu: the rivers are ancient, but the moment is new, so what if we do? What if we do? What if we do?

🐋 From *Silt: Prose Poems* (2019)

Where to Go from Here

Books (author and coauthor)

Levins Morales, Aurora, and Rosario Morales. *Getting Home Alive.*
Ithaca, NY: Firebrand Books, 1986.

My first book was a collaboration with my mother, Rosario Morales, published in 1986. Weaving the voices of two Puerto Rican women of different generations, mother and daughter, one of us Jewish, this collection of poetry and prose explores many facets of identity, community, political struggle, and cultural celebration. A groundbreaking work in both content and genre, it has been widely excerpted for anthologies and textbooks.

Levins Morales, Aurora. *Medicine Stories.* Cambridge, MA: South
End Press, 1998.

This collection of essays has been the most widely read and used of my books. Accessibly written, both personal and expansive, these essays call out injustice, celebrate connection, and offer hope and empowerment.

Levins Morales, Aurora. *Remedios.* Boston: Beacon, 1998; 2nd ed.
forthcoming.

The core of my doctoral dissertation, *Remedios* retells the history of the Atlantic world through the lives of Puerto Rican women and our kin in prose poetry vignettes. *Remedios* weaves the stories of people known and unknown with the voices of plants and extends from 200,000 years ago to the year of my birth, a vast mosaic of resistance, survival, and healing. The new edition will include an epilogue with pieces covering the years 2016–22.

Latina Feminist Group. *Telling to Live: Latina Feminist Testimonios.*
Durham, NC: Duke University Press, 2001.

In the early 1990s a group of eighteen Latina feminist scholars, with a grant to compare our research on US Latinas, discovered we were far more interested in our own stories. Using the Latin American tradition of testimonio, a kind of social autobiography in which individual lives illuminate social conditions, we turned to the tools of our disciplines on our life stories as Latina feminist intellectuals and artists and modeled a new way of studying ourselves and our society. *Telling to Live* is both a collection of narratives and an epistemology, a theory of knowing.

Levins Morales, Aurora. *Kindling: Writings on the Body.*
Palabrera Press, 2013.

This collection of poetry and prose arose directly out of the material conditions of illness. I needed money to pay for attendant care after a serious back injury and thought I would assemble a chapbook of writings about bodies. Turned out, I had 250 pages of mostly unpublished work about illness and ecology, health and liberation. *Kindling* was among the first disability justice texts, writing that spoke of illness and disability as societal phenomena, intimately linked to oppression—and one of the first written by a woman of color. In it, I weave my personal life story as a sick and disabled, colonized, multirooted Caribbean Jew, with all the struggles and insurgencies of my flesh, into the wider geographies of domination, chronicles, and medicine kits of resistance. *Kindling* is widely used as a disability studies text.

Levins Morales, Aurora, and Rosario Morales. *Cosecha and Other Stories.* Palabrera Press, 2014.

My mother, Rosario Morales, and I were close collaborators for forty years. We wrote our first book together and at some point noticed we each had half a book of stories, both fiction and memoir, and talked about publishing a new collection—but illness and other challenges got in the way. A couple of years after her death in 2011, I decided to go ahead and do that. Five out of the fourteen stories in *Cosecha* deal with death. Five are memoir. Seven are about Puerto Rican families, our own and other people's, and one is about my Jewish

garment-working ancestors. There is a scathing fictional critique of the sexism of the Puerto Rican left, and another story, a memoir, about liberal racism in an elite school. Our stories echo each other, just as much of our writing did for four decades.

Levins Morales, Aurora. *Medicine Stories: Essays for Radicals*. Rev. and expanded ed. Durham, NC: Duke University Press, 2019.

Following the dishonorable demise of South End Press, Duke University Press approached some of South End's authors about reissuing our work with them. Then readers of the manuscript suggested I revise and expand the 1998 collection, and the result is a brand-new book with twenty essays that are new or deeply revised. The essays are written in a personal, lyrical style that bridges the intimate and the global in highly accessible language, and they cover a wide range of topics connected to the work of social justice: the trauma of being oppressed, the centrality of ecology, feminism, identity politics, childhood, antisemitism, racism, class, nationalism, solidarity, and the political importance of joy.

Levins Morales, Aurora. *Silt: Prose Poems*. Palabrera Press, 2019.

This collection, the completion of a project begun in 2005, explores the natural and social landscapes and histories of the Mississippi River system and the Caribbean Sea through the movements of water and all it carries. It's history and ritual, denunciation and invocation, medicine and hope.

Levins Morales, Aurora. *Filigree: A Norma Morales Mystery*. Forthcoming.

Set in 1897, on the eve of the US invasion of Puerto Rico, *Filigree* is about the lasting impact of slavery as a system of sexual as well as racial exploitation. A white woman of an elite family is found dead right after a public quarrel with her brother's Black mistress, Malú. Malú is arrested and Norma, her best friend, sets out, in uneasy alliance with Malú's white lover, to find the real killer, a search that takes her deep into the past, and the hidden histories of violence that underlie the surface of small-town life. The voices of the dead weave through the novel, telling their own stories.

Levins Morales, Aurora. *Rimonim: Ritual Poetry of Jewish Liberation.* Forthcoming.

Over the years quite a few of my poems have found their way into Jewish ritual life. This book started as a response to many requests for more poetry that could be used in ritual and communal spaces. These poems, rooted in tradition and flowering in the present, transform existing liturgy and invent additional spiritual tools to help us meet the challenges of our times. There are poems that follow the cycles of the day, the week, and the year; poems for the mending of the world and the practices of inclusion and care that support that work. My voice is that of a mestiza Caribbean Jew of Color and explicitly braids together all my ancestries, calling in all my global Jewish kin.

Selected Anthologies

1981 *This Bridge Called My Back: Writings by Radical Women of Color.* Edited by Cherríe Moraga and Gloria E. Anzaldúa. Watertown, MA: Persephone Press.

1983 *Cuentos: Stories by Latinas.* Edited by Alma Gómez, Cherríe Moraga, and Mariana Romo-Carmona. New York: Kitchen Table: Women of Color Press.

1988 *The Courage to Heal: A Guide for Women Survivors of Child Sexual Abuse.* Ellen Bass and Laura Davis. New York: Collins Living.

1995 *Boricuas: Influential Puerto Rican Writings—an Anthology.* Edited by Roberto Santiago. New York: One World.

1998 *Las Christmas: Favorite Latino Authors Share Their Holiday Memories.* Edited by Esmerelda Santiago and Joie Davidow. New York: Knopf.

2001 The Latina Feminist Group. *Telling to Live: Latina Feminist Testimonios.* Durham, NC: Duke University Press.

2002 *September 11 and the U.S. War: Beyond the Curtain of Smoke.* Edited by Roger Burbach and Ben Clarke. San Francisco: City Lights.

2003 *Women Writing Resistance: Essays on Latin America and the Caribbean.* Edited by Jennifer Browdy de Hernandez. Boston: South End Press.

2003 *Wrestling with Zion: Progressive Jewish-American Responses to the Israeli-Palestinian Conflict.* Edited by Tony Kushner and Alisa Solomon. New York: Grove Press.

2014	*Alternatives to* EMS *Anthology.* Rosehip Medic Collective.
2017	Jewish Voice for Peace. *On Anti-semitism: Solidarity and the Struggle for Justice.* Chicago: Haymarket Books.
2022	*Mapping Gendered Ecologies: Engaging with and beyond Ecowomanism and Ecofeminism.* Edited by K. Melchor Quick Hall and Gwyn Kirk. Lanham, MD: Lexington Books.
2025	[anti-Zionist theology anthology]
2025	*Beauty Is a Verb*

Periodicals

1977	"Monense." *Revista Chicano-Riqueña.*
1991	"Dancing on Bridges." *Bridges* 2 (1): 42–43.
1992	"First but Not Least." *The Women's Review of Books.*
1992	"Fragments of a Broken History: The Women of Boriken." *The Women's Review of Books.*
1992	"Tsu Got Vel Ikh Veynen." *Bridges* 3 (1): 74–77.
1996	"Migration: The Story I Call Home." *Diálogo.*
1996	"Nadie la tiene: Land, Ecology and Nationalism." *Bridges* 5 (2): 31–39.
1997	"Patria y Muerte: Nationalism, Women and Suicide." *The Women's Review of Books.*
2004	Featured poet in spring issue of Poetrymagazine.com.
2008	"Thinking Outside the (Ballot) Box." *Z Magazine.*
2010	"chicken house goat girls." *Yellow Medicine Review.*
2011	"Straddling Worlds, Bringing Your Whole Self." With Margaret Randall. *Bridges* 16 (1): 44–50.
2012	"Chiripismo: A Thrivalist Strategy for the Sick and Disabled." *Communities.*
2013	"Guanakán." *nineteen sixty nine: an ethnic studies journal* 2 (1). https://escholarship.org/uc/item/8pj3f4qt.
2015	"Sovereign Waters: Queer and Womanist Indigenous Reflections on Water: An International Indigenous Roundtable Discussion." *Hawai'i Review*, no. 81, 13–29.
2017	"The Aftermath of Hurricane Maria Is a Chance to See Puerto Rico Clearly." *Buzzfeed*, October 3.
2021	"Radical Inclusion." *Evolve*, Reconstructing Judaism, March 12.
2022	"Fatigue #1." *Zoeglossia*, February 28.

Supporting Aurora's Work

I am a community-supported writer. I do not have a salary from any institution, and I don't have the physical capacity for sustained work or travel. My politics, and the ways in which I trouble the boundaries of genres and styles, make it hard for me to get grants and fellowships, which are also very labor intensive to apply for. One of the ways I'm maintained by community is through Patreon, a funding platform for artists that collects small monthly donations from supporters. This is also the best way to learn about new projects and read unpublished material. Larger donations can be made through my fiscal sponsor Fractured Atlas. We are in the process of setting up an old-age trust to sustain me for what I hope will be the next twenty or twenty-five years. You can join my mailing list or Patreon to be informed about developments.

PATREON

https://www.patreon.com/auroralevinsmorales

FRACTURED ATLAS

https://fundraising.fracturedatlas.org/aurora-levins-morales

MAILING LIST

http://www.auroralevinsmorales.com/join-my-mailing-list.html

Index

power relationships, revealing hidden, 135–36

"Prayer for White Allies," 182, 211–12

"pretendians," 4

privilege, 2, 26–28, 80–81, 83, 225, 227, 262, 316, 363, 383, 384, 386–88, 394

"Prologue to *Filigree*," 287–89

PROMESA Act, 109, 117n1

"Prophecy," 377

prophecy, 377–78, 379

proxies, 387

psychiatry, 236

PTSD, 13

Puebla, bishop of, 276

Puerto Rican culture, 3, 7

Puerto Rican diaspora, 18, 173; culture of, 3; literature of, 11–12, 318

Puerto Rican garment workers, 269, 280–81

Puerto Rican heritage, 224–25

Puerto Rican identity, 25, 130, 325, 387, 390

Puerto Rican independence movement, 59

Puerto Rican labor movement, 130

Puerto Rican nationalists, 76–77, 281, 308

Puerto Rican resistance, 311–14

Puerto Rican Socialist Party, 10

Puerto Rican Syndrome, 33

Puerto Rican women, 13; garment workers, 269, 280–81; history of, 4–5, 12, 44, 46, 128–30, 135–38, 159, 161–64, 262–63; labor of, 135–37, 269, 280–81

Puerto Rico, 61–63, 172–73, 284, 287–89, 315, 372–75; childhood in, 7, 12, 23, 48–53, 69–70, 121, 383; climate violence in, 394; conquest of, 132; Cuba and, 307–10; cuisine of, 136–37; ethnicity in, 162–63; food shortages in, 116; freedwomen of, 269, 273–74, 278–79; garment workers in, 280–81; history of, 3, 44, 298–306; Hurricane Fiona and, 19; Hurricane Maria and, 18, 174–76, 378; Indigenous identity and, 14; Medicaid in, 116; medical experimentation in, 110, 117n2; medicinal history of, 128–29; nationality in, 130;

Navidades in, 48–53; poverty in, 163–64; PROMESA Act and, 109; rematriation to, 1–2, 109–17; slavery in, 162–63; US invasion of, 141, 263–64; women of, 269–70, 275, 278–79, 298–306. *See also specific locations*

Puerto Rico women's history, 20

Pulse nightclub massacre, 18, 378, 396–97

questions, asking, 132–33

"Questions for the Media," 160, 177–78

Quilapayún, 9

race, 11, 227–28; race riots, 394; teshuvah of, 227

racial justice initiative, 182, 223–28

"Racial Justice Invocation," 228

racism, 85, 223–25, 385–86, 387

"Radical Inclusion," 182–83, 223–28

Radio Havana, 308

Radnóti, Miklós, 252–53

Raffo, Susan, 19

"Rain," 328–29

rape, 11, 59, 262–68

rape culture, 11

reciprocity, call for, 169–71, 190

Reconquest, 45

Reconstructing Judaism, 182–83, 223–28

Reconstructionism, 223–28

Red Cloud, 359

redlining, 386

Red May, 309

refrain, 6

Reiter, Joel, 99

rematriation, 1–2, 109–17, 373

"Rematriation: A Climate Justice Migration," 63, 109–17

Remedios, 6, 141, 159, 181, 183, 232, 377; as medicinal history, 13–14, 269–70; new edition of, 19; as testimonio, 128–29; writing of, 44

"Remedy for Heartburn, A," 182, 217–22

Rendon, Marcie, 183, 213

repetition, 6

repetitive strain injury (RSI), 15

resistance, 13, 35, 126, 181; communal, 227; culinary, 181, 191–97; heritage of, 47; history of, 134–35; landholding and, 79; to male domination, 182, 198–210, 217–22

"Resurrection," 329, 365

"Revision," 159, 161–64

Rhoades, Cornelius P., 117n2

rhythm, 6

Rice, Condoleeza, 148–50

Rich, Adrienne, 8

Rimonim Project, 18, 19

Rimonim: Ritual Poetry of Jewish Liberation, 6, 182–83, 229–31, 377, 379

Rincon, Diego, 347–52

Río Cubuy, 372

ritual, rebellious, 6

River Road, 359

Robert Frost Place, 9

Robles, Naiomi, 19

Rodríguez, Krys, 113

Rodriguez, Silvio, 9

Roselló, Ricky, 117n3

Rosh Hashana, 328, 329

Roundup, 116

Russell, Diana, 11, 59

Russia, 388

Russian Empire, 383

"Sacrifice Zones," 160, 179–80

Sakhnin family: Abraham, 76, 249, 282–83, 285–86, 384; Alter, 76; Basi, 249; Basya, 249; Boris, 250; Fira, 249; Gitl, 249; Hershel, 250; Leah, 249; Musia, 250; Perl, 250; Riva (Rivieka), 248, 249; Samuel, 249

"Salt," 236, 237

Sand Creek, 358–59

San Francisco, California, 9, 59, 269

San Juan, Puerto Rico, 141, 162, 287–89, 302, 304

Santa Rosa, California, 18

Santiago, Zoraida, 9

Sauck, 256

science, art and, 121–25. *See also* ecology

scriptwriting, 10

seizures, 15

self-defense, 98, 100, 309

Seminoles, 122

Seneca, 358

Sephardim, 20n2, 227

September 11, terrorist attacks of, 144–47, 237–40, 328, 339–46

sermons, 391–95

settler colonialism, 3, 225–26, 229–31

sexism, 167–68, 169–71

sex trafficking, 44, 46–47, 61, 102, 244–45, 262–68

sexual abuse, 32

sexuality, 6; disability and, 235–36, 241–43; sexual orientation, 84–85

sexual violence, 11, 15, 23, 87, 262–68

Shakespeare, William, 9, 131, 136, 141

shaping this book, 5–6

Sha'wano'ki, 358

Sheehan, Donald, 9

Shema, 145–46, 328, 339–46

"Shema: September 12, 2001," 14, 145–46, 328, 339–46

Shevelev, Henke, 283

Shevelev, Leah, 249, 282, 283

Shevelev family, 250. *See also specific family members*

Shoah, 385

Shoshone, 256

showing yourself in your work, 142–43

"Silt of Each Other," 328, 353–55

Silt: Prose Poems, 6, 14, 16, 19, 179–80, 270, 328–29, 356–62, 378

"*Silt* Sequence," 328–29, 356–62

Sins Invalid, 16, 23, 241–43

Sixth Pan American Congress, 301

slaveholding, 75

slavery, 13, 44, 45, 126, 162–63, 186, 191, 194, 263; abolition of, 223, 278; escapees from, 102, 121; Great Lakes, 102

slave ships, 256

slave trade, 162–63

"Slichah for a Shmita Year," 329, 366–67

Smith, Andrea, 263

social injustice, 33

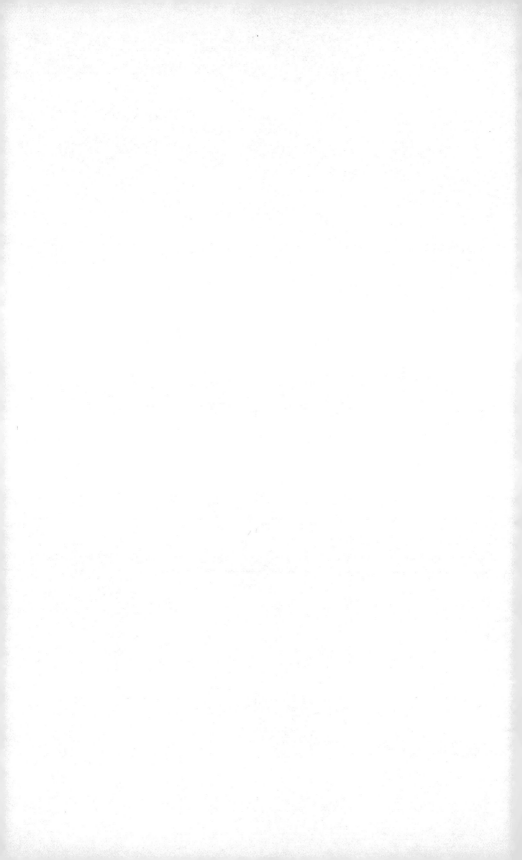